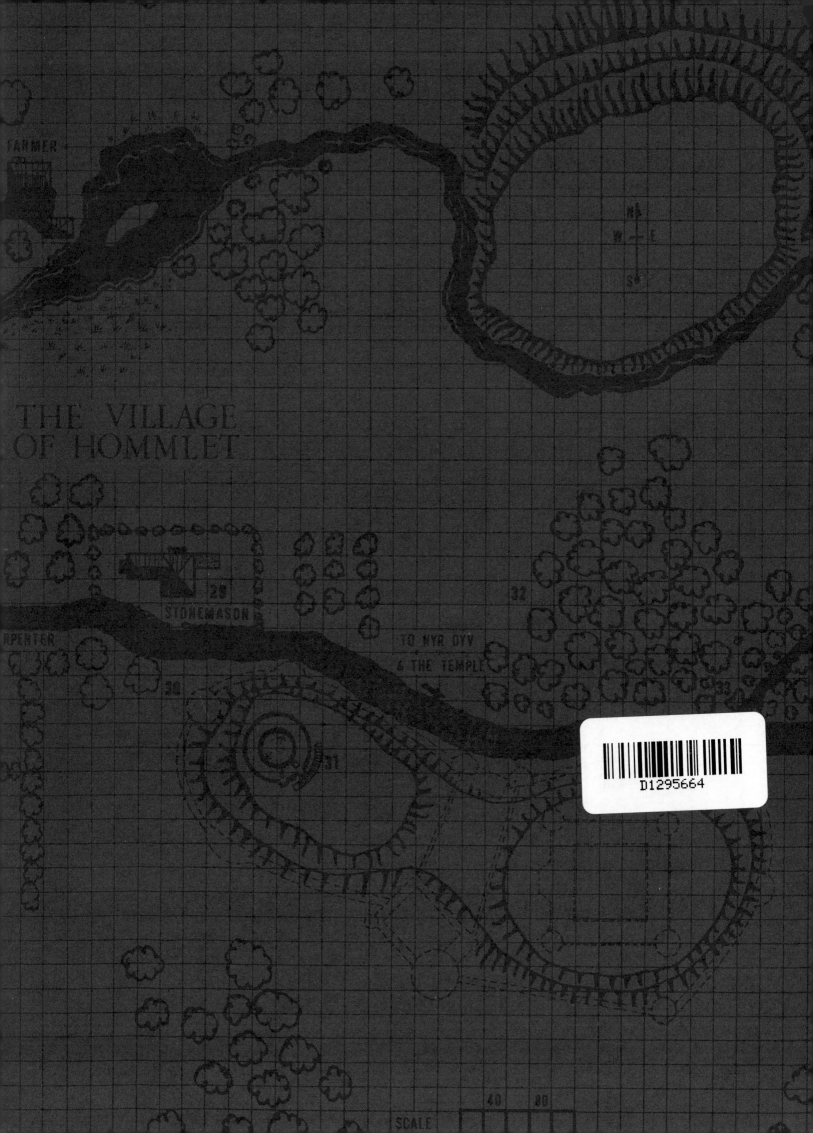

THE VILLAGE
OF HOMMLET

DUNGEONS & DRAGONS®
ART & ARCANA

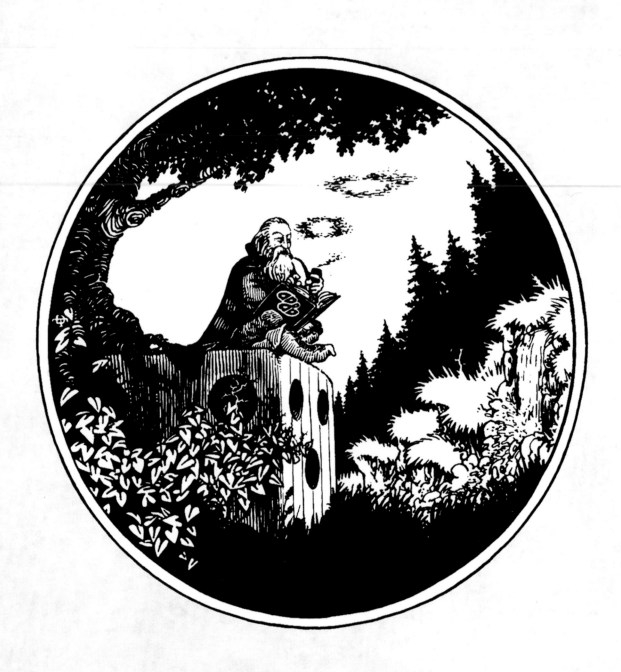

DUNGEONS & DRAGONS®

ART & ARCANA

A VISUAL HISTORY

A COMPILED VOLUME OF INFORMATION AND IMAGERY
FOR LOVERS OF **DUNGEONS & DRAGONS**, INCLUDING ART,
ADVERTISING, EPHEMERA, AND MORE.

MICHAEL WITWER • KYLE NEWMAN • JON PETERSON • SAM WITWER

TEN SPEED PRESS
California | New York

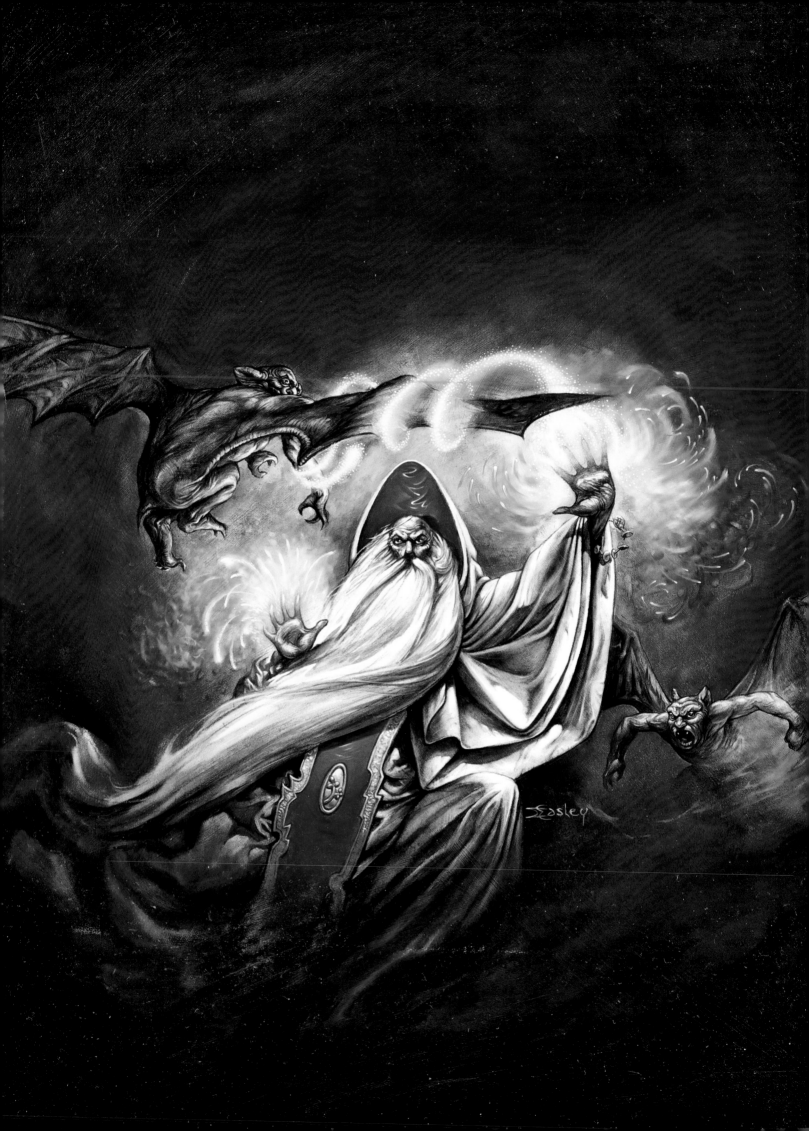

CONTENTS

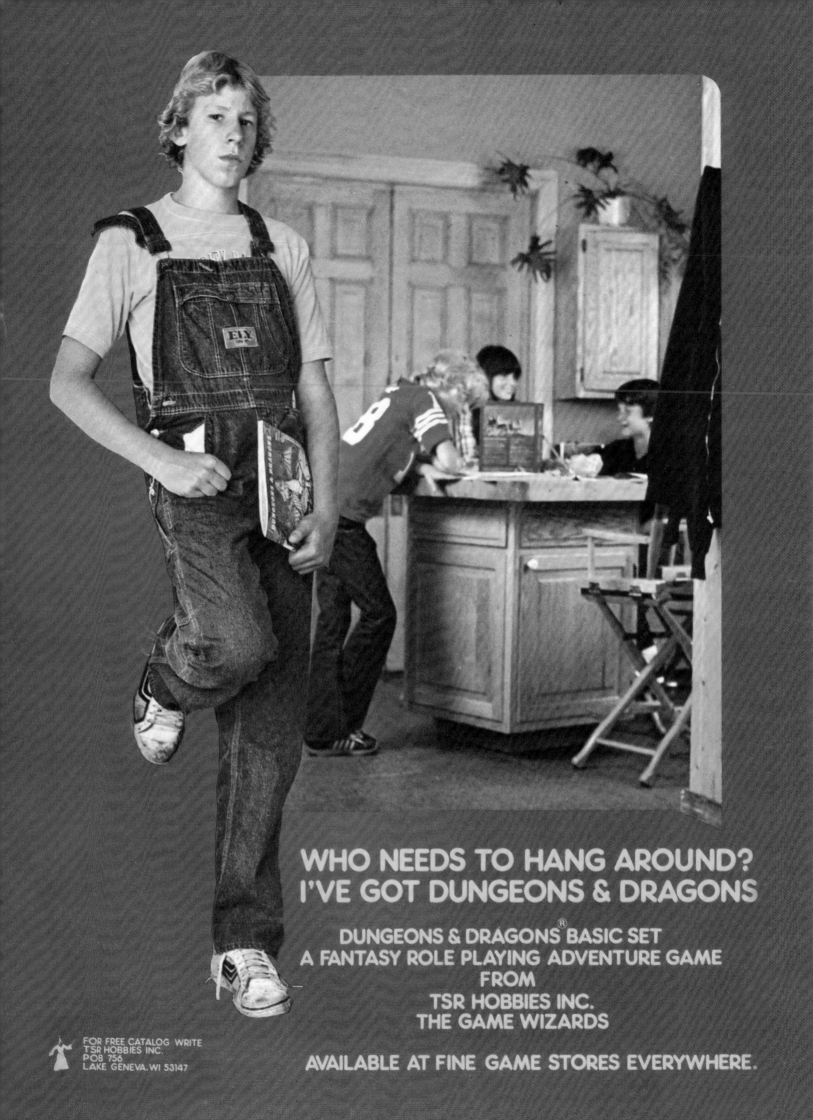

FOREWORD

BY JOE MANGANIELLO

I GREW UP IN the 1980s, and despite what *Stranger Things* would have you believe, in those days, Dungeons & Dragons wasn't cool. In fact, mentioning it at all opened you up to various forms of societally accepted ridicule and potential physical altercations. Like I said, this was the eighties, an era when anything that didn't look like it belonged at a yacht party was deemed Satanic. Apart from Ozzy Osborne, a man who once bit the head off of a live dove in a business meeting, I'm not sure anyone or anything bore a stronger or more unfair stigma than Dungeons & Dragons.

Enter young me: a tall, skinny yet athletic, and excruciatingly nerdy kid. I became obsessed with all things fantasy from the first time the chime told me to turn the page of my little *Hobbit* record book. That *Hobbit* record was my gateway drug to tracking down everything one needed to play Dungeons & Dragons, but for the aforementioned reasons, I had no one to play with. So, I stocked up on all of the *Choose Your Own Adventure* and *Super Endless Quest* books I could find and resigned myself to staring down the soulfully sentient eyes of Larry Elmore's magnificent, red dragon as I tried to trick myself into forgetting I'd played the adventure inside the red box—solo— a dozen times already.

Then, one fateful day at the bookstore, my eye caught a familiar art style gracing the front of several novels in the fantasy section. They were *The Dragonlance Chronicles* by Margaret Weis and Tracy Hickman, with cover art by none other than TSR's Larry Elmore. I purchased all three books at once and absolutely devoured them, and then did the same with the next three, and then the next twenty or so books after that. I read them so fast that I ultimately turned to shoplifting them in order to support my habit. (I actually went back twenty years later and repaid the bookstores for what I took, and I have subsequently apologized to Margaret and Tracy.) It was during this phase that a schoolmate named Bill Simons noticed me reading one of the novels and revealed his shared love for the books. Bill was the one who introduced me to the rulebooks and artwork of Advanced Dungeons & Dragons and the playable Dragonlance adventure modules. It was a revelation. My eyes were opened to the legendary artwork from masters like Clyde Caldwell, Todd Lockwood, the great Erol Otus and his iconic *Deities & Demigods* cover, and the visionary Jeff Easley, whose paintings are what most people have, for decades, pictured when they think about D&D (that is until very recently, when modern D&D artist Hydro74 and his otherworldly limited edition covers for 5th edition supplements *Volo's Guide to Monsters* and *Xanathar's Guide to Everything* proved that the look of the universe is perpetually expanding).

As Dungeons & Dragons has evolved, so has the look of the game. And that's exactly what *this* book is all about. Within these pages you will find the most complete history of Dungeons & Dragons ever assembled: a book that's long overdue but one that's lacked the proper perspective until now. In the last fifteen years, there's been a major cultural shift. We now live in a world in which *The Lord of the Rings* trilogy amassed three billion dollars at the box office and garnered seventeen Academy Awards including Best Picture, while *Game of Thrones* continues to dominate at the Emmys and Golden Globes.

This 1980 ad was ostensibly TSR's answer to the stigma that D&D was exclusively for geeks, suggesting instead that playing the game and being cool were compatible.

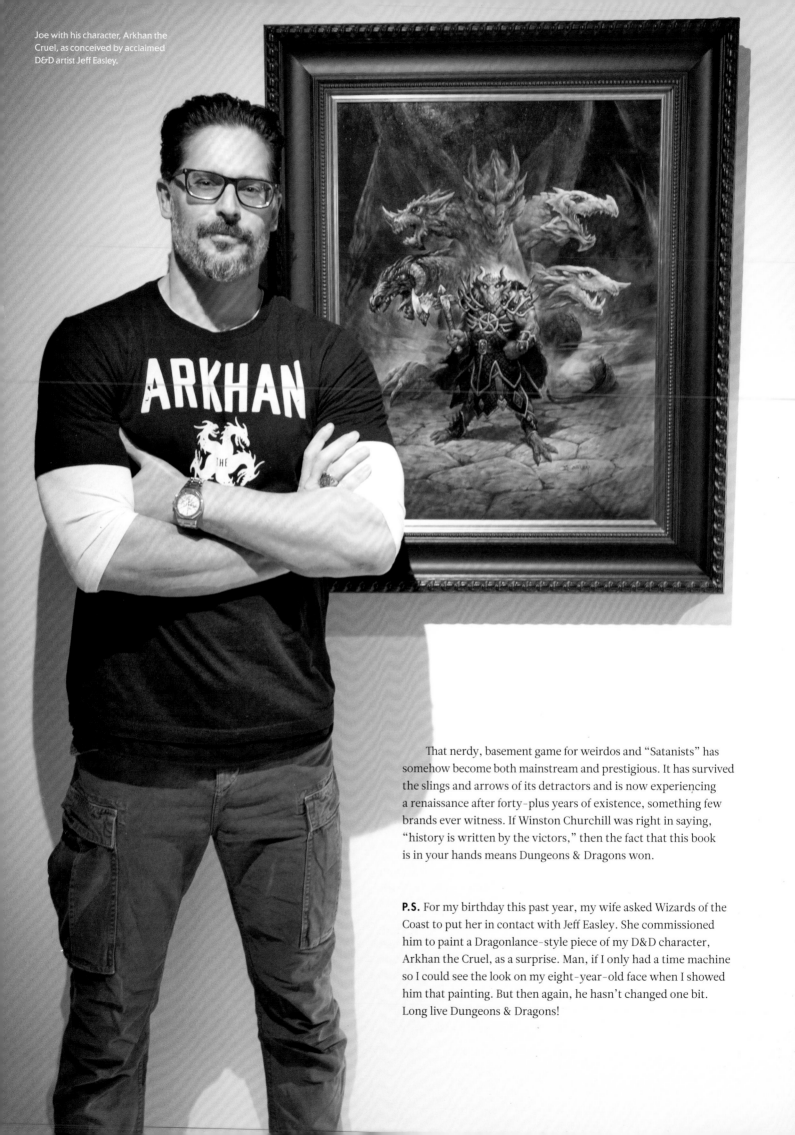

Joe with his character, Arkhan the Cruel, as conceived by acclaimed D&D artist Jeff Easley.

That nerdy, basement game for weirdos and "Satanists" has somehow become both mainstream and prestigious. It has survived the slings and arrows of its detractors and is now experiencing a renaissance after forty-plus years of existence, something few brands ever witness. If Winston Churchill was right in saying, "history is written by the victors," then the fact that this book is in your hands means Dungeons & Dragons won.

P.S. For my birthday this past year, my wife asked Wizards of the Coast to put her in contact with Jeff Easley. She commissioned him to paint a Dragonlance-style piece of my D&D character, Arkhan the Cruel, as a surprise. Man, if I only had a time machine so I could see the look on my eight-year-old face when I showed him that painting. But then again, he hasn't changed one bit. Long live Dungeons & Dragons!

INTRODUCTION

IF IT'S TRUE THAT we live in an era when it is "chic to be geek," then Dungeons & Dragons is just about the coolest thing out there. It was, it is, and it always will be the game of the geeks, but its fandom is no longer so neatly contained. Once an esoteric diversion known only to a small but passionate group of wargamers, the game and the foundational concepts that it brought forth became among the most influential phenomena of the Information Age. The reason? The game's earliest adopters happened to share an interest in other "geeky" things like computers, electronics, digital technologies, visual effects, filmmaking, performing arts, and beyond. These geeks grew up to develop the social and business infrastructure of the twenty-first century using concepts they had once learned on poorly lit tabletops set in dining rooms and basements. Dungeons & Dragons, according to *Wired* editor Adam Rogers, "allowed geeks to venture out of our dungeons, blinking against the light, just in time to create the present age of electronic miracles." It is indeed chic to be geek, and the prophesy has finally been fulfilled: the geek shall inherit the Earth (and the parallel D&D world of Oerth).

Today, if you are one of the millions of subscribers to an MMO (massively multiplayer online game) such as *World of Warcraft*; a tourist in the exotic worlds of a computer role-playing franchise such as *Final Fantasy* or *The Elder Scrolls*; a virtual marksman in any first-person-shooter video game; a lover of modern fantasy television, films, or literature such as *Game of Thrones*; or even anyone who has ever "leveled up" in a game or rewards program, then you have Dungeons & Dragons to thank. Simply put, D&D has either directly or indirectly influenced them all. John Romero, co-creator of the seminal first-person-shooter *Doom*, attributes his success to D&D, calling it "the most influential game," adding that "the gaming concepts put forth by D&D inspired the earliest groups of gamers and computer programmers, and set into motion a revolution of creative and technical innovation." The numbers of actors and directors who credit the game with providing them inspiration is immense, from Vin Diesel and Stephen Colbert to Rainn Wilson and the late Robin Williams. Celebrated director Jon Favreau suggested the game gave him "a really strong background in imagination, storytelling, understanding how to create tone and a sense of balance." National Book Award-winner Ta-Nehisi Coates agrees, suggesting the game helped introduce him to "the powers of imagination." All this is to say, the story of D&D is as important now as it has ever been, and with the recent success of 5th edition and an array of D&D-inspired blockbuster books, shows, and films surfacing, from *Ready Player One* to *Stranger Things*, its history will become increasingly visible and relevant.

Nothing conveys the story of D&D better than its visuals. At a time when fantasy and science fiction were, at best, fringe diversions, D&D was creating a culture of do-it-yourself fantasy

world-building through its immersive narrative environments, given life by its ever-evolving illustrations and artwork. It depicted monsters, magic, swords, and sorcery in a way that taught fans a visual vocabulary of the unreal, fixing in the minds of a whole generation how to picture the fantastic. The relationship between Dungeons & Dragons and its artwork goes beyond symbiosis, but to outright reliance—one simply couldn't exist without the other. The art informed the game, and the game informed the art.

Beginning as amateur, homebrew sketches used to illustrate to the initiated simple concepts such as maps and the physical appearance of monsters, characters, and weapons, the art of D&D rapidly became an essential teaching tool as the game reached wider audiences less familiar with some of its fundamental concepts. The illustrations quickly had to become instructional in nature, helping players to not only conceptualize the landscapes, inhabitants, and equipment of the imagined world, but even how to use them in the context of the game. Soon the game and its fandom demanded even greater levels of sophistication—full color artwork with higher and higher levels of character and composition. This movement gave way to a wave of master artists who eventually developed the most important and influential fantasy art from the late 1970s to today—a collection simply unsurpassed in the fantasy genre.

The book you are holding is the dynamic story of this incredible game as told through its incomparable imagery, as well as the story of the visuals themselves. It is a carefully curated selection of art, advertising, and ephemera that we feel best represents D&D's incredible forty-plus-year journey—a visual archive that tells a remarkable story of evolution, innovation, turmoil, perseverance, and ultimately triumph. While we expect that much of the enclosed imagery will be at least remotely familiar to D&D aficionados, the collection that follows includes numerous one-of-a-kind rarities, many of which have never been released to the public. We truly hope that you enjoy what you read and see, and that you as readers might approach this piece the same way we did—with unadulterated passion and a taste for adventure. After all, this is an adventure module of sorts, one that is intended for you personally, just as it has been for each of us. "So enjoy, and may the dice be good to you!"

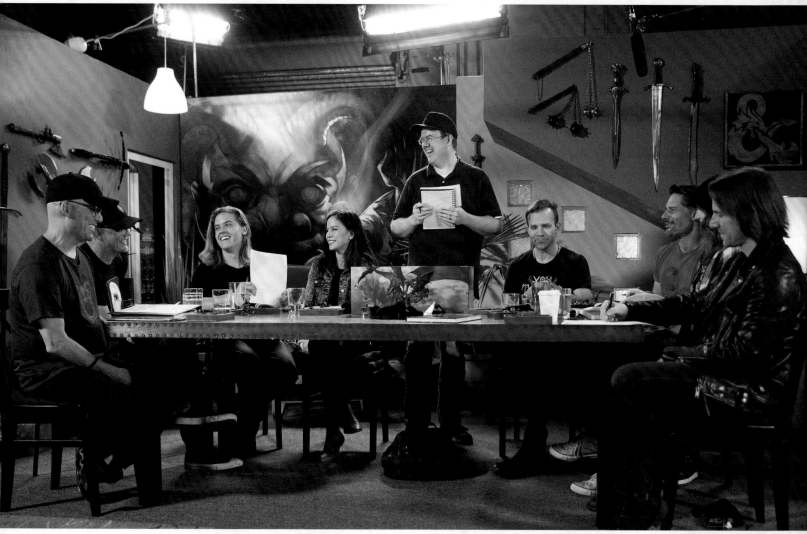

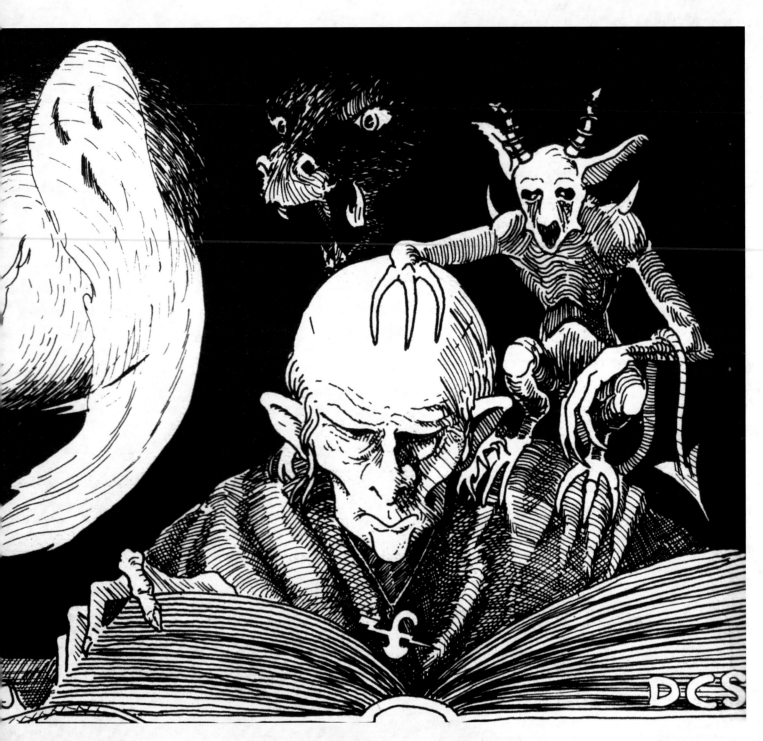

A Dave Sutherland panel from the 1978 *Players Handbook* featuring a magic-user studying with his quasit familiar.

READ MAGIC
ABOUT THIS BOOK

Covering forty-five years of art, advertising, and ephemera of the greatest game on Earth is a formidable task and one that requires an appropriately comprehensive approach. To this end, we have endeavored to provide as many of angles, flavors, and perspectives as possible to match the diversity of the visual archive itself. Here are a few devices we used to unlock this narrative (beware of traps!).

THE STORY

D&D is a game of stories. Stories you read, stories you tell, and stories you play. But D&D itself has a story all of its own, and one that is true, though often stranger than fiction. The bulk of this book is written as a chronological narrative and this "standard text" appears on pages without a special theme or design. Here, we endeavor to cover all of the most important developments, events, and products in the game's history, and the arrow of time moves only one direction: forward.

ARTEOLOGY

D&D is a game of visuals. When it comes to the art of D&D, there is always a notable influence or a story behind the story being told on the canvas. Many times these influences or stories are lost to history, but sometimes we're lucky enough to capture them. *Arteology* is a recurring callout feature intended to provide analysis, commentary, or other background information behind a piece of art, an artist, or a movement.

ARTIST FAVORITE

D&D is a game of artists. From homebrew doodlers to classically trained masters, the artists of D&D have given the game its uniform platform for discovery and imagination. While there are simply not enough pages to truly give each artist their due, there's nothing more telling about an artist than the piece that they choose as their best. This emblem signifies the pieces that each artist has chosen as their single favorite or one of their favorites, and they're often not the pieces you would expect.

DEADLIEST DUNGEONS

D&D is a game of dungeons. Of course, dungeons come in many shapes and sizes, but one thing they all have in common is that they are places of peril. Unsurprisingly, in the D&D universe the more dangerous the dungeon, the more beloved and iconic. *Deadliest Dungeons* is a repeating feature where we provide some brief background and imagery on a few select examples, and generally tip our helms to these veritable death traps.

EVILUTION

D&D is a game of monsters. Nothing defines the game quite like the bizarre and grotesque creatures it introduced into our world, while also quantifying and reimagining countless others. These recurring features show the evolution of iconic D&D monsters through the various editions.

MANY FACES OF . . .

D&D is a game of characters. Whether they are player-generated characters or come from modules, novels, or beyond, the D&D world is teeming with heroes and villains. *Many Faces Of . . .* is a periodic feature that pays homage to iconic D&D characters and shows their visual evolution through the years. Sometimes a character was rendered by several different artists in a single work or time period, while others have been reincarnated and reimagined numerous times over the decades.

SUNDRY LORE

D&D is a game of ideas. Sometimes these ideas package nicely into tables or charts; sometimes they require sprawling narratives or even interdimensional planes. The story of D&D also has some ideas that are not always easy to explain or summarize. In these cases, we have developed a number of encapsulated features that endeavor to cover an entire theme or movement all at once. These features bear a separate page design and cover major movements in D&D history, from campaigns and miniatures to movies, computer games, and beyond.

A NOTE ABOUT DATES: While the artwork development date and actual publication date for a given product can vary significantly, as a matter of convention, we use product copyright dates as the functional dates of both the products as well as their associated artwork.

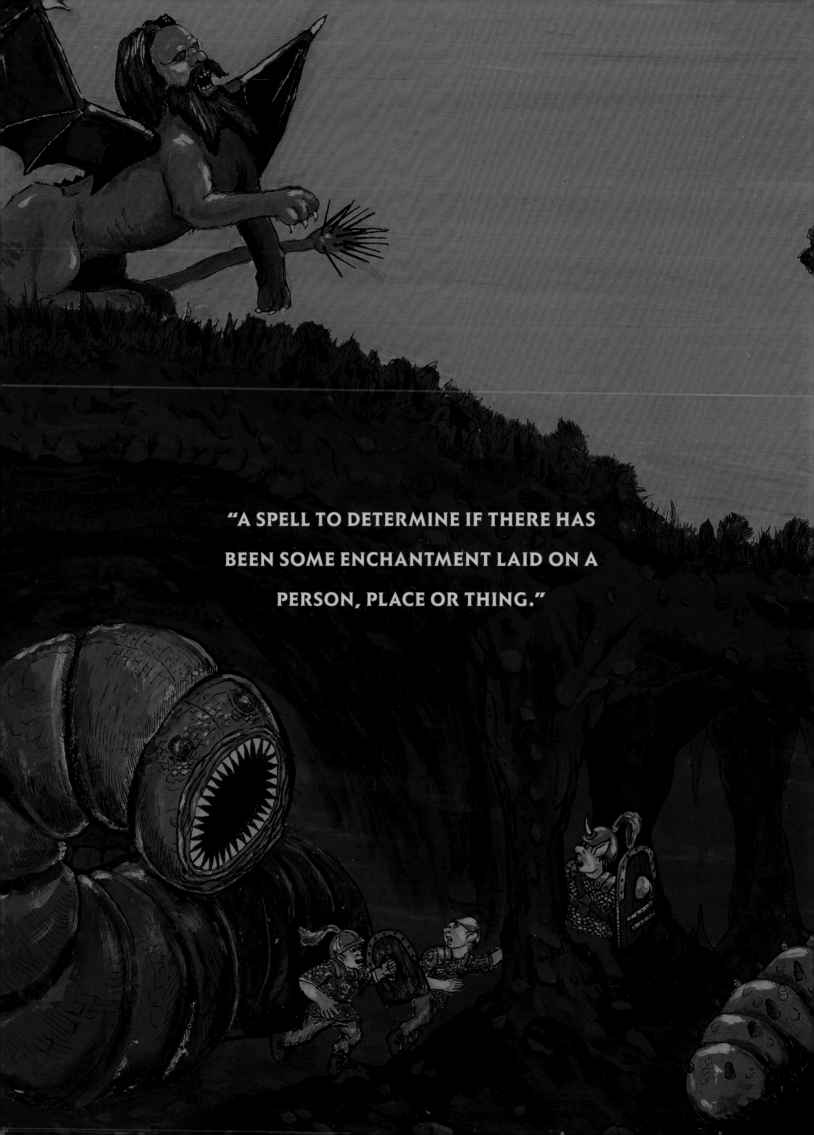

"A SPELL TO DETERMINE IF THERE HAS BEEN SOME ENCHANTMENT LAID ON A PERSON, PLACE OR THING."

DETECT MAGIC

ORIGINAL EDITION

DUNGEONS & DRAGONS

Rules for Fantastic Medieval Wargames Campaigns Playable with Paper and Pencil and Miniature Figures

GYGAX & ARNESON

3-VOLUME SET

PUBLISHED BY
TACTICAL STUDIES RULES
Price $10.00

OPPOSITE Perhaps the world's best-preserved example of the first printing of Dungeons & Dragons, one of the original one thousand "brown boxes" hand-assembled in dining rooms and basements by co-creator Gary Gygax and his partners and family in 1974.

BELOW Where it all began: the three original Dungeons & Dragons rules booklets.

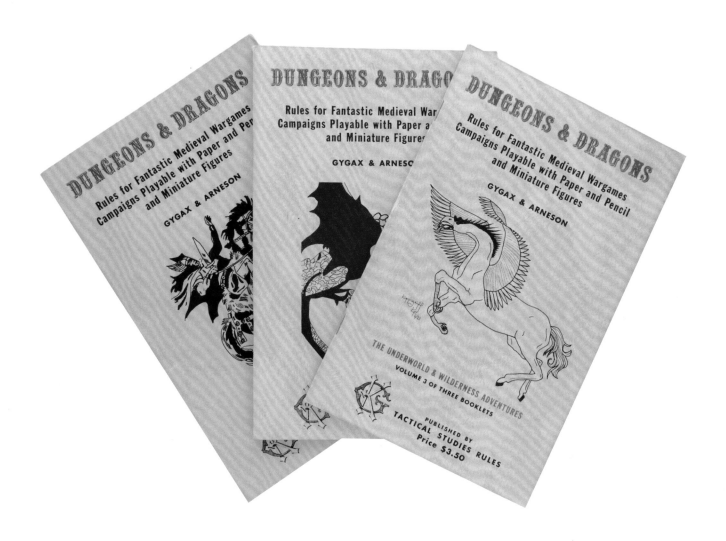

IT ALL STARTED with one thousand curious boxes marked with unfamiliar symbols and verbiage. Throughout 1974, they slipped into the hands of an unsuspecting public, most arriving by mail, though a few were sold on shelves if you knew where to look. No one would mistake their woodgrain casing for an actual treasure chest made of oak, but their cardboard walls nonetheless contained treasures. Who could have foreseen, when they lifted the lid, the adventures that would burst forth? The cover legend promised "Rules for Fantastic Medieval Wargames Campaigns" inside, where three digest-sized booklets vowed to tutor readers on *Men & Magic*, *Monsters & Treasure*, and a revolutionary way to experience *Underworld & Wilderness Adventures*.

Dungeons & Dragons is not necessarily something you look at while you play it, the way you stare at a board game or video game. The three slim rulebooks in the Dungeons & Dragons box taught the world how to turn a spoken conversation into a fantasy adventure game, one you could pretty much play with your eyes closed. A Dungeon Master, or "referee" as was the original vernacular in 1974, describes to the players the situation that their characters face in a shared imaginary world, and players respond by proposing actions for their characters to attempt. The Dungeon Master and players take turns crafting action statements, cooperatively riffing off and strategizing against each other—each trying to outsmart the other—appending snippets to a story they are telling collectively. Because this all happens through spoken words, players had little need for a board or pieces they could see and touch: D&D came to life in the imagination of participants.

But read the fine print on the box cover: the game promises to be "playable with paper and pencil and miniature figures." That last element—miniature figures—is where the visual history of D&D begins.

> "I get all the relaxation I want from my collection of model soldiers . . . I like to play 'war,' a game invented by H.G. Wells, himself a collector."
>
> —PETER CUSHING

LITTLE WARS, BIG IDEAS

In 1913, noted British science-fiction author H.G. Wells published an influential rulebook titled *Little Wars*. The basic principles of Wells's rules allowed gamers to fight battles with the lead miniature figures found in British nurseries of his time: toy soldiers modeled after the infantry, cavalry, and artillery of nineteenth-century warfare. However, before Wells released his game, some adult hobby communities had already collected these same figures to arrange them in dioramas depicting the great battles of military history, and it was only natural for these same hobbyists to repurpose their still-life scenes into dynamic games of strategy and tactics.

Inspired by Wells, a small but dedicated community of British tabletop wargamers emerged, staging increasingly elaborate battles with toy soldiers. Like diorama building, it was a visual pastime: a miniature wargame is necessarily something that you look at. The whole point of using toy soldiers, instead of the abstract tokens one might push around the flat segmented maps of most board games, was to re-create the appearance of an actual war. Determined players would build elaborate three-dimensional terrain of a battlefield where mighty armies would meet, incorporating scale-model trees, or houses, or hills—anything to add to the illusion. Their first and most urgent question about a battle was always, "What would it look like?" Meaning, what did people wear, which weapons did they wield, and what was the landscape like where they fought? The process of designing, casting, and painting miniature figures for wargaming involved diligent research into the historical period of the battle to learn the proper look of uniforms, armaments, and vehicles. The pastime appealed to retired veterans and other civilized British gentleman, so re-creating these battles was taken seriously, and accuracy was paramount.

By the 1950s, miniature wargaming had developed into an organized American hobby, with fledgling conventions and newsletters dedicated to gaming culture. Companies like Avalon Hill vastly expanded the hobby by selling mass-market board games, such as *Gettysburg* (1958), which were based on the same principles but marketed to a younger, more general audience. Originally, wargame fans mostly fought battles set between the Napoleonic and the modern era, staging their own conflicts from *Waterloo* to *D-Day*. But, by the 1970s, there was also a burgeoning market of miniatures inspired by the medieval era: castles, hordes of armored troops, foot soldiers, mounted knights, and equipment like swords, bows, pikes, axes, and more. This wealth of raw material begged for a printed set of medieval wargaming rules.

A thirtysomething Midwestern insurance underwriter and fanatical wargamer named Gary Gygax rose to that calling. Gygax was extraordinarily active in the national wargaming scene; he was an officer in the largest clubs and frequent contributor to an array of wargaming newsletters, but he also became an advocate of local gaming activity in his quaint Wisconsin hometown of Lake Geneva. In 1968, he held a gathering at the local horticultural hall of nearly one hundred gamers called the Lake Geneva Wargames Convention, which would soon become known as the Geneva Convention, or "Gen Con" for short. It was at this first Gen Con event that Gygax stumbled onto a game called the *Siege of Bodenburg*, which stoked his interest in medieval wargaming. He subsequently wrote, "There is a great interest in wargames of ancient and medieval times but few games are published." Two years later, he founded in his hometown a small, general-interest wargaming club called the Lake Geneva Tactical Studies Association (LGTSA). By this time, Gygax had proved to be a champion of all things wargames, as few people at the time had gone to such trouble to connect to the disparate American wargaming community, made up mostly of teenagers with modest budgets. He also possessed the requisite passion, which is all the compensation that could be hoped for—almost no one made enough money from wargaming to make a living.

In 1970, Gygax founded a second, more specialized interest group, composed of just a few dozen subscribers, called the Castle & Crusade Society, with a mission to publish and perfect miniature wargame rules for the Middle Ages. In collaboration with a fellow LGTSA member and medieval enthusiast, college-aged Jeff Perren of Rockford, Illinois, Gygax designed a set of rules for infantry and cavalry combat that drew heavily on historians such as C.W.C. Oman as authorities on how people fought in the period.

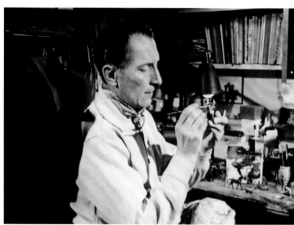

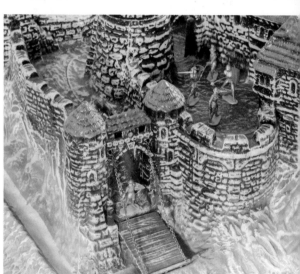

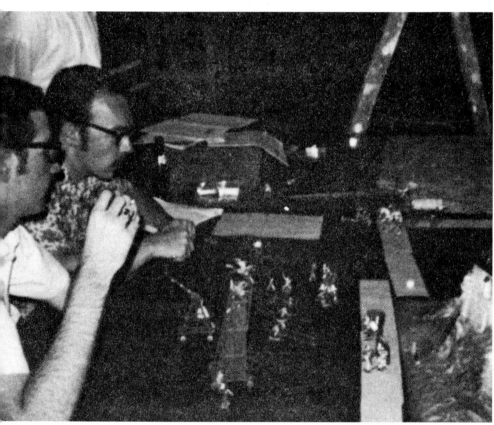

Castle & Crusade
DOMESDAY BOOK

NOTHING PRINTED THAT IS NEWER THAN MEDIEVAL!

STORY*HERALDRY, ARMS*ARMOR, BATTLES* BATTLE REPORTS, MAPBOARD GAMES*MINIATURES and ever
NTASY are covered in the pages of this journal of the CASTLE & CRUSADE SOCIETY of IFW.
mbership is only $2.00 for IFW members ($3.00 for others). To join, or for further in-
rmation, contact; Gary Gygax, 330 Center St., Lake Geneva, Wisc. 53147

Chainmail
rules for medieval miniatures
by
Gary Gygax & Jeff Perren

GUIDON GAMES
"WARGAMING WITH MINIATURES"
WM101-200

CRESCENT AND CROSS

But to visualize these conflicts, Gygax turned to popular historical illustrators like Jack Coggins, whose book *The Fighting Man: An Illustrated History of the World's Greatest Fighting Forces* contained a chapter heading with an image of a mounted crusader. Coggins answers the question "What did it look like?" for us: he shows us a mounted swordsman wearing a metal helmet and chainmail about to strike at foot soldiers who awaited the blow with shields and spears.

Perren and Gygax each drew their own copies of that Coggins illustration in 1970 for preliminary articles about their medieval miniature rules, which appeared in obscure venues like the Castle & Crusade Society's newsletter, the *Domesday Book*, reaching only a sparse subscription base. A year later, a mail-order games business owner named Don Lowry founded an imprint known as Guidon Games to publish wargame rules in rural Evansville, Indiana. Lowry was looking to make a dent in a wargames market dominated by well-established companies like Avalon Hill, so he took a chance on the duo's medieval rules under the title *Chainmail*, which he would sell by mail for two dollars a copy. Lowry, who frequently contributed cover art for various wargaming fanzines, drew his own rendition of Coggins's mounted knight for the *Chainmail* cover. These sorts of close imitations of professional art were common in the open and collaborative wargaming community of the time, much like the "swipes" produced by comic book fans, who would copy and modify panels by famous illustrators like Jack Kirby for use in their homebrew comics. As the later Dungeons & Dragons rulebooks would rely heavily on the existing *Chainmail* system, Lowry's copy of Coggins's battle scene is effectively the first true piece of Dungeons & Dragons art.

CLOCKWISE, FROM TOP LEFT Jack Coggins's mounted crusader from *The Fighting Man* (1966). Jeff Perren (top) and Gary Gygax (right) both did renditions of Coggins's crusader in 1970 to support fanzine articles they authored about their medieval wargaming rules.

OPPOSITE Don Lowry's swipe of Coggin's panel from *The Fighting Man* was used for the cover of the published version of *Chainmail* (1971). Pictured here is Gary Gygax's personal play copy of the game.

RIGHT Early *Chainmail* adopter Alan Lucien's "conversion" of a miniature dinosaur into a dragon.

BELOW For the header image of the "Fantasy Supplement," Don Lowry drew his own rendition of a Pauline Baynes illustration that was used for J.R.R. Tolkien's 1949 *Farmer Giles of Ham*. Lowry's version shows a mounted knight armed with a lance charging at a fire-breathing dragon.

Fantasy
supplement

J. R. R. TOLKIEN

Up he got and turned to fly, and found that he could not. The farmer sprang on the mare's back. The dragon began to run. So did the mare. The dragon galloped over a field puffing and blowing. So did the mare. The farmer bawled and shouted, as if he was watching a horse race; and all the while he waved Tailbiter. The faster the dragon ran the more bewildered he became; and all the while the grey mare put her best leg foremost and kept close behind him.

On they pounded down the lanes, and through the gaps in the fences, over many fields and across many brooks. The dragon was smoking and bellowing and losing all sense of direction. At last they came suddenly to the bridge of Ham, thundered over it, and came roaring down the village street. There Garm had the impudence to sneak out of an alley and join in the chase.

All the people were at their windows or on the roofs. Some laughed and some cheered; and some beat tins and pans and kettles; and others blew

114

SUPPLEMENTING FANTASY

Adherence to detail and historical accuracy in both the miniature figures and the rules was the order of the day for wargamers. But Gary Gygax, an avid lover of fantasy fiction, decided to give gamers an exotic new option: an expansion to the medieval rules that exchanged historical accuracy for the magical and mythical. The "Fantasy Supplement," which makes up the final third of the *Chainmail* booklet, challenged gamers' expectations by describing how wargames could involve goblins, trolls, giants, dragons, heroes, and wizards drawn from sword-and-sorcery literature. Gygax and Jeff Perren suggest that their "Fantasy Supplement" rules "allow the medieval miniatures wargamer to add a new facet to the hobby, and either refight the epic struggles related by J.R.R. Tolkien, Robert E. Howard, and other fantasy writers; or you can devise you own 'world,' and conduct fantastic campaigns and conflicts based on it." Using *Chainmail*, wargamers could now stage a battle like Helm's Deep from the *Lord of the Rings* complete with orcs, elves, and dwarves. And why did they append these fantastic rules to *Chainmail*? Because, they explain, that "most of the fantastic battles related in novels more closely resemble medieval warfare than they do earlier or later forms of combat."

Apart from a single image to introduce the "Fantasy Supplement" (pictured opposite), *Chainmail* itself furnished no illustrations that might help miniature wargamers decide how to depict these unreal entities. Who could say what an orc looks like? Tolkien gives some descriptions of fantastic creatures and characters in his books, but offered little practical guidance to an illustrator or model-builder—the ambiguous description of the Balrog is a notorious example, cryptically described as "like a great shadow, in the middle of which was a dark form, of man-shape maybe, yet greater." With no off-the-shelf options for

monsters of this type, Gygax and his local gaming circle in Lake Geneva, Wisconsin, took to adapting all sorts of existing figures and unrelated toys for their fantasy game. Gygax himself had the time on his hands after he lost his insurance job in late 1970; he subsequently worked odd jobs, including shoe repair, to make ends meet—and they usually didn't.

Gygax's group used plastic 40-millimeter Elastolin figures as their standard men; slightly smaller archers and Turks as elves and orcs, respectively; 25-millimeter medieval figures as goblins and dwarves; and 54-millimeter plastic Native American figures repainted black, grey, green, and purple as trolls and ogres. Gygax confessed in a 1972 issue of *Wargamer's Newsletter* that the 70-millimeter figure he used as a giant is "a pure blue fellow with a head of bushy hair (snipped from one of my daughters' dolls when they weren't looking)." Less humanoid miniature figures featured in *Chainmail* required more ingenuity. They converted plastic dinosaur models into dragons: for example, Gygax's childhood friend and confidante, Don Kaye, equipped a brontosaurus "with two smaller heads added to the long neck, spikes along the back, wings and so on" to morph it into something magical. Gygax amassed, according to the article, "soft plastic 'horrors' and insects from the dime store," which would "serve as elementals and giant insects," and for his Balrog, he repurposed "a giant sloth from an assortment of plastic prehistoric animals," which they converted with a fresh paint job and a bit of modeling putty. Beyond informing *Chainmail* customers how to follow his example, Gygax used this article about his travails scrounging up fantastic miniatures as an opportunity to encourage professional toy makers to get on board: "The way the rules are selling here, it seems a good bet for some model figure firm to start producing a line of properly-scaled fantasy figures!"

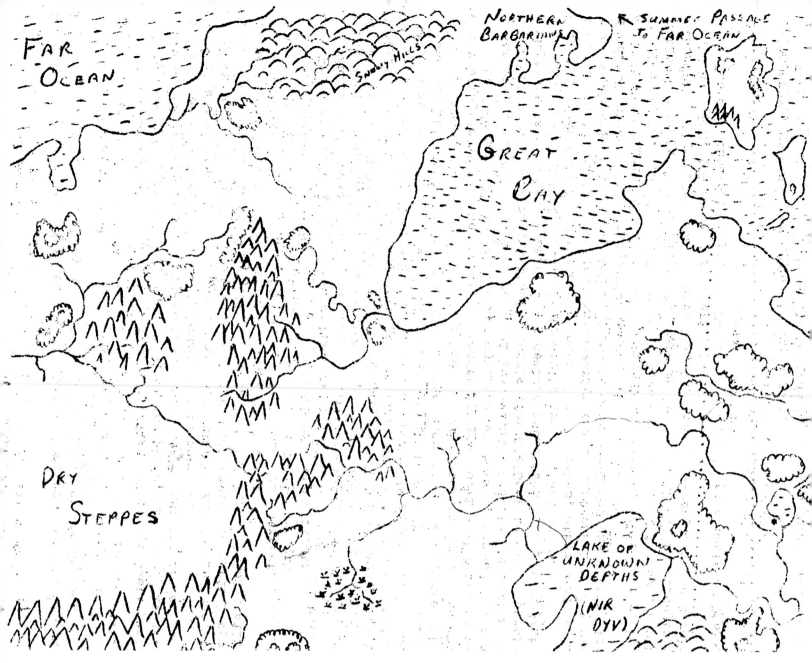

THE GREAT KINGDOM

One individual who shared Gary Gygax's passion for both figure casting and the fantasy genre was an imaginative college history major from St. Paul, Minnesota, named Dave Arneson; he was one of the early adopters who picked up *Chainmail* in 1971. Arneson and other members of his prodigious college gaming club had joined Gygax's Castle & Crusade Society the year prior and participated in the development of a shared imaginary realm that would provide a backdrop for a Society-wide medieval wargame. They called this setting the Great Kingdom.

Mainly through the mail, the Society shared information about the development of different parts of the Great Kingdom, including the section developed personally by Arneson, a marshy northern land called Blackmoor, anchored by a great and ancient castle. Arneson, who had been collaborating and experimenting with other Twin Cities game designers and players on unconfined, "open sandbox" games that suggested a degree of role assumption, populated the dungeon below Castle Blackmoor with strange and dangerous creatures, starting with the monsters in *Chainmail*. Small squads of adventurers, made up of individual "characters,"

each controlled by a player, would explore that underworld; cooperation was essential if they were to survive the horrors that a "referee," usually Arneson, would pit against them in the treasure-laden maze. Arneson moreover added to the baseline hero (fighter) and wizard (magic-user) classes in *Chainmail* a new priestly (cleric) type, as well as the notion that adventurers would improve with experience and go up in "level." Arneson started sharing information about Blackmoor through his own fanzine, *Corner of the Table*, and subsequently through the C&CS's original fanzine, the *Domesday Book*. Gygax, having spent his youth between the pages of the pulp magazine *Weird Tales* reading Robert E. Howard's Conan stories, understood the value of Arneson's contribution. Here was the chance to cast himself and his fellow Castle & Crusade Society members as the heroes of their own pulp fantasy. Gygax began developing a dungeon similar to Arneson's beneath a fortress in the south of the Great Kingdom, Castle Greyhawk. In ongoing private correspondence, Gygax and Arneson then began developing their ideas into a draft of a radical new game that would soon be called Dungeons & Dragons.

WESTERN

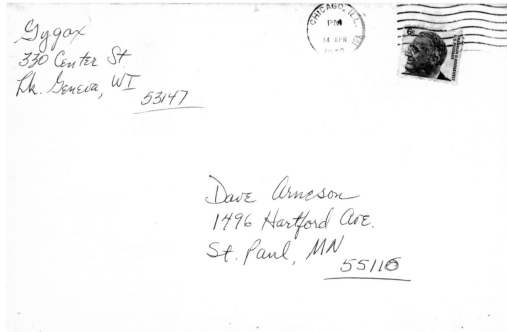

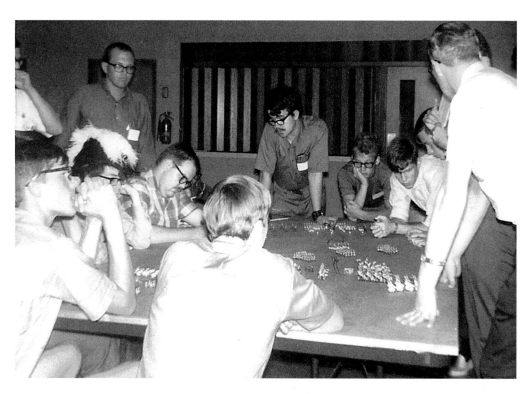

Gygax
330 Center St.
Lk. Geneva, WI 53147

Dave Arneson
1496 Hartford Ave.
St. Paul, MN 55116

TOP Dave Arneson (seated third from left) and other Twin Cities gamers at Gen Con in 1970.

ABOVE The mailing label of a 1970 copy of the third issue of the *Domesday Book*, hand-addressed by Gary Gygax to Dave Arneson.

OPPOSITE Gary Gygax's map of the Great Kingdom, as printed in the *Domesday Book* in 1971. Located at the map's center is Nir Dyv, the Lake of Unknown Depths, a fictional counterpart to the waters of Gygax's hometown haunt, Geneva Lake.

DUNGEONS & DRAGONS

Rules for Fantastic Medieval Paper, *& pencil* Board, and Miniature Figure Campaigns/ Games.

by Gary Gygax and Dave Arneson

DUNGEONS, DRAGONS, AND DRAWINGS

The collaboration between Gary Gygax and Dave Arneson toward Dungeons & Dragons was scarcely underway when a prominent miniature firm took an interest in fantasy. California-based Jack Scruby, one of the fathers of American miniature wargaming, planned to cast his own fantasy figures for use with games like *Chainmail*, so he reached out to *Chainmail*'s publisher, Guidon Games. This provided Gygax with a fortuitous opportunity to comment on the general appearance of all manner of creatures familiar from Tolkien, and also to signal a new interest in visualizing the fantastic. In a May 1973 letter to Scruby, Gygax foreshadowed that "Dave [Arneson] and I are working on a campaign rule booklet which will tie in to *Chainmail*" and that "these campaign rules will be illustrated with many drawings and contain an entire phantasmagoria of weird critters." These illustrations would be the first art developed specifically for Dungeons & Dragons. Gygax's talents as a draftsman were perhaps not equal to this task, but he explained to Scruby, "One of my associates in the LGTSA has a rather talented spouse, and I hope that she will do a number of illustrations for use with the booklets." Gygax would provide Scruby with "a couple of fast sketches she made."

OPPOSITE Cover of the first draft of Dungeons & Dragons, which survived both the by-mail collaboration process and the ages to preserve the authors' hand annotations.

BELOW The first logo of Tactical Studies Rules, a simple yet bold monogram composed of the first letter of each partner's last name: "G" for Gygax and "K" for Kaye.

BOTTOM The Gygax home in Lake Geneva (right), and the basement entrance (left). A close examination of the basement door that provided gamers access to the cellar reveals "Entrance Wargames Room" written in marker.

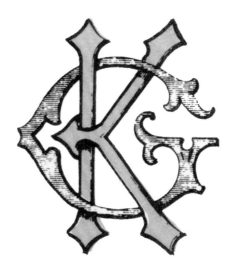

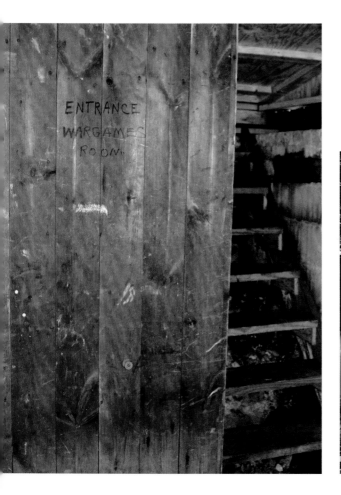

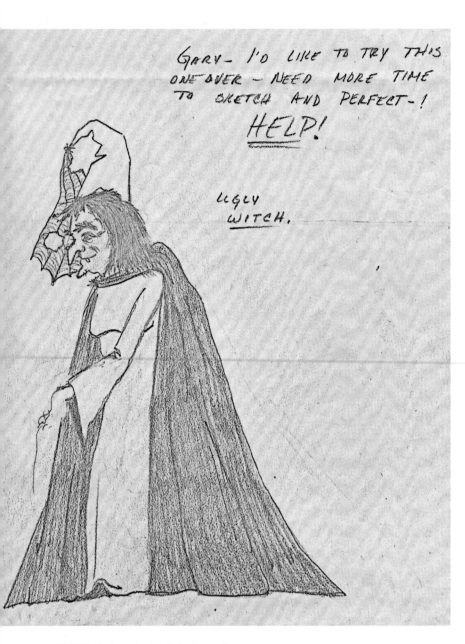

GARY— I'D LIKE TO TRY THIS
ONE OVER — NEED MORE TIME
TO SKETCH AND PERFECT—!
HELP!

UGLY
WITCH.

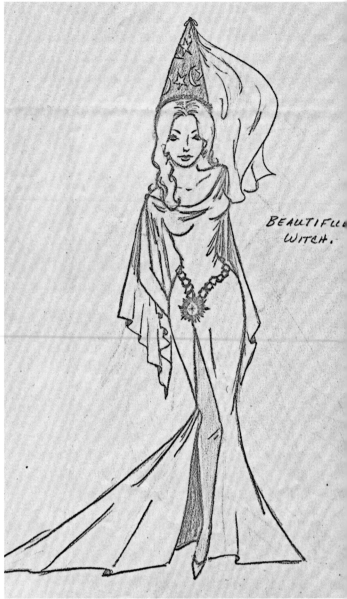

BEAUTIFUL
WITCH.

ABOVE Preliminary sketches for Dungeons &
Dragons by Cookie Corey. "Beautiful Witch" was
included in the published edition of Dungeons
& Dragons; the "Ugly Witch" was not. Corey
herself felt that the unused panel was not a
success: "Gary, I'd like to try this one over—need
more time to sketch and perfect! Help!"

RIGHT Keenan Powell's evil genie-like efreet.

OPPOSITE Looking back on the project today,
Keenan Powell remembers "sitting in a library,
looking at illustrations and photographs of eagles
and horses" to inspire her hippogriff, which
would ultimately appear on the cover of the third
Dungeons & Dragons rule booklet.

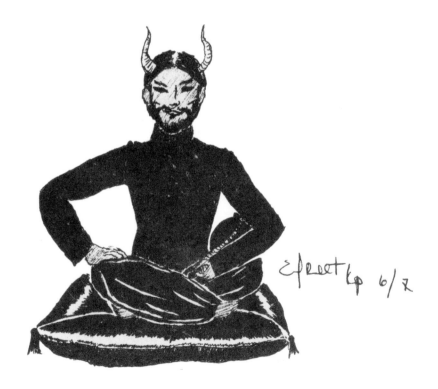

efreet kp 6/7

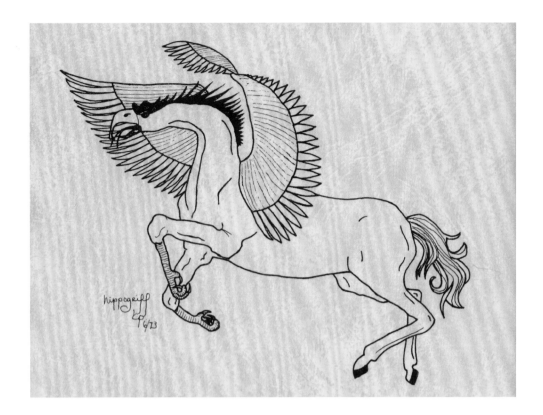

The drawings in question were by local artist Cookie Corey, the spouse of LGTSA member Bill Corey, a wargamer who the driver's licenseless Gygax frequently begged for car rides. Of those "fast sketches" by Corey, two made it into the published Dungeons & Dragons books and one did not. Gygax had hoped that Corey would do the bulk of the illustrations for his forthcoming game, but as the project evolved and time grew short, other artists ultimately provided the remainder of the art for D&D.

Guidon Games had little pay to offer for artwork, and as Gygax hoped to publish D&D through that imprint, he proceeded effectively without an art budget. He implored pretty much anyone to contribute art to the project, but free work is hard to come by outside of family, so Gygax soon found himself turning to his wife Mary's half-sister, Keenan Powell. Powell lived in California, but she came to visit Lake Geneva for a few days at this crucial time, staying at the Gygax family home. With a hulking shoe-cobbling apparatus in the basement, the tiny white house at 330 Center Street could barely contain the seven members of Gygax's immediate family, let alone houseguests. Powell had graduated from high school only weeks before, but as a fan of fantasy literature with some practice at illustration—though no formal training—she was recruited to provide additional art for the Dungeons & Dragons project.

Powell executed her work between June and August of 1973, providing a dozen of the total illustrations that would appear in the original Dungeons & Dragons. Of these, ten are creatures previously listed in the 1972 revision to *Chainmail*, but she captured two newcomers as well: the pegasus and medusa, both of which were featured in the draft of Dungeons & Dragons that had been circulated to a small group of wargamers for testing. As the list of monsters planned for the game grew, and as it expanded beyond the famous creations of Tolkien, the need to show players what monsters looked like became more pressing. For creatures like the hippogriff (pictured above), Powell took to the library to find images of real-world creatures from which she could draw components and inspiration to create the fantastical. Like Corey, Powell's sketchbook drawings were done in pencil, which required someone to trace over her lines in pen before the illustrations could be photographed for printing. This inelegant process lends these images their thin, somewhat wispy character in the printed game.

By the time Powell's artwork arrived from California, it had become clear that Guidon Games was in not in a financial position to publish this lengthy and experimental new game, which left Gygax with few choices; if Dungeons & Dragons was going to be published, he was going to have to start his own company to do it. But with a large family and only sporadic employment, Gygax had no money to fund such an operation—he had only passion, time, and ideas to contribute. As a result, he would need to take on a partner, and who better than his trusted friend and fellow plastic-miniatures tinkerer Don Kaye of the LGTSA. According to Gygax, Kaye, of modest means himself, "borrowed $1,000 against a life insurance policy" to provide the seed capital. They named their new imprint after their local club: Tactical Studies Rules (TSR). For both men, TSR promised a continuation of the childhood adventures they shared around Lake Geneva. It was more a hobby than a business, more a club than a company—or so they expected at the time.

As an inaugural release, and in an effort to raise quick funds to produce the expensive Dungeons & Dragons game, the fledgling TSR put out a conventional miniature wargame based on the English Civil War called *Cavaliers and Roundheads*, a second effort by the winning team of Gygax and Perren. It was the first product to feature the distinctive "GK" logo of TSR (pictured on page 19).

DRAGON

1-1
center on
sheet
DRAGON

For the sixteen illustrations in *Cavaliers and Roundheads*, Tactical Studies Rules contracted the services of Greg Bell, a teenage wargamer from Jeff Perren's hometown of Rockford, Illinois. Bell had also been a member of the Castle & Crusade Society, and he occasionally made the fifty-five-mile trek to Lake Geneva to game with Perren and Gygax. His style, a blocky rendering of strong shapes and lines, translated surprisingly well to the crude printing process TSR could afford.

Bell effectively became TSR's first staff artist: he furnished the bulk of the illustrations for all four of TSR's earliest wargame releases, including the lion's share of the images for Dungeons & Dragons. Roughly two dozen of his contributions made it into the published product, and some unused leftovers would spill into the first Dungeons & Dragons supplement. By the end of 1973, Gygax's plan for the game's art and production had changed several times; accordingly, much of Bell's work was done quite late in the publication process. Bell, for his part, recalls their collaboration as being largely through the mail: Gygax would send requests for illustrations a few at a time, rather than as one big list. Gygax would ask, "Can you whip up something real quick?" Bell recalls, inevitably "at the eleventh hour." Indeed, on December 27, 1973, in a letter to Arneson, Gygax frets that "the cover art isn't in from Bell, and we cannot roll without some," so at the last minute the production of Dungeons & Dragons stalled on Bell's deliverables.

As aggressive as the timeline was, Bell's challenges were exacerbated by the fact that the bulk of his work, and indeed his very mission, was to create images of fantastic creatures that no one had ever seen or even imagined on paper. Many of the requests for fantastic creatures left Bell flustered and confused: "Okay, what is this thing?" he would ask himself. Under ceaseless time constraints and in unfamiliar territory, Bell borrowed some direct inspiration from well-established comic books, most notably *Strange Tales* #167, for the cover art of Dungeons & Dragons and several other interior pieces.

Originally published in April 1968, the Marvel comic *Strange Tales* #167 was a major inspiration for Bell's early art in *Dungeons and Dragons*. His cover illustration of a rearing rider closely follows a panel from the Dr. Strange story inside, "This Dream . . . This Doom!" The illustration Bell provided for the end of the second volume of Dungeons & Dragons, showing a sorcerer standing in front of a flaming brazier, draws several elements from another panel in that same Dr. Strange adventure. He also mined the Nick Fury segment "Armageddon!" which fills up the other half of that issue of *Strange Tales*, borrowing from Nick Fury's poses a dramatic illustration of a barbarian, as well as one of the last images in third D&D rulebook, a swordsman who defiantly raises his blade next to the words "Fight On!" Numerous other Bell contributions can be traced back to similar prototypes.

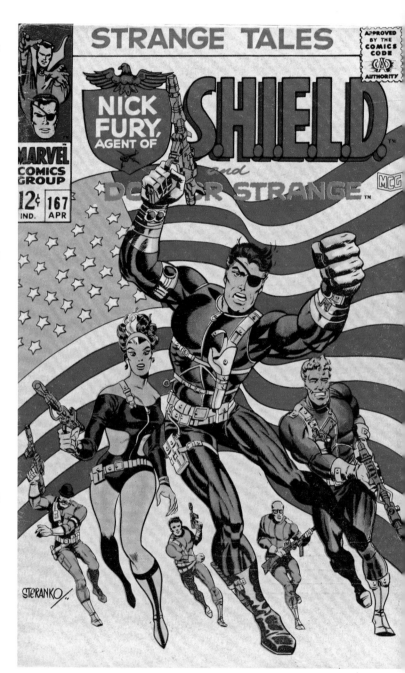

THIS PAGE Jim Steranko's cover for *Strange Tales* #167, © MARVEL.

OPPOSITE Greg Bell's original cover illustration for the *Monsters & Treasure* booklet from the original Dungeons & Dragons boxed set.

STRANGE INSPIRATIONS

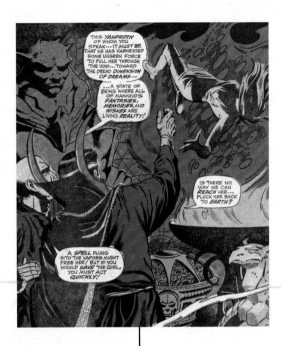

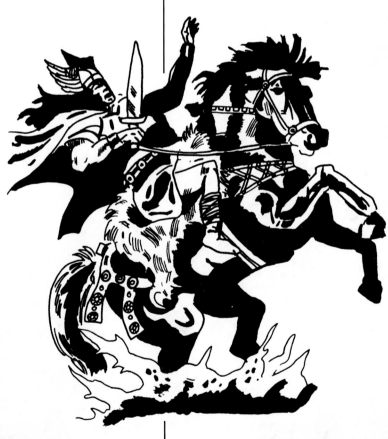

Bell's sorcerer from the second volume of
Dungeons & Dragons, inspired by a panel from the
Dr. Strange story in *Strange Tales* #167.

Bell's rearing rider, beneath the *Strange
Tales* #167 panel on which it was based.

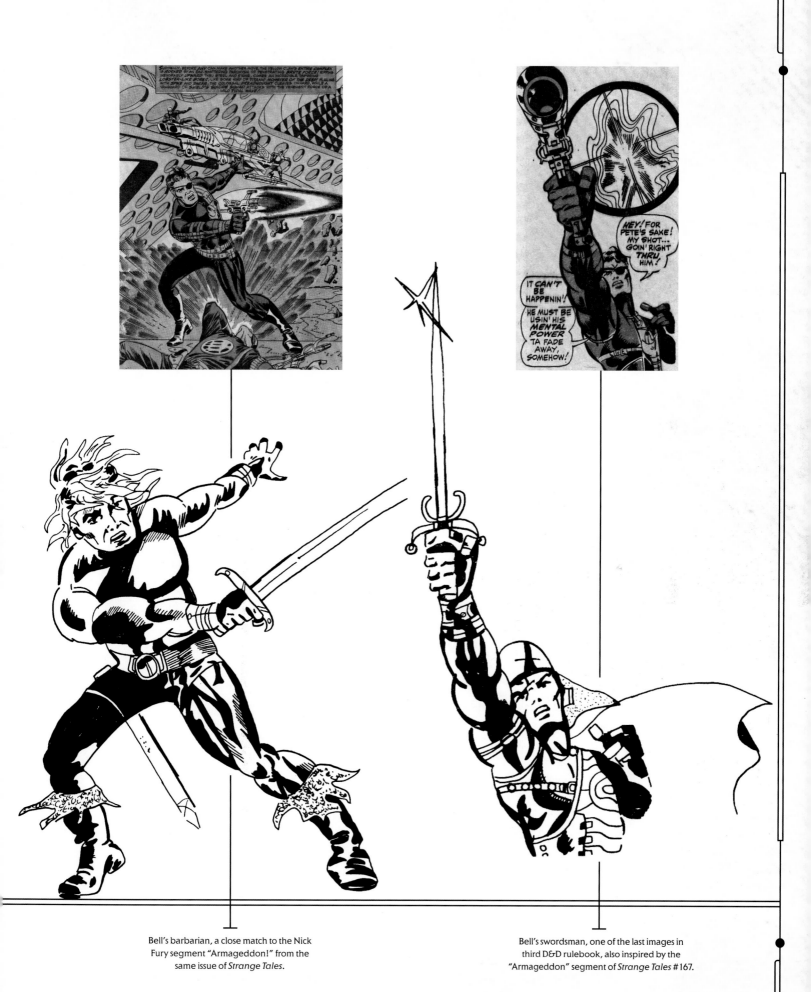

Bell's barbarian, a close match to the Nick
Fury segment "Armageddon!" from the
same issue of *Strange Tales*.

Bell's swordsman, one of the last images in
third D&D rulebook, also inspired by the
"Armageddon" segment of *Strange Tales* #167.

Top images © MARVEL.

> "Don Kaye, Brian Blume, and I staked the whole company on this venture, for it took every bit of capital we had to produce the game. We also spent hundreds of hours readying it to print—hours we could not spend gaming, or with our families."
>
> —GARY GYGAX

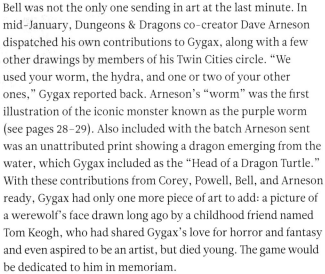

HYDRA

Bell was not the only one sending in art at the last minute. In mid-January, Dungeons & Dragons co-creator Dave Arneson dispatched his own contributions to Gygax, along with a few other drawings by members of his Twin Cities circle. "We used your worm, the hydra, and one or two of your other ones," Gygax reported back. Arneson's "worm" was the first illustration of the iconic monster known as the purple worm (see pages 28–29). Also included with the batch Arneson sent was an unattributed print showing a dragon emerging from the water, which Gygax included as the "Head of a Dragon Turtle." With these contributions from Corey, Powell, Bell, and Arneson ready, Gygax had only one more piece of art to add: a picture of a werewolf's face drawn long ago by a childhood friend named Tom Keogh, who had shared Gygax's love for horror and fantasy and even aspired to be an artist, but died young. The game would be dedicated to him in memoriam.

In retrospect, the art of the original Dungeons & Dragons can look amateurish, even crude. But none of the contributors were schooled artists: they were mostly high-school-aged "doodlers" doing this as a favor to Gygax, and to hold them to the same standard as later professional artists would be unfair. Consider that the entire art budget for the first printing of Dungeons & Dragons was around one hundred dollars: artists were to be paid two dollars for a smaller work like a monster portrait, or three dollars for a larger piece showing a more complex scene. Gygax and company had little choice but to exercise these types of

cost controls because the entire budget for printing the first one thousand Dungeons & Dragons sets, which included the cost of its boxes and cover stickers, was projected at around two thousand dollars—a figure that they ended up exceeding by nearly half again. Moreover, each of the artists would be paid a royalty of two to three dollars every time that another thousand copies were to be printed. In a letter to Arneson, Gygax groaned, "That means that each time we reprint we have to shell out more beans to some grubby artist, but that is life." In practice, this hardly threatened the financial viability of TSR, and the art set an accessible, if primitive, tone for visualizing the fantastic in games.

When the game ran over its modest budget, raising yet more capital required Gygax and Kaye to take on a third partner at the last minute before they could send the game to the printers. His name was Brian Blume, and he was relatively new to Gygax's local gaming group, but according to Gygax's period accounts, he "seemed like a good chap." An apprentice toolmaker with a good salary, Blume frequently commuted from his northern Illinois home in Wauconda to Lake Geneva, where he would often stay on Gygax's couch after long nights of hacking, slashing, and adventuring. When Blume learned of the financial plight of his gaming buddies' new venture, he was quick to jump in, cash in hand. Times being what they were, Gygax and Kaye accepted Blume into the TSR partnership. His help made Dungeons & Dragons a reality, and the three partners took charge of assembling and selling those first thousand copies.

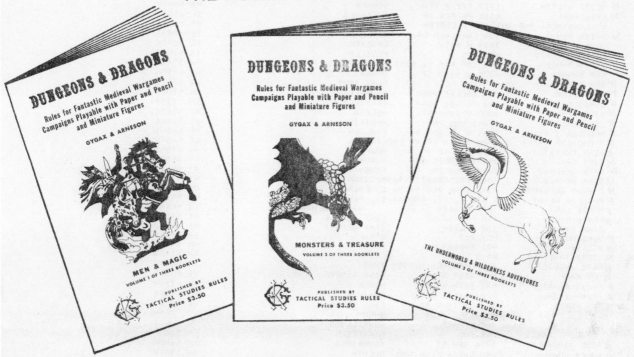

Swords & Sorcery

From
TACTICAL STUDIES RULES
THE RULES FOR WARGAMERS

Rules for Fantastic Medieval Wargames
Campaigns Playable with Paper and Pencil
and Miniature Figures

DUNGEONS & DRAGONS comes in a sturdy box designed to be stored on your bookshelf. The set contains three booklets, with separate reference sheets, all heroically illustrated for ONLY $10.00 postpaid.

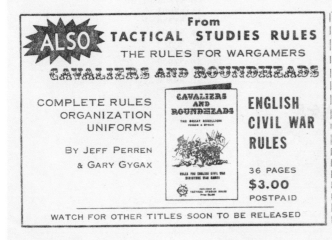

From
TACTICAL STUDIES RULES
THE RULES FOR WARGAMERS
CAVALIERS AND ROUNDHEADS

ALSO

COMPLETE RULES
ORGANIZATION
UNIFORMS

By JEFF PERREN
& GARY GYGAX

ENGLISH CIVIL WAR RULES

36 PAGES
$3.00
POSTPAID

WATCH FOR OTHER TITLES SOON TO BE RELEASED

--- ORDER FORM ---

Please send me _____ sets of Dungeons & Dragons and _____ copies of Cavaliers and Roundheads.

Name _____

Address _____

City _____

State _____ Zip _____

I have enclosed $_____ to cover the cost of this order.

AVAILABLE FROM YOUR HOBBY DEALER OR DIRECT FROM
TACTICAL STUDIES RULES
DEPT. B, 542 SAGE ST., LAKE GENEVA, WI. 53147
NO C.O.D. ORDERS PLEASE. WIS. RESIDENTS ADD 4 PER CENT TAX.

ABOVE The first formally designed D&D ad from 1974, which appeared in various wargaming fanzines.

OPPOSITE, LEFT It was D&D co-creator Dave Arneson who drew the hydra that graced the interior cover of the game's third volume, *The Underworld & Wilderness Adventures*.

OPPOSITE, RIGHT Almost certainly the oldest piece of art that would become incorporated into the original D&D booklets, Tom Keogh's drawing of a werewolf was at least ten years old by the time the game came out—Keogh passed away in April of 1963.

PURPLE WORM

Original edition, 1974

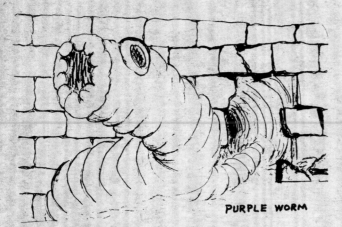

PURPLE WORM

1st edition, 1977

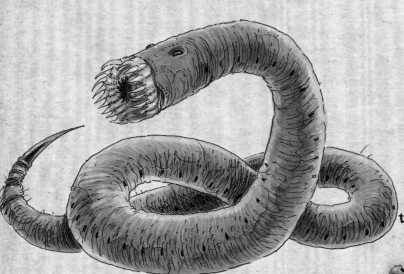

2nd edition, 1993

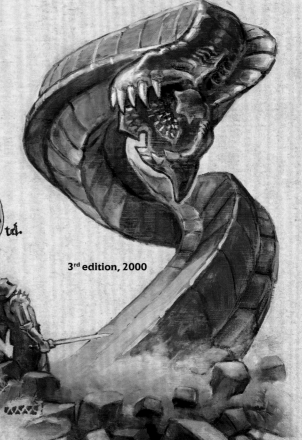

3rd edition, 2000

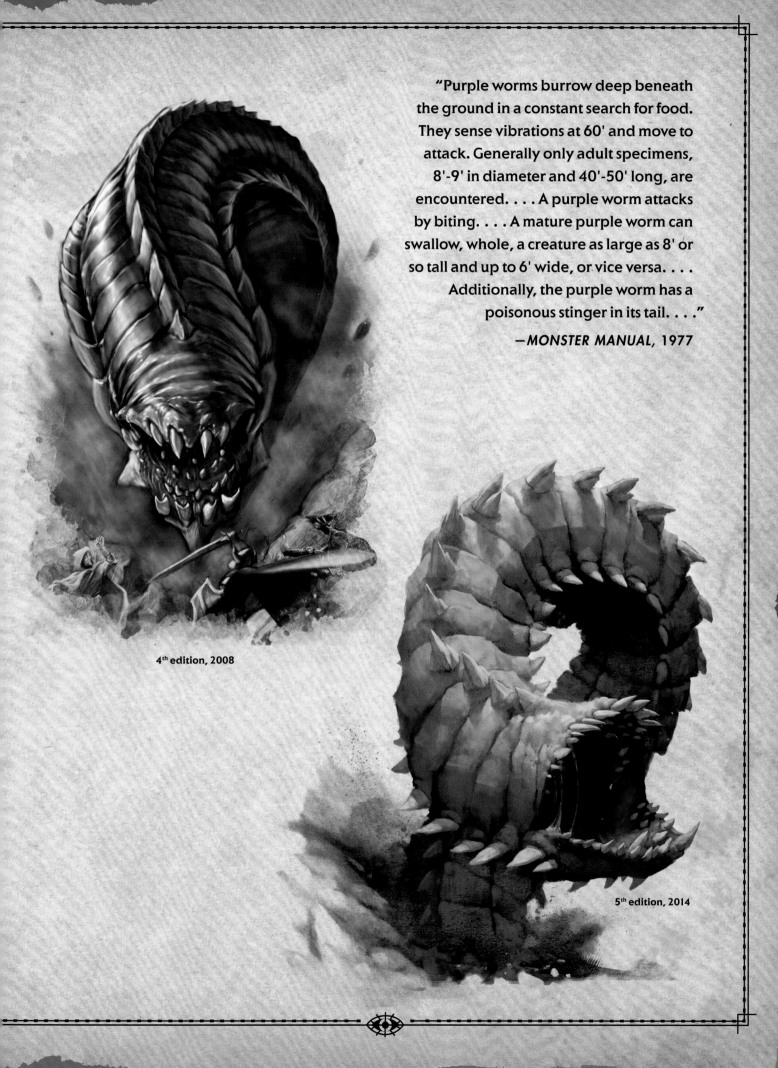

"Purple worms burrow deep beneath the ground in a constant search for food. They sense vibrations at 60' and move to attack. Generally only adult specimens, 8'-9' in diameter and 40'-50' long, are encountered. . . . A purple worm attacks by biting. . . . A mature purple worm can swallow, whole, a creature as large as 8' or so tall and up to 6' wide, or vice versa. . . . Additionally, the purple worm has a poisonous stinger in its tail. . . ."

—*MONSTER MANUAL*, 1977

4th edition, 2008

5th edition, 2014

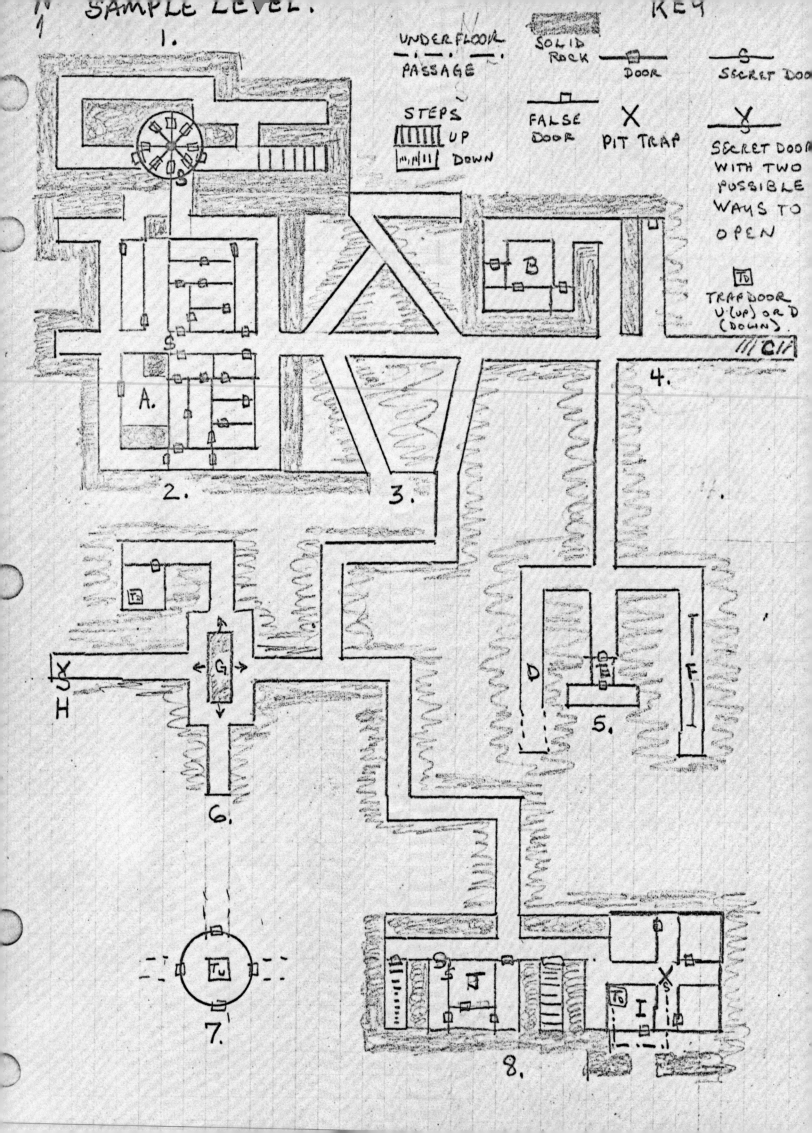

SAMPLE LEVEL.

1.

KEY

UNDERFLOOR PASSAGE

SOLID ROCK

DOOR

SECRET DOOR

STEPS
UP
DOWN

FALSE DOOR

X PIT TRAP

Y SECRET DOOR WITH TWO POSSIBLE WAYS TO OPEN

TD TRAP DOOR U (UP) OR D (DOWN)

ABOVE A circa 1972 player map drawn by Dave Megarry, an original participant in Dave Arneson's Blackmoor campaign. This particular spread maps the second level of Castle Blackmoor's infamous dungeon.

OPPOSITE The sample dungeon map from the 1973 draft of Dungeons & Dragons, drawn by Gary Gygax, and reproduced in the published box set. A more refined version would appear in the fourth printing of the published rules in 1975.

ACCESSORY TO ADVENTURE

The art in the original Dungeons & Dragons booklets helped players understand what characters might see when they encountered a monster, but an equal part of understanding the game, and its visual history, lies in the paraphernalia that a player might have seen scattered across a tabletop while the game was in progress. "Before it is possible to conduct a campaign of adventures in the mazey dungeons," the original Dungeons & Dragons rulebooks explained, "it is necessary for the referee to sit down with pencil in hand and draw these labyrinths on graph paper." Dungeons & Dragons ostensibly required every referee to produce hand-drawn maps corresponding to several levels of underground dungeons. The rules provided examples of what levels might look like and guidelines for dungeon architecture, but the referee was at liberty to devise whatever sorts of perils might best challenge a party of adventurers. A referee was to "construct at least three levels at once," and "a good dungeon [would] have no less than a dozen levels." Developing conventions for mapping an underworld required a new language of symbols: for example, each square of graph paper represented a ten-foot by ten-foot space, which provided guide rails for dungeon designers to carve suitable tunnels and chambers out of the earth. A whole lexicon of glyphs for doors, traps, stairs, slides, and related features began to emerge from the simple key included in the earliest rulebooks.

Referees designed dungeons in secret, but players could share in this process of illustration: they could choose to draft their own maps based on the referee's verbal descriptions to avoid becoming lost in the underworlds that they were exploring. The Dungeons & Dragons rules recommended that dungeon designers incorporate contrivances like one-way transporters as ways to inspire "sure-fire fits for map makers among participants." Effectively, a referee created a dungeon map and described to players what their characters would see while they explored, which in turn enabled players to create their own copies of the map as they went along. Once a party had explored a dungeon entirely, their map should ideally be an exact copy of the referee's map, but in practice dungeons rarely yielded all of their secrets to adventurers. Most player-generated maps showed only part of the dungeon, and even that part was invariably distorted by errors that arise from misunderstanding the dungeon layout.

TOMB OF HORRORS

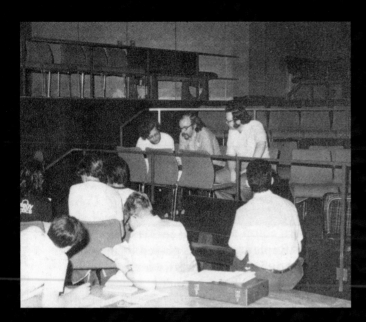

Gygax (upper row center) runs the seminal Tomb of Horrors tournament for a group in 1975.

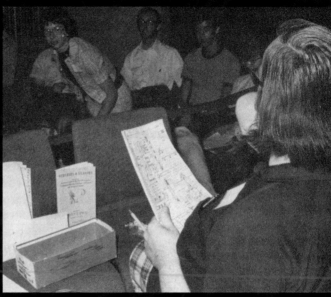

View over Gygax's shoulder as he holds his Tomb of Horrors map (pictured OPPOSITE) safely out of sight of the fresh-faced participants who could only wonder at the horrors that were to face them—and only few of their characters would live to tell the tale.

IN 1975, TSR'S NEWEST artist, Tracy Lesch, would soon work on a project that marked a turning point for the art of Dungeons & Dragons. The game had picked up significant traction in wargaming circles and TSR had been invited to stage a Dungeons & Dragons tournament for 120 players at the inaugural Origins convention, hosted by the leading producer of wargames, Avalon Hill. TSR's event staff wanted to make the tournament fair for different groups, even if they were to be refereed by different people: Gygax, his son Ernie, Dave Arneson, and TSR partner Brian Blume were slated to oversee two adventuring parties each. Although each referee was running the same basic dungeon that Gygax designed, any one of them might describe the rooms and encounters a bit differently given the freeform nature of the game. Time was also of the essence: each party of fifteen adventurers had only two hours to explore before the scoring would begin. To try to encourage more standardization of the experience, Gygax, who already understood the need for an artist's hand to visually define fantastic worlds and monsters, hit upon the idea of giving the players something to look at. So, at the last minute, in mid-June, Gygax asked Arneson, "Care to do a couple of sketches for the chaps to see as they enter the major areas, etc.?" Ultimately, it was Lesch that ended up crafting this series of two-dozen illustrations for the tournament, the famous Tomb of Horrors. It was an adventure that would prove as legendary to early players of the game as it was deadly to their characters.

In the Tomb of Horrors illustrations, we see not just monsters drawn in isolation, like in the D&D rulebooks that had been released, but scenes from a dungeon full of traps, puzzles, and unfortunate adventurers. In one, a roof caves in on a screaming swordsman; in another, a different warrior shrieks as he plummets down a smooth ramp toward a pit of flames. Some show still-life scenes: an empty throne, on which rests a crown and scepter; or an enormous horned face embedded with a howling wide mouth. Our perspective could be that of an adventurer watching what befalls his fellows, or it could be a birds-eye view of a ruined chapel, where beyond the pews, a skeleton points toward a doorway shrouded in mist. Art like this, showing the characters and monsters in their situations within a dungeon, simply did not exist in the prior Dungeons & Dragons rulebooks and newsletters. For those 120 participants in the tournament, the Tomb of Horrors lifted Dungeons & Dragons into an entirely new visual realm.

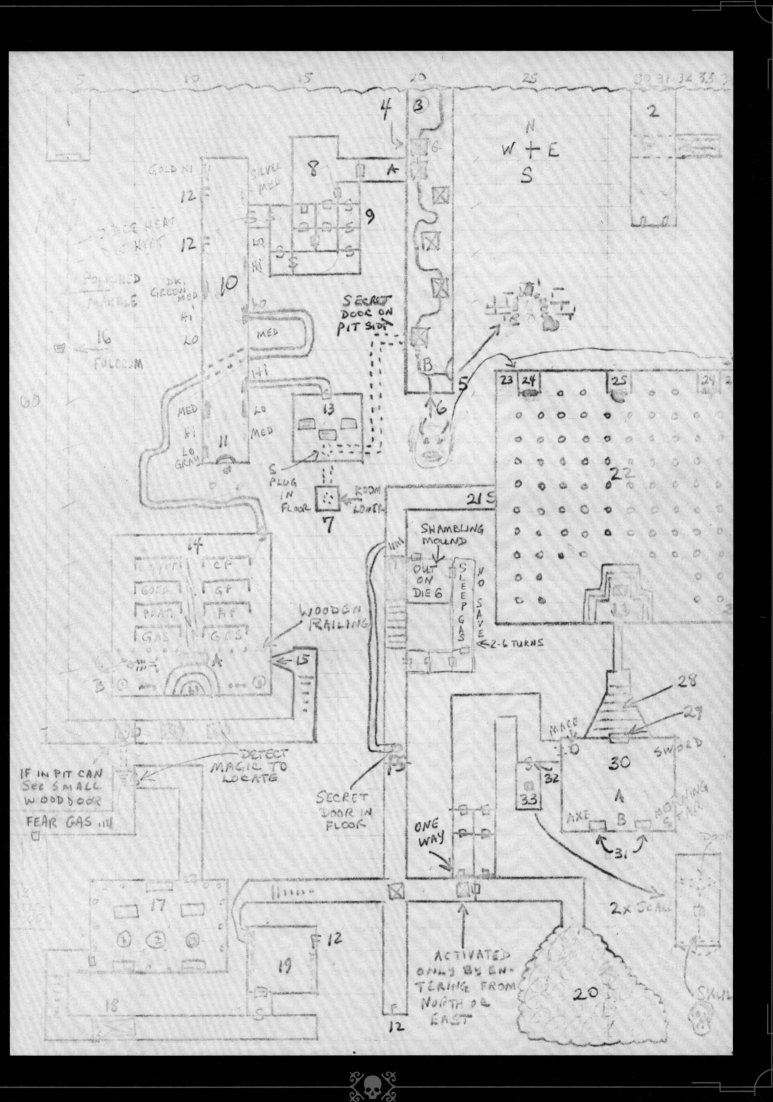

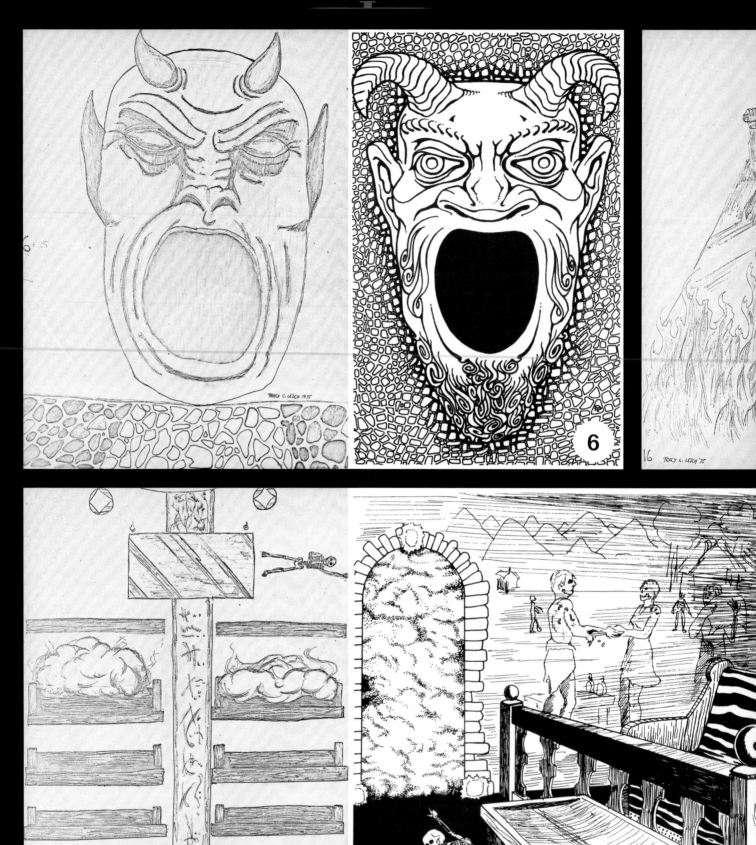

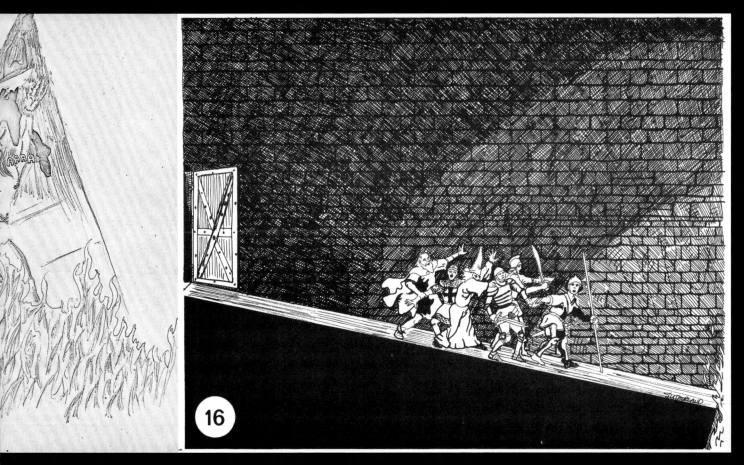

16

14

33A

Original illustrations by Tracy Lesch provided visual uniformity to players competing in the Tomb of Horrors tournament. These previously unreleased panels were all reimagined for the published 1978 module (shown alongside), which went on to be, by many accounts, the most deadly D&D adventure module of all time. The *Tomb of Horrors*, and its numerous sequels and offshoots, has claimed the lives of untold thousands of player characters.

Robilar, Black Lord, Dragon Master
Strength: 18
Constitution: 18
Wisdom : 9-12 ?
Dexterity : 12-15 ?
Intelligence: 14
Charisma : 16

Magic items: +3 Sword, +2 Armor, +2 Shield, Boots of Flying
Cloak of invisibility, Rings of Spell Turning
+ Mammal Control

Gold: 50,000 in denominations of: 30,000 gold, 100,000
silver + 50 gems of 200 gold peice value each)

ring - Emerald ⬭ Dragon symbol on it =
10,000 gold value.

Finely Carved Box of Teakwood with inlaid Jade
And small green emeralds = 1,200 G.P. Value

(Black Mane) - 500 g.P. - Finest Stallion in all of
Greyhawk Area.

Barding , Battle Axe, 3 Lances

Armorer , Animal trainer, Fletcher, Sage - Bookeeper,
2 Black smiths , 20 servents, minstrels + dancing girls

Men: 20 cross bowmen (Mtd), 20 med. Horse, 10 Lt. Hs. Scouts.
20 crossBow, 30 Hr. H., 2 orcs +1 armor
3rd Level Preist: Staff of Healing - 5th Level Fighter: +1 sword

AS ENTICING AS A dungeon may have been to players, under-worlds full of monsters could not exist in a vacuum: What adventures awaited you on the surface? To provide a broader setting for adventures in Blackmoor, in 1972, Arneson had lighted upon the idea of scavenging an overland, hex-based map from an Avalon Hill game called *Outdoor Survival* as a venue for adventuring in the wilderness. The original *Outdoor Survival* game focused on commonplace hikers becoming lost in an ordinary wilderness, finding food and water, and avoiding dangerous encounters with wildlife. The Dungeons & Dragons rules reinterpreted the map as a staging area for fantastic adventure: ponds, for example, are considered castles, and passing one by can trigger an encounter with belligerent occupants. As a consequence, a copy of *Outdoor Survival* became one of the recommended accessories for purchasers of Dungeons & Dragons. The use of hexagonal maps for the outdoors, with a vast scale of roughly five miles per hex, became as much of a standard as the graph paper depicting the much smaller scale of the dungeon.

Players of the original Dungeons & Dragons had further use for paper and pencil beyond merely drawing maps. The rules also required players to note the ability scores and related data of characters they played on a character "record" sheet. The example given in the Dungeons & Dragons rules showed only the six standard abilities—Strength, Intelligence, Wisdom,

Constitution, Dexterity, and Charisma—along with the name, character class, gold piece holdings, and "experience point" totals of the character, which allowed for the enhancement of individual abilities through leveling. At first, players just wrote these totals down in a notebook, but over time, character sheets became standardized forms that players would fill in with data during character generation and amend as the game progressed.

While rule booklets, maps, and character sheets recorded much of the fundamental information needed to play the game, Dungeons & Dragons could assign no ability scores nor have any objective way to determine success versus failure without one more material component, one that became its most distinctive visual symbol: dice. Three six-sided dice would be rolled for each of the ability scores on the character sheet. But the dice that became practically synonymous with the game were the striking polyhedral dice: the four-, eight-, twelve-, and twenty-sided dice resolving many actions described in the rulebook. When they first released the game, TSR did not supply dice in the woodgrain box—those had to be ordered separately. This became an important source of independent revenue for the young company, and a source of frustration to early adopters. Many pirated the scarce rulebooks in the first few years after the game's release with the help of a Xerox machine, but you can't photocopy dice.

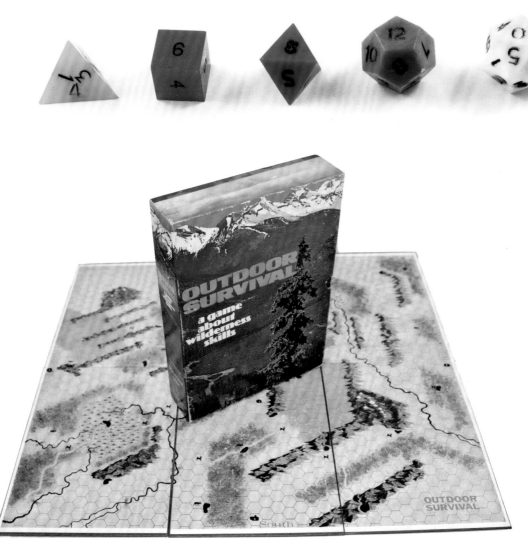

ABOVE An original set of polyhedral dice from Creative Publications, sold by TSR separately alongside D&D. The notoriously poor-quality dice imported from Hong Kong included the hard-to-find 20-sided die, which featured two sets of 0–9, forcing players to take measures such as shading one-half of the sides to differentiate 1–10 and 11–20 (see far right).

LEFT A 1972 copy of Avalon Hill's *Outdoor Survival*. The game's hex-map board would prove to be a useful tool for outdoor D&D adventures that grew beyond the confines of a dungeon.

OPPOSITE An original handwritten character record for Rob Kuntz's character Robilar, from the earliest days of Dungeons & Dragons. An original member of the Castle & Crusade Society and only a teenager when D&D came out, his lawful evil character here became legendary in D&D circles for conquering seemingly impossible dungeons, often through the ruthless use of henchmen as cannon fodder.

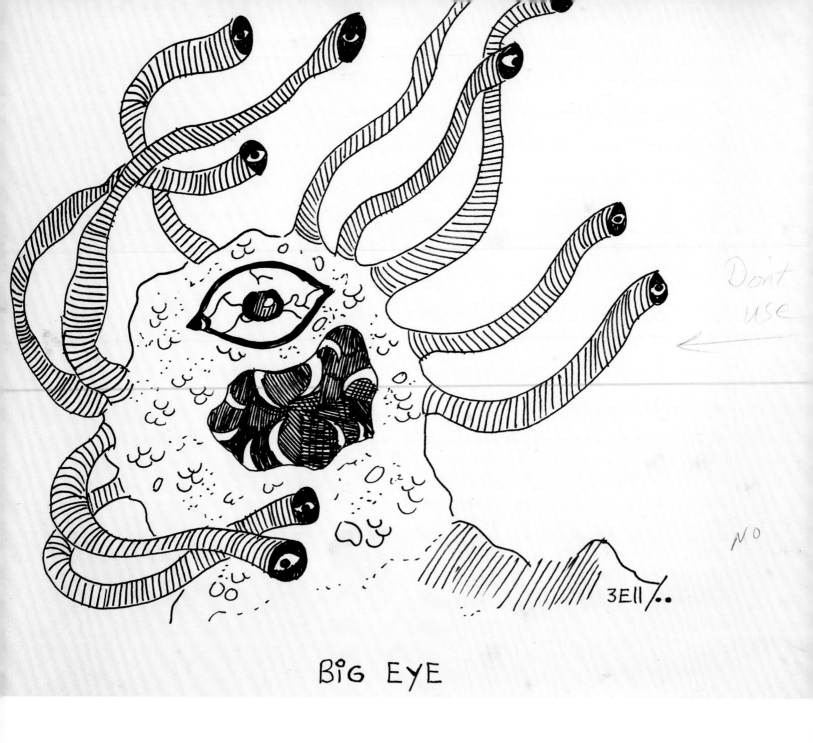

BIG EYE

REVIEWING THE STRATEGY

Maps, character sheets, and dice were all important parts of playing Dungeons & Dragons, but none could be more essential than for players to know that the game even existed. Aside from strong word of mouth, cleverly targeted print advertising was the only other way to encounter the game. To support this effort, Gygax had taken to writing stories and articles about his radical new game in small, content-hungry wargaming fanzines, who would sometimes even pay him for the contribution. While these efforts might only reach a few hundred gamers at a time, they were targeted to exactly the audience who may be inclined to give D&D a try. However, a bigger challenge remained: How to convey

in a single slick sheet the adventures pent up in that woodgrain box? The words "Swords & Sorcery" featured more prominently in the earliest advertisements than the name of the game itself, but the graphics did little more than show the product cover. Greg Bell's rearing rider, as well as his dragon and Keenan Powell's hippogriff, became the game's earliest ambassadors.

Long before the first thousand copies printed at the beginning of 1974 had sold out, Gygax planned for a Dungeons & Dragons supplement. As Dungeons & Dragons expanded, it incorporated new monsters, many unfamiliar from fantasy literature, which players might have trouble envisioning from a verbal description.

THIS PAGE, FROM LEFT Greg Bell's original cover drawing from the *Greyhawk* supplement alongside the *Dax the Damned* panel by Esteban Maroto from a 1974 issue of *Eerie Tales* that inspired it and the published supplement cover.

OPPOSITE An unused Greg Bell illustration labeled "Big Eye," developed for the 1975 *Greyhawk* supplement. This mysterious creature seems to share characteristics of the newly minted beholder and roper. Gygax's "Do Not Use" and "No" annotations suggest his disapproval of the beast.

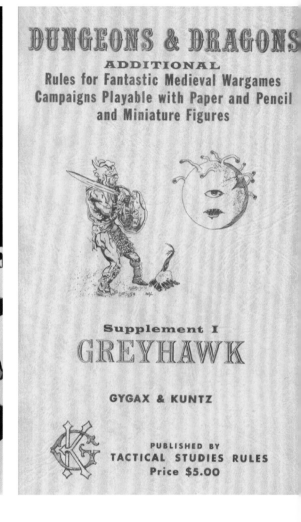

Yet the art of Dungeons & Dragons in this period remained an afterthought. When TSR launched its own periodical at the start of 1975, *The Strategic Review*, it was a simple black-and-white newsletter with a masthead but no cover for artwork. The first issue contained a description of a new creature, the mind flayer, described as a "man-shaped creature with four tentacles by its mouth which it uses to strike its prey," but no picture. When the *Greyhawk* supplement arrived later that year, bringing with it new, more dynamic classes such as the thief and the paladin, Bell was its only credited illustrator. Bell's beholder, first alluded to by Gygax in a June 1974 letter where he describes "a sphere with

11 eyes" where "each eye throws a high-level cleric or magical spell, and the main peeper is anti-magic" faces off against a warrior who bears an uncanny resemblance to *Dax the Damned* from *Eerie Tales*.

The release of *Greyhawk* demonstrated that the market had an appetite for Dungeons & Dragons products beyond just the woodgrain box—people sensed there was something magical about the game. But 1975 would prove a tumultuous year for TSR. At the end of January, thirty-six-year-old Don Kaye died suddenly, forcing an already overburdened and grieving Gygax to assume the role of company president.

THE BEHOLDER

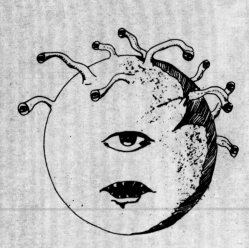

Original edition, 1975

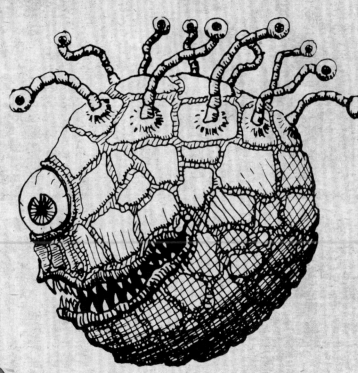

1st edition, 1977

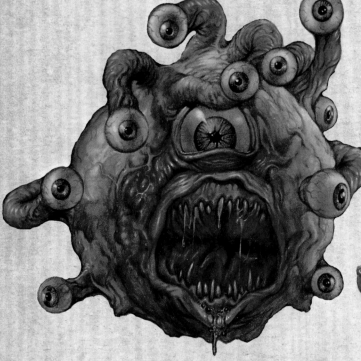

2nd edition, 1989

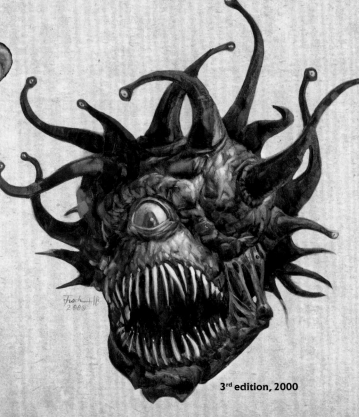

3rd edition, 2000

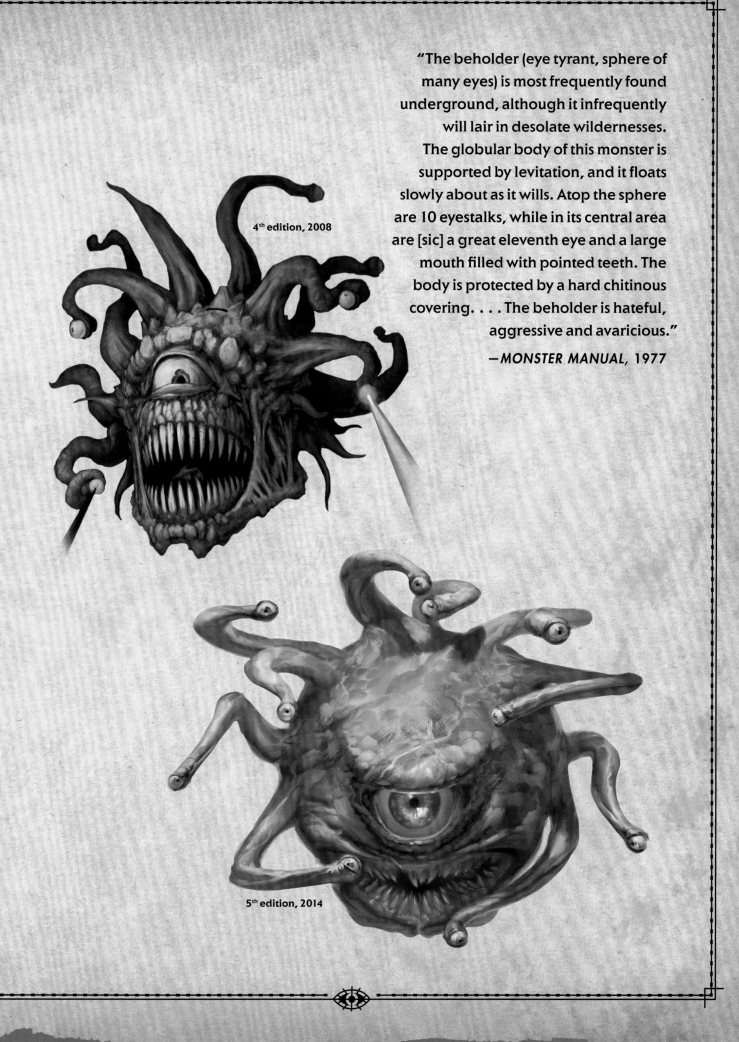

4th edition, 2008

"The beholder (eye tyrant, sphere of many eyes) is most frequently found underground, although it infrequently will lair in desolate wildernesses. The globular body of this monster is supported by levitation, and it floats slowly about as it wills. Atop the sphere are 10 eyestalks, while in its central area are [sic] a great eleventh eye and a large mouth filled with pointed teeth. The body is protected by a hard chitinous covering. . . . The beholder is hateful, aggressive and avaricious."

—*MONSTER MANUAL,* 1977

5th edition, 2014

LIZARD-MAN

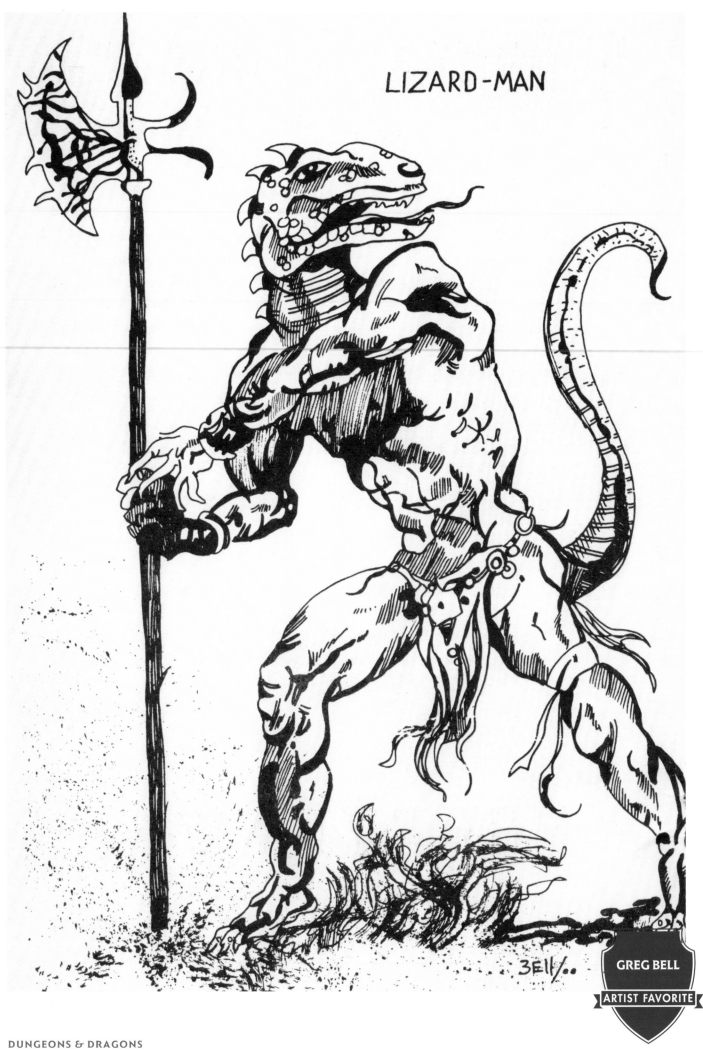

WARGAME RULES · FIGURES · BOARD GAMES · ACCESSORIES

TSR Hobbies, Inc.

DAVID L. ARNESON
RESEARCH DIRECTOR

414-248-3625

P. O. BOX 756
LAKE GENEVA, WI. 53147

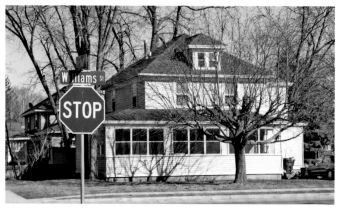

A DICEY BUSINESS

It was around this time that the invitation in the back of the original D&D booklets encouraging fans to create their own additions and interpretations began to set in motion forces outside of TSR's control: the first imitators entered the market, like *Tunnels & Trolls*; fans began producing their own magazines dedicated to the game, like *Alarums & Excursions*; and the first enthusiasts started homebrewing computer versions of D&D, like the innovative graphical games on the intercollegiate PLATO network—something of an early online community. Such activity was met with ambivalence by the still modest but growing TSR; the imitators were castigated and sometimes threatened with legal action, while the efforts of others that promoted D&D were encouraged, but only cautiously, so as to not relinquish its tightly held control of any aspect of the game. In the wake of this growing diversity, the term "role-playing game" began to creep into outside product reviews and ads from competitors, often as a way to describe a D&D-type game without using its name, thus avoiding TSR's legal ire. This term quickly became a label for the emerging genre that flowed from D&D.

TSR's ambitions grew proportionately. The first international distributors began making D&D available overseas, like the startup UK publisher Games Workshop. TSR bought some of the back catalog of the struggling Guidon Games, and now put out *Chainmail*, still featuring Don Lowry's swipe of Jack Coggins on the cover, under its own logo. It also officially assumed sponsorship of Gen Con, the Lake Geneva–based gaming convention Gary Gygax had founded in 1968. In order to relieve Don Kaye's widow of her responsibility for the growing business, Gygax and Brian Blume transferred its assets to a new corporation, TSR Hobbies, Inc., which could afford to pay only shabby wages to Gygax and a few other daring and frugal accomplices. A new imprint required new trade dress, and Greg Bell's illustration of a lizard man (pictured at left) from the inside cover of *Greyhawk* would soon serve as the logo for their new company.

Bell would continue to support the company's growing need for art as it invested in more attractive and sophisticated products: the first issue of the company's newsletter *The Strategic Review* was to include cover artwork featured a piece by Bell. Gygax wanted Bell, who still lived an hour away in Rockford, Illinois, to move to Lake Geneva to work for TSR full time as a true staff artist, but Bell remembers that at the time he had other career aspirations, and that doing art was just "something on the side."

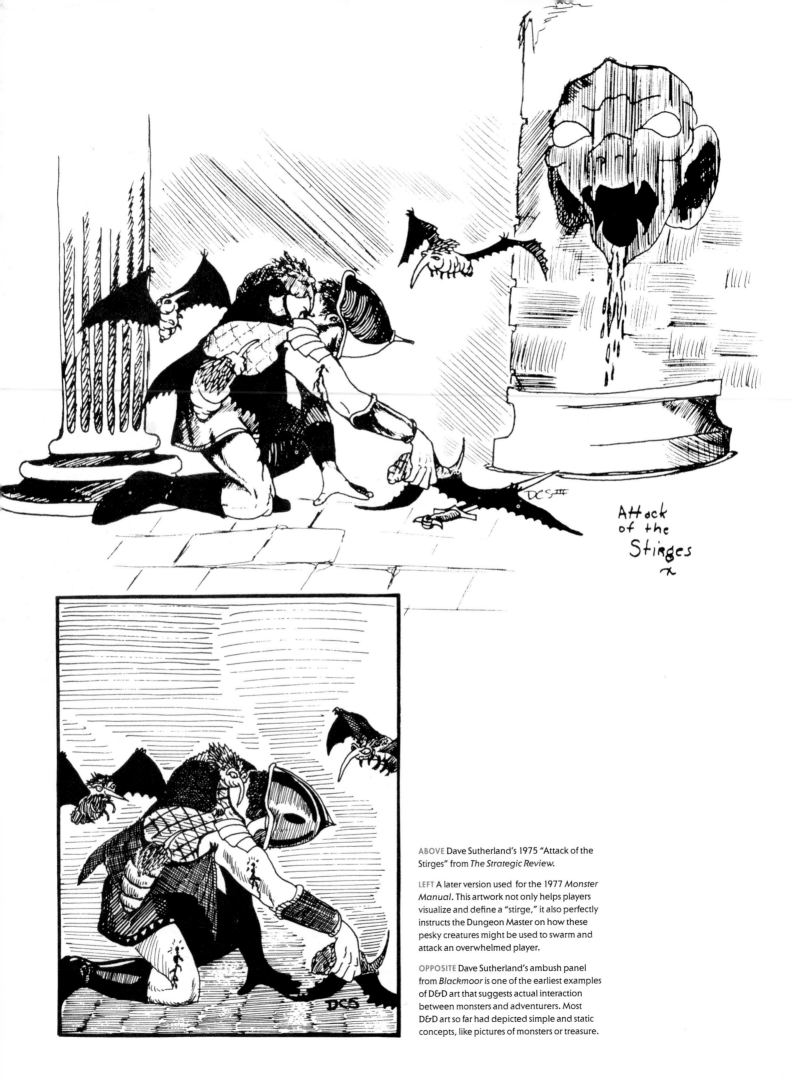

Attack
of the
Stirges

ABOVE Dave Sutherland's 1975 "Attack of the Stirges" from *The Strategic Review.*

LEFT A later version used for the 1977 *Monster Manual.* This artwork not only helps players visualize and define a "stirge," it also perfectly instructs the Dungeon Master on how these pesky creatures might be used to swarm and attack an overwhelmed player.

OPPOSITE Dave Sutherland's ambush panel from *Blackmoor* is one of the earliest examples of D&D art that suggests actual interaction between monsters and adventurers. Most D&D art so far had depicted simple and static concepts, like pictures of monsters or treasure.

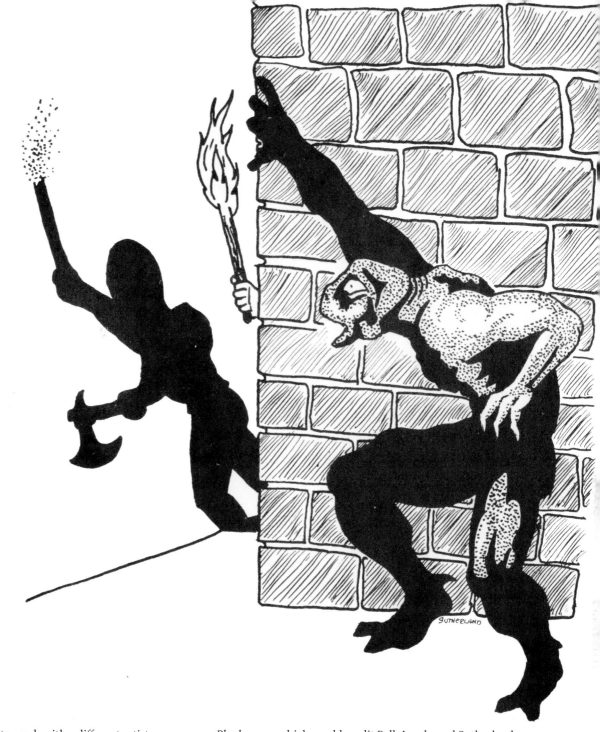

Gygax also in 1975 planned to work with a different artist on a certain "wild west booklet," that is the forthcoming *Boot Hill*: another teenager, this time a fourteen-year-old Lake Geneva local named Tracy Lesch, who had originally been brought to Gary by his eldest daughter Elise when she saw his sketches in junior high history class. However, in the fifth issue of *The Strategic Review* can be found a drawing by another illustrator who would soon become TSR's most prolific and recognizable artist: Dave Sutherland. A resident of the Twin Cities, Sutherland came to Gygax's attention through his artwork for another early TSR role-playing game, *Empire of the Petal Throne* by Minneapolis-based linguistics professor M.A.R. Barker. Upon seeing Sutherland's work, Gygax called him "a really excellent artist" and indicated "I've asked that he do more." Sutherland was quickly recruited to develop art for *The Strategic Review*, including an early piece called "Attack of the Stirges."

Sutherland would go on to provide illustrations for the second Dungeons & Dragons supplement, Dave Arneson's *Blackmoor*, which would credit Bell, Lesch, and Sutherland as its illustrators. Like the *Greyhawk* supplement, *Blackmoor* introduced new character classes, this time the monk and assassin, pushing Dungeons & Dragons into broader areas of fantasy. The supplement also introduced a new term to the D&D lexicon, the "Dungeon Master," a title that had already replaced "referee" in various parts of the gaming community. Bell's contributions included another swipe from *Dax the Damned* as well as a few monster portraits, while Lesch visualized two iconic D&D monsters, the mind flayer and roper (pictured on page 46). But Sutherland's striking portraits of the umber hulk and chimera, as well as his dungeon scene of the ambush awaiting a party of torch-carrying adventurers around a blind corner, brought the artwork of TSR products to a new level with a visibly superior quality that connoted formal art training.

There is no more telling indication of Sutherland's imminent prominence at TSR than that the fourth printing of Dungeons & Dragons, of which TSR printed a healthy five thousand copies

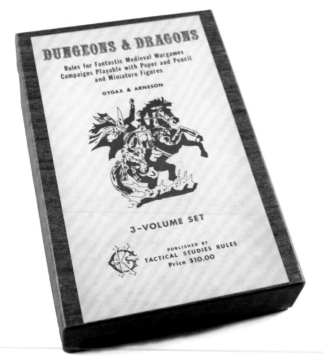

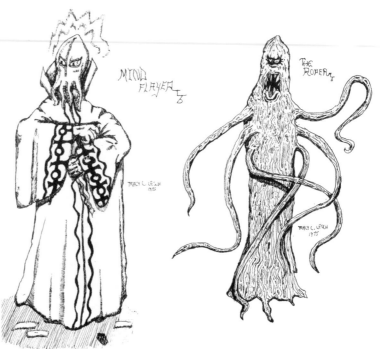

"Gary gave me very good initial direction on both the mind flayer and the roper . . . The mind flayer struck me as very dangerous, very powerful, an evil figure like a Ming the Merciless, with the mental powers of a Professor X. When I showed Gary the drawings, he told me that I had nailed it, that I had set the look for the two monsters."

—TRACY LESCH

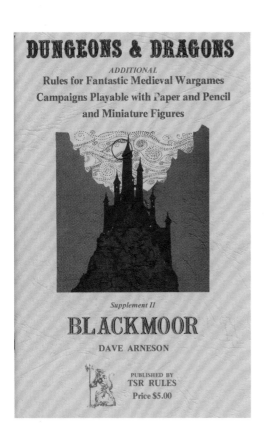

TOP The third printing of the Dungeon & Dragons "brown box" from 1975 featured a slightly longer box label.

ABOVE D&D's second supplement, *Blackmoor*, from 1975.

ABOVE, RIGHT Tracy Lesch's illustrations of the mind flayer and roper from *Blackmoor*—the first published depictions of these iconic D&D monsters.

OPPOSITE A contemporary ad that appeared in hobby gaming trade publications, seeking to convince retailers to not miss the boat, or the rocket ship as it were.

at the end of 1975, now featured cover art by Sutherland instead of Bell: a new scene of a wizard confronting adversaries in a dungeon. The rearing rider also disappeared from the cover of the *Men & Magic* rulebook at this time, to be replaced by another Sutherland illustration showing an eclectically armored foot soldier. Advertisements from this period thus showcased Sutherland, Bell, and Powell as the artistic ambassadors of Dungeons & Dragons.

In early 1976, TSR's modest success allowed them to purchase a small gray house in Lake Geneva to serve as their headquarters and retail outlet, with space enough to maintain a handful of employees. Among the company's new employees was D&D's co-creator, Dave Arneson, brought down from the Twin Cities, followed soon thereafter by another Twin Cities transplant, Dave Sutherland, who would serve as the company's first art director. Sutherland would rapidly put his stamp on the TSR product line, elevating the art in both quantity and quality.

ACERERAK

1978

1978

1978

1981

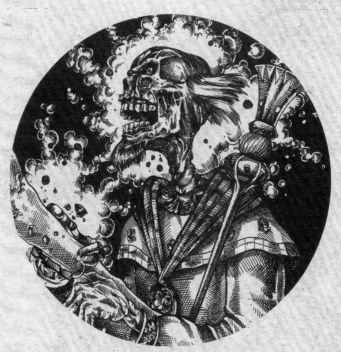

1998

"Ages past, a human magic-user/cleric of surpassing evil took the steps necessary to preserve his life force beyond the centuries he had already lived, and this creature became the lich, Acererak. Over the scores of years which followed, the lich dwelled with hordes of ghastly servants in the gloomy stone halls of the very hill where the Tomb is. Eventually even the undead life force of Acereak began to wane, so for the next 8 decades, the lich's servants labored to create the Tomb of Horrors . . . All that now remains of Acereak are the dust of his bones and his skull resting in the far recesses of the vault . . ."

—*TOMB OF HORRORS*, 1978

2010

2014

2014

2017

DUNGEONS AND DRAGONS* CHARACTER RECORD

	Experience	Gold
Name _____		
Class _____		
Level _____		
Alignment_____		
Strength _____		
Intelligence_____		
Wisdom _____		
Dexterity _____		
Constitution_____		
Charisma		

Languages
 known

Equipment	Spells	Magic Items

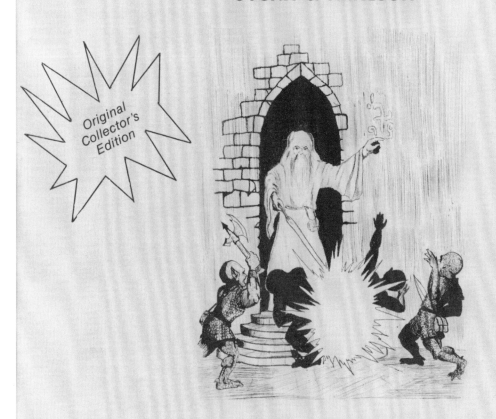

DUNGEONS & DRAGONS

Rules for Fantastic Medieval Wargames Campaigns Playable with Paper and Pencil and Miniature Figures

GYGAX & ARNESON

Original Collector's Edition

3-VOLUME SET

PUBLISHED BY
TACTICAL STUDIES RULES

ABOVE An *Original Collector's Edition* white box set of the original D&D game.

OPPOSITE A rare 1976 formal character sheet printed by TSR.

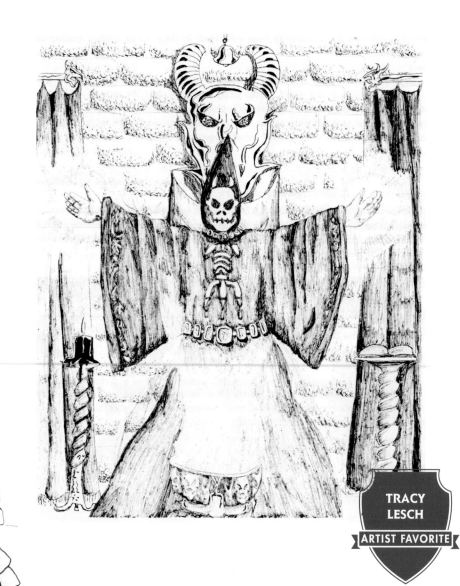

RIGHT Tracy Lesch provided only a single illustration for *Eldritch Wizardy*, but he made it count. The image he calls "Deaths-Head," a depiction of a lich performing an unholy ceremony, is among the most striking and unsettling in the book.

OPPOSITE Gary Gygax's hand-written art direction for the demon illustrations of *Eldritch Wizardry*. Also pictured is Sutherland's type I demon illustration, but one of many examples found in *Eldritch Wizardry* that shows how closely he adhered to Gygax's exact design specifications, from the "feathered tail" to the "vulture's head atop a long neck."

BELOW Instead of depicting simple monsters or static scenes, Gary Kwapisz used his single entry in *Eldritch Wizardry* to create a more complex in-game scenario, inspired by his "love of comics and telling stories with pictures." This panel served as an early piece of instructional art that may have suggested to players that using their move-silently or hide-in-shadows abilities might come in handy.

ANCIENT AND POWERFUL MAGIC

By the time TSR released the *Eldritch Wizardry* supplement in May 1976, which introduced the druid class and rules for psychic mind powers (known as *psionics*) into Dungeons & Dragons, Greg Bell was no longer contributing illustrations. That booklet's cover, the first full-color TSR art, features a nude woman on a sacrificial altar, illustrated in pastels by a young, Minneapolis-based artist named Deborah Larson. The scene was perhaps an early hint that this was not necessarily a game for children. *Eldritch Wizardry* became famous, or infamous, for its depiction of various demons drawn from ancient real-world mythological sources, including Orcus and Demogorgon, whose portraits Dave Sutherland produced under the direct guidance of Gary Gygax. The interior art is almost exclusively by Sutherland, though it still includes a solitary occult scene by Tracy Lesch and another of a dramatic dungeon scene by seventeen-year-old Michigan native Gary Kwapisz.

DEMONS

	TYPE I	TYPE II	TYPE III	TYPE IV	BALROG TYPE V	ORCUS	DEMOGORGON
HEIGHT	8.4' 35mm	7.2' 30mm	9.6' 40mm	10.8' 45mm	12' 50mm	15.6' 65mm	18' 75mm
BUILD	THIN	THICK SQUAT	BROAD SHOULDERED	HEAVY	MANLIKE	HUGE	SLENDER
SKIN	FEATHERED	SMOOTH, WARTS	WRINKLED HIDE	HAIRY	SCALED	FURRED?	PLATED
HEAD	VULTURE'S — ATOP LONG NECK	TOAD'S — HUGE MOUTH HUMAN EARS	DOG'S — EARS	BOAR'S —	HUMAN —	GOAT'S —	BABOON OR MANDRIL (SEE OTHER)
FACE	HUMANOID BUT BIRD-EYED	TOAD	DOG MUZZLE	AS BOAR WITH TUSHES	HUMAN, BUT FANGED ?		AS HEAD
HORNS	—	—	GOAT'S	—	BULL'S ?	RAM'S	—
BODY	BIRD'S	GROSS, TOAD-LIKE	MAN-LIKE	APELIKE	WELL-MUSCLED MAN	GROSSLY FAT HUMAN	REPTILIAN
ARMS	WITH VULTURE'S TALONS	VERY LONG, HUMAN, CLAWED	MAN'S ENDING IN PINCERS	HUGE-SPLAYED FINGERS+ NAILS LONG	HUMAN (SEE OTHER)	HUMAN COULD HOLD SKULL-TOPPED WAND	TENTACLES
LEGS	HUMAN, VULTURE'S FEET	TOAD	BOWED HUMAN	BOAR'S	HUMAN-MUSCLED	GOATISH	LIZARD
WINGS	BIRD	—	—	—	BAT	BAT	—
TAIL	FEATHERED	—	—	PIGS	—	TIPPED WITH ARROW HEAD	FORKED
OTHER			SMALL ARMS PROJECTING FROM CHEST		CAST WITH WHIP & JAGGED SWORD		TWO HEADS ATOP SERPENT NECKS

D&D AND ITS PULPY ROOTS

The supine female figure on the cover of *Eldritch Wizardry* bears a certain resemblance to a figure on the uncredited cover of A. Merritt's pulp classic *Dwellers in the Mirage* (Horace Liveright, 1932).

GARY GYGAX AND DAVE ARNESON were heavily inspired by both the art and thematic content of popular fantasy of the 1920s, 1930s, and 1940s. "Pulps" of this era were largely considered fringe publications due to their often violent and sexually explicit content, frequently set in the esoteric genres of horror, fantasy, or science fiction. Foremost among these for the creators of D&D was the fiction of Robert E. Howard and his seminal swords-and-sorcery series *Conan the Cimmerian*, which conquered the pages of *Weird Tales* between 1932 and 1936.

However, many other fantasy authors played important roles in influencing the game's thematic content and its art, such as Edgar Rice Burroughs, H.P. Lovecraft, Fritz Leiber, and Jack Vance, who was the direct inspiration of D&D's unique memorize-and-forget spell system—which proved to be a simple mechanism to limit and balance the power of the magic-user class in the D&D system.

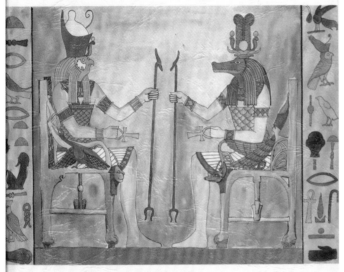

ABOVE Dave Sutherland furnished the burning scroll on the cover of *Swords & Spells* (1976), the successor of the aging *Chainmail* fantasy miniatures rules.

LEFT D&D's second full-color cover, this one by Dave Sutherland with his Egyptian-themed illustration for *Gods, Demi-Gods & Heroes* (1976).

Sutherland's preeminence in D&D's art continued with his Egyptian-style cover for the fourth and final supplement to Dungeons & Dragons, called *Gods, Demi-Gods & Heroes*; within, it contained little original art, just public domain prints used mostly for page ornamentation. The publication of these final two supplements completed the original Dungeons & Dragons line—with the addition of one afterthought, a booklet of tactical fantasy wargaming rules called *Swords & Spells* that kept one of D&D's feet planted in the miniatures world from which it came.

By the end of 1975, Dungeons & Dragons had sold more than four thousand copies, and in the first quarter of 1976 it sold another fifteen hundred—extraordinary sums for a fledgling hobby game with limited distribution. This established there was enough of a

market for TSR to risk an ambitious new step, replacing its low-budget *Strategic Review* newsletter with a periodical focused entirely on fantasy: *The Dragon*. A glossy magazine with full-color covers, it quickly became not just an advertising venue for TSR, but a recruitment tool for illustrators and game designers alike. Important future D&D artists like Erol Otus and Jennell Jaquays would do their first work for TSR as early contributors of interior pieces for the first handful of issues. The cover became a coveted spot for fantasy artists to show off: Sutherland painted the cover of the fifth issue himself, and as Dungeons & Dragons grew in importance, renowned artists showcased their talents in *The Dragon*.

DEMOGORGON

1976

Demogorgon

1977

2002

20|02

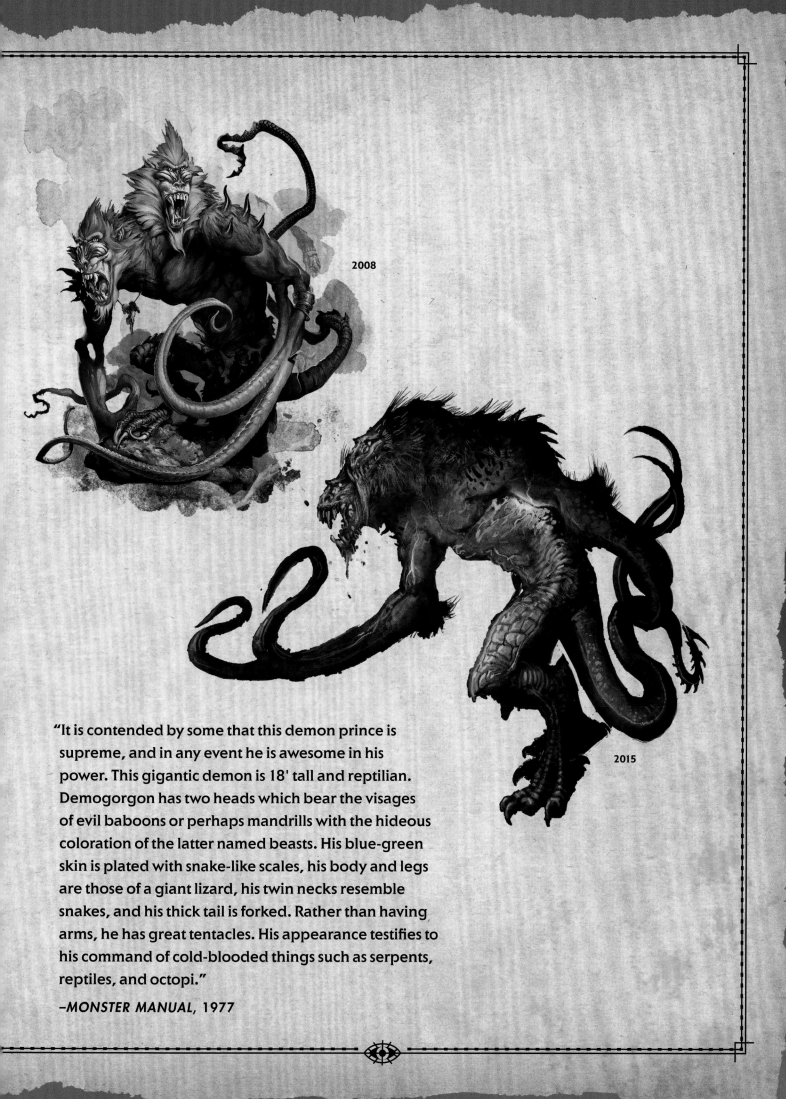

2008

2015

"It is contended by some that this demon prince is supreme, and in any event he is awesome in his power. This gigantic demon is 18' tall and reptilian. Demogorgon has two heads which bear the visages of evil baboons or perhaps mandrills with the hideous coloration of the latter named beasts. His blue-green skin is plated with snake-like scales, his body and legs are those of a giant lizard, his twin necks resemble snakes, and his thick tail is forked. Rather than having arms, he has great tentacles. His appearance testifies to his command of cold-blooded things such as serpents, reptiles, and octopi."

—MONSTER MANUAL, 1977

ENTER THE DRAGON

DUNGEONS & DRAGONS WAS gradually becoming a force in the gaming world, and its fans wanted more, usually faster than TSR could develop new official game material. This often meant that fans would take gaming content in their own hands, and in this pre-Internet era, the gaming community was still galvanized by "fanzines," black-and-white, micro print-run, homemade publications that catered exclusively to the niche. But despite their limited reach, they were an essential part of the fabric of an underground culture on the verge of the mainstream. Once D&D exploded into the zeitgeist, *The Dragon*, or later just *Dragon* magazine, a "prozine," became the natural extension of this new form of gaming. As the community grew from grassroots to global, conversation that was once limited to small-town gaming tables, or at best the local game shop, now had a grander platform.

Dragon became a creative safe haven for a diverse stable of talents—creators, amateur and professional alike—to experiment with new ideas, envision exotic monsters, introduce or revise mechanics, and present pre-scripted modules and adventure settings, many of which eventually found their way into the pages of TSR rulebooks. A shining example is Ed Greenwood's legendary Forgotten Realms campaign setting, first introduced via a series of articles in the early 1980s. Meanwhile, artists were free to push the visual envelope, exploring comedy, violence, and the absurd, all the while constantly redefining the perceived thresholds of the brand itself. The breadth of the magazine, much like the game, was seemingly infinite.

Most important, *Dragon* magazine was home to a passionate community of fans. Sprinkled between the mirth, mechanics, and mayhem were columns by creators, rumblings of upcoming releases, editorials on exciting events, art competitions, creature-naming contests, and even a forum to voice praise or dissent—Gygax himself would occasionally chime in to settle the random debate. In the pages of *Dragon*, the fans mattered . . . and those fans would never feel alone again.

ABOVE The "Creature Feature" was a mail-in fan art contest opened in *Dragon* #13. Pictured here are the four winners, most notably "3rd Place" Stephen Sullivan (second from left) and "Honorable Mention" Erol Otus (third from left), who went on to long and memorable careers in Dungeons & Dragons design.

OPPOSITE The first issue of *The Dragon* with cover art by Bill Hannan, who was the junior college art instructor of the magazine's editor in chief, Tim Kask.

June Vol. 1, No. 1

Premier Issue

In this Issue:

- Fritz Leiber: a conversation with Fafhrd & the Mouser
- Languages in D&D by Lee Gold
- Part One of a new fantasy novel "The Gnome Cache"

$1.50

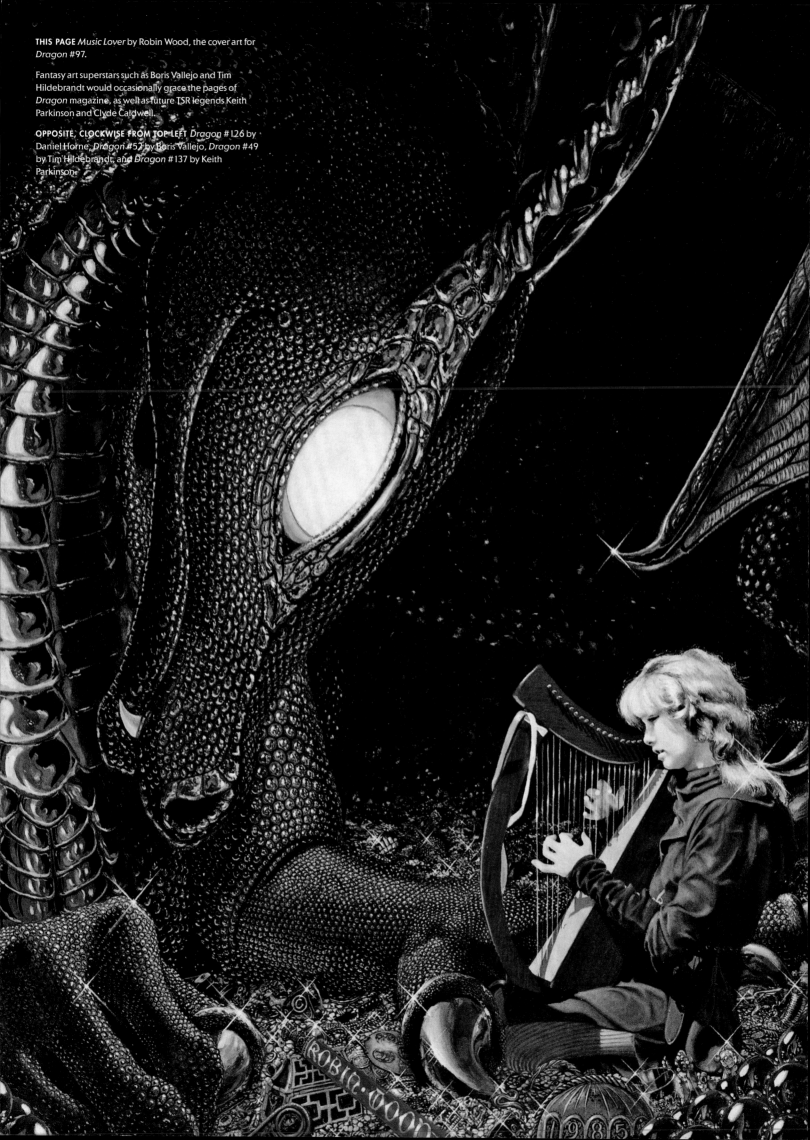

THIS PAGE *Music Lover* by Robin Wood, the cover art for *Dragon* #97.

Fantasy art superstars such as Boris Vallejo and Tim Hildebrandt would occasionally grace the pages of *Dragon* magazine, as well as future TSR legends Keith Parkinson and Clyde Caldwell.

OPPOSITE, CLOCKWISE FROM TOP LEFT *Dragon* #126 by Daniel Horne, *Dragon* #52 by Boris Vallejo, *Dragon* #49 by Tim Hildebrandt, and *Dragon* #137 by Keith Parkinson.

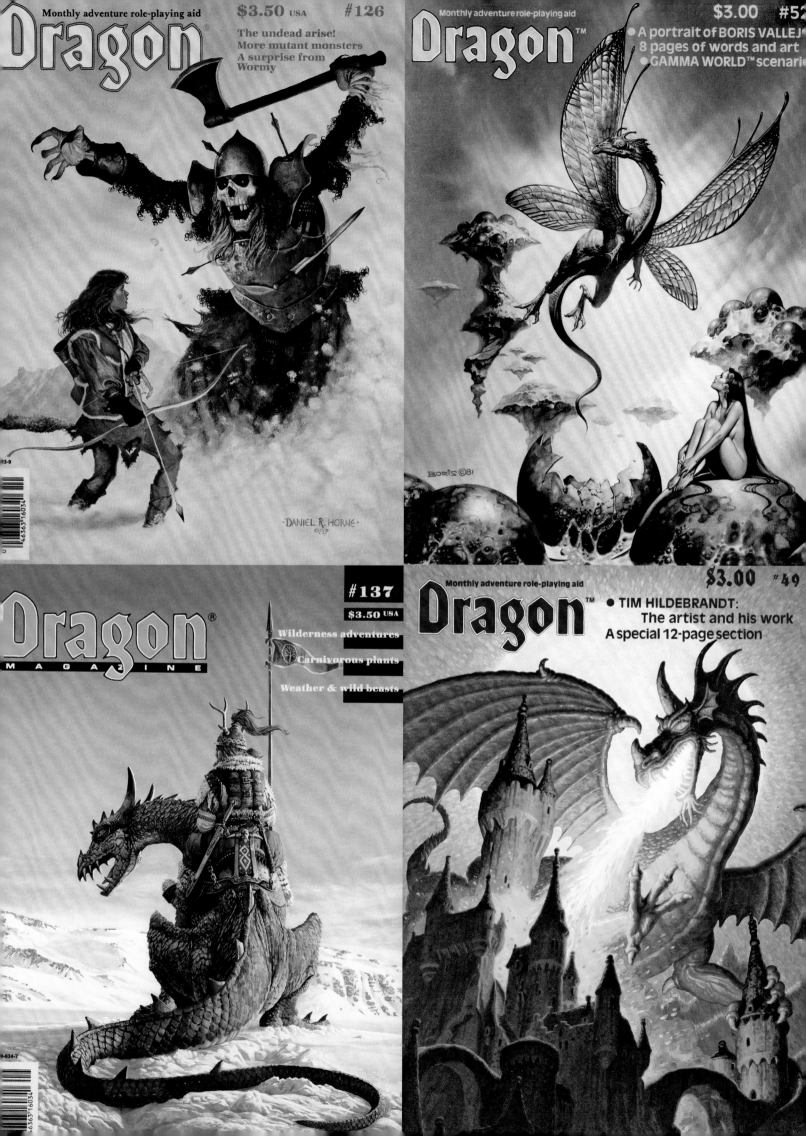

Monthly adventure role-playing aid

Dragon

$3.50 USA #126

The undead arise!
More mutant monsters
A surprise from
Wormy

DANIEL R. HORNE
'87

Monthly adventure role-playing aid

Dragon™

$3.00 #52

● A portrait of BORIS VALLEJ●
8 pages of words and art
● GAMMA WORLD™ scenari●

BORIS ©81

Dragon

MAGAZINE

#137
$3.50 USA

Wilderness adventures
Carnivorous plants

Weather & wild beasts

Monthly adventure role-playing aid

Dragon™

$3.00 #49

● TIM HILDEBRANDT:
 The artist and his work
A special 12-page section

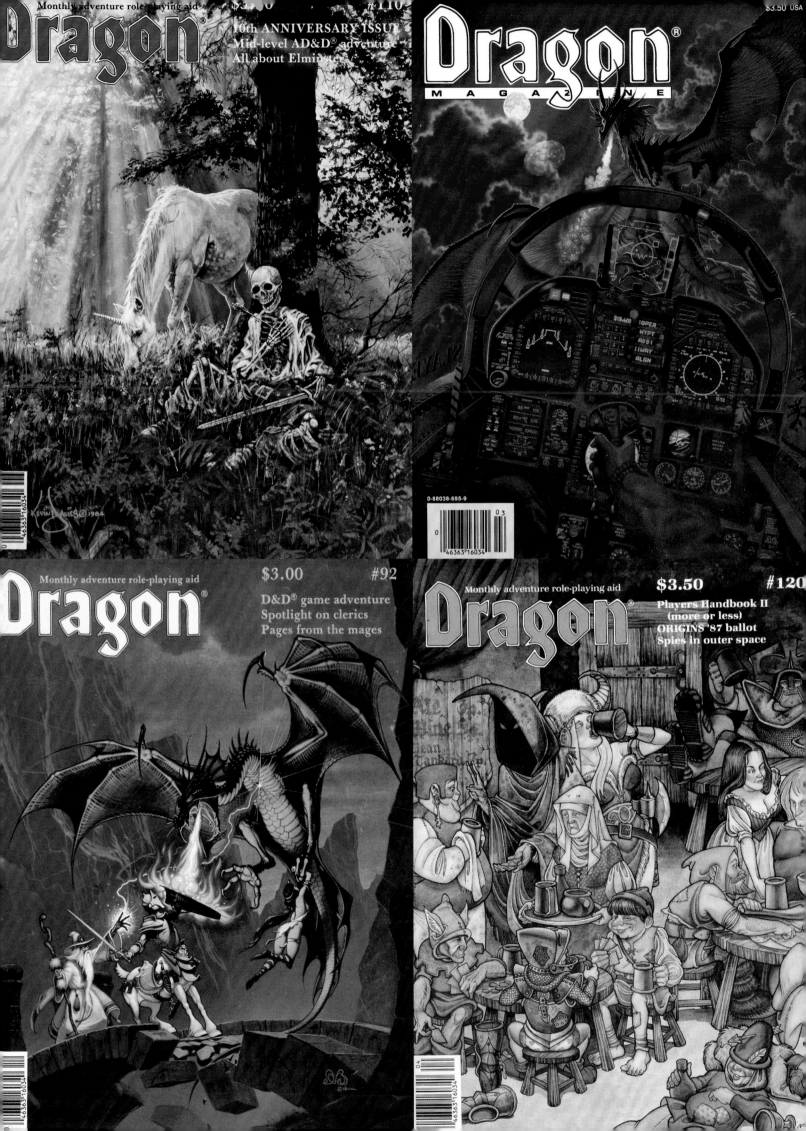

Dragon

$3.50 USA #110

10th ANNIVERSARY ISSUE
Mid-level AD&D® adventure
All about Elminster

Dragon MAGAZINE

$3.50 USA

0-88038-695-9

03

0 46363 16034

Monthly adventure role-playing aid $3.00 #92

Dragon®

D&D® game adventure
Spotlight on clerics
Pages from the mages

Monthly adventure role-playing aid $3.50 #120

Dragon®

Players Handbook II
(more or less)
ORIGINS '87 ballot
Spies in outer space

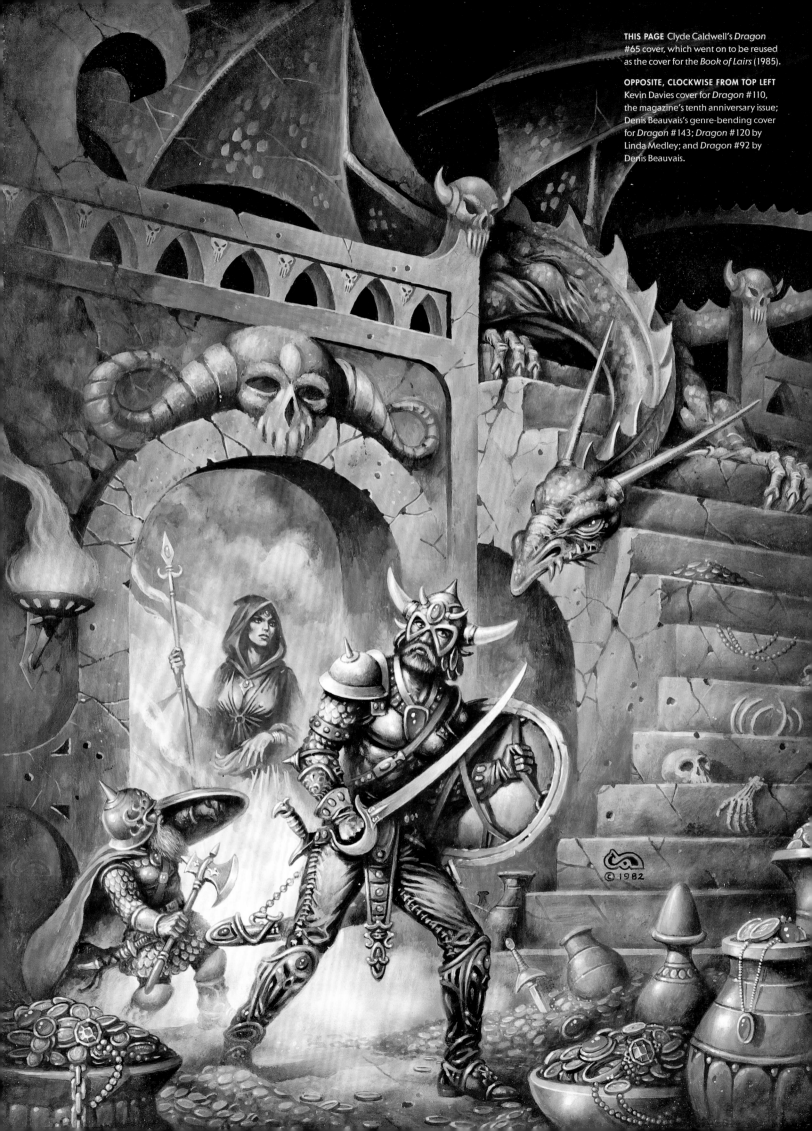

THIS PAGE Clyde Caldwell's *Dragon* #65 cover, which went on to be reused as the cover for the *Book of Lairs* (1985).

OPPOSITE, CLOCKWISE FROM TOP LEFT Kevin Davies cover for *Dragon* #110, the magazine's tenth anniversary issue; Denis Beauvais's genre-bending cover for *Dragon* #143; *Dragon* #120 by Linda Medley; and *Dragon* #92 by Denis Beauvais.

© 1982

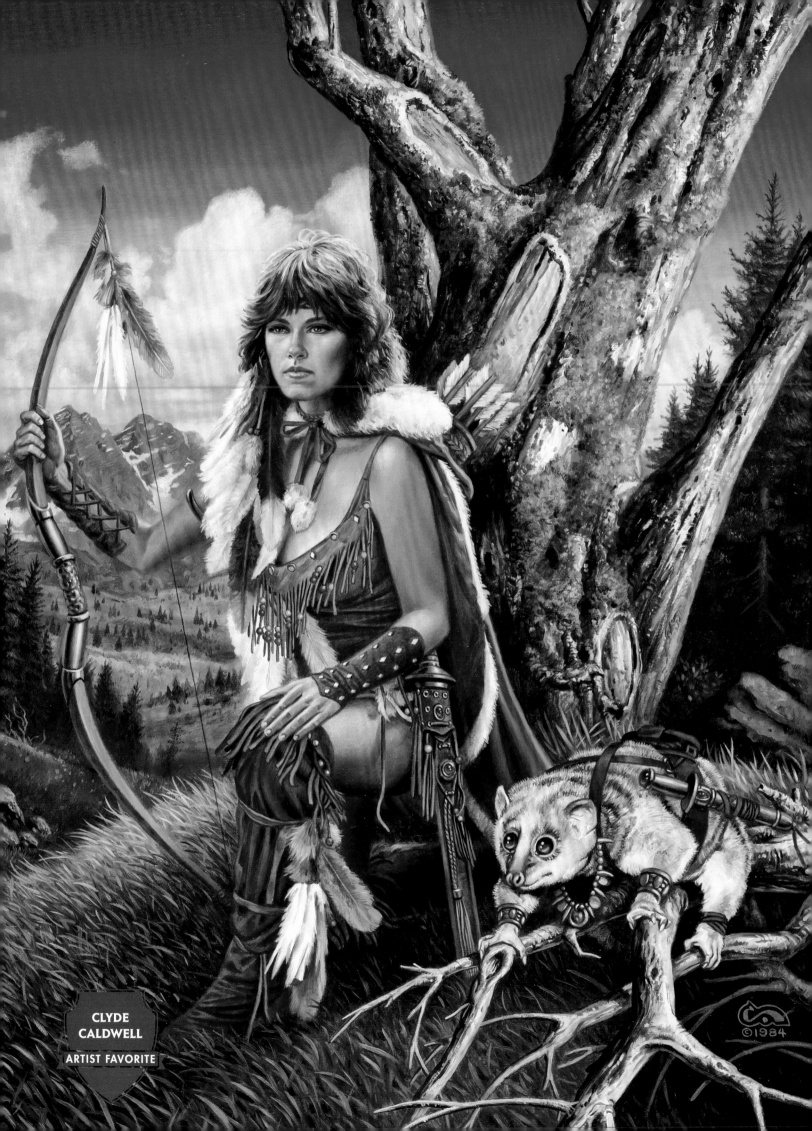

CLYDE
CALDWELL

ARTIST FAVORITE

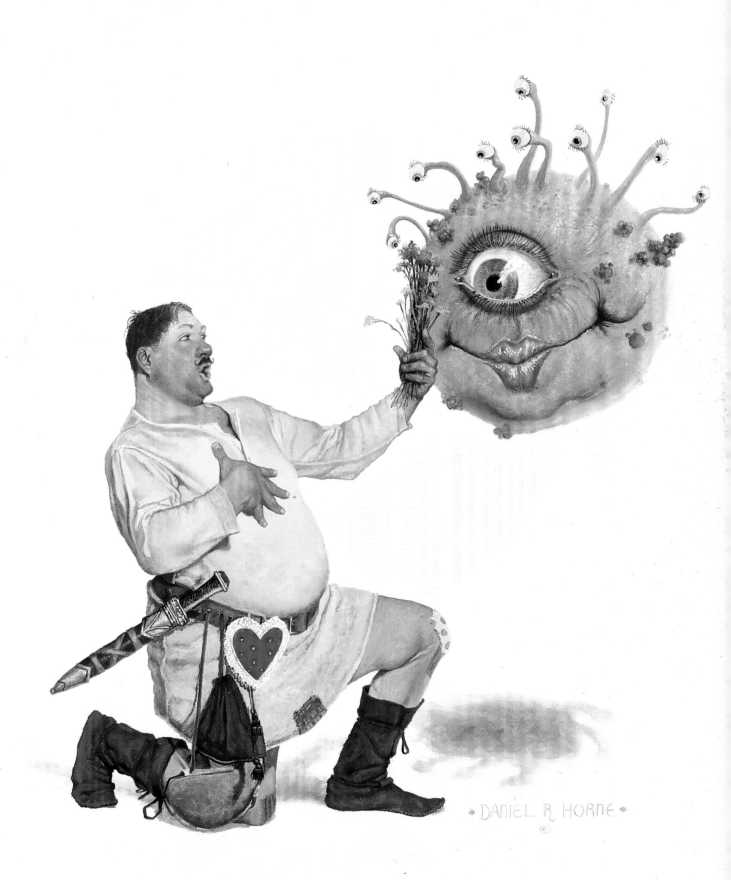

THE ORIGINS OF THE OWL BEAR, BULETTE, AND RUST MONSTER

Bell's 1975 owlbear from *Greyhawk* bears no resemblance to the plastic inspiration or Sutherland's version from the cover of the 1977 *Monster Manual*.

Sutherland's first drawing of the bulette from *Dragon* #1 and the dime-store miniature that inspired it.

Gary Gygax's sketch for a rust monster from around 1975, plus the plastic inspiration for the rust monster and the Dave Sutherland version that appears in the 1977 *Monster Manual*.

IN THE MID-1970s, PHYSICAL props began to directly inspire visual elements of D&D. We know from his 1972 article in *Wargamer's Newsletter* that Gary Gygax said he played *Chainmail* with "soft plastic 'horrors'" and "plastic prehistoric animals" from the start, but in the first issue of *The Dragon*, we see a monster illustration by Dave Sutherland plainly influenced by one of those miniature figures: the slow-witted, roughly bullet-shaped bulette, sometimes known as the "landshark." Others would follow a year later in the *Monster Manual*, where Sutherland depicts a rust monster, which bears a striking resemblance to a plastic horror often found in the same packet as the prototype bulette. The strangest case is perhaps that of the owlbear. Like the rust monster, the owlbear was introduced in *Greyhawk*, but while the rust monster has no illustration in *Greyhawk*, the pamphlet does contain a portrait of the owlbear. The 1975 *Greyhawk* image looks nothing like the later version done two years later by Sutherland for the *Monster Manual*. Sutherland's rendition clearly used one of the plastic horrors for its model.

YOU'LL BE AMAZED

DUNGEON!

THE FANTASY ADVENTURE GAME FOR THE WHOLE FAMILY OR EVEN SOLO DUNGEON ADVENTURES. PLAYERS ARE ELVES, WIZARDS, HEROES AND SUPERHEROES. EACH MONSTER SLAIN COULD MEAN YOU GAIN THE WINNING TREASURE!

IF YOUR FAVORITE BOOK OR HOBBY SHOP DOESN'T HAVE THEM, ORDER YOUR COPIES DIRECT

TSR HOBBIES, INC.
POB 756 Dept. S
Lake Geneva
Wisconsin 53147

☐ DUNGEON $9.95
☐ DUNGEONS & DRAGONS $9.95
☐ Complete color catalog FREE

Name_____
Address_____
City_____
State_____Zip_____

DUNGEONS & DRAGONS
*T.M. REG. APP. FOR

THE SWORD AND SORCERY GAME OF ROLE PLAYING FOR THREE OR MORE ADULTS. THE BASIC SET ☞ CONTAINS EVERYTHING YOU NEED TO BEGIN PLAYING. THE GREATEST FANTASY GAME EVER!

A 1978 advertisement promoting D&D alongside its board game counterpart, *DUNGEON!* by TSR staffer Dave Megarry, a Twin Cities native who had played in Dave Arneson's original Blackmoor campaign.

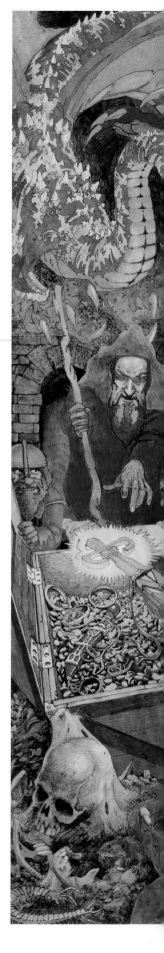

ABOVE Tom Wham's whimsical image of dungeon adventurers was incorporated into the original D&D "white box" editions, and also appeared on the cover of TSR Hobbies, Inc.'s *Character Records Sheet* product.

RIGHT TSR is not the first company to want to turn its fans into walking advertisements, as seen here by this hefty Western-style belt buckle. Today, only a handful remain, and those that do fetch in excess of $1,000 on the collector market, making the original $5.00 investment seem like a steal.

OPPOSITE The original 1979 *Dungeon Master Screen* painting by Dave Trampier.

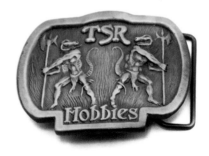

AT THE END OF 1976, a bitter dispute with management caused Dave Arneson to leave TSR and return to the Twin Cities. Arneson's role in creating D&D never transitioned into a viable role at the company, and his departure heralded a protracted legal battle. However, his Twin Cities compatriot Dave Sutherland would remain a presence at TSR for decades to come. He oversaw the look of the brand during the crucial transition from the original Dungeons & Dragons product, now completed, into two separate branches: *Basic* and *Advanced* Dungeons & Dragons. But he couldn't do it alone. The May 1977 issue of *The Dragon* noted that Tom Wham had recently joined that company, and that "he'll be doing screwy things for us." Wham had earlier worked for Don Lowry at Guidon Games, and his cartoonish and whimsical style would adorn the cover of the first packaged character sheets that TSR produced. Two issues later, *The Dragon* would introduce Dave Trampier, "our newest artist here at TSR," whose comic strip *Wormy* would become a fixture in *Dragon* magazine for the next decade. "Tramp," as he was known to TSR staffers, brought with him both a humorous side and a gritty, realistic style that served as a refreshing contrast to the work of Sutherland.

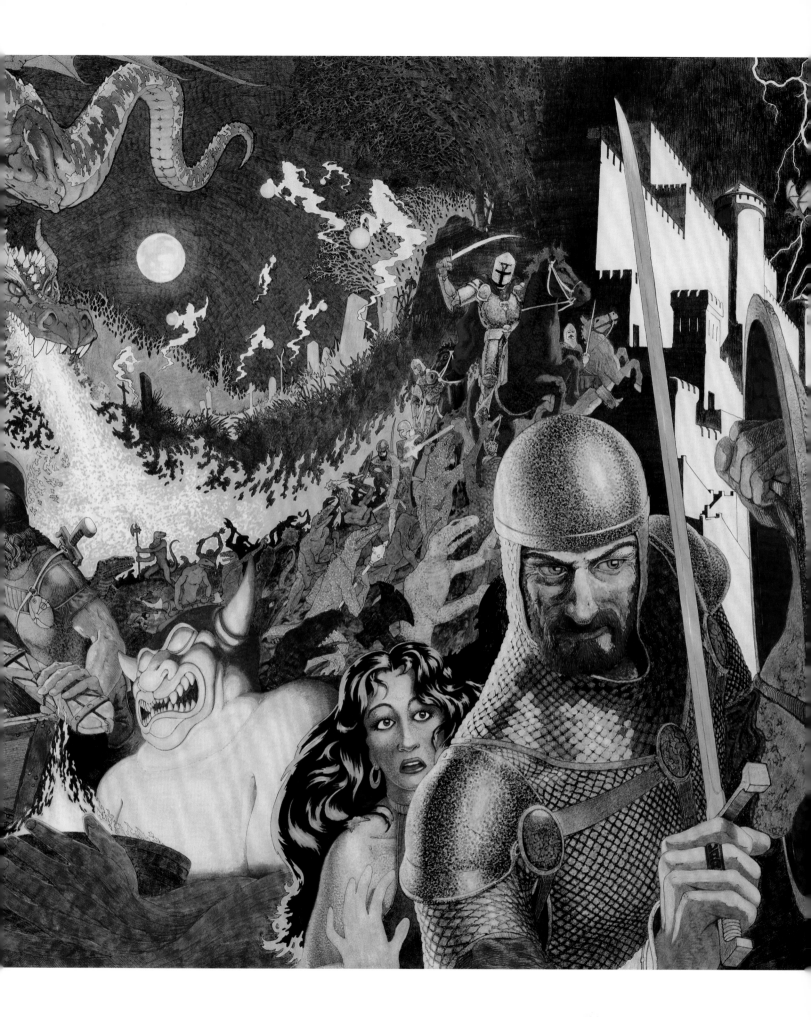

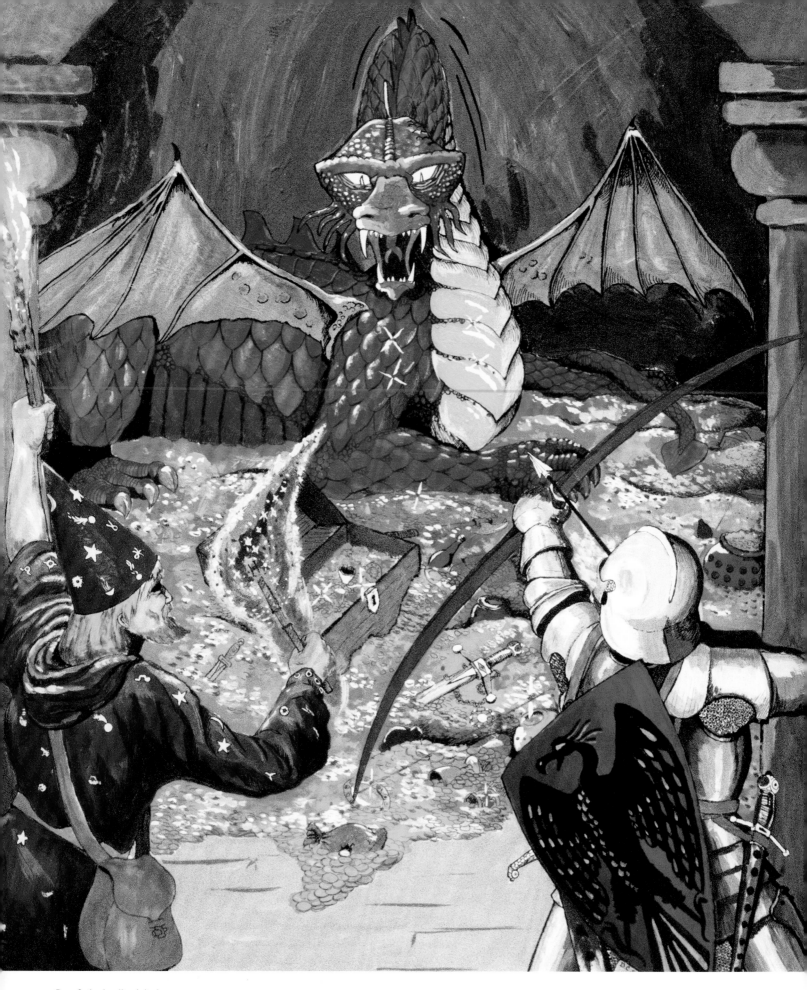

Dave Sutherland's original
cover painting for the *Basic Set*,
a scene that can truly be said to
do justice to the game's title.

A small monster with the head, wings and legs of a cock and
the tail of a serpent. The cockatrice can fly and it turns opponents
to stone with its touch if it scores a hit.

 The monster is not intelligent.

<u>Dervishes</u>

<u>Move</u> 12⊕/turn
<u>Hit Dice</u> 1 + 1 additional point
<u>Armor Class</u> Variable
<u>Treasure</u> A
<u>Alignment</u> Lawful

 These fanatically religious nomads fight like Berserkers. They
add +1 to the roll of their attack die because of their ferocity.
Always led by a 8-10th order cleric.

 Composition of Force is like Nomads:

 50% light horse lancers, leather armor

 30% medium horse lancers, chain mail

 20% light horse bowmen, leather armor

 No prisoners. Carry no gold or silver

<u>Displacer Beast</u>

<u>Move</u> 15⊕/turn
<u>Hit Dice</u> 6
<u>Armor Class</u> CM + S 4
<u>Treasure</u> D

 The Displacer Beast resembles a puma with six legs and a pair
of tentacles which grow from its shoulders. It attacks with the
tentacles which have sharp horney edges. It is highly resistant to
magic, gets a +2 on its saving throws.

LEFT The description of the displacer beast from the 1975 *Greyhawk* supplement clearly borrowed from A.E. van Vogt's pulp-era short story *Black Destroyer*. This depiction drawn by Eric Holmes's son Christopher from the *Basic Set* draft manuscript was never published, but it is perhaps the earliest illustration of this iconic D&D monster.

BELOW The 1977 *Basic Set* in its original shrink-wrapping.

FOLLOWING SPREAD Dave Sutherland's original cover painting of the AD&D *Monster Manual*, depicting monsters in their natural habitats—a D&D terrarium of sorts.

With TSR's rapid growth, the budget had increased enough to support three staff artists on the payroll, but with that came an expectation of professionalism that was simply absent in earlier times when the company operated as more of a hobby than a business. Throughout 1977, the triumvirate of Sutherland, Trampier, and Wham busily tag-teamed the core art for Dungeons & Dragons, each developing a unique style and delivering in heavy volumes. Their three names would also be listed as the entire art staff for *The Dragon* until the spring of 1979. They illustrated effectively all of TSR's major releases of 1977, most significantly a simplified *Basic Set* and, at the end of the year, the *Monster Manual*, the debut product of Gygax's comprehensive reworking and expansion of D&D into Advanced Dungeons & Dragons. Leaving behind the soft-cover, digest-sized booklets, both the *Basic Set* and the *Monster Manual* were high-quality products in 8.5 x 11-inch mass-market form factors. These were suitable for distribution outside of just hobby circles, the sorts of products that could appear on a shelf at Kmart or Waldenbooks. Sutherland personally painted the covers of both.

As TSR began to think about the mass market, it became clear that efforts were needed to distill D&D's complex and esoteric rules into a game that could be understood by the masses. Serendipitously, a neurologist named Eric Holmes at the University of Southern California had taken to the game and wrote to TSR volunteering to condense the rules for low-level characters into a single volume of organized and approachable

rules, an offer that the overworked staffers in Lake Geneva gladly accepted. As TSR's first attempt to appeal to newcomers, Holmes's *Basic Set* became the entry point to a general audience outside of the dedicated fans of wargaming and fantasy fiction.

Inside the *Basic Set* box was a single paperback rulebook with a monochrome blue version of the cover painting, a bagged set of polyhedral dice, and a few loose sheets of *Dungeon Geomorphs*—modular dungeon maze sections that allowed Dungeon Masters to build custom dungeons quickly and with minimal preparation—along with a *Monster & Treasure Assortment* to help new Dungeon Masters get their underworlds furnished with adversaries and rewards. The *Basic Set* quickly began selling upward of one thousand copies per month.

Just as D&D began to cross over into the mainstream, a few fantastic creatures had to exit TSR's menagerie. Elan Merchandising, a sublicensee of the Tolkien Estate who held certain non-literary rights to Tolkien's creations, sent TSR a cease-and-desist order that led to the replacement of hobbits, ents, and balrogs with halflings, treants, and the balor type of demon. While this change was largely cosmetic, it did throw a speedbump in TSR's path, which forced hasty modifications to the *Basic Set* and delayed the *Monster Manual* until the final days of December. Some Tolkienisms, however, would accidentally linger in straggling products released over the next year. But for whatever problems the company may have had, D&D was a game very much on the rise, and TSR's fate would be inexorably tied to it.

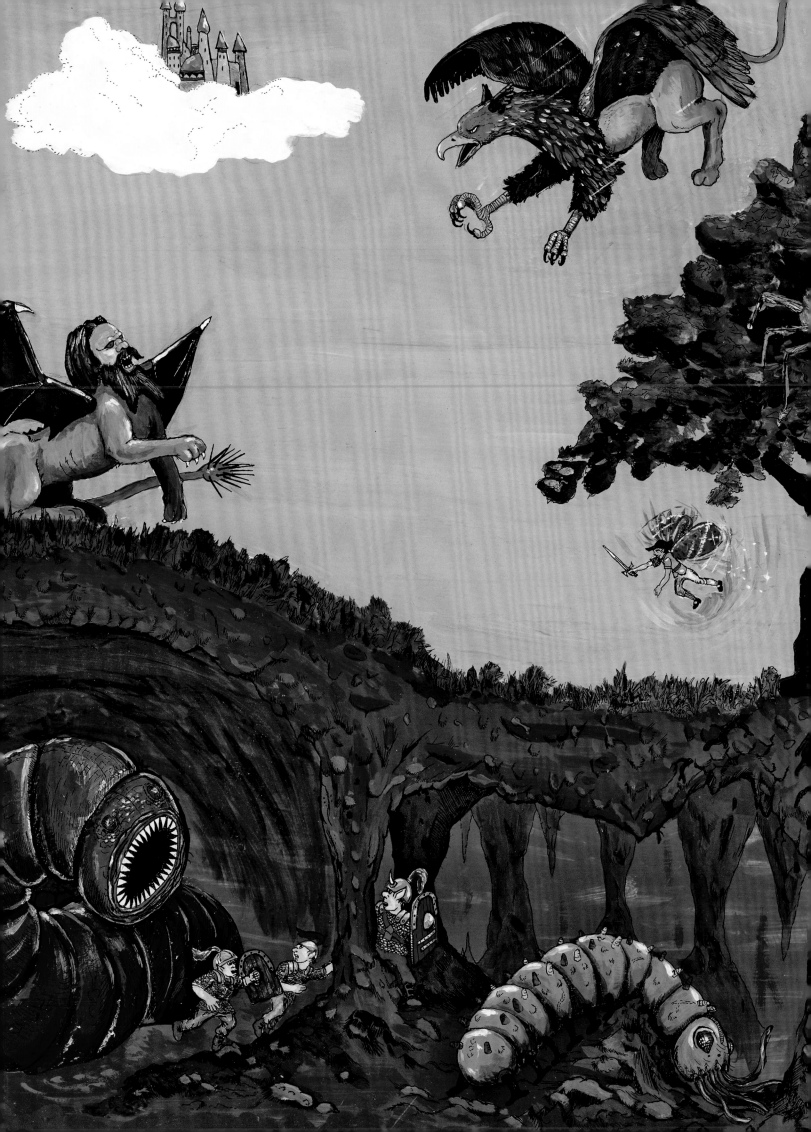

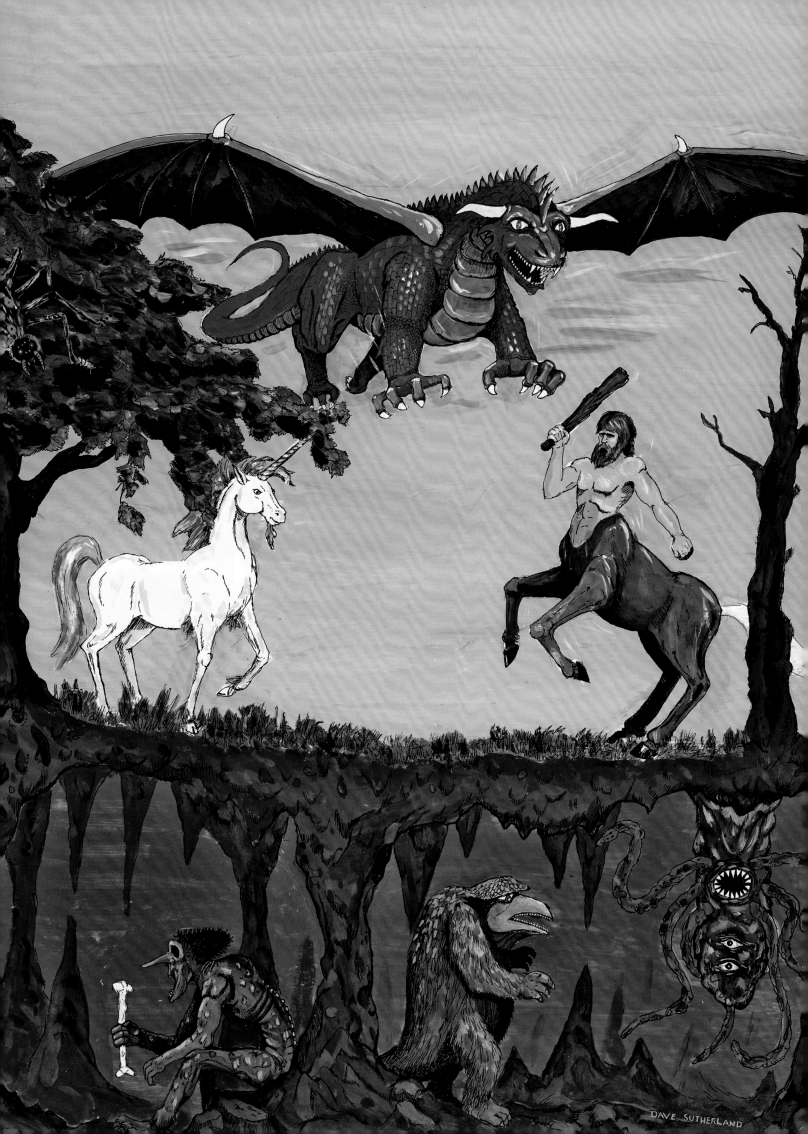

"IT PRODUCES A FLASHING AND FIERY BURST OF
GLOWING, COLORED AERIAL FIREWORKS . . . "

PYROTECHNICS

1ST EDITION

2-1

STONE GIANT

36%

ILLO.
#84

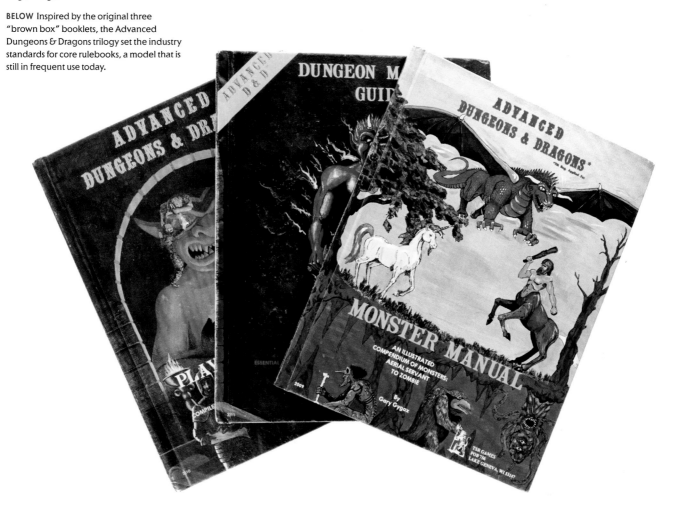

WITH THE CONTINUED success of the *Basic Set* and the release of the encyclopedic *Monster Manual* at the end of 1977, TSR started 1978 with a roar (and perhaps a hiss and a growl as well). The groundbreaking new rulebook made the standard visualization of monsters just as important as how they were specified and quantified in the D&D system. It included more than two hundred individual drawings, most of them portraits that accompanied nearly every monster entry in the book. Once again, the lion's share of the work was handled by Dave Sutherland and Dave Trampier, though Tom Wham contributed several iconic images, notably his beholder, and Jean Wells, who would soon join TSR's design staff, furnished a couple of additional monster portraits of her own. Collectively, the *Monster Manual* images became the canonical representations of these fantastic creatures for an entire generation, a modern bestiary that has served as an authoritative resource for countless subsequent fantasy games.

While the *Basic Set* continued to nurture the burgeoning beginner market, the *Monster Manual* whetted the more experienced player's appetite for the revelation of the full Advanced Dungeons & Dragons system, which would begin in the summer of 1978 with the unveiling of the *Players Handbook*. It collected and rationalized in one sturdy hardcover volume the many character classes, spells, races, alignments, weapons, and other system elements necessary to play Dungeons & Dragons, all of which had formerly been scattered in a baffling labyrinth of rulebooks, supplements, and periodicals. It instantly became the one indispensable resource for playing the game. Perhaps the single most iconic image in the history of Dungeons & Dragons is the scene Dave Trampier painted for the cover of the *Players Handbook*, showing a party in the aftermath of a dungeon encounter.

By the time the *Players Handbook* was released, Dungeons & Dragons had already undergone several visual transformations. The game was rapidly gaining in popularity, but there was already a strong awareness at TSR that D&D was a challenging game to explain to newcomers. "Is it a board game? How do you win?" Accordingly, there was a need to translate and deliver instructional knowledge directly into the minds and imaginations of a new generation of gaming enthusiasts. With Trampier's cover for the *Players Handbook*, everything you needed to know was right there on the canvas. It was full color. It was graphic. It was dark and dirty. But more than anything, it was visually verbose and explained to the uninitiated what they could expect to be doing in a typical game of Dungeons & Dragons.

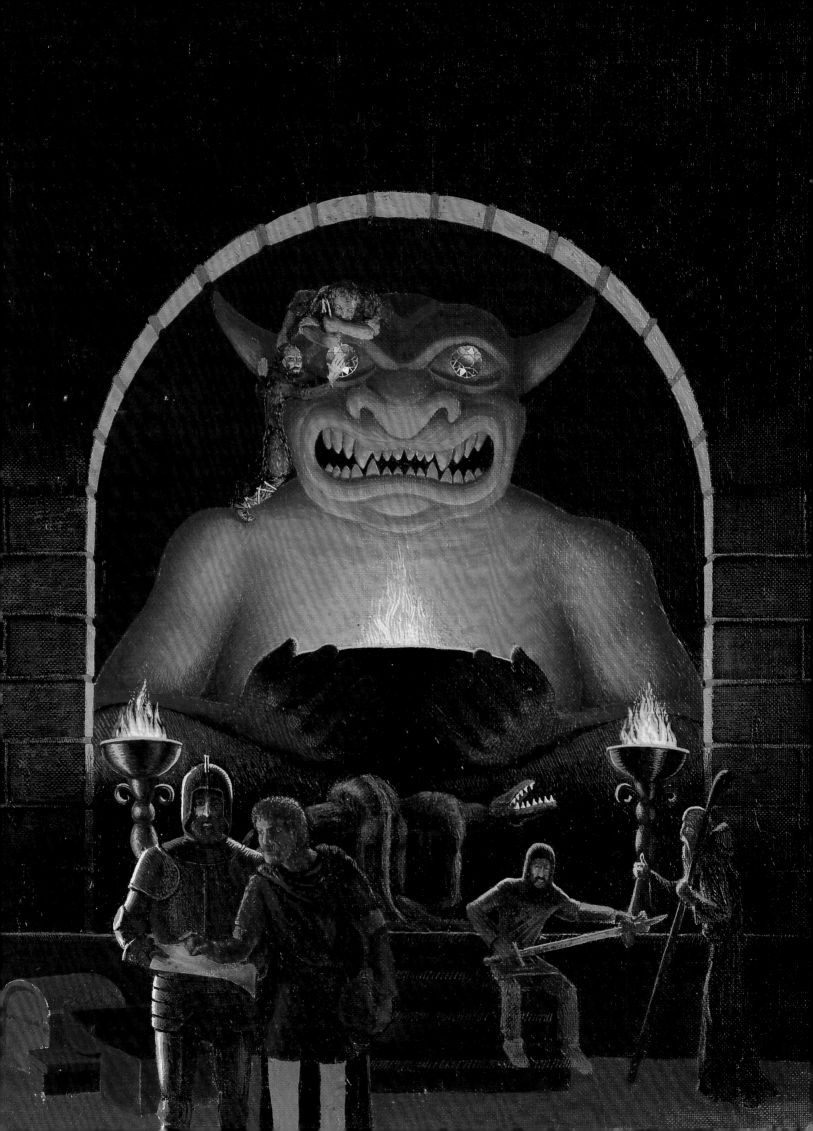

GAMES FOR IMAGINATIVE PEOPLE

FROM

TSR

ROLE-PLAYING GAMES

We introduced this concept to the gaming hobby! In the role-playing game it is usual for one individual to act as game referee while the balance of the participants create game personas which then engage in successive game "adventures" in order to gain skill and wealth. TSR's role-playing games include **Dungeons & Dragons, Advanced Dungeons & Dragons, Gamma World, Metamorphosis Alpha,** and **Boot Hill**. In the near future still others will be added, such as **Top Secret**.

FANTASY & SCIENCE FICTION GAMES

While many of the role-playing games mentioned above fall into this category, we offer still more. Included are: **Dungeon! Divine Right, Lankhmar, Star Probe,** and **Star Empires**. New releases in this category, such as **Star Squadrons,** are forthcoming.

HISTORICAL BATTLE GAMES

The hobby of wargaming is one of the fastest growing pastimes, and TSR offers a line of fully researched and accurate conflict simulation games for wargamers such as: **Fight In The Skies** and **African Campaign**. Innovative new games will be added periodically to increase this portion of the game line, including **Battles for the German Frontier!**

ADULT AND FAMILY GAMES
from

THE GAME WIZARDS

PARLOR GAMES

Family games, as well as those for younger players, will be increasingly featured by TSR. Already mentioned are such titles as **Dungeon!** and **4th Dimension** and we also offer **Cohorts** (the Roman Checkers Game), **Suspicion** (the ultimate in murder mystery games), **Warlocks & Warriors** (an introductory level fantasy game), and **Snits Revenge** - pure fun!

RULES FOR MINIATURE WARGAMES

TSR started operations as a producer of miniatures rules, and we have not forgotten this aspect of the gaming hobby. We provide many leading titles for recreating battles with miniature figurines. A complete list is found later, but these titles encompass history from ancient times with **Classic Warfare**, through the Middle Ages, with **Chainmail**, the Revolutionary War with **Field Regulations** and **Valley Forge**, and the modern period with such rules as **Air Power, Panzer Warfare, Tractics** and **Modern Armor**.

GAMING MAGAZINE

For the devotee of imaginative gaming TSR publishes **The Dragon**, the monthly magazine of gaming in all of its popular forms - - heroic fantasy, science fiction, military miniatures, simulation board games, strategy games, and more. Each issue is designed to keep the game hobbyist abreast of trends and informed on the latest releases in role playing, boardgames, and miniatures.

TSR Hobbies, Inc.
TSR Games - TSR Periodicals - TSR Rules
POB 756 Lake Geneva, WI 53147 - (414)248-3625 or (800)558-2420

OPPOSITE TSR's 1979 color catalog shows a company very much on the rise, producing a wide variety of high-quality gaming products.

RIGHT A 1978 advertisement announcing TSR's entrance into the adventure module space with the introduction of the beloved "G" series of modules by Gary Gygax. Accompanying the rollout was a new company logo—Bell's lizardman was replaced by a wizard and a tag line: "The Game Wizards."

BELOW By 1978, TSR had taken on additional space around Lake Geneva, including the once tony Hotel Clair located in the heart of town. The former hotel lobby became TSR's Dungeon Hobby Shop, while the now-shabby upper floors were reserved for management, design, and development.

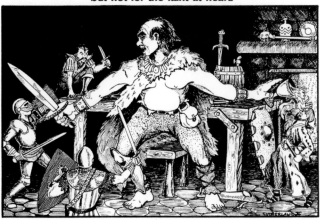

DUNGEON ADVENTURES . . .
but not for the faint at heart!

Here is a series of adventure modules to challenge even the most intrepid DUNGEONS & DRAGONS players!

Men - - heroes - - in the lairs of giants . . . Daring to enter these forbidding places to pay back the giants for their marauding raids of death and destruction against human settlements . . . Seeking some clue as to who or what is causing these giants to ally against mankind . . . Trying to deliver a blow to prevent them from ever menacing civilization again . . .

Dungeon modules G1, G2 and G3 are the first three releases in a new series of playing aids for ADVANCED DUNGEONS & DRAGONS, specially prepared by co-author Gary Gygax. By using them, a Dungeon Master can moderate a pre-developed game situation with a minimum of preparation - - and players can use new or existing characters for adventuring. The applications and possibilities are many - - incorporation of the modules and their locales into existing D & D campaigns, or as one-time adventures simply for a change in pace. Whatever your choice, you're sure to find the modules an interesting and worthwhile addition to your library of D & D materials.

Dungeon modules G1, G2 and G3 are designed to provide an ordered progression of successive adventures as marked, or to function as individual modules if purchased separately.

DUNGEON MODULE G1, Steading of the Hill Giant Chief	$4.49	
DUNGEON MODULE G2, Glacial Rift of the Frost Giant Jarl	$4.49	
DUNGEON MODULE G3, Hall of the Fire Giant King	$4.98	

Plus three new modules to be released at GenCon!

TSR HOBBIES
THE
GAME
WIZARDS

OFF-THE-SHELF ADVENTURES

Concurrently with the release of the *Players Handbook*, TSR opened a whole new product line that turned their preconceived convention tournament scenarios into something playable in your living room: adventure modules. At roughly thirty pages in length, a module was a prefabricated story complete with maps, treasures, and villains that could be plugged into anyone's home game, pretty much at any time. With only an unattached wraparound cardboard cover, which also served as a Dungeon Master's screen and map, as well as a softcover booklet, these lower-cost productions were intended to be used alongside the core books: to provide not only gaming and story content, as each module was a stand-alone mission, but as a professional example for Dungeon Masters of how to design compelling scenarios.

Directly following the 1978 Origins tournament, which featured Gygax's three-stage battle against a succession of hill, frost, and fire giants, TSR began selling those adventures packaged as modules; they would do the same for a similar three-part tournament at their own Gen Con show a month or so later. With a practical need for simple product codes, TSR introduced a number-and-letter code for each module, so that the first title, the *Steading of the Hill Giant Chief*, was coded G1—a naming convention that became used by fans almost as much as the module titles themselves. What would become the golden

age of "monochrome" modules, named for their single-color-spectrum cover designs, was brought to life by the pens of Dave Sutherland and Dave Trampier, who contributed virtually every piece of art in these early classics. At the end of the year, TSR also began to raid its back catalog of tournament dungeons, finally releasing the *Tomb of Horrors* as an independent product, much to the horror of the thousands of players who would see their beloved characters die ignominious deaths in its depths.

Given the ongoing success of the 1978 module releases, the following year TSR chose to swap in to the *Basic Set* a new module written especially for it, Mike Carr's *In Search of the Unknown*. Carr, another Twin Cities transplant, had been part of the famous Blackmoor campaign that inspired D&D—he played the first cleric—and had collaborated with Gygax and Arneson on earlier wargaming projects. Because he was first and foremost a wargamer, he brought an objectivity to D&D that made him one of the game's best practical translators and arms-length editors; he edited the *Players Handbook*, among other things. His *Basic Set* module is significant for artistic reasons as well, as its cover is a rare collaboration between Trampier and Sutherland: Trampier drew a more cartoonish original version, which Sutherland then adapted into the finished illustration.

DUNGEONS & DRAGONS®

Dungeon Module G1
Steading of the Hill Giant Chief
by Gary Gygax

...module contains background information, referee's notes, two level maps, and exploration matrix keys. It provides a complete module for ...f ADVANCED DUNGEONS & DRAGONS, and it can be used alone or as the first of a three-part expedition adventure which ...mploys DUNGEON MODULE G2 (GLACIAL RIFT OF THE FROST GIANT JARL) and DUNGEON MODULE ...ALL OF THE FIRE GIANT KING).

©1978, TSR Games

TSR Games
POB 756
LAKE GENEVA, WI 53147

PRINTED IN U.S.A. 9016

DUNGEONS & DRAGONS®

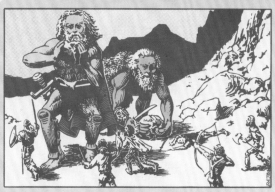

Dungeon Module G2
The Glacial Rift of The Frost Giant Jarl
by Gary Gygax

This module contains background information, referee's notes, two level maps, and exploration matrix keys. It provides a complete module for play of ADVANCED DUNGEONS & DRAGONS, and it can be used alone or as the second of a three-part expedition adventure which also employs DUNGEON MODULE G1 (STEADING OF THE HILL GIANT CHIEF) and DUNGEON MODULE G3 (HALL OF THE FIRE GIANT KING).

©1978, TSR Games

TSR Games
POB 756
LAKE GENEVA, WI 53147

PRINTED IN U.S.A. 9017

DUNGEONS & DRAGONS

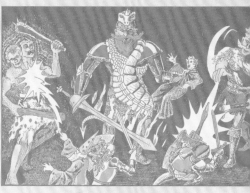

Dungeon Module G3
Hall of the Fire Giant King
by Gary Gygax

This module contains background information, referee's notes, three level maps, and exploration matrix keys. It provides a complet... for play of ADVANCED DUNGEONS & DRAGONS, and it can be played alone or as the last of a three-part expedition adventure... which also employs DUNGEON MODULE G1 (STEADING OF THE HILL GIANT CHIEF) and DUNGEON MO... G2 (GLACIAL RIFT OF THE FROST GIANT JARL).

If you have enjoyed these modules, watch for the release of the next series, D1-D3, DESCENT INTO THE DEPTHS O... EARTH, which continues where this series ends. ©1978, TSR Games

TSR Games
POB 756
LAKE GENEVA, WI 53147

PRINTED IN U.S.A

ADVANCED DUNGEONS & DRAGONS®

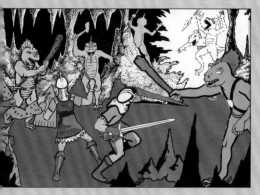

Dungeon Module D1
Descent Into the Depths of the Earth
by Gary Gygax

...dule contains background information, a large-scale referee's map with a matching partial map for players, referee's notes, special ...on and encounter pieces, a large map detailing a cavern area, encounter and map matrix keys, and an additional section pertaining to a ...ew creature for use with this module and the game as a whole. A complete setting for play of ADVANCED DUNGEONS & ...ONS is contained herein. This module can be played alone, as the first part of a series of three modules (with SHRINE OF THE ...'OA, D2, and VAULT OF THE DROW, D3), or as the fourth part of a continuing series of modules which form a special ...ive campaign scenario (DUNGEON MODULES G1, G2, G3, D1, D2, D3, and Q1, QUEEN OF THE DEMONWEB PITS, soon to be released).

If you have found this module and its companions exciting, stay tuned for more action from The Game Wizards!

©1978, TSR Games

TSR Games
POB 756
LAKE GENEVA, WI 53147

PRINTED IN U.S.A. 9019

ADVANCED DUNGEONS & DRAGONS®

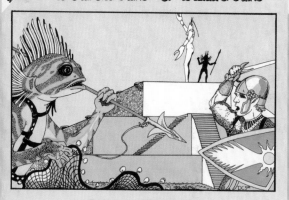

Dungeon Module D2
Shrine of The Kuo-Toa
by Gary Gygax

This module contains background information, a large-scale referee's map with a matching partial map for players, referee's notes, special exploration and encounter pieces, a large map detailing a temple complex area, encounter and map matrix keys, and an additional section pertaining to a pair of unique new creatures for use with this module and the game as a whole. A complete setting for play of ADVANCED DUNGEONS & DRAGONS is contained herein. This module can be played alone, as the second part of a series of three modules (with DESCENT INTO THE DEPTHS OF THE EARTH, D1, and VAULT OF THE DROW, D3), or as the fourth part of a continuing scenario (DUNGEON MODULES G1, G2, G3, D1, D2, D3, and Q1, QUEEN OF THE DEMONWEB PITS).

If you have found this module and its companions exciting, stay tuned for more action from The Game Wizards!

©1978, TSR Games

TSR Games
POB 756
LAKE GENEVA, WI 53147

PRINTED IN U.S.A. 9020

ADVANCED DUNGEONS & DRAGONS

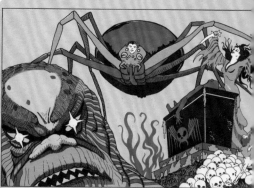

Dungeon Module D3
Vault of the Drow
by Gary Gygax

This module contains background information, a large-scale referee's map with a matching partial map for players, referee's notes, exploration and encounter pieces, a hex map detailing an enormous cavern area, a special temple map, encounter and map matrix keys, additional sections pertaining to unique new creatures for use with this module and the game as a whole. A complete setting for ADVANCED DUNGEONS & DRAGONS is contained herein. This module can be played alone, as the final part of a series of modules (with DESCENT INTO THE DEPTHS OF THE EARTH, D1 and SHRINE OF THE KUO-TOA, D2), ... sixth part of a continuing series of modules which form a special campaign scenario (DUNGEON MODULES G1, G2, G3, D1, D2, D3, and Q1, QUEEN OF THE DEMONWEB PITS, soon to be released).

If you have found this module and its companions exciting, stay tuned for more action from The Game Wizards!

©1978, TSR Games

TSR Games
POB 756
LAKE GENEVA, WI 53147

PRINTED IN U.S.A.

ADVANCED DUNGEONS & DRAGONS®

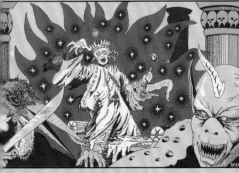

TOMB of HORRORS
by Gary Gygax

...module was originally used for the Official DUNGEONS & DRAGONS tournament at Origins I. The author wishes ...ress his thanks to Mr. Alan Lucien who was kind enough to submit the ideas for this dungeon. This version has ...revised and updated to conform to ADVANCED DUNGEONS & DRAGONS. Included herein is background ...nation for players, including the Legend of the Tomb—as is true of all TSR DUNGEON MODULES, the location of ...rea is upon the Map of the World of Greyhawk (WORLD OF GREYHAWK from TSR)—DM notes, level map and ...x, player character statistics for varying numbers of participants, and over two dozen special illustrations to ...ically enhance your players' enjoyment of the adventure, as the drawings are keyed to various scenes and ...encounters in the Tomb.

If you enjoy this module, be sure to try any of the many other unique offerings in this line from TSR!

© 1978, TSR Games

TSR Games
POB 756
LAKE GENEVA, WI 53147

ADVANCED DUNGEONS & DRAGONS™

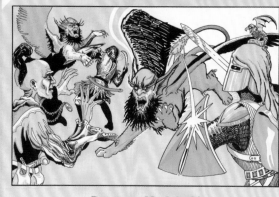

Dungeon Module S2
White Plume Mountain
by Lawrence Schick

This module contains background information, referee's notes, player aids, a complete map level, and a cutaway view of the mountain complex. WHITE PLUME MOUNTAIN is from the Special ("S") series; like others in this series, it is meant to stand on its own and is a complete ADVANCED DUNGEONS & DRAGONS adventure. The recommended number of players is four to ten, with levels ranging from fifth to tenth.

If you find this module interesting and challenging, look for the TSR logo on future publications from The Game Wizards!

©1979, TSR Games

TSR Games
POB 756
LAKE GENEVA, WI 53147

ADVANCED DUNGEONS & DRAGONS

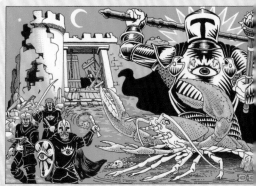

Dungeon Module T1
The Village of Hommlet
by Gary Gygax

INTRODUCTORY TO NOVICE LEVEL

The Village of Hommlet has grown up around a crossroads in a woodland. Once far from any important activity, it be... embroiled in the struggle between gods and demons when the Temple of Elemental Evil arose but a few leagues away. Luc... its inhabitants, the Temple and its evil hordes were destroyed a decade ago, but Hommlet still suffers from incursions of ... and strange monsters ...

This module contains a map of the village and lands around, a large scale map of the inn, church, trading post, and guar... (main floor, upper rooms and cellars), an informational key regarding the inhabitants, and a map and exploration ke... destroyed moat house, a former outpost of the Temple of Elemental Evil. The whole provides a complete, ready-to-play adv... and is a lead-in to DUNGEON MODULE T2, THE TEMPLE OF ELEMENTAL EVIL.

©1979, TSR Games

TSR Games
POB 756
LAKE GENEVA, WI 53147

ABOVE Dave Trampier's cartoonish original cover for Mike Carr's *In Search of the Unknown*, shown above Dave Sutherland's adaptation, which was used on the final product. They both showed some sense of humor at the collaboration, cleverly signing the piece with a stylistic form of their initials: "DIS & DAT."

OPPOSITE The original "monochrome" modules from 1978 and 1979, featuring cover art exclusively from Dave Sutherland and Dave Trampier.

Enter The Gateway to Adventure

with
Dungeons & Dragons®

A game that will take you to new worlds of fun and adventure with an assortment of characters and game plans that will bring you hours of enjoyment.

Dungeons and Dragons® Basic Set, for ages 12 to adult contains everything you need to start playing: A 48 page game booklet, an introductory module, and a set of randomizer chits. For the best in fantasy role-playing games look to The Game Wizards at TSR Hobbies.

Available wherever better games are sold.

TSR Hobbies

POB 756, Lake Geneva, WI

OPPOSITE A 1980 advertisement for the Basic Set featuring Gygax's *The Keep on the Borderlands* and numbered chits to compensate for the fact that TSR had run out of dice due to demand.

LEFT Copies of the new *Dungeon Masters Guide* signed by Gary Gygax and Dave Sutherland were available at TSR's rapidly growing trade show, Gen Con XII.

FOLLOWING SPREAD Dave Sutherland's cover painting for the AD&D *Dungeon Masters Guide* (1979), featuring the fabled City of Brass, looming ominously above the treacherous elemental Plane of Fire.

BELOW A 1980 ad featuring the "holy trinity" of AD&D books.

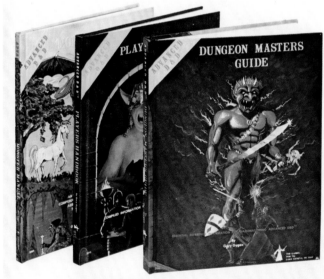

EXPERIENCE BONUSES

The summer of 1979 would shortly bring real fireworks for Dungeons & Dragons and unexpected notoriety. Bolstered by the strength of the *Basic Set* and the new AD&D line, TSR had experienced exceptional growth in 1978, with D&D product sales ramping up to five to six thousand copies per month. By 1979, sales of the *Basic Set* alone became so heavy—over one hundred thousand in the fourth quarter—that TSR literally ran out of dice, and was forced to instead distribute chits, little pieces of cardboard marked with numbers to draw out of a hat, which could serve instead of dice in a pinch. In an effort to encourage repeat buys, TSR swapped out Mike Carr's *In Search of the Unknown* in the *Basic Set* before the end of the year for another introductory module, Gygax's own *The Keep on the Borderlands*. And as D&D attracted this eager audience, the newly printed *Dungeon Masters Guide* was there to meet them. In addition to providing counsel on the design of adventures and the adjudication of combat, the *Dungeon Masters Guide* also contained the ultimate treasure room of magic items that every adventurer coveted—pages where players would endlessly window-shop and fantasize about artifacts that might turn their characters into gods. The cover painting by Dave Sutherland, which shows a party fighting an enormous, devilish red efreet, wraps around the back cover to reveal a bizarre lake of fire and the geometrical City of Brass floating above it. With the publication of the *Dungeon Masters Guide*, the core Advanced Dungeons & Dragons system was complete, and the game had reached the mature form that would see it through the popular culture fad that was dawning.

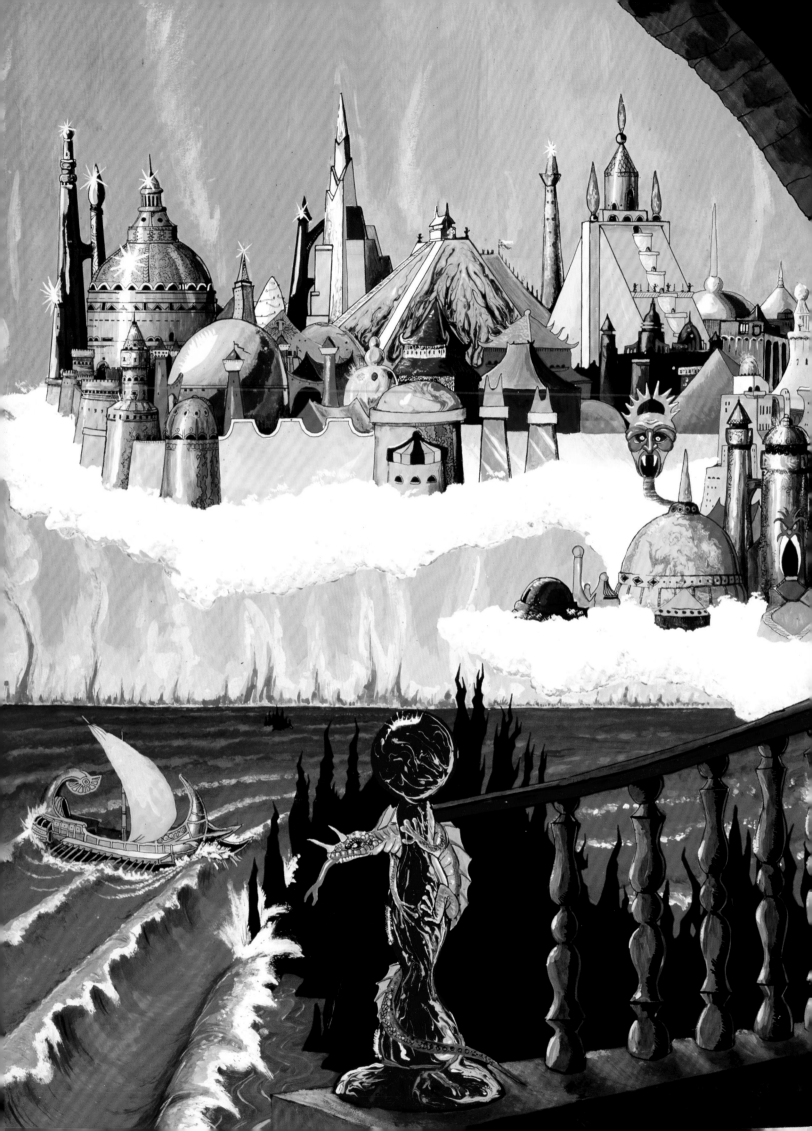

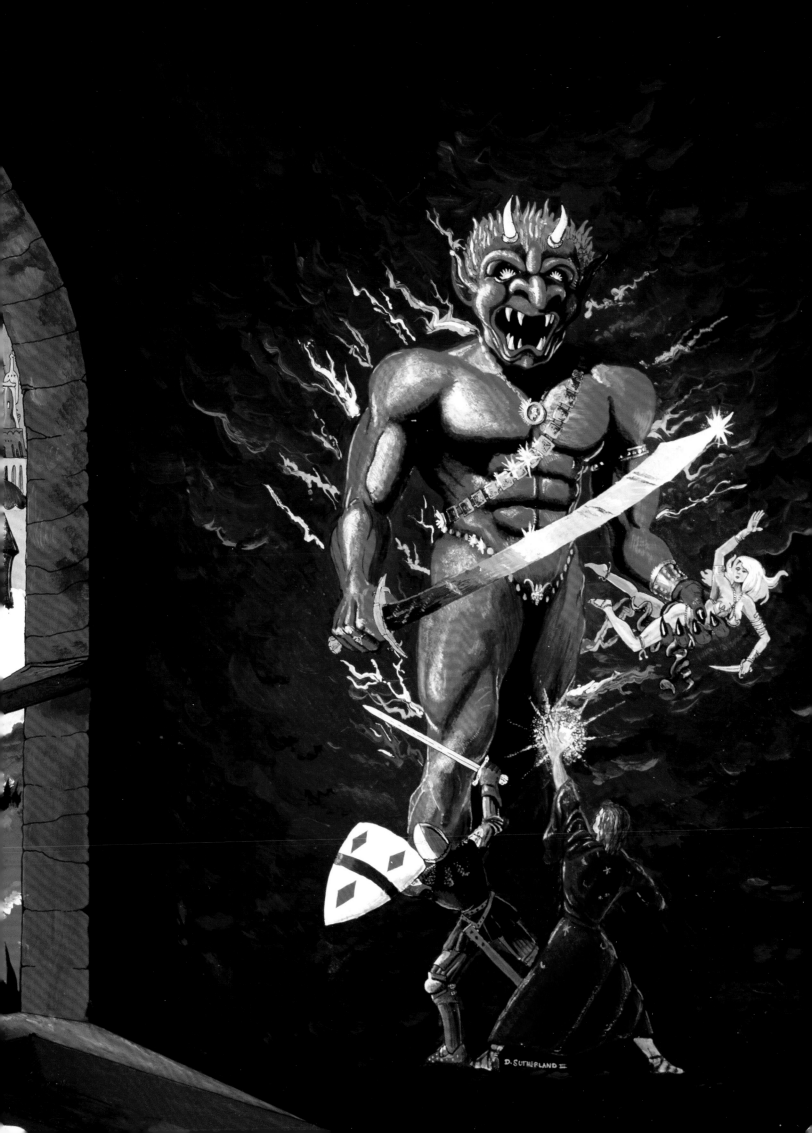

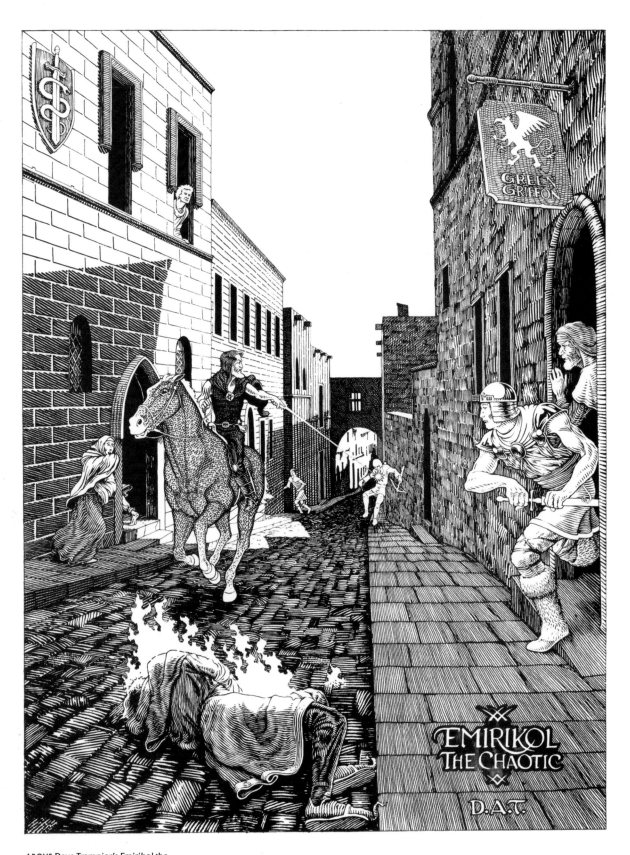

ABOVE Dave Trampier's *Emirikol the Chaotic* from the *Dungeon Masters Guide*.

OPPOSITE Dave Sutherland's original ink-on-paper illustration for *A Paladin in Hell* from *Players Handbook*.

"The *A Paladin in Hell* piece from the first-edition *Players Handbook* was so iconic to me that, when given the chance, I wrote a whole second-edition module about it."

—MONTE COOK, TSR DESIGNER

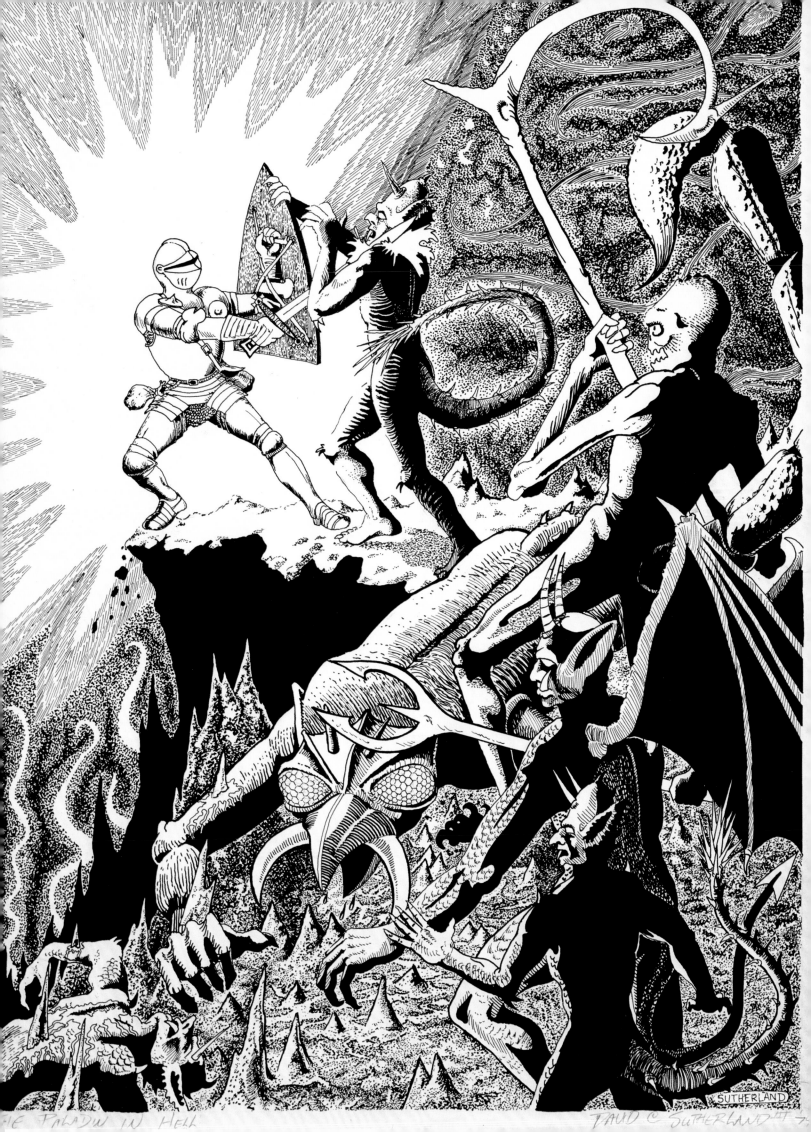

THE PALADIN IN HELL

DAVID C SUTHERLAND

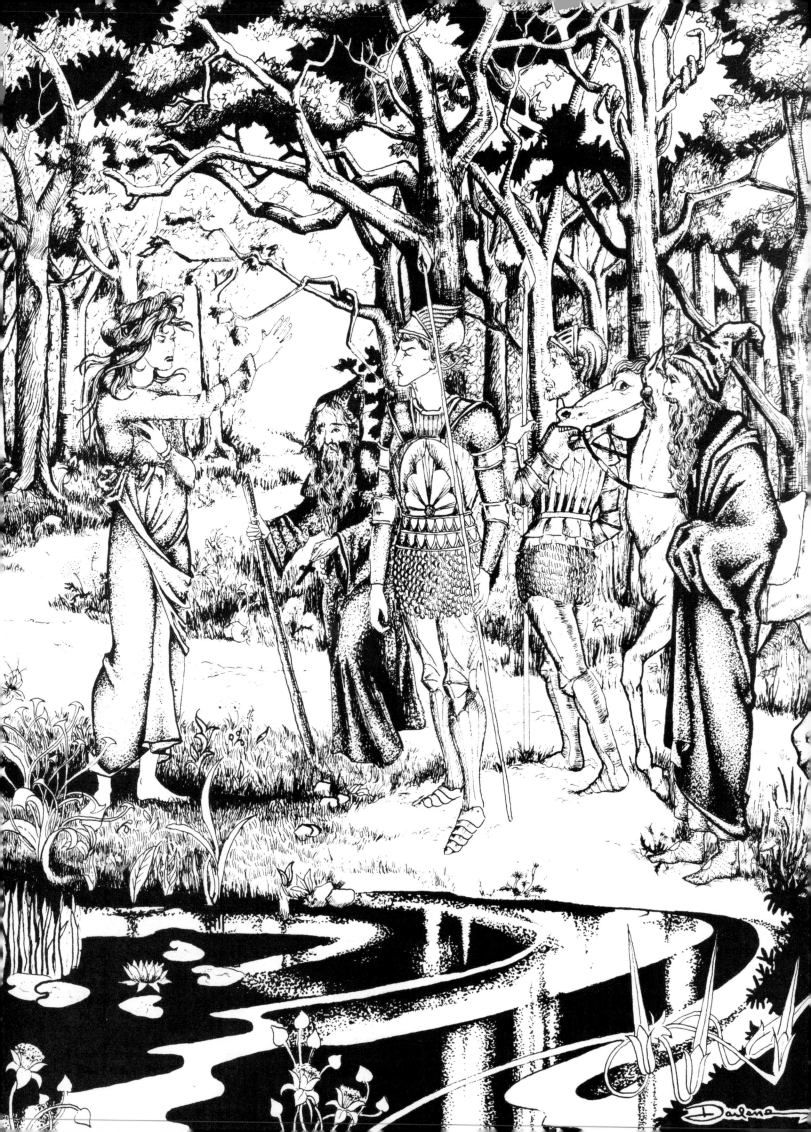

> "Often, there was little to go on but the briefest of descriptions, usually four or five words."
>
> —DARLENE ON TSR'S TYPICAL LEVEL OF EARLY ART DIRECTION

OPPOSITE Darlene's full-page homage to nineteenth-century English illustrator Aubrey Beardsley.

BELOW Darlene's stippled unicorn from the *Dungeon Masters Guide* title page.

DARLENE
ARTIST FAVORITE

THE "HOLY TRINITY" OF Advanced Dungeons & Dragons books were so beloved and scrutinized by millions of young gamers of the day that it is almost impossible to reduce their art down to a few notable pieces: every piece of art inside, no matter how incidental, has become iconic. The eye is perhaps drawn first to the signature full-page black-and-white illustrations contributed by Dave Sutherland and Dave Trampier, like their famous pieces *A Paladin in Hell* from the *Players Handbook* and *Emirikol the Chaotic* from the *Dungeon Masters Guide*. Even the distinctive over-crammed pages of small Futura font and hard-to-read tables have become a much-beloved style that would influence game books for years to come.

But the overtasked team of Sutherland and Trampier would not be able to keep up with the product load to come. Already, in the *Dungeon Masters Guide*, we see them sharing the work with other artists who would play a leading role in visualizing Dungeons & Dragons moving forward. Darlene, whose first work for TSR was providing column header illustrations for *Dragon* magazine, produced a good deal of the interior art, including a full-page homage to Aubrey Beardsley and the title page illustration of a stippled unicorn—she would effectively take Dave Trampier's place on the art staff in 1979. William McLean's humorous cartoons, like the armored warrior leaping into the arms of an exasperated magician at the sight of a rust monster, helped reinforce the visual vocabulary of the game and bond together fans who were in on the joke. Former TSR shipping clerk-turned-artist Diesel LaForce chipped in as well, and a young, psychedelic artist out of Berkeley named Erol Otus managed to sneak some art in after the first *Dungeon Masters Guide* printing.

"It's a great new fantasy role-playing game. We pretend we're workers and students in an industrialized and technological society."

"Well, either it allows a magic-user to throw the various Bigby's hand spells, or it's a +2 backscratcher. So far we're not sure which"

"Whaddya mean we gotta talk to this lynx?? The last monster we talked to ate half of the party!"

THIS PAGE, TOP AND CENTER A series of humorous panels (at least to experienced D&D players) by artist William McLean from the *Dungeon Masters Guide*.

THIS PAGE, ABOVE Tom Wham's lynx comic, from the *Monster Manual*.

OPPOSITE, TOP Tom Wham's light-hearted rendition of a mind flayer flaying minds, from the *Monster Manual*.

OPPOSITE, CENTER AND BOTTOM Dave Sutherland's comedic panels from the *Players Handbook*.

EROL OTUS: D&D'S SURREALIST

IN A DANK SUBTERRANEAN cavern, a pool of primordial flesh bubbles, incessantly spawning rubbery appendages, or jagged maws, or swollen eyeballs, or temporary horrors that might crawl, or slither, or even flap their putrid wings and fly for a moment before collapsing back into the ooze: a living embodiment of chaos from *Deities & Demigods* (1980). And unmistakably, an Erol Otus.

Like all fantasy artists of his time, Otus studied Frank Frazetta, famous for his Conan covers of the 1960s and 1970s, but Otus's own warriors are less brawny than scrawny, and his wizards come across like freaks and misfits. He would explain that his madcap style owed as much to Dr. Seuss as it did to horror artist Bernie Wrightson. We might also discern a 1930s pulp sensibility: the surreal excesses of Hannes Bok, the funhouse lights of Virgil Finlay, as if from a cover of *Weird Tales*. But Otus adds to those ingredients a strong dose of contemporary counterculture, of the psychedelic style of underground West Coast comix.

A year before he graduated from high school in Berkeley, California, Otus did his first professional game art for the *Arduin Grimoire* (1977)—an early unofficial supplement—including its original cover. With friend and game designer Paul Reiche, he produced Bay Area supplements like *Necronomican* and *Booty and the Beasts*. When Otus submitted his artwork to the "Creature Feature" fanart contest advertised in *Dragon* magazine #13 (pictured on page 58), he won an honorable mention—and landed a job at TSR. Reiche joined the design department not long thereafter, having discovered from visiting Otus that "contrary to what I had heard—the men and women of TSR were not evil, hateful creatures," no doubt a sentiment shared by many would-be competitors in the industry.

Fans of Dungeons & Dragons know Otus for his covers of *Deities & Demigods* and the 1981 *Basic* and *Expert* sets. His *Basic Set* cover art, showing a pair of adventurers fighting a half-submerged green dragon in an underground cave, reached the most eyeballs, as it shipped on TSR's flagship product at the height of the D&D fad. During his tenure as a staff artist at TSR, from 1979 to 1981, Otus joined Dave Sutherland as a workhorse artist who drew countless covers and interior illustrations for modules before he returned to Berkeley to study art.

An interior drawing by Erol Otus, from *Deities & Demigods* (1980).

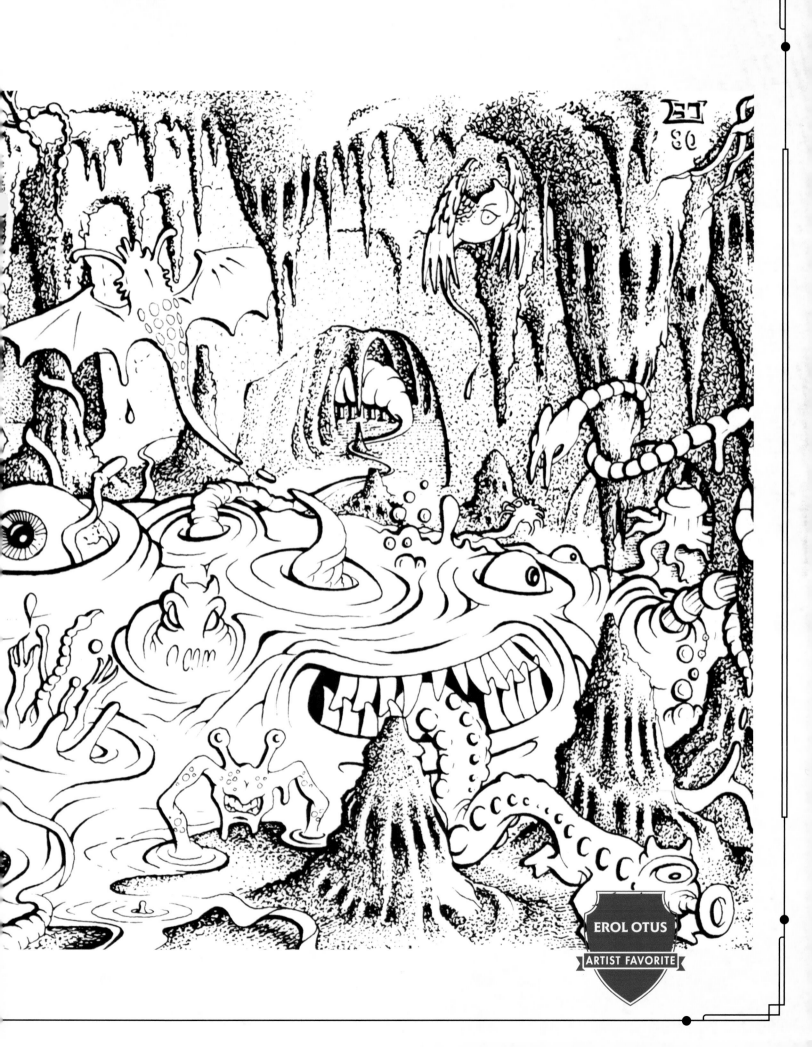

EROL OTUS
ARTIST FAVORITE

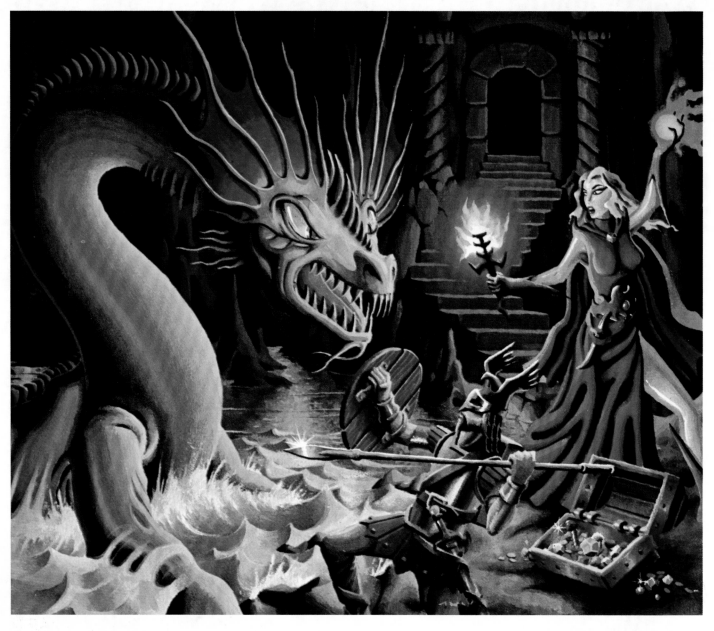

ABOVE Erol Otus's cover art for the 1981 *Basic Set* edited by Tom Moldvay. Otus manages to create an atmosphere of adventure-filled claustrophobia by using a seemingly shallow pool to produce a large dragon in a modest dungeon space.

OPPOSITE, TOP An interior panel from the 1981 *Basic Set* booklet featuring less-than-wise wizards who have given way to their greed.

OPPOSITE, BOTTOM A perversely beautiful gibbering mouther from module *The Hidden Shrine of Tamoachan*.

In Otus's world, doomed mortals prostrate themselves before lecherous gods, things half insect and half slug, all eyes, tongues, and tentacles. You wouldn't want anyone else to sketch you a gibbering mouther. Sometimes his vision took him outside the boundaries of family entertainment. The notorious first printing of the *Palace of the Silver Princess*, module B3, contained its share of controversial images, but perhaps nothing more transgressive than Erol's three-headed hermaphrodites with leering faces. Famously, the module was recalled and pulped, and even years later, executive Kevin Blume would circulate a memo demanding that any remaining copies harbored by employees be destroyed.

Tunnels Are Searched for Missing Student

By NATHANIEL SHEPPARD Jr.
Special to The New York Times

EAST LANSING, Mich., Sept. 7 — The authorities at Michigan State University and private investigators are combing an eight-mile maze of steam tunnels underneath the campus here in an effort to find a 16-year-old computer science student who disappeared Aug. 15.

The student's disappearance in summer school is shrouded in mystery, and school officials believe that he may either have become lost in the tunnels, which carry heat to campus buildings, while playing an elaborate version of a bizarre intellectual game called Dungeons and Dragons or that the disappearance might be just a hoax.

"He could be in the tunnels, he could have committed suicide or it could be just a hoax," said Capt. Ferman Badgley, chief of field services for the university's police force and coordinator of the search.

James Dallas Egbert 3d, a sophomore, was last seen on campus Aug. 15 at dinner in the student dining hall. He was reported missing a week later by a former roommate, and the search is now in its third week.

Described as Brilliant

Mr. Egbert was described as a brilliant student with a grade point average above 3.5 and a penchant for science fiction and intellectually challenging games.

When the school authorities and the youth's parents searched his dormitory room they found a note printed in large capital letters that said, "To whom it may concern: If my body is found I wish to be cremated."

However, handwriting specialists who compared the note with other samples of the student's writing said they doubted it had been written by him.

William Dear, head of the five-man private investigator team hired by the student's family, said, "It is our opinion that the boy is dead."

Anonymous Phone Calls

Captain Badgley said the authorities had received anonymous telephone calls from a woman who said Mr. Egbert and other students had been playing Dungeons and Dragons in the steam tunnels and that if the student was found he would be found dead.

Dungeons and Dragons is a game produced by T.R.S. Hobbies of Lake Geneva, Wis. The game is an apparent takeoff on the popular J.R.R. Tolkien trilogy, "Lord of the Rings," a fantasy that deals with the search for a magic ring and features an assortment of terrible creatures that menace the heroes and threaten the world.

Dungeons and Dragons, like "Lord of the Rings," features a wizard, a fearless hero, dwarfs, "halfings," "orks" and various other nasties. Each player portrays a character and the object is for the players to find a way out of an imaginary labyrinth to collect great treasures.

Students at Michigan State University and elsewhere reportedly have greatly elaborated on the game, donning medieval costumes and using outdoor settings to stage the contest.

A spokesman for T.R.S. Hobbies said that more than 300,000 Dungeons and Dragons games had been sold in the last few years.

The school authorities said that if Mr. Egbert had gone into the tunnels it was likely that he had become lost and would likely have died from the intense heat, well above 100 degrees during the day, or from lack of oxygen.

The heat is so intense during the day that the search has been conducted at night when the temperatures are somewhat lower.

Mr. Egbert's mother, Anna Egbert of Dayton, Ohio, said her son had a history of not being where he was supposed to be.

'He'd Suddenly Disappear'

"Throughout life he wasn't always where you told him to be," she said in a telephone interview. "We would go shopping and he would suddenly disappear for half an hour. Then I would turn around and he would be there.

"Even when he was a small child, he would get out of his crib and someone would bring him back from the street," she said.

Mrs. Egbert said her son was particularly interested in science fiction, attending every convention that he could, and that he had dabbled with computers and calculators since he was about 10. "At age 12 he had his own programmable calculator," she said, "and he programmed it to play games with him."

Mrs. Egbert also said the condition of her son's dormitory room bothered her when she inspected it. "It was in immaculate condition, with books stacked neatly according to height, his clothes were washed, ironed and put away, and his socks were stacked almost in military style," she said. "Even the wall posters had been removed and rolled up neatly."

"It was so strange and eerie," she said, "because it was nothing like him. He was never neat. It looked like he was checking out."

The note left in large letters and the condition of the room led to speculation that Mr. Egbert had been the victim of foul play and that efforts had been made to cover up a crime or that the incident was a hoax.

James Dallas Egbert 3d
Associated Press

William Dear, a private detective, beginning his search for James Dallas Egbert 3d in the steam tunnels beneath Michigan State University. The student has been missing since Aug. 15. At right is Mr. Dear's helper, Dick Riddle.
Associated Press

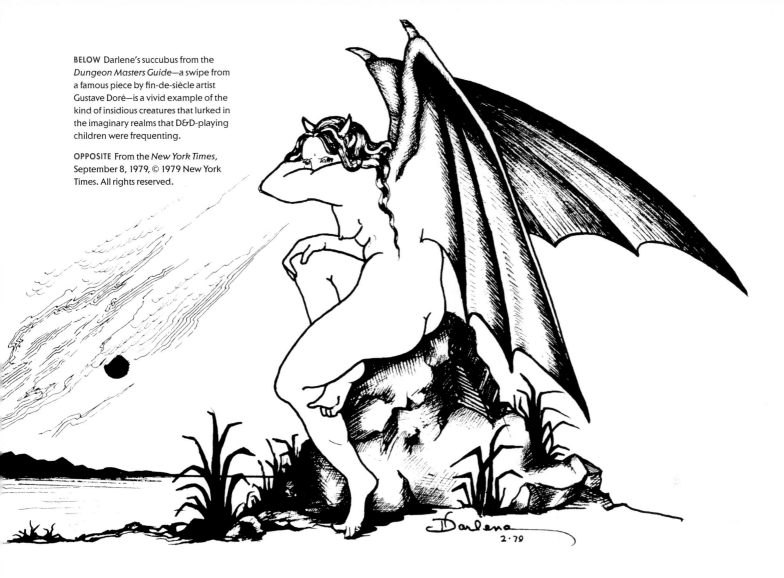

> "In some instances when a person plays the game, you actually leave your body and go out of your mind."
>
> —*THE DRAGON* QUOTING PRIVATE INVESTIGATOR WILLIAM DEAR

THE DEVIL IN THE DETAILS

In August 1979, a sixteen-year-old Michigan State University computer science student disappeared from campus during the summer term. His name was James Dallas Egbert III and he happened to play Dungeons & Dragons. Shortly after Egbert's disappearance, his worried parents hired William Dear, a private detective from Texas who was known for his unconventional but often effective methods.

When Dear arrived in East Lansing, Michigan, he scoured the young student's room looking for clues, and he thought he found a big one: Advanced Dungeons & Dragons products featuring bizarre rules and occult imagery, which in turn cast a sinister light on a bulletin board with an unusual placement of thumbtacks. Dear questioned Egbert's classmates who, according to an anonymous tip, sometimes played the game with Egbert in the vast network of steam tunnels beneath the university—a dungeon of sorts. After personally observing a D&D session put on by other students, Dear became fixated on one theory: Dungeons & Dragons was such an immersive game that it blurred the lines between fantasy and reality. Egbert, according to his theory, had likely assumed the identity of his character and become lost adventuring in the labyrinthine steam tunnels.

Because skeptical university officials were initially reluctant to let Dear search the tunnels, he shared his theory with East Lansing detectives and the press, and a media circus had begun. Within weeks, several newspapers had picked up the story, including the *New York Times*, which gave life to Dear's theory, calling D&D a "bizarre intellectual game." The story had caught on like wildfire, and dozens more papers all over the country followed suit. The word "cult" appeared in many related headlines. Meanwhile, the staffers at TSR were being asked to analyze pictures of Egbert's bulletin board for a secret D&D code or map that might provide a clue. There was nothing there. When Dear finally got his wish and searched the tunnels, there wasn't anything there either.

In mid-September, Egbert surfaced in Louisiana—he had simply run away to escape academic pressures and other personal problems. Unsurprisingly, this resolution was not nearly such "good copy" as the sensationalized D&D theory, and it failed to get the same widespread media coverage. While the Egbert incident had been resolved and the D&D theory effectively debunked, a new level of scrutiny had been placed upon the game. Dark suspicions took root. Nervous parents began to take a closer look at the rulebooks of the game their children were playing, only to find graphic images of demons, liches, and owlbears, oh my!

Like early pulps and horror comics that had drawn the ire of censors roughly forty years earlier, D&D books featured suggestive scenes of violence and sexuality. And there were spells and even rules about how to cast them. To an audience who had no understanding of the mechanics of a role-playing game, and especially to those inclined toward religious fundamentalism, this was all scary stuff.

In no time flat, new allegations emerged, often driven by a casual perusal of the imagery: D&D was a clandestine recruitment vehicle for Satan worship and witch covens. TSR did little to calm these concerns when it unveiled another AD&D hardcover core book, the 1980 *Deities & Demigods* cyclopedia—a revision of the 1976 release *Gods, Demi-Gods & Heroes*, but this time with all new artwork instead of the mostly public domain medieval header pieces and ornamental designs that had been used in the work previously. It contained a mix of sections nominally based on historical beliefs as well as pantheons of gods and godlings drawn from fantasy fiction. Ironically, rather than reducing the

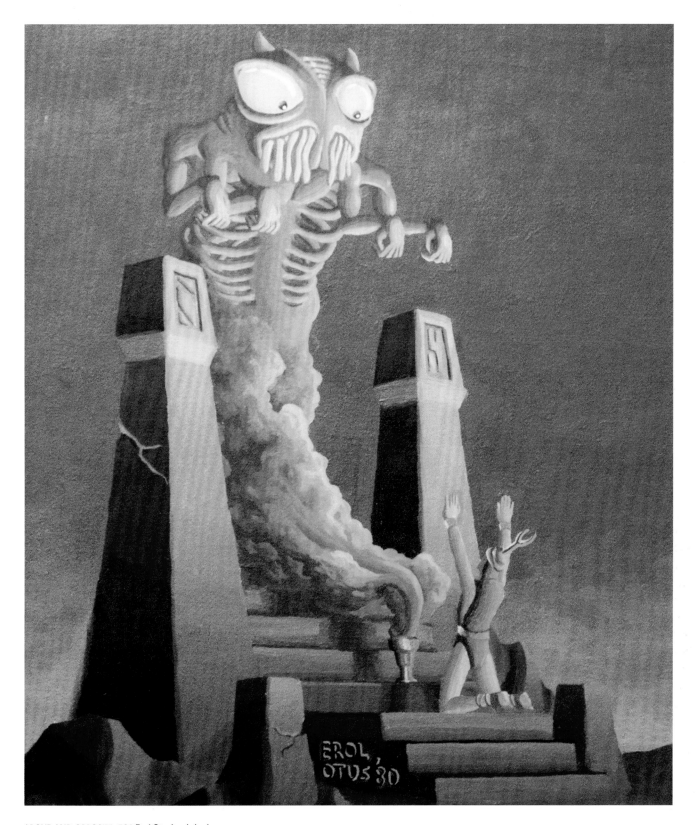

ABOVE AND OPPOSITE, TOP Erol Otus's original cover painting for the 1980 AD&D hardcover, *Deities & Demigods*. With a certain pulp-inspired flare, Otus shows us the pathetic plight of mortals, battling for and bowing to otherworldly, uncaring, and indifferent gods who vie for domination of the heavens.

LEFT A character sheet contemporary with the Egbert incident. The intellectual energy and methodical tracking of strange, arcane details, referencing strange religions, spiritual alignments, weapons, and ominous sounding magic spells could have only been misunderstood by adults, who were meanwhile reading newspapers that tied the game to a mysterious disappearance.

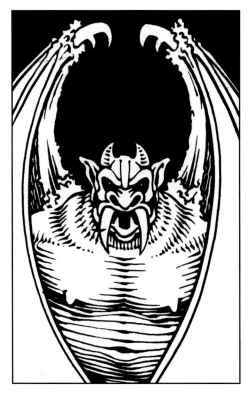

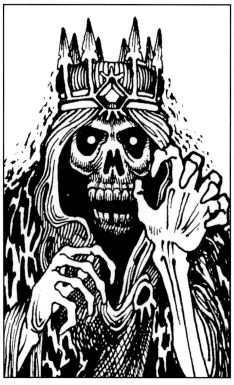

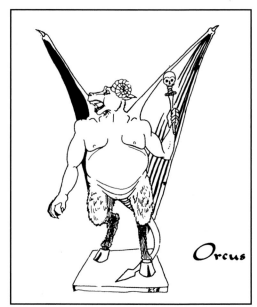

Orcus

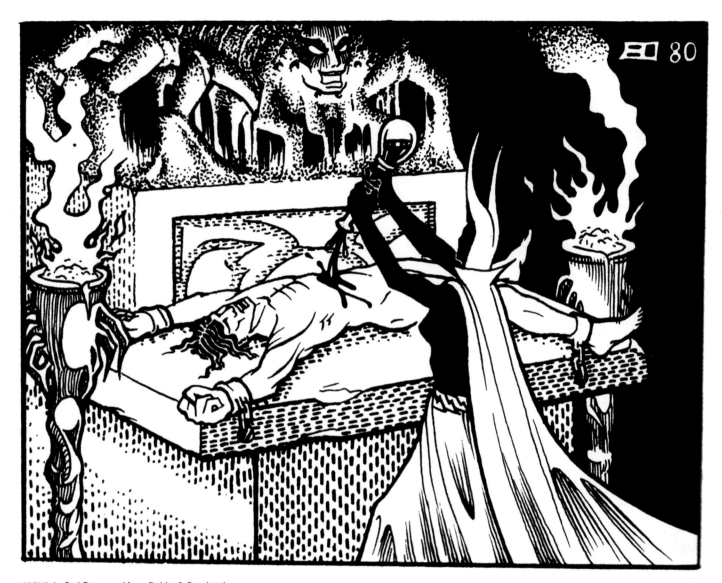

ABOVE An Erol Otus panel from *Deities & Demigods* (1980) depicting a human sacrifice to Lolth, the demon queen of spiders.

OPPOSITE, CLOCKWISE FROM TOP LEFT Dave Trampier's pit fiend and lich (*Monster Manual*, 1977); Dave Sutherland's Demon Type VI and Orcus (*Eldritch Wizardry*, 1976); Dave Sutherland's succubus and Asmodeus (*Monster Manual*, 1977).

OPPOSITE, BOTTOM A devilish Dave Trampier illustration from the 1978 *Players Handbook*.

BELOW Not all imagery from *Deities & Demigods* was controversial. Shown here is one of the book's tamer images by Dave "Diesel" LaForce.

book's appropriations from real-world religions after the first couple printings, which may have given comfort to its religious critics, TSR would instead remove the make-believe sections from twentieth-century fantasy fiction stories for rights purposes. D&D unintentionally doubled down on its link to religion, and controversies would heat up accordingly.

Now, any time an adolescent who happened to play D&D had a problem, it was due to the game and its corrupting influence. Even worse, TSR was no longer in control of the conversation around the game; it had been commandeered by overprotective parents and a story-hungry press. All told, the public was quick to vilify D&D due to its combination of disturbing imagery and highly immersive, yet poorly understood, gaming system. But all of this backlash backfired. TSR would quickly prove true the old adage that "all press is good press," as it found itself justified in the place where it mattered most: its bottom line.

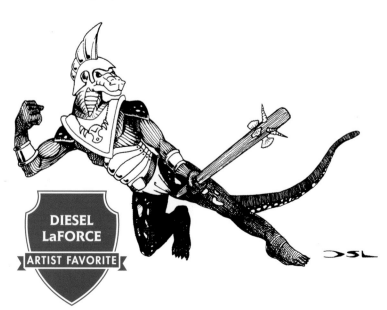

DIESEL LaFORCE
ARTIST FAVORITE

THE GAME WIZARDS
PRESENT YOUR . . .

GATEWAY TO ADVENTURE

TSR HOBBIES, INC.

LAKE GENEVA, WI 53147

TSR's 1980 catalog featuring a demon-faced door that inadvertently may have suggested to watchdogs that this "gateway to adventure," was really a portal to the occult.

TSR HOBBIES' GAMES & ACCESSORIES

© 1980 TSR Hobbies, Inc. All Rights Reserved.

YOUR
GATEWAY
TO
ADVENTURE

Don't worry folks, there's nothing scary about this gateway to adventure! TSR's 1981 catalog conspicuously featured the cartoonish Morley the Wizard, conceptualized by TSR's advertising chief and longtime friend of Gary Gygax, Dave Dimery. Morley was the perfect foil for devils and demons and served as the poster child for the softer, child-friendly image for TSR and its flagship game, D&D.

Bring a Dragon
into your classroom

ABOVE AND OPPOSITE, TOP Reacting to both the scrutiny of censors and religious groups, as well as a desire to expand D&D playership to younger audiences, TSR made a strong push in their advertising and product packaging to appear as a fun, child-friendly game.

OPPOSITE, BOTTOM In what may have been another reaction to its critics, TSR made a logo change in 1980. Shown here is a 1980 colophon concept by Jim Roslof.

BELOW The final 1980 TSR logo, with art drawn by Darlene.

THE MORLEY OF THE STORY

Riding the wave of notoriety created by the "steam tunnel" debacle the previous summer, 1980 promised to be not just a good year for D&D, but a great one. With a rapidly growing product base that could barely keep up with the demand of an insatiable and expanding role-playing game market, TSR had already managed to roughly double its revenue over the last two years and it projected similar continuing growth for the fiscal year ending in 1980. But beyond even the company's wildest expectations, TSR's revenue wouldn't just double but nearly quadruple during that period, skyrocketing from $2.3 million to $8.7 million. While D&D had received an incredible financial shot in the arm from the exposure of controversy, it now had new challenges to deal with: the scrutiny of nervous parents, censorship groups, religious organizations, and the mainstream press. The company fought hard and vociferously against claims that the game was somehow dangerous or occult, but in the background, real efforts were already being made to soften D&D's image, making it seem more of a family-friendly game that promoted literacy, morals, and healthy social interaction.

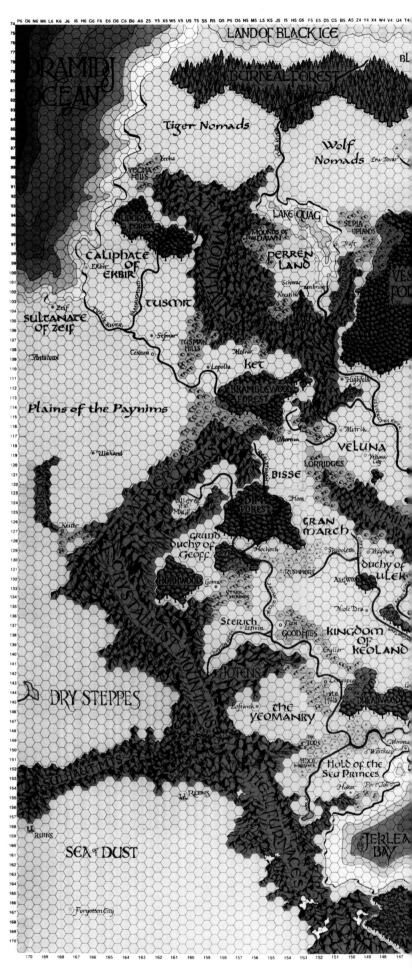

Meanwhile, TSR continued to churn out a record level of new products, such as the *World of Greyhawk* folder, the first campaign setting published by TSR. Instead of the guided-path, single-shot story approach of a module, the introduction of campaign settings brought to gamers maps, histories, and backgrounds of the geographical, political, and mythological landscape, but without a preconceived story for adventurers to follow. By 1980, the Greyhawk setting had ample material to draw on, providing a backdrop for gameplay that harkened back to Gary Gygax's original Great Kingdom of the Castle & Crusade Society.

By summer 1980, sales of the *Basic Set* alone reached nearly fifty thousand copies per month. To keep up with demand, TSR began to rework and re-release popular adventure modules and other products from the late 1970s, sprucing them up with full-color covers, revised content, and highly stylized new artwork by staff artists Jim Roslof, Jeff Dee, Bill Willingham, and Erol Otus.

ABOVE *The World of Greyhawk* folio (1980).

OPPOSITE Darlene's map of the Flanaess from the *World of Greyhawk* folio. This full-color hexmap is considered the definitive map of the Greyhawk setting. "The artwork's dimensions were so large, I had to practically lay on the board to work," explained Darlene. A two-piece, fold-up map at thirty-four inches by forty-four inches, it served as the reference geography for all future Greyhawk publications.

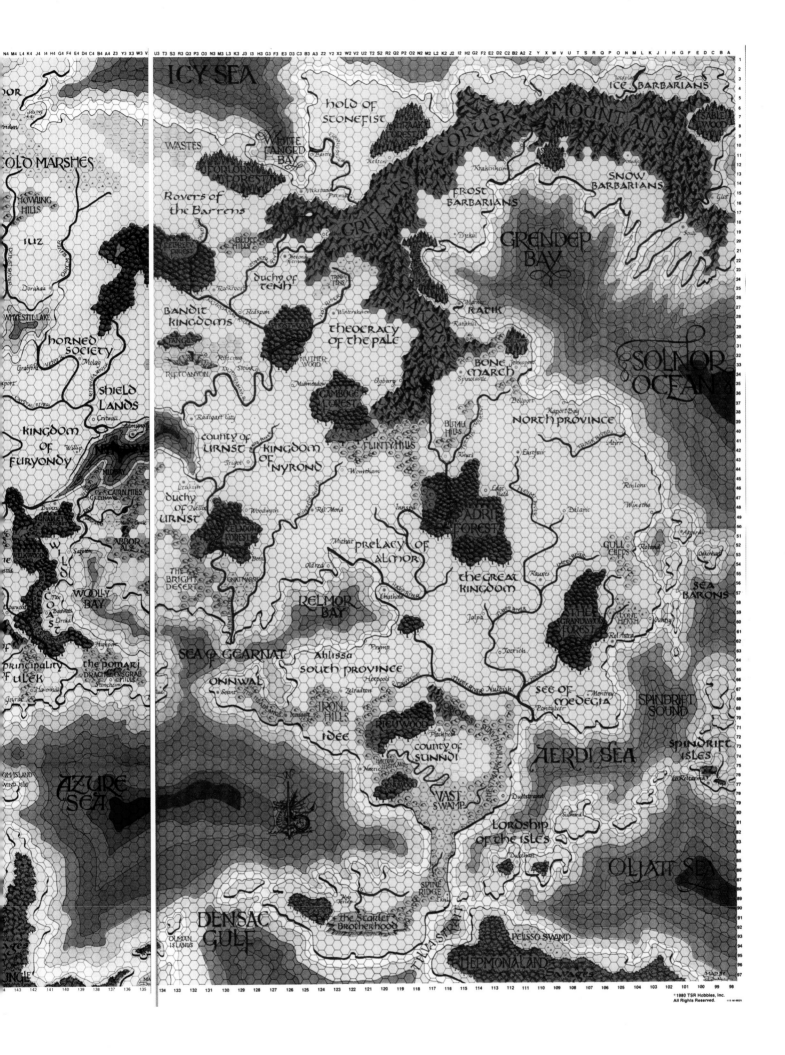

ICY SEA

HOLD OF
STONEFIST

WASTES

FORLORN
FOREST

Rovers of
the Barrens

BLUFF
HILLS

duchy of
TENH

BANDIT
KINGDOMS

THEOCRACY
OF THE PALE

HOWLING
HILLS

IUZ

COLD MARSHES

WHYESTIL LAKE

horned
SOCIETY

shield
Lands

kingdom
OF
FURYONDY

county of
URNST

kingdom
OF
NYROND

duchy
OF NELLIX
URNST

THE
BRIGHT
DESERT

WOOLLY
BAY

AZURE
SEA

WILD
COAST

principality
OF ULEK

the pomarj

SEA OF GEARNAT

RELMOR
BAY

ONNWAL

IRON
HILLS

IDEE

county of
SUNNDI

Ahlissa
SOUTH PROVINCE

DENSAC
GULF

OUMAN
ISLANDS

THE SCARLET
BROTHERHOOD

SPINE
RIDGE

VAST
SWAMP

ICE BARBARIANS

CORUSK MOUNTAINS

SABLE
WOOD

SNOW
BARBARIANS

FROST
BARBARIANS

GRENDEP
BAY

RATIK

BONE
MARCH

BLEMU
HILLS

NORTH PROVINCE

SOLNOR
OCEAN

GAMBOGE
FOREST

FLINTY HILLS

CELADON
FOREST

prelacy OF
ALMOR

ADRI
FOREST

the great
KINGDOM

GULL
CLIFFS

SEA
BARONS

THE
GRANDWOOD
FOREST

LONE
HEATH

see of
MEDEGIA

AERDI SEA

SPINDRIFT
SOUND

SPINDRIFT
ISLES

lordship
OF THE ISLES

OLJATT SEA

PELISSO SWAMP

HEPMONALAND SAVAGES

©1980 TSR Hobbies, Inc.
All Rights Reserved.

1978

1978

1980

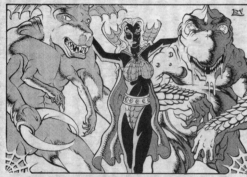

1980

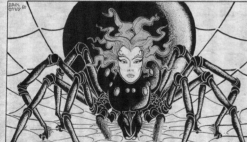

1980

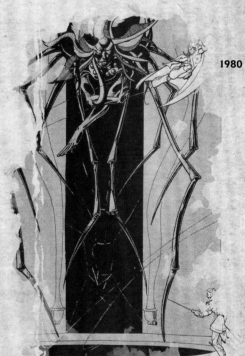

1980

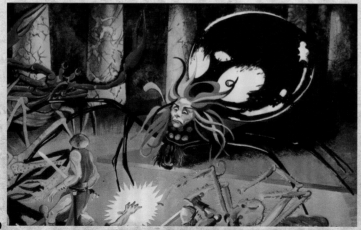

1980

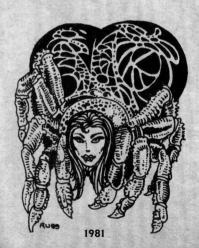

1981

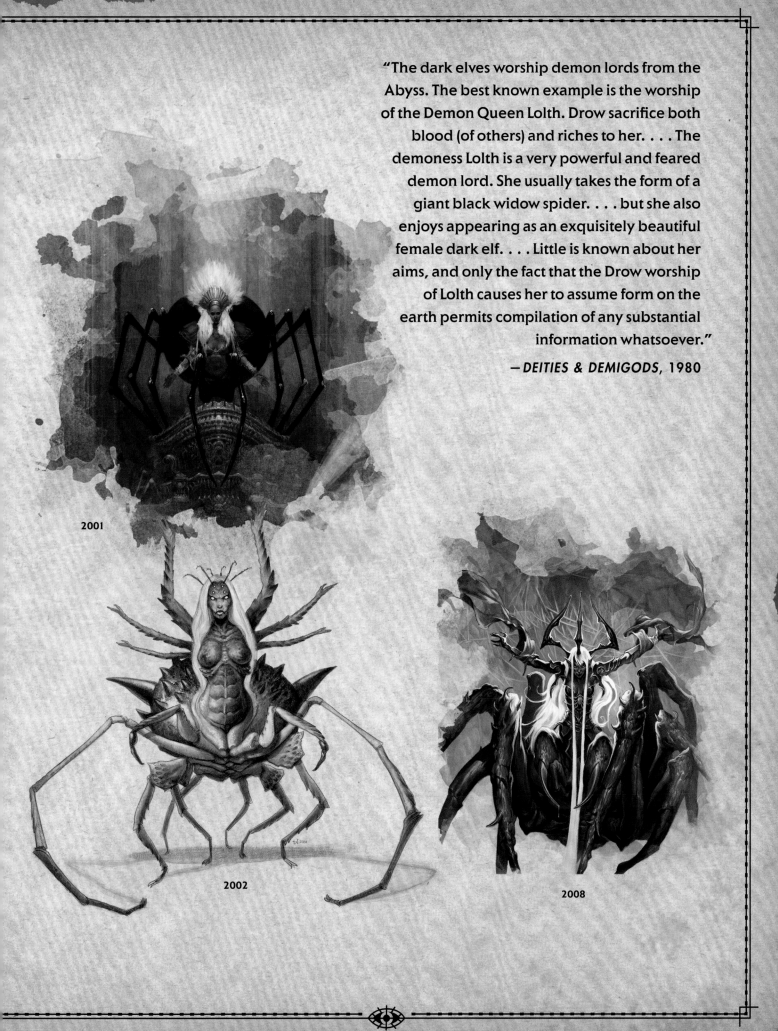

"The dark elves worship demon lords from the Abyss. The best known example is the worship of the Demon Queen Lolth. Drow sacrifice both blood (of others) and riches to her. . . . The demoness Lolth is a very powerful and feared demon lord. She usually takes the form of a giant black widow spider. . . . but she also enjoys appearing as an exquisitely beautiful female dark elf. . . . Little is known about her aims, and only the fact that the Drow worship of Lolth causes her to assume form on the earth permits compilation of any substantial information whatsoever."

— *DEITIES & DEMIGODS*, 1980

2001

2002

2008

CAVES OF CHAOS

The cover of 1980 adventure module *The Keep on the Borderlands* alongside an earlier watercolor on parchment color study by cover artist Jim Roslof.

IN 1980, GARY GYGAX swapped out the module in TSR's best-selling D&D *Basic Set*. Previously, it had housed Carr's *In Search of the Unknown*, but now, players were introduced to Gygax's own *The Keep on the Borderlands*. Millions of players now faced his newest peril: the monster-infested Caves of Chaos, which were for many players the first steps into the world of Dungeons & Dragons. The multitiered caves became a popular haunt for adventurers seeking fame and fortune who were staying at the Keep, but choosing the wrong cave could mean an insidious game of Russian roulette for a less experienced party, depending on what lurked inside.

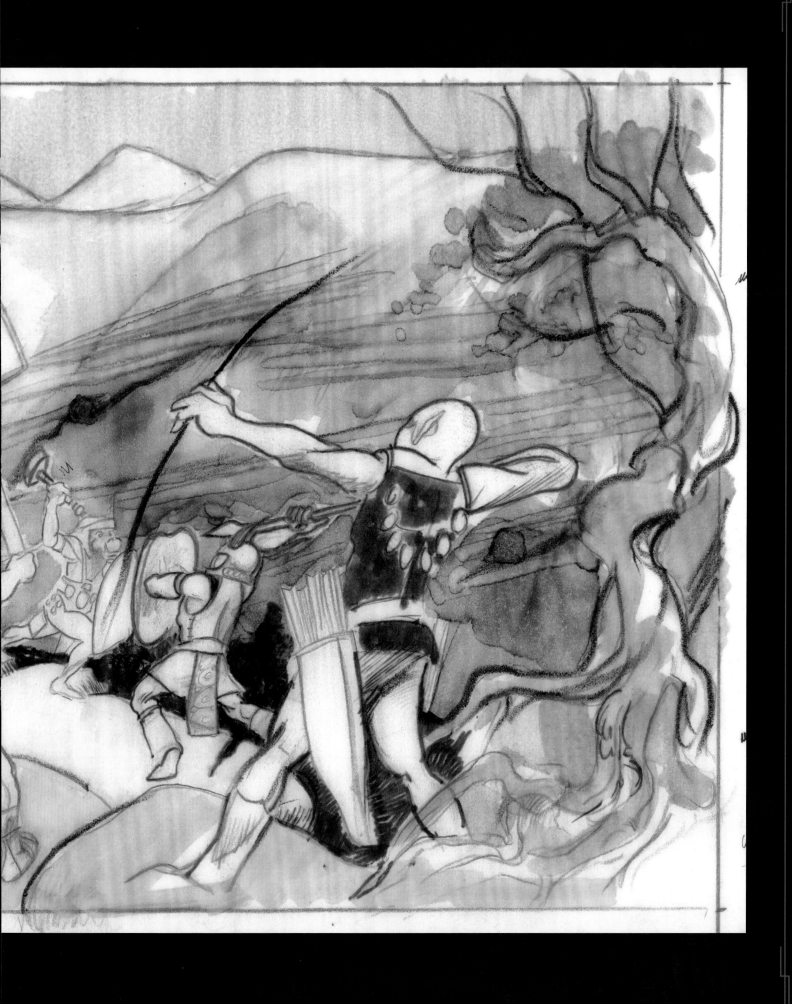

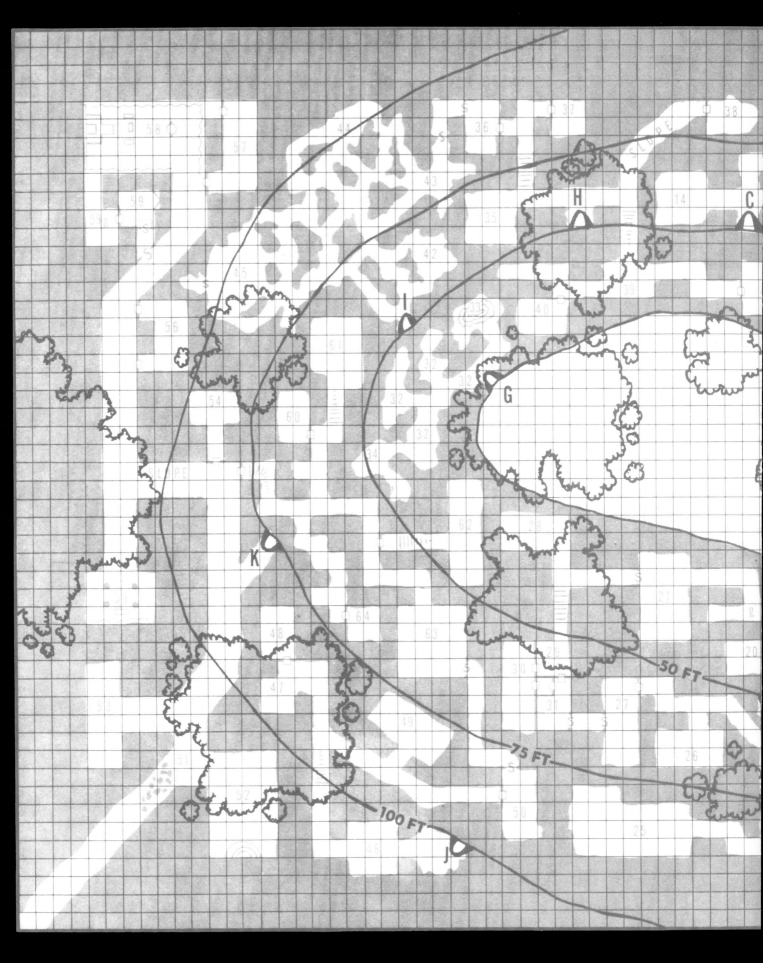

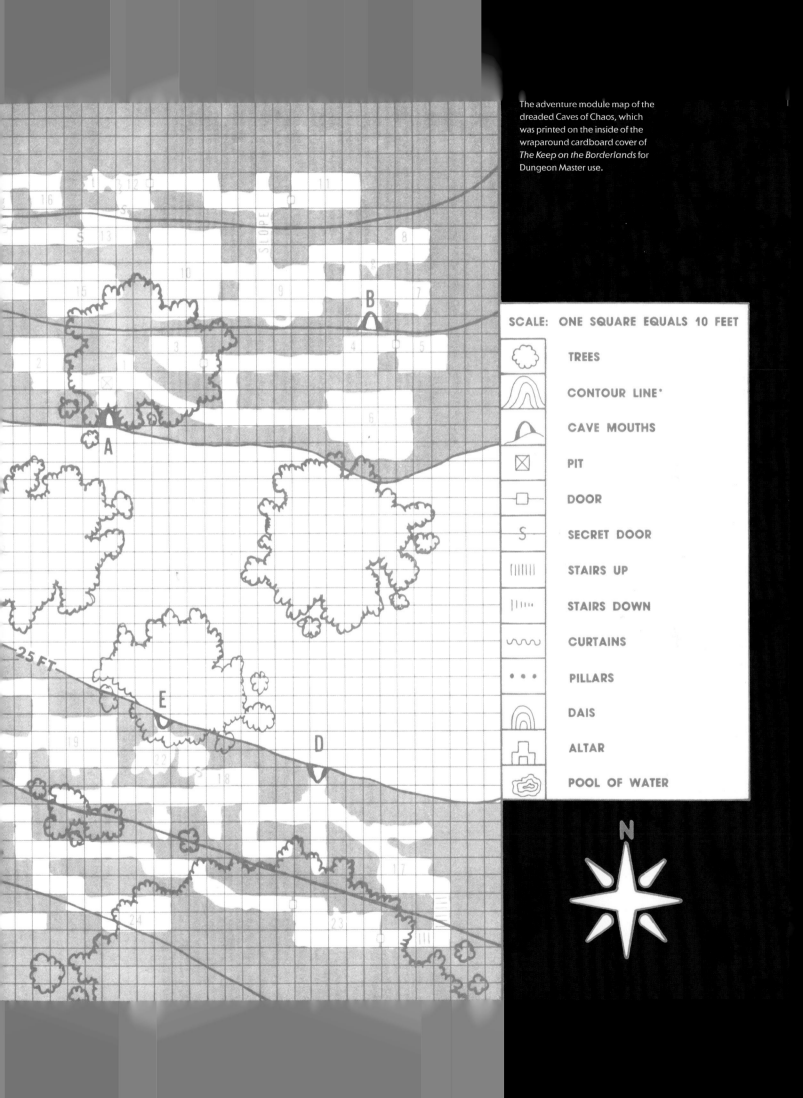

The adventure module map of the dreaded Caves of Chaos, which was printed on the inside of the wraparound cardboard cover of *The Keep on the Borderlands* for Dungeon Master use.

SCALE: ONE SQUARE EQUALS 10 FEET

	TREES
	CONTOUR LINE*
	CAVE MOUTHS
	PIT
	DOOR
	SECRET DOOR
	STAIRS UP
	STAIRS DOWN
	CURTAINS
	PILLARS
	DAIS
	ALTAR
	POOL OF WATER

N

GOLDEN AGE ADVENTURES

THE EARLY 1980S SAW the development of some of the most successful and iconic adventure modules in D&D history. However, much of this gaming content wasn't new, but rather re-faced and sometimes recompiled versions of popular modules from the 1970s. Following the tradition of modules like *Tomb of Horrors* and those of the giants series, other tournament modules such as *The Lost Caverns of Tsojcanth* and *Lost Tamoachan* were adapted to become retail modules, with the latter also getting a title change to *The Hidden Shrine of Tamoachan*. One of the most distinctive features of these adaptation efforts was the redesign of the front and back covers, which included new, full-color artwork. While the "monochrome" modules of the 1970s had been more than suitable for hobby shop and mail-order channels, now that D&D was selling in mainstream retail outlets, it needed more colorful and professional looking jackets to compete on the shelves of major toy and book stores.

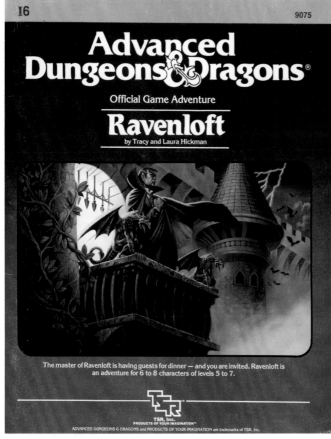

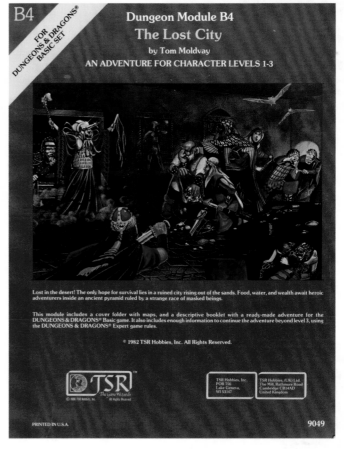

ABOVE Some of the most popular adventure modules of the "Golden Age," including (clockwise from top left) the 1980 *Expedition to the Barrier Peaks* with cover art by Erol Otus, the 1981 *Castle Amber* with cover art by Erol Otus, the 1982 *The Lost City* with cover art by Jim Holloway, and the 1983 *Ravenloft* with cover art by Clyde Caldwell.

OPPOSITE, LEFT The original tournament module for *The Lost Caverns of Tsojcanth*, along with the published module.

OPPOSITE, RIGHT The original tournament module for *Lost Tamoachan*, along with the two published *Hidden Shrine of Tamoachan* modules.

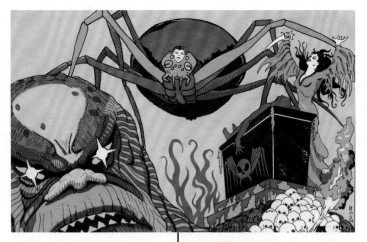

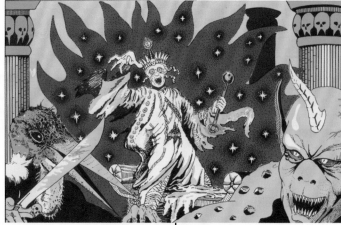

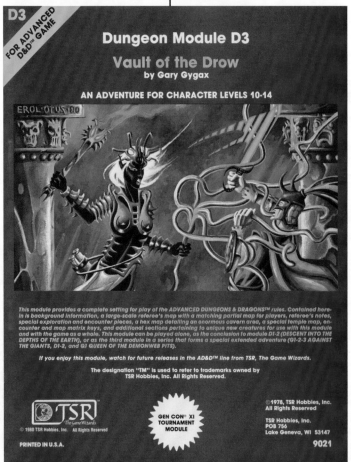

Dungeon Module D3
Vault of the Drow
by Gary Gygax

AN ADVENTURE FOR CHARACTER LEVELS 10-14

This module provides a complete setting for play of the ADVANCED DUNGEONS & DRAGONS™ rules. Contained herein is background information, a large-scale referee's map with a matching partial map for players, referee's notes, special exploration and encounter pieces, a hex map detailing an enormous cavern area, a special temple map, encounter and map matrix keys, and additional sections pertaining to unique new creatures for use with this module and with the game as a whole. This module can be played alone, as the conclusion to module DI-2 (DESCENT INTO THE DEPTHS OF THE EARTH), or as the third module in a series that forms a special extended adventure (G1-2-3 AGAINST THE GIANTS, D1-2, and Q1 QUEEN OF THE DEMONWEB PITS).

If you enjoy this module, watch for future releases in the AD&D™ line from TSR, The Game Wizards.

The designation "TM" is used to refer to trademarks owned by TSR Hobbies, Inc. All Rights Reserved.

TSR The Game Wizards
© 1980 TSR Hobbies, Inc. All Rights Reserved

GEN CON® XI TOURNAMENT MODULE

©1978, TSR Hobbies, Inc.
All Rights Reserved

TSR Hobbies, Inc.
POB 756
Lake Geneva, WI 53147

PRINTED IN U.S.A.

9021

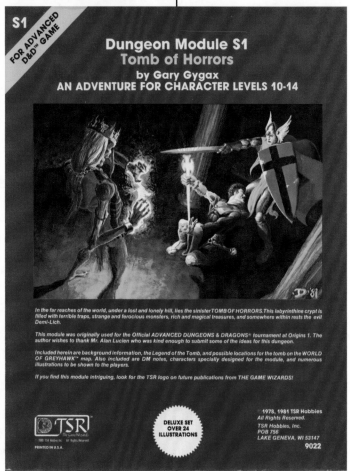

Dungeon Module S1
Tomb of Horrors
by Gary Gygax

AN ADVENTURE FOR CHARACTER LEVELS 10-14

In the far reaches of the world, under a lost and lonely hill, lies the sinister TOMB OF HORRORS. This labyrinthine crypt is filled with terrible traps, strange and ferocious monsters, rich and magical treasures, and somewhere within rests the evil Demi-Lich.

This module was originally used for the Official ADVANCED DUNGEONS & DRAGONS® tournament at Origins 1. The author wishes to thank Mr. Alan Lucien who was kind enough to submit some of the ideas for this dungeon.

Included herein are background information, the Legend of the Tomb, and possible locations for the tomb on the WORLD OF GREYHAWK™ map. Also included are DM notes, characters specially designed for the module, and numerous illustrations to be shown to the players.

If you find this module intriguing, look for the TSR logo on future publications from THE GAME WIZARDS!

TSR The Game Wizards

DELUXE SET OVER 24 ILLUSTRATIONS

©1978, 1981 TSR Hobbies
All Rights Reserved.

TSR Hobbies, Inc.
POB 756
LAKE GENEVA, WI 53147

PRINTED IN U.S.A.

9022

Over 1980 and 1981, some of the most successful "monochrome" modules of the 1970s received a significant facelift. Dave Sutherland's covers for *Vault of the Drow* got a full-color treatment by Erol Otus.

Tomb of Horrors, re-imagined by Jeff Dee.

The three part "G" series of modules, which previously bore covers by Sutherland and Trampier, became the *Against the Giants* super module with cover art by Bill Willingham.

In what may have been the biggest stylistic shift, Trampier's iconic movie-poster-style cover for *Village of Hommlet* received a comicbook-style treatment at the hands of Jeff Dee.

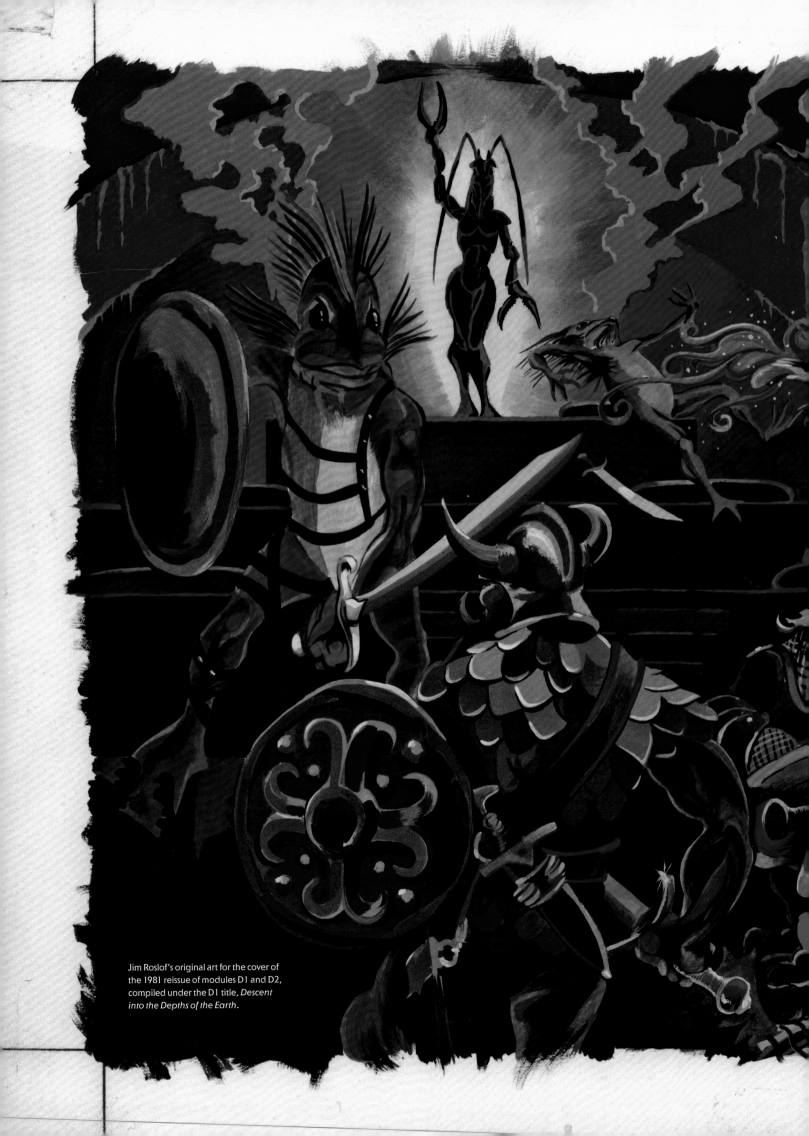

Jim Roslof's original art for the cover of the 1981 reissue of modules D1 and D2, compiled under the D1 title, *Descent into the Depths of the Earth*.

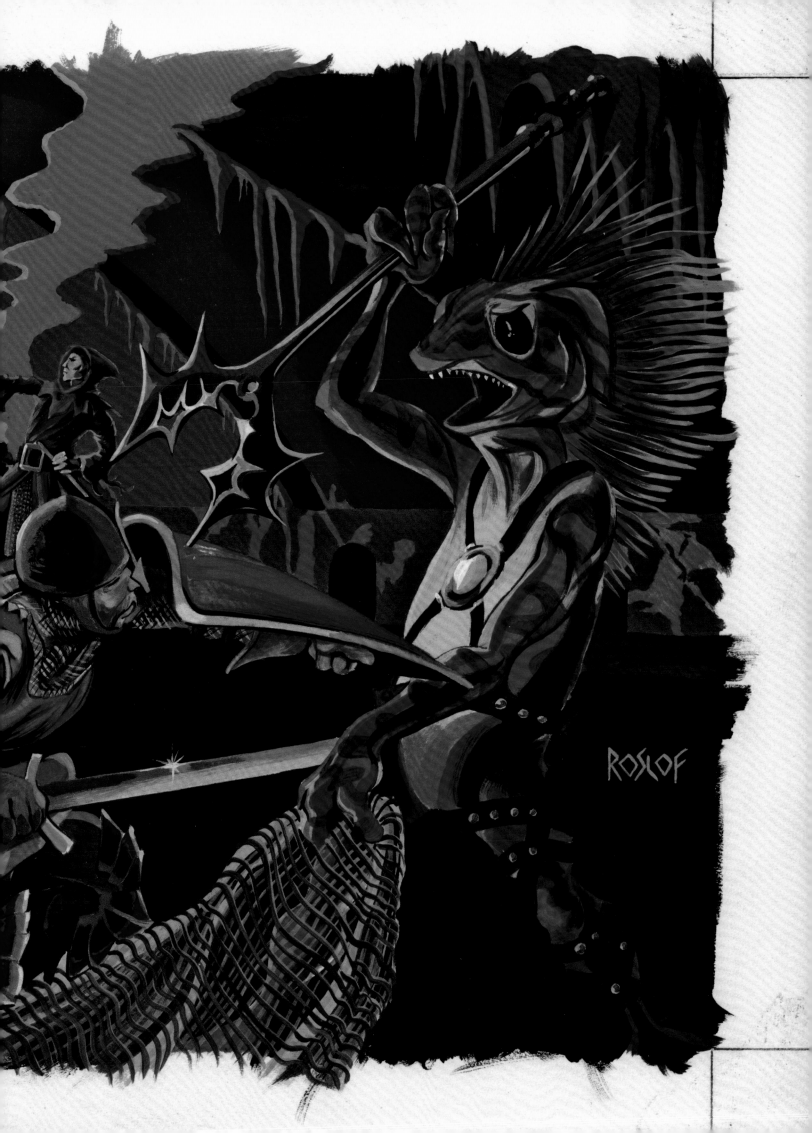

CLOCKWISE FROM TOP Jeff Dee's back-cover illustration to *Queen of the Demonweb Pits*, an adventure by fellow TSR artist Dave Sutherland; Bill Willingham's 1981 back cover to *Descent to the Depths of the Earth*; Erol Otus's back-cover panel from the 1981 reprint of the *Tomb of Horrors*, featuring the fabled "Face of the Great Green Devil."

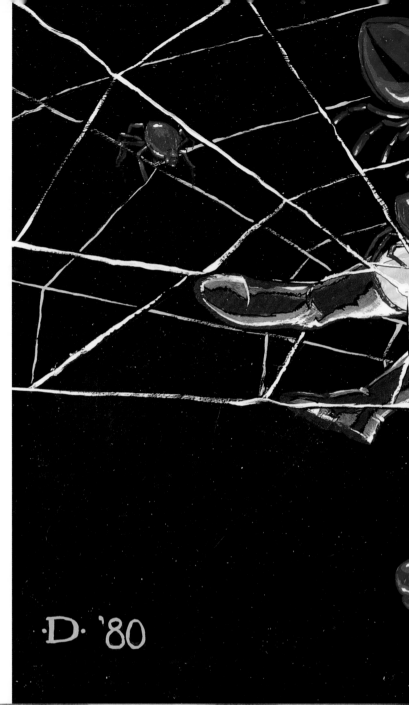

CREATIVE FUN
EQUALS
GROWING SUCCESS

© 1980 TSR Hobbies Inc. All Rights Reserved

"When it came to taking risks, I was always rather conservative," says E. Gary Gygax, president and founder of TSR Hobbies, Inc., "but everyone else was ultra-conservative."

Gygax's "conservativism" certainly paid rich dividends — in the seven years since he introduced the Dungeons & Dragons fantasy role playing game, the product has revolutionized the gaming industry. This TSR flagship has become so popular that it is now often credited as the catalyst for the creation of a new segment of the toy and hobby industry: Adventure Gaming.

Adventure gaming includes board games, role playing games, and games using miniature figures. It covers the topics of fantasy, science fiction, and history, among others. The newest and most rapidly growing area of adventure gaming is that of fantasy role playing games: the Dungeons & Dragons game is the biggest of this type.

E. Gary Gygax, President and founder of TSR Hobbies, Inc.

ABOVE, LEFT TSR's rented executive offices of the early 1980s on Sheridan Springs Road, commonly called the LRP building after its former tenants, a company called Leisure and Recreation Products.

ABOVE, RIGHT A TSR profile from 1981, which suggests the company had taken on a business-minded corporate image—a vast departure from the basement hobby business that it had been just a few years before.

LEFT This cartoon, depicting Morley the Wizard as a buffoon and child murderer, was owned by art director Jim Roslof, illustrating both the department's off-color sense of humor and its general disdain for the company's child-friendly direction.

OPPOSITE TSR Hobbies, Inc. Human Resources executive Doug Blume posing at TSR's Dungeon Hobby Shop.

LEVELING UP

After six years of existence, much of the identity of Dungeons & Dragons was still wrapped up in the "homebrew" art lovingly produced by TSR's in-house art department. Dave Sutherland handed over the reins of the department to Jim Roslof in 1980, but even under new management, it remained one of the more rambunctious groups at the company—albeit the entire development, design, and art department was a youthful and brash outfit. This group, populated largely by men in their early twenties and younger, certainly marched to the beat of their own drum—a sentiment encouraged at the founding of TSR when the company was a happy-go-lucky group of gamers. However, as the business grew and the pace of product development accelerated, executives began to encourage a more sober vision and insisted on more structure. No longer would TSR tolerate humorous and sometimes lewd caricatures hanging about the office.

By April 1981, the tensions between the fancy-free development, design, and art department and TSR executives reached a predictable conclusion. According to designer Steve

Winter, two teenage staffers, Paul Reiche and Evan Robinson, had been fired in the spring on "trumped-up charges of insubordination," but more likely on account of simple immaturity and casual unprofessionalism. The following week, when artists Jeff Dee and Bill Willingham openly made their displeasure about the firing known by symbolically packing their belongings in expectation of imminent dismissal, they too were let go for "having bad attitudes." Other artists and designers resigned in protest, leaving Roslof with an art department virtually empty of artists—only he and Erol Otus remained. The event became known around the company as the "Great Purge," and the issue of TSR's employee newsletter, *Random Events*, published May 13, 1981, only seemed to confirm that by insisting, "There is no 'purge' or any implied threat to our employee population!" With an art department that was already struggling to meet ever-growing demands, this was cause for major concern—though help would soon be on the way.

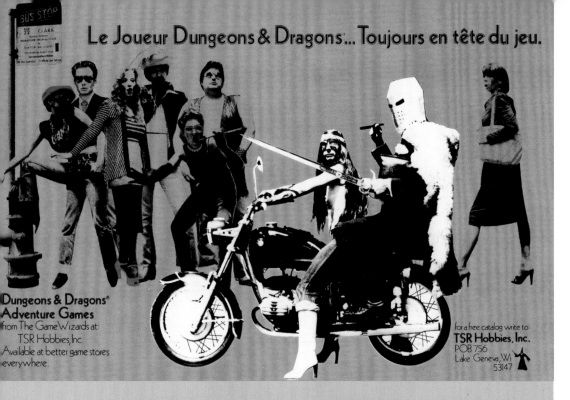

Le Joueur Dungeons & Dragons... Toujours en tête du jeu.

Dungeons & Dragons®
Adventure Games
from The Game Wizards at:
TSR Hobbies, Inc.
Available at better game stores
everywhere.

for a free catalog write to:
TSR Hobbies, Inc.
POB 756
Lake Geneva, Wi
53147

**Eht Dungeons & Dragons® reyalp...
syawla daeha fo eht emag.**

Dungeons & Dragons
Adventure Games
from
The Game Wizards
TSR Hobbies, Inc.
Available at better game stores everywhere.

for free color catalog write to: TSR HOBBIES, INC. POB 756
Lake Geneva, Wi. 53147

Ads translated into French, Hsilgne
(English), and German that appeared
in 1980 and 1981 issues of the popular
science-fiction magazine, *Omni*. TSR
staffers (below) such as Mike Carr (host),
Elise Gygax (far left), advertising chief
Dave Dimery (helm and sword), and
others served as inspiration for the
German ad.

Der "Dungeons & Dragons" Spieler... ist immer einen Schritt voraus.

Dungeons & Dragons®
Adventure Games
from The Game Wizards at:
TSR Hobbies, Inc.
Available at better game stores everywhere
for a free catalog write to: **TSR Hobbies, Inc.** POB 756 Lake Geneva, Wi 53147

LEFT A 1981 ad for the next AD&D hardcover, the *Fiend Folio*—a collaboration between US and UK designers and artists.

FOLLOWING SPREAD Emmanuel's original wraparound cover painting for the 1981 *Fiend Folio*.

By the late 1970s, the international appetite for D&D had reached a level that required TSR to create a UK subsidiary called TSR Hobbies UK, Ltd. Growing pains were only natural, as D&D's star was very much on the rise. Between international expansion and the success of AD&D hardcovers, the stage was set for D&D products that came from outside of TSR's Lake Geneva headquarters. In August of 1981, the TSR UK *Fiend Folio* hit shelves with a distinct art and style, featuring primarily monsters submitted to the pages of *White Dwarf* magazine, a gaming publication of TSR's original UK distributor, Games Workshop. The book became known for introducing new monsters and foes including the githyanki, among others.

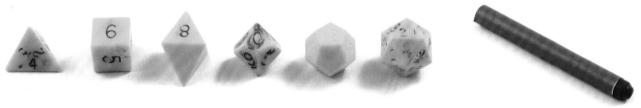

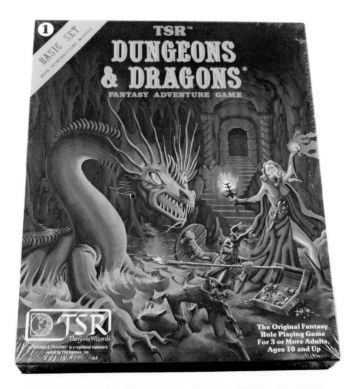

TOP The 1981 *Basic Set* and *Expert Set* as published, with vibrant, highly stylized new cover art by Erol Otus.

ABOVE The *Isle of Dread* adventure module, with cover art by Jeff Dee.

OPPOSITE, TOP A cover-concept painting by Jim Roslof for Tom Moldvay's 1981 *Expert Set*.

OPPOSITE, BOTTOM Having recovered from its dice shortage that forced TSR to supply chits as part of the last set, for the 1981 *Basic Set*, TSR started shipping dice of its own manufacture.

In 1981, TSR's flagship *Basic Set* underwent a two-part revision and expansion comprising an updated *Basic Set* by Tom Moldvay and a sequel for higher-level characters called the *Expert Set*, developed by David "Zeb" Cook and Steve Marsh. Both products featured new cover art by Erol Otus, and the *Expert Set* would include the iconic *Isle of Dread* module, which informally unveiled D&D's introductory campaign world, the "known world" of Mystara. At this new peak in popularity, sales of the *Basic Set* reached 750,000 per year, and in December, *Inc.* magazine had named TSR on its list of the one hundred fastest growing privately held companies in the United States.

Largely a fan-built community up until now, TSR sought new and innovative ways to nurture the rapidly growing D&D market. In the past, institutions like Gen Con and *Dragon* magazine filled these roles, but with an audience quickly trending toward the mainstream, TSR had an increased need to formalize its fandom and create a dedicated club. At the start of 1981, TSR formed the Role Playing Game Association (RPGA) to promote quality role-playing and unite gamers across the nation, aided by its own *Polyhedron* magazine. So far, everything D&D touched had turned to gold.

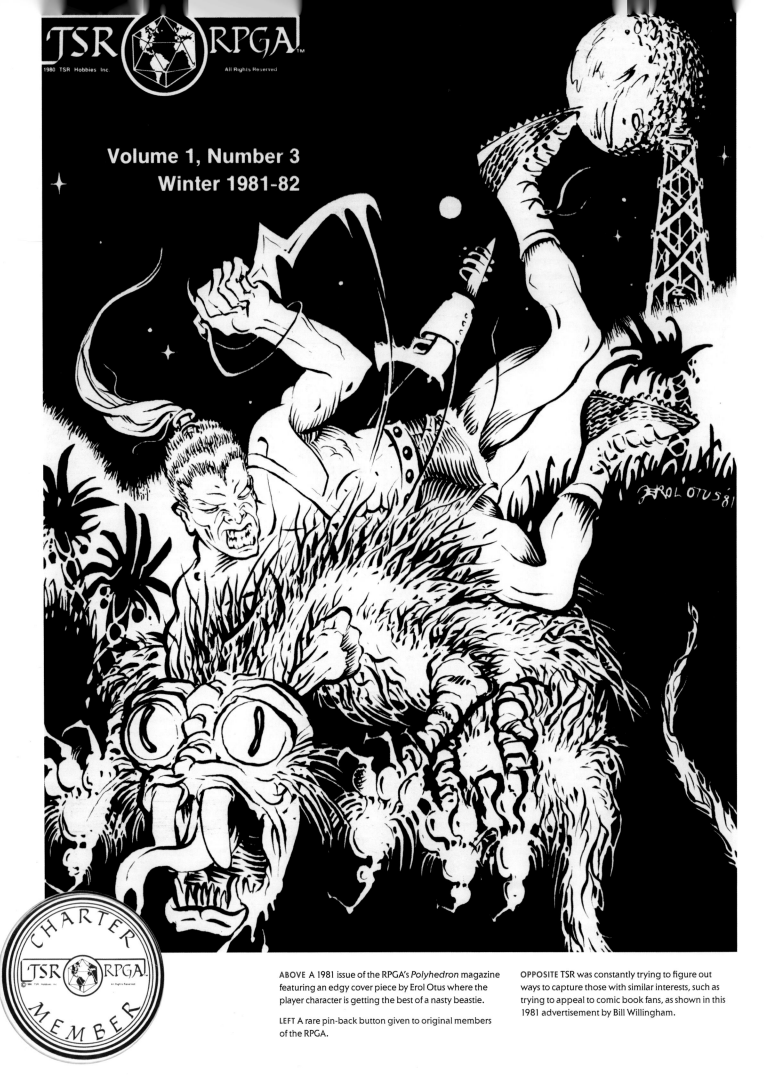

Volume 1, Number 3
Winter 1981-82

EROL OTUS 81

HEAVY METAL

THE EARLIEST DISTRIBUTORS AND hobby shops to carry Dungeons & Dragons also sold miniature figures, which made various tie-in promotions between D&D and fantasy miniatures inevitable. The first official license for D&D figures went to MiniFigs, the New York branch of a venerable English miniatures firm. They produced a 1976 line following TSR's exacting specifications, including depictions of the famous demons in *Eldritch Wizardry*, like Demogorgon. Their miniatures entered a fantasy figure marketplace teeming with competitors, including Heritage's "Fantasy Fantastics" and Grenadier's "Wizzards & Warriors."

By 1980, TSR had discovered that it could license segments of the D&D brand independently. When TSR awarded a new two-year license for Advanced Dungeons & Dragons 25-millimeter miniatures in 1980, it went to Grenadier—but TSR reserved the right to assign the original non-*Advanced* D&D license elsewhere, as well as that for properties like the Greyhawk campaign setting, which MiniFigs added to its portfolio. TSR had already licensed Grenadier to make figures for *Gamma World* the year before, and were impressed enough to offer a larger opportunity. Lawrence Schick vetted the Grenadier miniature designs for TSR to gauge their fidelity to the *Monster Manual* and the desired representations of player characters. Grenadier's distinctive golden box packaging, with the AD&D trade dress above Ray Rubin's fanciful paintings of their miniatures, became a huge part of the visual identity of the game at the time.

TSR's monumental success in the early 1980s led them to bring much of their production in-house and diversify their core business. Miniatures were a clearly adjacent market, so in 1982, TSR hired industry legend Duke Seifried, lately of Heritage, to head an internal miniatures division to complement many of TSR's game product lines. However, the boxed sets and blister packs of AD&D miniatures in this line enjoyed a relatively short heyday, as Seifried would leave the company during its downsizing rounds in 1983, and investment in miniatures waned thereafter.

Coincidentally in 1983, Games Workshop, TSR's original UK distributor and a growing British game publisher, began selling its signature *Warhammer* fantasy miniatures game along with associated figures produced by its house forge Citadel. The favorable reception of that game induced TSR to re-enter the market with a competing product: their *Battlesystem* fantasy mass combat rules, which promised compatibility with the AD&D line and returned the game to its miniatures wargaming roots. *Battlesystem* shipped with two lead figures, and even a glossy pamphlet on *The Art of Three-Dimensional Gaming* by Steve Winter. While *Battlesystem* failed to reverse the growing popularity of *Warhammer*, it was TSR's first attempt since *Swords & Spells* in 1976 to bring fantasy miniature gaming under the D&D umbrella, a need that would become more pressing in the decades to come.

OPPOSITE An ad for Grenadier's miniatures, featuring the gold box packaging with art by Ray Rubin.

LEFT A 1976 Demogorgon miniature by MiniFigs, designed after Gygax's specifications and Dave Sutherland's illustrations from *Eldritch Wizardry*.

BELOW A rare Grenadier prototype, custom-made for TSR in an attempt to win their business.

Introducing TSR's Own Official
ADVANCED DUNGEONS & DRAGONS®
Metal Miniatures

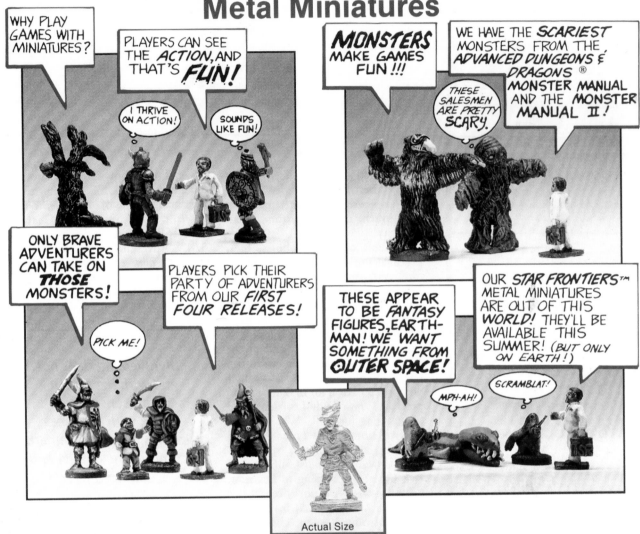

Actual Size

The Only Miniatures With The Best Known Names in Adventure Gaming

Now you can offer a total retail package to the hobby enthusiast with our all-new lines of metal miniatures, paints and accessories. TSR's best-selling role-playing games team with 3-dimenional products to make any store a one-stop shopping center.

All feature the finest packaging and an integrated, in-store merchandising system.

Our releases begin with four sets of AD&D™ Player Characters: "Fighters, Rangers & Pala-dins," "Clerics & Druids," "Magic-Users & Illusionists," and "Monks, Bards & Thieves."

Players and collectors alike will want these finely crafted miniatures, which are sculpted and cast according to the highest quality standards. Our "state-of-the-art" operation is personally directed by Duke Seifried, appointed by TSR President Gary Gygax to inaugurate our hobby division. Watch for our complete line of hobby products... Names you won't forget.

For your free catalog call or write:
Sales Department
Toy, Hobby & Gift Division
TSR Hobbies, Inc.
P.O. Box 756 T203
Lake Geneva WI 53147
(414)248-3625

TSR Hobbies, Inc.
Products Of Your Imagination

Circle No. 32 on Reader Service Card

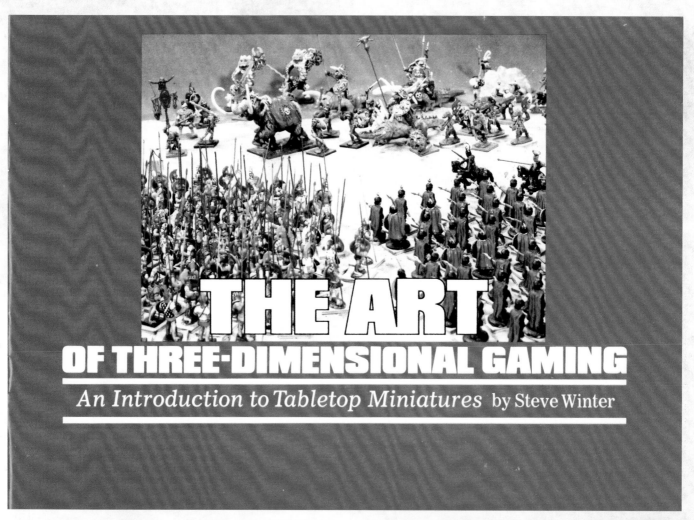

THE ART
OF THREE-DIMENSIONAL GAMING
An Introduction to Tabletop Miniatures by Steve Winter

TOP Included in the *Battlesystem* box was Steve Winter's pamphlet *The Art of Three-Dimensional Gaming*.

ABOVE With TSR's renewed focus on miniatures, they hoped that players might apply the same energy they dedicated to their character sheets to the delicate process of painting their character's miniature. TSR was happy to provide the lead canvas.

RIGHT An ad for TSR's *Battlesystem*

OPPOSITE An ad for TSR's own line of miniatures, featuring legendary figure caster Duke Seifried miniaturized to converse with his creations.

The " New Look" staff. Seated, from Left: David LaForce, Ruth Hodges, Harry Quinn. Standing: Jim Roslof, Jeff Easley, Keith Parkinson, Jim Holloway, Gene Kostiz, Tim Truman, Steve Sullivan & Larry Elmore.

A 1982 photo of TSR's totally revamped art department, as featured in the company's employee newsletter, *Random Events*.

Larry Elmore's self-portrait in *Dragon* #55 showing him conversing with some of his creations as he receives a letter regarding a long-awaited check from TSR.

"But if these artists make the new look, what was the old? 'It was amateurish,' says Roslof. The old artists lacked the talent and professionalism that the job now demands, he explains. The old artists weren't bad, say the new. But the old *look* wasn't good."

—TSR HOBBIES, INC.'S *RANDOM EVENTS* COMPANY NEWSLETTER, 1982

ART NOUVEAU

By 1982, TSR finally had something that it never boasted before: a staff of exclusively professional artists. No longer would D&D illustrations be at the mercy of talented but mercurial teenagers, or gamers who happened to draw a bit. These were pros, most of whom had formal education in art and seemingly no limits in their ability to visualize and illustrate the fantastic. Art director Jim Roslof, who had been left virtually artist-less the year prior, had managed to raise his department like a phoenix from the ashes. Now when the publishers of *Dragon* were impressed with the work of a freelance artist, TSR could afford to relocate them to Lake Geneva and bring them on staff to produce covers for games, as they did for Larry Elmore—who contributed a painting to TSR's 1982 *Days of the Dragon* calendar and famously sent in a three-page cartoon complaint about the lateness of his payment, which depicted the artist in debt to a dragon. Other extraordinary talents soon followed, such as future D&D luminaries Jeff Easley and Keith Parkinson.

Beyond sheer quality and a more mature department, there were other important factors influencing D&D's art efforts. Since late 1979, TSR had partnered with publishing behemoth Random House to exclusively distribute D&D products to the book trade, giving TSR previously unavailable access to mainstream book, toy, and department stores. Random House, though, had conditions to meet their publishing and retail standards: they needed higher-quality, demon-free covers. The reach of the Random House deal and the improved appearance of its products all contributed to making D&D a legitimate cultural icon, enjoying frequent mainstream media appearances and even a cameo in Stephen Spielberg's blockbuster film *E.T.*

THE DAWN OF DIGITAL

Not exactly *World of Warcraft*, this 1981 Dungeons & Dragons handheld game by Mattel was one of the first harbingers of the electronic revolution that would help propel the game into the twenty-first century.

AS ELECTRONIC HANDHELD GAMES, arcade games, and computer games swept the world at the start of the 1980s, TSR stood at a crossroads: should it embrace the digital revolution or stick with its tabletop heritage? Already titles like *Akalabeth* and the *Temple of Apshai* by fledgling software firms had brought D&D-like dungeon adventures to home computers. TSR decided to hire a few employees for a pilot program on computer gaming—including Bruce Nesmith, later a key *Elder Scrolls* designer—but when it came to D&D, why build it themselves? The game was red hot, and everyone wanted to license it.

So, in the summer of 1980, TSR granted Mattel an exclusive license to produce electronic games based on the Dungeons & Dragons and Advanced Dungeons & Dragons brands. For the handheld market, Mattel designed a liquid crystal display electronic game where an adventurer navigated a maze, avoiding pits and bats, to find a magic arrow and slay a dragon from the safe distance of an adjacent room. The gameplay owed an obvious debt to the classic hobbyist adventure game *Hunt the Wumpus*, but it was hampered by a primitive user interface, even by the standards of the time. The game lacks directional buttons to navigate the maze—you have toggle a cursor button three times to make a left turn, effectively—and even a way to turn it off other than by removing the batteries.

At the Consumer Electronics Show in 1981, Gary Gygax was on hand to demonstrate the next product in Mattel's line up, the D&D *Computer Labyrinth Game*. The game mounts an eight-by-eight red checkerboard on a thick, dark gray plastic castle where users position figurines representing adventurers, walls, treasure, and a dragon. The system generated a random labyrinth for every game, enabling one or two players to seek and retrieve a hidden treasure while avoiding its scaly guardian.

The original licensing agreement that TSR struck with Mattel granted a right of first refusal on any home video game products. By 1982, Mattel had developed an initial AD&D game cartridge for its Intellivision console. The eponymous AD&D game plays much like Atari's *Adventure*, with the addition of overworld map exploration similar to *Akalabeth*, but it is probably best remembered for how it gradually revealed the underground dungeon as players explored. Its sequel, the 1983 *Treasure of Tarmin*, offers an experience more worthy of the brand. Players navigate a randomly generated dungeon up to 256 levels deep through a first-person interface, slaying monsters and gathering equipment to power up. But there is nothing to the game besides that dungeon crawl, and by the time it came out, it was competing with franchises like *Ultima* and *Wizardry*, which delivered gameplay much more faithful to tabletop D&D.

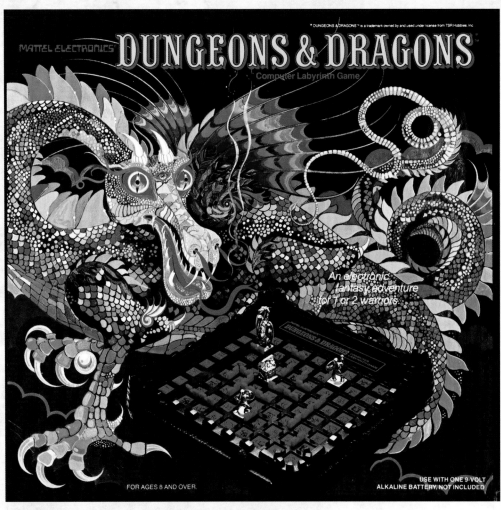

LEFT Mattel's *Computer Labyrinth Game* features unique box art and distinctive sound effects that trigger decades of nostalgia.

OPPOSITE Mattel's final foray into electronic D&D games was for its home gaming console, the Intellivision, which was a competitor to the Atari.

BELOW Two game cartridges for the Intellivision.

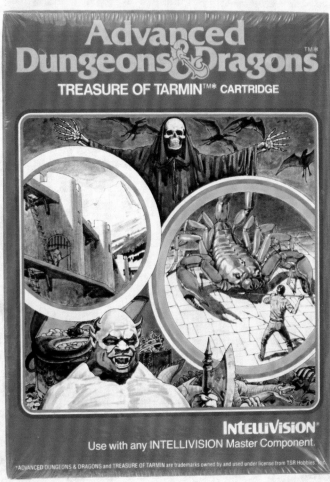

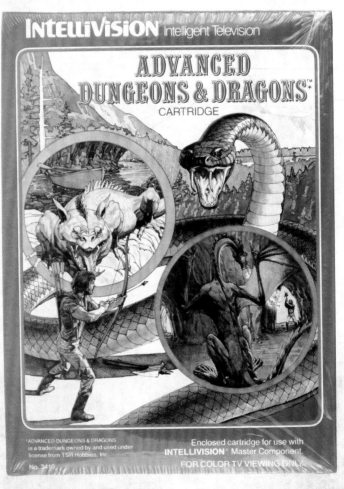

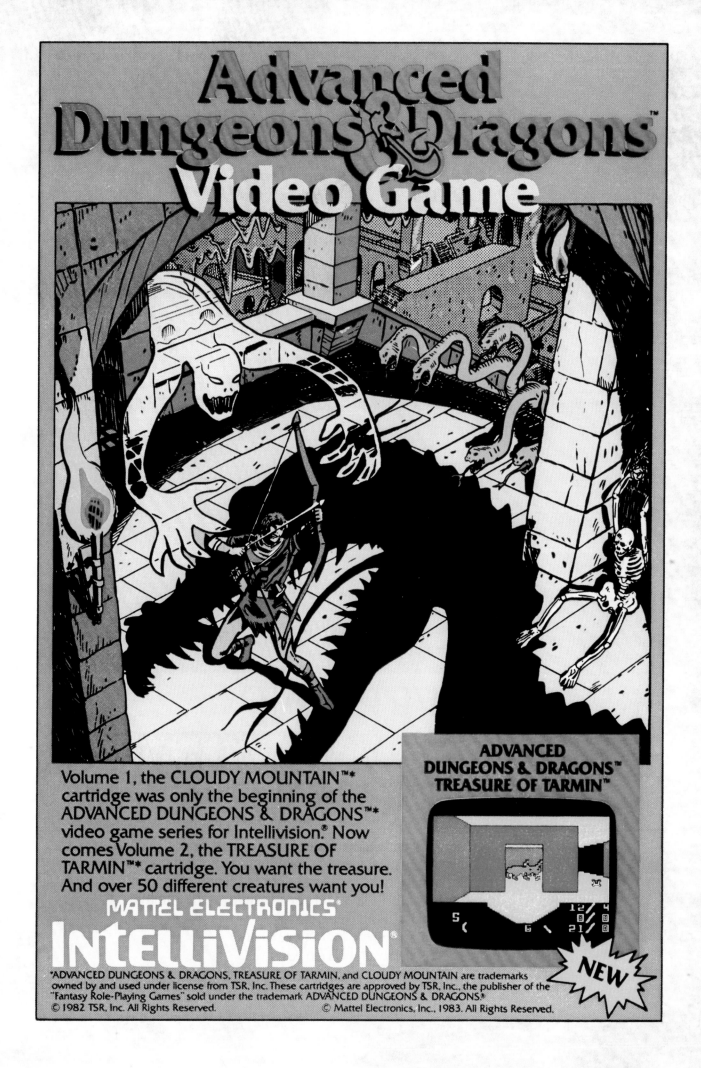

Advanced Dungeons & Dragons™ Video Game

Volume 1, the CLOUDY MOUNTAIN™* cartridge was only the beginning of the ADVANCED DUNGEONS & DRAGONS™* video game series for Intellivision.® Now comes Volume 2, the TREASURE OF TARMIN™* cartridge. You want the treasure. And over 50 different creatures want you!

MATTEL ELECTRONICS®

INTELLIVISION®

ADVANCED
DUNGEONS & DRAGONS™
TREASURE OF TARMIN™

NEW

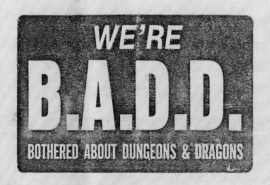

WE'RE
B.A.D.D.
BOTHERED ABOUT DUNGEONS & DRAGONS

Non Profit Organization

P. O. BOX 5513
RICHMOND, VA
23220

(804) 264-0403

A LAW ENFORCEMENT

PRIMER ON

FANTASY

ROLE PLAYING

GAMES

This brochure was prepared by:
Patricia Pulling, Director
of B.A.D.D., Inc. (Bothered
About D & D and other harm-
ful influences on children),
Board Member of the National
Coalition on TV Violence,
Vice-President/Ritualistic
Crime, Advisory Council for
the American Federation of
Police,
Licensed Private Investigator
State of Virginia.

For additional information
please write to:
B.A.D.D. INC.
P.O. Box 5513
Richmond, Virginia 23220

Additional reading materials of
interest.

THE DICTIONARY OF MYSTICISM AND
THE OCCULT, by Nevill Drury,
Harper & Row Publishers, retail
value $12.95 (can be purchased
or ordered through most book-
stores). Topics covered: General
occult terms.

LIFE FORCES, A CONTEMPORARY GUIDE
TO THE CULT AND OCCULT, by Louis
Stewart, copyright 1980, Andrews
& McMeel, Inc-Time & Life Bldg.,
suite 3717, 1271 Ave. of the
Americas, NY, NY 10020 (this book
can be most easily obtained through
most public libraries). Topics
covered: General occult.

THE BLACK ARTS, by Richard Cavendish,
copyright 1967, Perigee Books, The Put-
nam Publishing Company, 200 Madison Ave
NY, NY 10016 (this book can be obtained
in many public libraries or can be pur-
chased/ordered through most bookstores
approx cost $7.95) Topics covered:
Occult, black mass and a number of
occult practices.

THE ULTIMATE EVIL, by Maury Terry,
A Dolphin Book, Doubleday & Company,
Garden City, NY, copyright 1987
(this book can be purchased/ordered
through most bookstores, $17.95)
Topic Covered: "An investigation of
America's most dangerous Satanic Cult
with new evidence linking Charlie
Manson and the Son of Sam".

MICHELLE REMEMBERS, by Michelle Smith
& Dr. Lawrence Pazder, M.D., copy-
right 1980, Congdon & Lattes, Inc,
Empire State Building, NY, NY 10001,
(this book can generally be obtained
in most public libraries or purchased
hardback, $12.95, paperback $4.95)
TOPIC COVERED: Ritual abuse of a child
now grown who was abused and raised
in a "satanic type family."

RAISING PG KIDS IN AN X-RATED SOCIETY,
by Tipper Gore, Abingdon Press, 201
Eight Ave S., Nashville, TN 37202,
copyright 1987, (this book can be
purchased/ordered through most book-
stores approx cost $8.95) Topics
Covered: Music which is having an
impact on the lives of teen includ-
ing explicit lyrics of such music
some "satanic type music."

SAY YOU LOVE SATAN, by David St. Clair
Dell Publisher, copyright 1987,

can be purchased most bookstores
for approx $3.95. Topic Covered:
Actual case of a boy, Ricky
Kasso, Long Island, NY, who
murdered another boy and forced
him to say he loved satan before
dying.

THE SATAN HUNTER, by Tom Wedge
and Robert L. Powers. This is
to be released Oct 31, 1987,
by Canton Publisher. Cost is
unknown. Topic covered: Focus-
ses on Satanists –"people who
worship Satan – and other oc-
cult practices in the 1980's.
Also included is some infor-
mation on Teen Devil Worship
and one Chapter on Fantasy
Role Playing Games.

TEEN

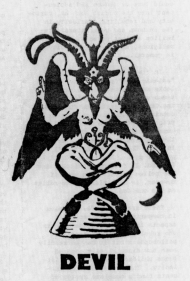

DEVIL

WORSHIP

OPPOSITE Propaganda materials from Bothered About Dungeons & Dragons (BADD), an anti-D&D community organization. BADD seemingly used different styles of design and imagery in their materials to attract different audiences. To incite nervous parents and religious groups, there was demonic and occult-style imagery, while more traditional fantasy themes and styles were presumably there to connect with mainstream authorities and perhaps even lure misguided gamers.

RIGHT *Dark Dungeons*, by evangelist Jack Chick, was a pocket-sized comic tract that explicitly suggested that D&D served as a gateway to occult practices and Satan worship.

BELOW Dave Trampier's barbed devil from the *Monster Manual*.

> "It appears that a significant amount of youngsters are having difficulty with separating fantasy from reality. Or in other instances, their role playing has modified their behavior to the extent that they react in real-life situations in the same fashion that they would react in a gaming situation."

— PATRICIA PULLING, DIRECTOR OF BAAD

BADD NEWS

Of course, with D&D's sudden mainstream prominence came more problems; new and increasingly sensationalized controversies began to surface around the game. In 1982, Patricia Pulling, a grieving mother searching for answers about her son's suicide, began working on a grassroots anti-D&D organization that would later become Bothered About Dungeons & Dragons (BADD). Its mission was to work with local governments, law enforcement, churches, and censorship groups to snuff out the D&D fad nationwide. These efforts gave prominence to theories that D&D was not only psychologically dangerous, but a gateway to more insidious occult phenomena such as Satan worship.

While TSR had learned from the Egbert incident that even negative press could boost sales, by 1982, sales were no longer climbing like they once were. Something needed to be done to counter this narrative before it obstructed future growth. TSR formed an internal task force that year to oversee a revamp of the product line, ridding it of its less-wholesome associations. This entailed scrubbing the text to make sure it did not glamorize evil. But more visibly, it involved changing the way the game looked on the shelf to consumers.

June 7, 1982

TO: E. G. Gygax E. Gygax W. Niebling
 B. Blume D. Sturm J. Witt
 K. Blume D. Blume M. Carr
 D. Snow D. Dimery J. Jaquet
 B. Knorr T. Malone D. Dimoneit
 H. Kilpin F. Mentzer G. Gierahn
 B. Pitzer D. Gleason G. Sanchez
 J. Pickens A. Hammack H. Johnson
 J. Roslof K. Mohan M. Pozorski
 S. Williams M. Gray G. Gile
 T. Quinn

FROM: Duke

RE: Religious "Persecution" Action Plan Programs. These are the <u>GUIDELINES</u>
 required for fulfilling programs RPR03, RPR06, RPR08, RPR09, <u>RPR10</u>,
 RPR16 and RPR18.

I am pleased to enclose the GUIDELINES required to complete program RPR02.
Our thanks to Brian Blume for his efforts on the preparation of these standards.
They are primarily drawn from the COMICS code. We will entertain your
suggestions and discussion of further additions to this code you may feel
worthwhile. Please contact this office if you have relevant input. It is our
desire to develop a workable and reasonable set of GUIDELINES fitting our
company's needs that are designed to create a wholesome yet interesting
impression on the public. We do not wish to be offensive to our potential
customers yet by the same token we do not need to eliminate the spark that
intrigues the buyer. These GUIDELINES are intended to provide a code of propriety
for TSR products and a reflection of the attitude of its staff and management.

DS/jh

ABOVE A 1982 internal TSR memo from Duke Seifried addressed to the entire leadership team introducing product guidelines that were intended to create "a wholesome yet interesting impression on the public."

OPPOSITE A 1982 ad featuring wholesome older teenagers having equally wholesome fun. These same actors appeared in contemporary television advertisements for D&D. Even the subtle suggestion of adventurers ascending from the dark versus descending into the dark gives a slightly brighter view of the game.

SEARCHING FOR GOLD ON THE SILVER SCREEN

"I promise you all, that if the D&D film isn't of the quality of Star Wars and Raiders of the Lost Ark, I will not only blast it . . . but I will apologize to you as well. . . . Give us a chance to prove that the genre can be good!"

—GARY GYGAX, *DRAGON*, JULY 1982

OPPOSITE, LEFT A 1982 page from *TV Guide* featuring an advertisement for the TV-movie adaptation of Rona Jaffe's *Mazes and Monsters*, starring a young Tom Hanks.

ABOVE Steven Spielberg's 1982 masterpiece, *E.T. the Extra-Terrestrial*, provided audiences with perhaps the most famous on-screen depiction of Dungeons & Dragons.

OPPOSITE, RIGHT The 1981 book *Mazes and Monsters* by Rona Jaffe was a thinly veiled retelling of the James Dallas Egbert III incident based on William Dear's original D&D theory. Other mainstream novels also used this premise for inspiration, including John Coyne's *Hobgoblin* that same year.

AS DUNGEONS & DRAGONS grew remarkably through the tail end of the 1970s and into the early 1980s, both the demand and opportunity for a big-screen movie adaptation became apparent. The media around the buildup to *Mazes and Monsters*, a sensational, made-for-TV adaptation of a novel about the dangers of Dungeons & Dragons, starring a young Tom Hanks as a college student who is driven mad by the game, had proven that there really was no such thing as bad press. Was Hollywood's watchful eye turning to Lake Geneva?

Gary Gygax dreamed of seeing D&D on the silver screen, harboring high hopes for a genre that was finally performing at the box office. John Boorman's 1981 epic *Excalibur* was a verified success, while the ever-popular Conan slashed his way onto screen in the summer of 1982 with the smash-hit *Conan the Barbarian*. Even the highly abridged animated adaptation of J.R.R. Tolkien's *The Lord of the Rings* managed to capture fan attention while an array of similar properties was also finding traction, from *The Beastmaster* and *Dragonslayer* to *The Sword and the Sorcerer* and *Clash of the Titans*. All this, not to mention a little space fantasy called *Star Wars*, steeped heavily in the classic myths, was still rewriting record books and dominating toy stores with no end in sight. It was only a matter of time for D&D . . . or so TSR executives assumed.

Gary Gygax was dispatched to Hollywood in 1983 to spearhead the translation of his tabletop titan into various narrative formats, including a Saturday-morning animated series with CBS. Gary enlisted veteran scribe James Goldman to craft a screenplay, but loomed heavily over a cagey development process, eager to maintain control of his creation—a difficult proposition for any outsider in the Hollywood studio system.

Goldman's script suggests that he may have poorly understood the game's concepts as it featured "heroes" doing nothing heroic. Not one of the main characters wields a weapon, casts a spell, picks a lock, uses a magic item, or indeed does much but flee danger, as a draft of the screenplay shows. Most interestingly, the plot surrounds teenage travelers from Earth transported to a fantasy realm where they are chaperoned by a wisdom-espousing elder as they seek passage back home. If any of this sounds familiar, it's because it bears striking similarity to the CBS Dungeons & Dragons animated series, albeit in a different tone and medium. The inclusion of these themes may suggest that the film, like Morley before and the cartoon after, intended to continue D&D's trajectory toward becoming more family-friendly and suitable for children.

Although Goldman's draft heavily deviated from traditional D&D tropes, Gygax maintained that with the subsequent rewrites he had spearheaded, it would have been a high-quality final product. The movie was not to be.

"WHEN READ, THE EXPLOSIVE RUNES DETONATE,
DELIVERING . . . DAMAGE UPON THE READER,
WHO GETS NO SAVING THROW."

3

EXPLOSIVE RUNES

THE CRASH OF 1983

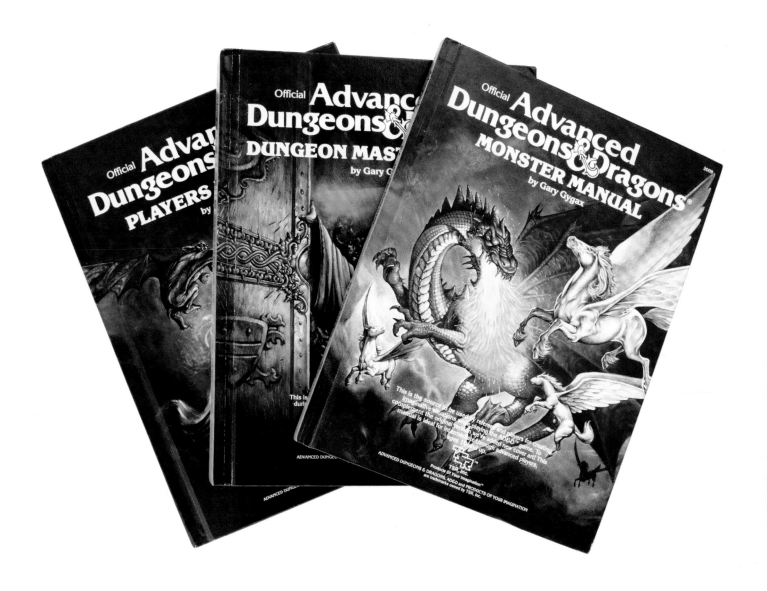

AT THE BEGINNING of 1983, TSR made its first concerted response to the pressures of the mass-market and religious fundamentalism. No longer did the logo of TSR feature a wizard or a depiction of anything fantastic: it was just the three letters "TSR" done in a blocky geometric style that could only obliquely suggest a dungeon map, a subtle indication of how TSR planned to diversify its business beyond fantasy. Jim Roslof also directed Jeff Easley to create new covers for all of the core rulebooks, replacing the former images by Dave Sutherland and Dave Trampier of suspiciously horned red fellows that might offend Middle American sensibilities. Famously, the trade dress of Dungeons & Dragons this year, both in the Basic and Advanced versions, began to form its ampersands into the shape of a dragon breathing fire, providing further visual distinction between TSR's D&D and non-D&D properties.

By 1983, D&D had reached its initial peak. The game had become a sensation not just in America, but also internationally, with translated versions of the game rolling out in French and eventually expanding into more than a dozen languages and over twenty countries, spanning from Western Europe to Asia. Driven by the strength of a steady stream of new products, such as *Monster Manual II* and ongoing revision of the Basic rules led by Frank Mentzer, TSR would reach the zenith of the hobby games industry, achieving revenues of nearly $27 million. Jeff Easley was the go-to cover artist for the hardbound AD&D product lines, but it would be Larry Elmore who provided the paintings that would grace the box covers of the growing Basic D&D product line.

Règles de Base, Module d'Introduction,
un Jeu de Six Dés, plus un Crayon, ci-inclus.

DONJONS & DRAGONS™

Jeu d'Aventures Fantastiques
Manuel de Base avec Module d'Introduction

Le Premier Jeu de Role de Fantaisie
Pour Trois Joueurs ou Plus, A Partir de 10 Ans.

TSR Hobbies, Inc.

ABOVE A variety of D&D products produced for foreign markets by local publishers. Foreign editions of the game often included size and format variations, and occasionally included variant cover art produced for the local market.

RIGHT The 1983 French edition of *The Keep on the Borderlands*, featuring alternate cover art by TSR artist Jim Holloway.

OPPOSITE The 1983 French edition of the Moldvay *Basic Set* was the first official D&D product produced in a foreign language.

ABOVE A 2017 photo of *Basic Rules* designer Frank Mentzer holding Larry Elmore's alternate design.

RIGHT A one-of-a-kind alternate cover concept for the *Basic Rules* by Larry Elmore.

RED BOX INSPIRATIONS

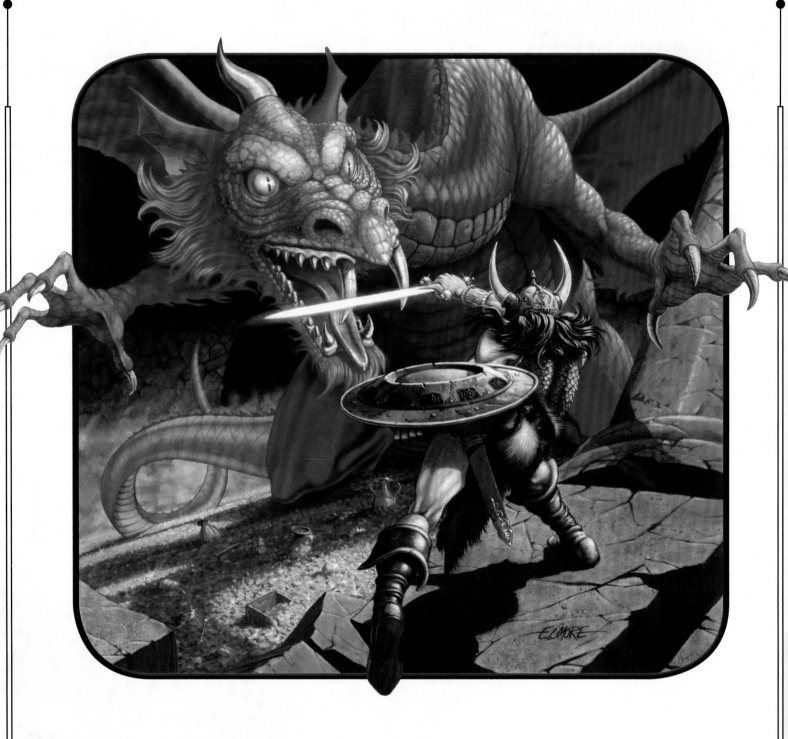

ACCORDING TO COVER ARTIST Larry Elmore, this iconic illustration was inspired directly by D&D co-creator Gary Gygax during an unscheduled visit by Elmore in 1982. Elmore had completed several concepts for the piece and become frustrated that comments and revisions from leadership would become diluted and ambiguous by the time they reached him, leaving him shooting in the dark. After another such round of commentary, Elmore marched down to Gygax's office and asked to see him. Gygax's gatekeeper and secretary was preparing to turn him away when Gygax himself emerged and invited the young artist in. When Elmore asked for clarification on what needed to happen in the piece, Gygax leaned forward and put up his hands like claws, suggesting the dragon should be "jumping out at you." Suffice it to say, Elmore got what he needed. The Dungeons & Dragons Basic Rules Set I, usually known as the "red box," went on to become one of TSR's best-selling products during the height of the game's popularity, and it became the entry point for millions of *D&D* players worldwide.

DIVERSIFICATION

D&D's success in the early 1980s led to overreach. Over the course of only three years, TSR had swelled from just a few dozen employees to more than three hundred, and the company's three controlling partners and presidents, Brian Blume, Kevin Blume, and Gary Gygax, feuded for control over corporate direction. Profitability eluded the sprawling company and, for the first time, TSR took a financial loss in 1983. Leadership reacted by forming a new corporate structure, with TSR, Inc. at the helm of the games business, to stop the financial bleeding of failing business areas while also managing toward desired areas of expansion, which included product licensing, miniature manufacturing, entertainment media, and published fiction. One of these independent ventures, the Dungeons & Dragons Entertainment Company (DDEC), took off when D&D got a regular slot on the small screen with a cartoon series called *Dungeons & Dragons* on CBS. Efforts like the television show increased the visibility of D&D, but as the company further diversified, some of the areas of expansion, such as an ill-advised attempt to cross over to the craft market, were only tenuously connected to the core business. TSR had all of the symptoms of a company growing faster than it knew how to manage: soon its lofty ambitions would catch up to the company and its fractured leadership.

ABOVE TSR's acquisition of Greenfield Needlewomen was a costly and unprofitable diversification venture for the D&D publisher. These D&D-themed craft sets exemplify a misguided attempt to merge two diametrically different hobbies.

BELOW Two of TSR's top designers, Zeb Cook (left) and Jim Ward (right), with Brian Blume (center) shown in 1983 receiving "Million Dollar Club" awards for the sales of their designs.

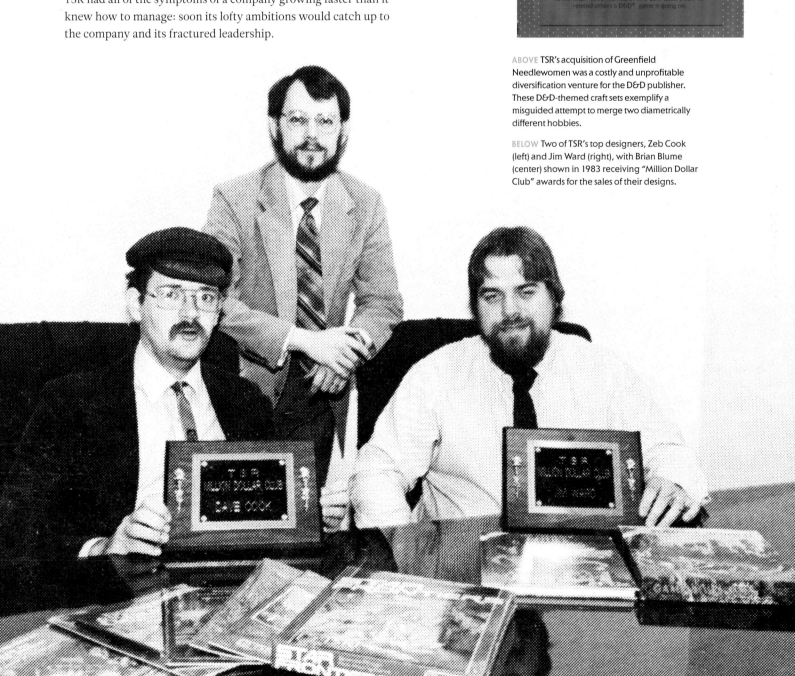

LICENSE TO PLAY

AS D&D REACHED THE mainstream, everyone wanted to license the brand—and for products that went far beyond cross-promotions such as miniature figures or electronic games. It is no coincidence these started with a coloring book, specifically one developed for Troubador Press. In TSR's own estimation, D&D had by 1982 saturated the market of eleven- to fourteen-year-old boys, so their licensing strategy focused on attracting even younger consumers to D&D.

Andy Levinson, head of TSR licensing at the time, maintained that all licenses had to satisfy one of two objectives: "A, the product must introduce young children to the characters and play concepts of our games, or B, it must enhance the play of our games itself." At the height of the fad, TSR struck roughly one new licensing agreement a month. Levinson called it "a practically no-overhead source of income," and it brought in nearly $2 million a year.

The demand for licenses led TSR to create a stable of iconic characters to grace these D&D products, including Strongheart the paladin, Kelek the dark wizard, Northlord the barbarian, and Warduke the evil fighter. Each was named by Gary Gygax personally, and their concept art was drawn by TSR staff artists, including Larry Elmore, Jeff Easley, and Tim Truman. Game statistics for all of them are given in the "Special Characters" section of the 1983 compendium *The Shady Dragon Inn.*

These iconic characters would appear in the coloring and activity books licensed to Marvel Comics that were marketed to younger readers. They familiarized children with basic concepts of fantasy role-playing like alignment and character class. Strongheart even had a cameo in an episode of the D&D animated series. Perhaps the most visible license went to LJN, maker of popular E.T. toys and Brooke Shields dolls, who sold articulated action figures of the iconic D&D characters. LJN reportedly booked $3 million in advertising for its D&D toys early in 1983, and TSR complemented the LJN line with its own rubber action figures of monsters, sometimes called "bendies"—products of Duke Seifried's Toy, Hobby and Gift division.

A dungeon from the 1979 Troubador Press coloring book by artist Greg Irons.

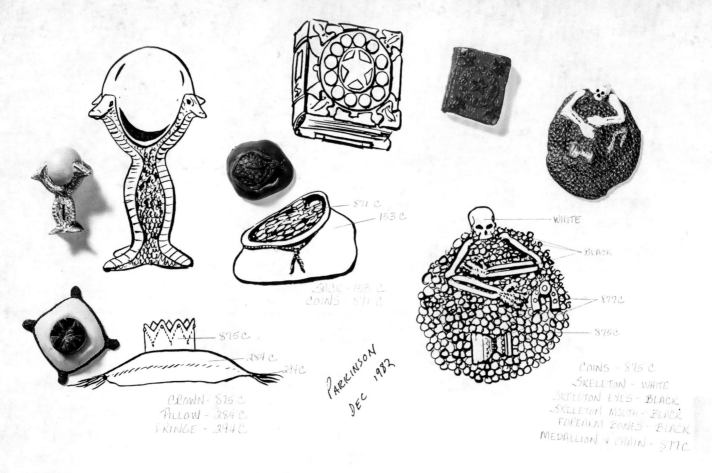

871 C

153 C

SACK - 153 C
COINS - 871 C

WHITE

BLACK

877 C

875 C

875 C.

284 C

394 C

CROWN - 875 C
PILLOW - 284 C
FRINGE - 394 C

Parkinson Dec 1982

COINS - 875 C
SKELETON - WHITE
SKELETON EYES - BLACK
SKELETON MOUTH - BLACK
FOREARM BONES - BLACK
MEDALLION + CHAIN - 877 C

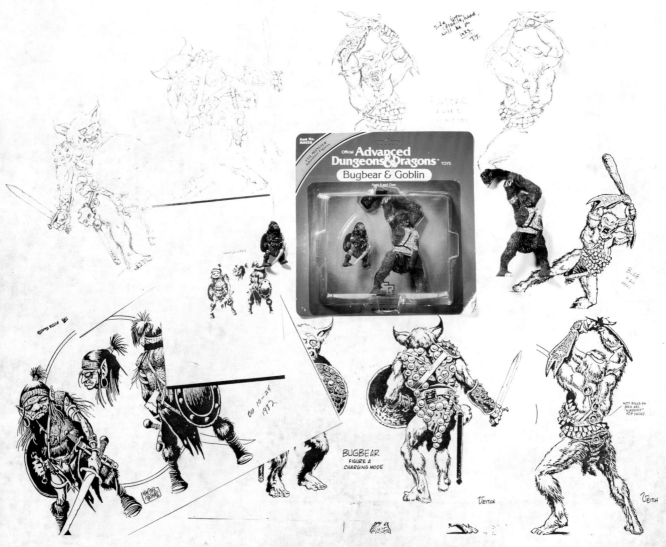

Official Advanced
Dungeons & Dragons TOYS
Bugbear & Goblin

BUGBEAR
FIGURE A
CHARGING MODE

VEITCH

VEITCH

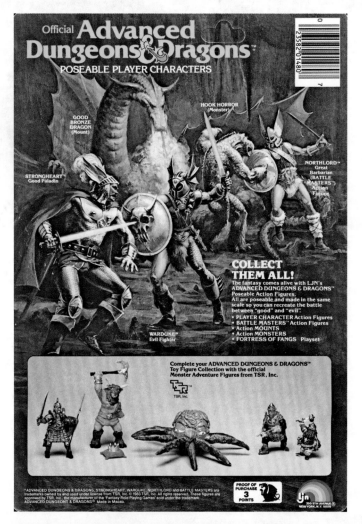

These licensed accessories shrewdly catered to the habits of contemporary children. You could find the iconic characters on popular toys from the era like Shrinky Dinks and Colorforms, see them in action in your View-Master, or read along with their adventures in the "talking story books" made by Kid Stuff Records & Tapes. If you wanted a birthday party with a D&D theme, your obliging parents could furnish it with branded paper plates, tablecloths, disposable napkins, and so on—all featuring Strongheart combating Warduke—made by C.A. Reed. From the Amurol Products Company, you could buy boxes of D&D candy shaped like various monsters and work those foes into your game with the statistics on the back of the box. If you were dragged away from the tabletop to the beach, you could console yourself by reclining on a dungeon-themed beach towel made by the R.A. Briggs company. You could even secure your lucre in a wallet made by Larami and emblazoned with Larry Elmore's red dragon from the cover of the 1983 *Basic Rules*.

LEFT AND BELOW Card backs from action figures produced by TSR and LJN, which encouraged young buyers to "Collect Them All!"

OPPOSITE An assortment of popular D&D and AD&D toys and accessories, accompanied by the original concept drawings by TSR artists Keith Parkinson (top) and Tim Truman and Richard Veitch (bottom).

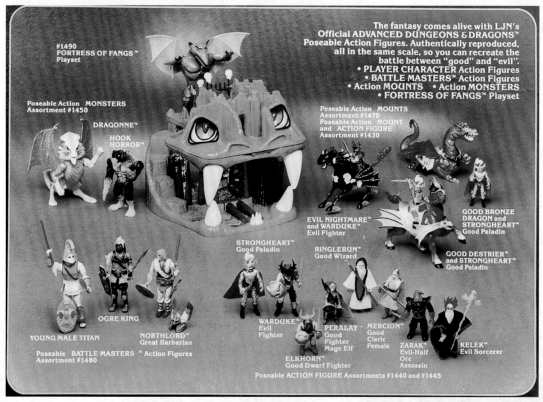

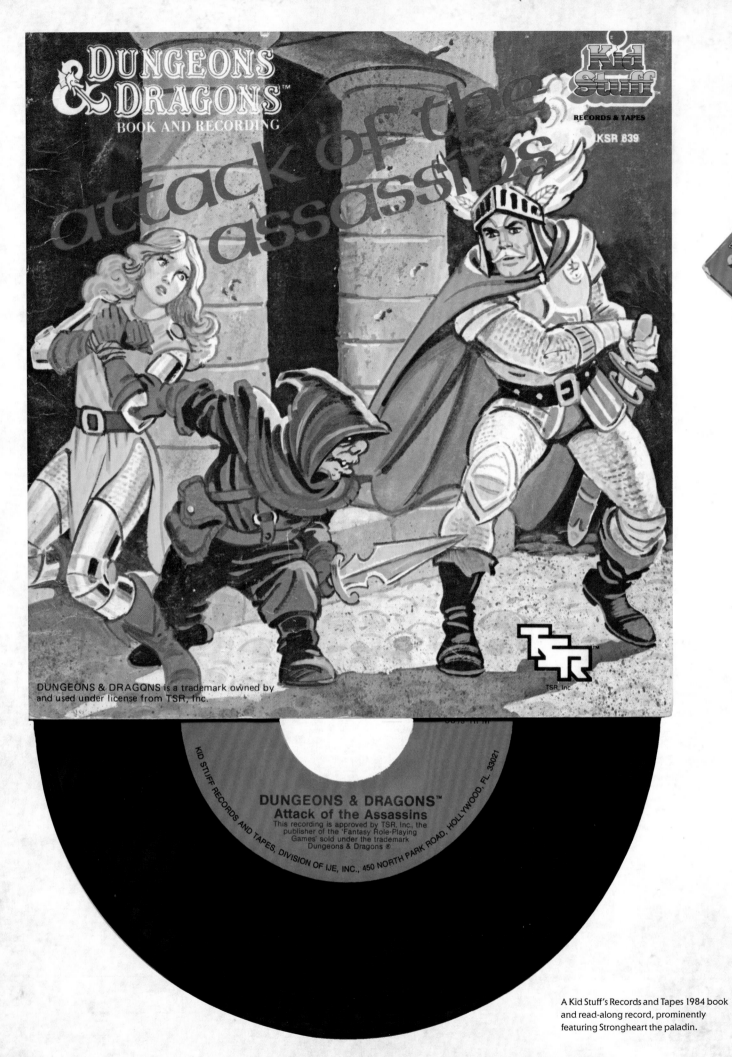

DUNGEONS & DRAGONS™
BOOK AND RECORDING

KID STUFF™
RECORDS & TAPES
KSR 839

attack of the
assassins

DUNGEONS & DRAGQNS is a trademark owned by
and used under license from TSR, Inc.

TSR™
TSR, Inc.

DUNGEONS & DRAGONS™
Attack of the Assassins
This recording is approved by TSR, Inc., the
publisher of the 'Fantasy Role-Playing
Games' sold under the trademark
Dungeons & Dragons ®

KID STUFF RECORDS AND TAPES, DIVISION OF IJE, INC., 450 NORTH PARK ROAD, HOLLYWOOD, FL. 33021

A Kid Stuff's Records and Tapes 1984 book
and read-along record, prominently
featuring Strongheart the paladin.

© MARVEL

BELOW D&D-licensed products from 1983 including a beach towel, Shrinky Dinks, and Colorforms.

OPPOSITE Ken Kelly's original box art painting for LJN's Dragonne toy—a half-lion, half-dragon monster that debuted in the 1977 *Monster Manual*. Kelly, a nephew of fantasy artist Frank Frazetta, was best known for his album covers, *Destroyer* and *Love Gun*, for legendary rock band Kiss.

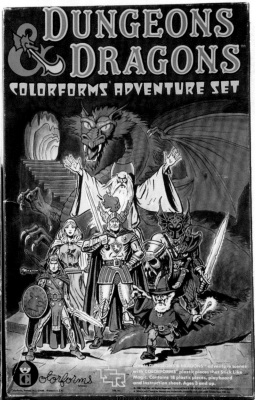

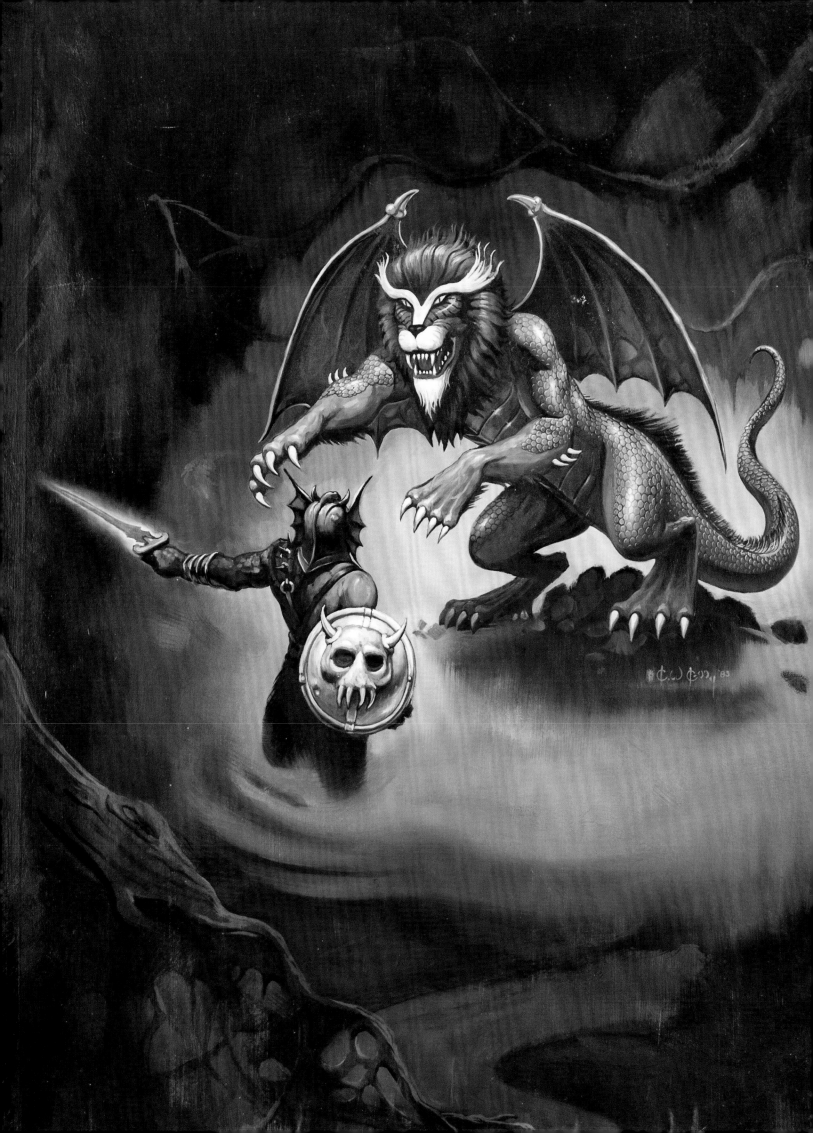

THE ANIMATED SERIES

WHEN TSR UNDERWENT CORPORATE reorganization in June 1983, Gary Gygax found himself spearheading a new venture for the ambitious publishing company—scripted entertainment. Gygax and brothers Brian and Kevin Blume had big dreams for the fledgling subsidiary known as Dungeons & Dragons Entertainment Corporation (DDEC). If Gygax could score big in Tinsel Town, any ancillary success generated would bolster the publishing arm of the company.

Go big or go home was essentially Gygax's philosophy as he settled into the former mansion of legendary Golden Age film director King Vidor in the heart of Beverly Hills to oversee the debut of *Dungeons & Dragons: The Animated Series*, a co-production of Marvel Productions and TSR, and animated by Japanese company Toei Animation. Behemoth television network CBS hosted the Saturday-morning series.

In the first episode of the series, six adolescents stepped onto a Dungeons & Dragons amusement park ride and were transported to a mystical land known only as The Realm, where they were greeted by Dungeon Master, a diminutive Yoda-like sage and physical embodiment of the tabletop game's omniscient judge. He would assign the heroic teens character classes upon arrival, along with corresponding magical equipment, and spouted fortune-cookie wisdom as he guided them through a treacherous fantasy landscape as well as life's growing pains. Hank the Ranger, Bobby the Barbarian, Presto the Magician, Sheila the Thief, Eric the Cavalier, and Diana the Acrobat (the latter two of the classes were both new, appearing mere months before the show's debut in early 1983 rules publications) formed the party of adventurers tasked with not only finding a way home, but also vanquishing evil along the way. Since these post-pubescent "players" were visitors to this otherworldly plane from a 1980s America where the role-playing game was an actual brand name, the tone was often self-aware, the narrative occasionally meta.

Venger, a cunning wizard who assumed many forms in his quest to defeat the teens and purloin their powerful artifacts, served as the show's central antagonist. Although he was new to the lexicon, numerous familiar faces from the pages of the *Monster Manual* made appearances, providing connective visual tissue, including the multi-headed dragon Tiamat and the brand's signature beast, the beholder.

Dungeons & Dragons: The Animated Series debuted on September 17, 1983, second in its time slot behind another fantasy franchise, *The Smurfs*. Similar to shows based on other juvenile fads such as Pac-Man and the Rubik's Cube, the D&D animated series exposed the game to a new, younger fan base and the

Dungeons & Dragons Entertainment Corporation's Beverly Hills headquarters and Gary Gygax's residence, alongside Gygax's business card.

DUNGEONS & DRAGONS
Entertainment Corp.

E. Gary Gygax
President

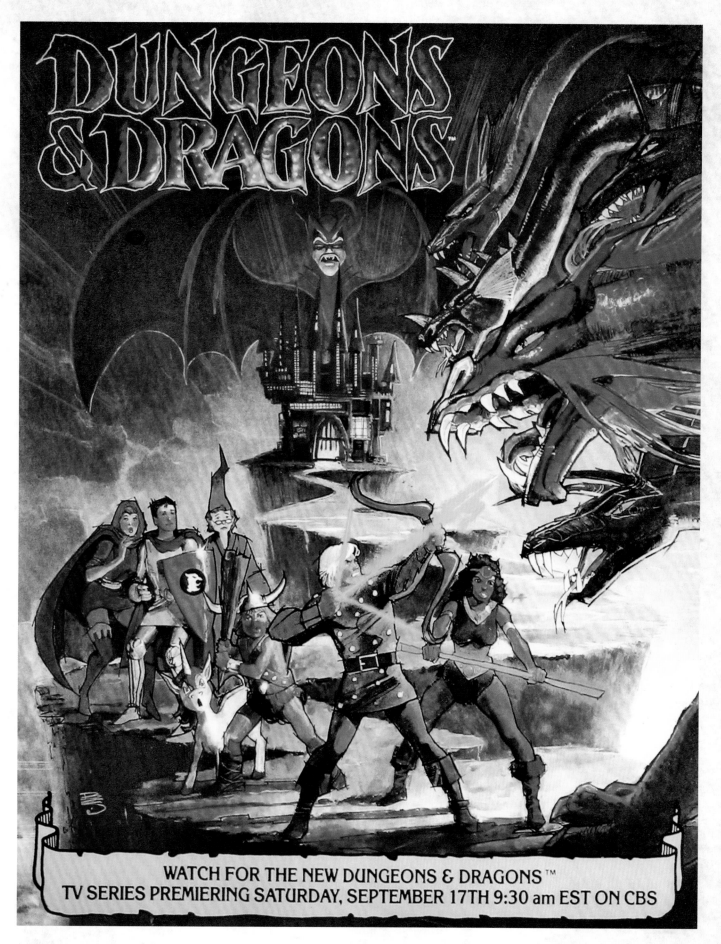

WATCH FOR THE NEW DUNGEONS & DRAGONS™
TV SERIES PREMIERING SATURDAY, SEPTEMBER 17TH 9:30 am EST ON CBS

A 1983 promotional poster by renowned
Marvel artist Bill Sienkiewicz, which may
have suggested to eager youths a far
more action-packed show than what was
eventually produced.

© Wizards of the Coast / © MARVEL

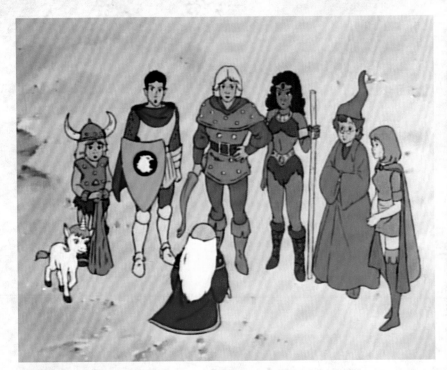

brand's largest audience yet, offering, for better or worse, the most definitive visualization of the game to the non-playing populace. It lasted twenty-seven episodes, spanning two-and-a-half seasons, before eventually being defeated by the vile beast known as "ratings" on December 7, 1985.

While the show spawned countless ancillary products, Gygax found it difficult to translate it to additional business for DDEC. Despite Hollywood's insatiable hunger for merchandisable intellectual property, the freeform role-playing game was not easily adapted to the formulaic medium of film. He was also faced with the cold reality that his revered status in the gaming community carried little weight in this foreign kingdom. He was put through the Hollywood grinder and ultimately banished to the painful plane of moviemaking known as "development hell," a place the prolific Gygax was unaccustomed to dwelling. Long before the animated show's demise, Gygax had retreated from the glitz of the Golden State, back home to Lake Geneva to face the maelstrom of a growing corporate crisis.

ABOVE "Hey look! A Dungeons & Dragons ride!" Stills from the *Dungeons & Dragons* animated series, where a group of teenage friends—Bobby, Eric, Hank, Diana, Presto, and Sheila—board a D&D rollercoaster, which magically transports them into the in-game universe called The Realm. Each character was granted a magical weapon by Dungeon Master for their trek across the supernatural terrain.

© Wizards of the Coast/© MARVEL

OPPOSITE Only *Quest for the Dungeonmaster* cover artist Keith Parkinson could possibly explain why Venger has decided to game with those he has been hunting mercilessly, or what kind of ambush Warduke and Strongheart are planning as they emerge from the bushes. Pictured here is Parkinson's original painting above the final product.

Advanced Dungeons & Dragons®	GREYHAWK® ADVENTURES	James M. Ward	TSR™	
Advanced Dungeons & Dragons®	MANUAL OF THE PLANES	by Jeff Grubb	TSR™	TSR, Inc.
Advanced Dungeons & Dragons®	DRAGONLANCE Adventures	by Hickman and Weis	TSR™	
Advanced Dungeons & Dragons®	WILDERNESS SURVIVAL GUIDE	by Kim Mohan	TSR™	TSR, Inc.
Advanced Dungeons & Dragons®	DUNGEONEER'S SURVIVAL GUIDE	by Douglas Niles	TSR	TSR Inc.
Advanced Dungeons & Dragons®	ORIENTAL ADVENTURES	Gary Gygax	TSR	TSR, Inc.
Advanced Dungeons & Dragons®	UNEARTHED ARCANA	by Gary Gygax	TSR™	TSR, Inc.
Advanced Dungeons & Dragons®	Monster Manual II	by Gary Gygax	TSR™	TSR, Inc.
Advanced Dungeons & Dragons®	LEGENDS & LORE	by James Ward with Robert Kuntz	TSR™	TSR, Inc.
Official Advanced Dungeons & Dragons®	DUNGEON MASTERS GUIDE	by Gary Gygax	TSR™	TSR, Inc.
Advanced Dungeons & Dragons®	PLAYERS HANDBOOK	by E. Gary Gygax	TSR™	TSR Hobbies, Inc.
Advanced Dungeons & Dragons®	MONSTER MANUAL	by Gary Gygax	TSR™	TSR, Inc.

ABOVE In 1983, TSR commenced production on a series of AD&D hardcovers informally known as the "orange spine books." Starting with the *Monster Manual II*, and followed by revisions and re-releases of the AD&D core books, this set of twelve books from 1983 to 1987 is often viewed as the zenith of D&D swords-and-sorcery art in its quality and composition—all completed by staff artist Jeff Easley.

LEFT Larry's Elmore's boxed-set cover painting features a high-fantasy artistic style that would flourish with the release of the concurrent Dragonlance series.

OPPOSITE Jeff Easley's original cover painting to the 1983 *Monster Manual II* along with the product cover.

WHEN D&D REACHED ITS tenth anniversary in 1984, TSR was on the financial ropes, but the average consumer would never know it. The company was downsizing under financial pressures, but it continued to produce new, innovative, and best-selling products such as the newly released *Companion Set*. That same year, D&D would redefine how a campaign setting could be organized and sold with the debut of the Dragonlance series of novels and adventure modules. But despite a steady stream of ostensibly successful products, and its best efforts to make the product more appealing to Middle America, the company could no longer find a way to make a profit.

COLOR
ROUGH
"DRAGONLANCE"

DRAGONLANCE

NEWCOMERS TO DUNGEONS & DRAGONS might sit down to their first game with two reasonable expectations: that it would include both dungeons and dragons. But how many early modules or campaigns pitted players against dragons—and among those few unlucky adventurers, who would live to tell the tale? Dragons were great for book and box covers; in games they were impractical. There simply wasn't a playable D&D framework for including dragons as a regular feature.

In 1982, dragons were on the mind of newly hired TSR staffer Tracy Hickman, a veteran D&D module designer who had recently conceived of a world where dragons dominated. The Salt Lake City native developed the dragon-world idea into a concept for a series of a dozen modules, which he called the Dragonlance Chronicles. But he immediately saw more to it than just packaged adventures: it would include books, calendars, wargames, miniatures, and even a novelization of the series, augmented by short stories in *Dragon* magazine.

In this epic transmedia campaign, an eclectic group of adventurers would pursue powerful artifacts and use them to eliminate a mythical and ancient evil: dragons. When playing a module, players would have the option of playing a pre-generated character from a stable of adventurers called the "Heroes of the Lance," each representing a different class and thematic concept. TSR management liked the idea, but wanted to see more. Development manager Harold Johnson and Hickman approached staff artist Larry Elmore, who was, according to Hickman, "So excited by the concept that he went home and in one weekend— on his own time—produced the four original Dragonlance paintings portraying the major characters and events."

Elmore's paintings were met with enthusiasm from TSR brass, and the project was not only approved, but expanded. Hickman was now tasked with guiding a team of designers to develop his concept for the first trilogy of modules in this radical new multimedia venture. It was the most complex rollout that TSR had ever undertaken for a single campaign—a risky but potentially lucrative endeavor.

Under the guidance of Hickman and Johnson, with help from designers such as Jeff Grubb and Doug Niles, a world called Krynn would soon take shape. It was a world of opposing polarities, where natural-born enemies were tasked with working together to maintain cosmic balance and avoid total destruction. The concepts of good, neutral, and evil were represented in the gods, the races, and even the main characters, who fans would read about and play. During long and heated ideation sessions, new races, such as the lovable halfling-like kender and the dragon-man abominations known as draconians, were added to further support the world's foundational themes. All the while, the world of Krynn began to find substance on the brushes of TSR's art department.

While Dragonlance was on the developmental fast track, TSR still needed to identify an author for the novels—and they discovered the talent they needed already within their walls. Hickman conscripted in-house editor Margaret Weis, a recent transplant from Missouri and single mother of two, who had been working on TSR's *Endless Quest* books, the Choose Your Own Adventure–style gamebooks that had been their only real book-trade publishing franchise to date.

In March 1984, TSR released its first Dragonlance product, module DL1: *Dragons of Despair*. Three additional modules followed in the coming months, accompanied by the first Dragonlance calendar, illustrated by Keith Parkinson, Clyde Caldwell, Jeff Easley, and, of course, Larry Elmore.

In November, TSR's first novel, *Dragons of Autumn Twilight*, hit bookstore shelves through its distribution deal with Random House. The combined impact of TSR's multipronged marketing approach evidently worked—*Dragons of Autumn Twilight* was a best seller by January of 1985, one that served as a new way to introduce and acclimate fans to Dungeons & Dragons.

Larry Elmore's 1984 concept art for Dragonlance, showing the brothers Caramon and Raistlin.

OPPOSITE Larry Elmore's acetate
sketch alongside his conceptual
"cover rough" (above), featuring
signature Dragonlance characters.

STEEL-GRAY BLUE

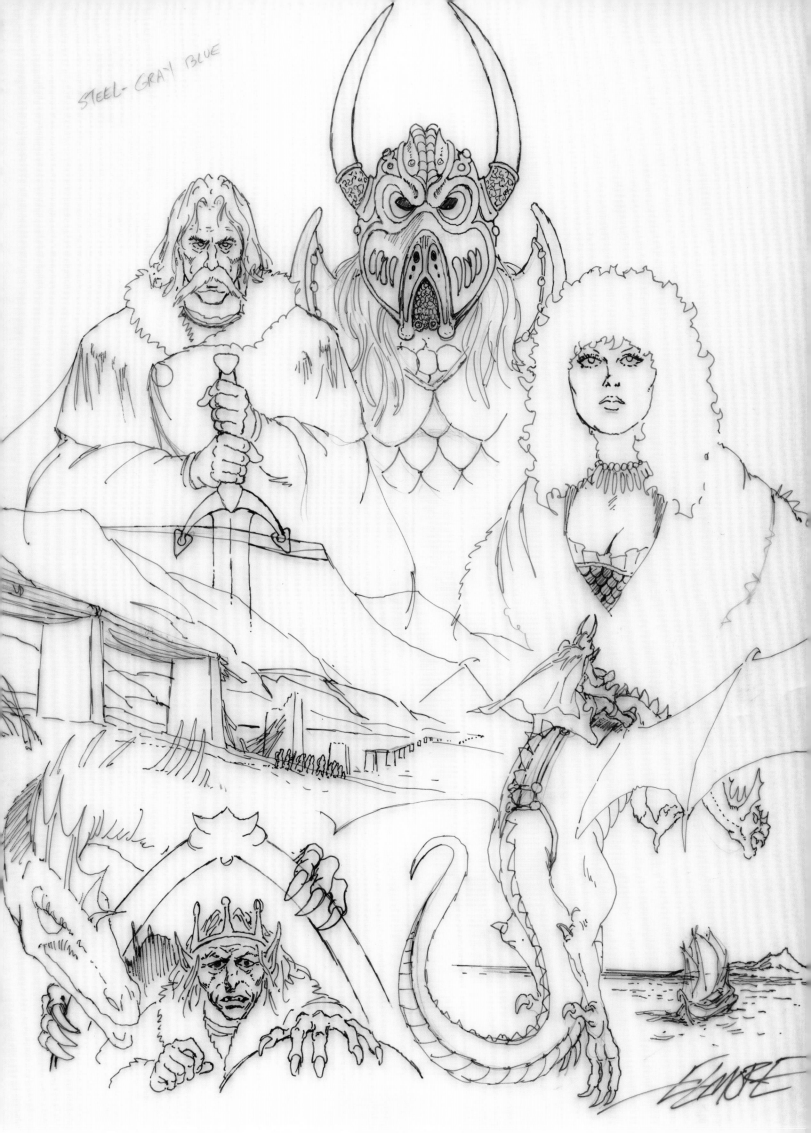

```
 1                               THE
 2                         DRAGONLANCE CHRONICLES
 3            Tracy Raye Hickman / Design Submitter  : July 13th, 1982
 4      Description                                        LINE NUMBERS
 5      **************************************************************
 6      Overview ---------------------------------------- <+> 100  /  185
 7      BOOK I: SANCTION -- : (1) Dragons of Darkness--- <+> 1000 / 1157
 8                            (2) Dragons of Flame  ----- <+> 1200 / 1253
 9                            (3) Dragons of Hope  ------ <+> 1300 / 1357
10
11      BOOK II: VOLITION - : (1) Dragons of Ice  ------- <+> 2000 / 2157
12                            (2) Dragons of Desolation <+> 2200 / 2256
13                            (3) Dragons of Faith  ----- <+> 2300 / 2353
14
15      BOOK III: STONEHOLD : (1) Dragons of Light  ----- <+> 3000 / 3157
16                            (2) Dragons of Thunder  --- < > 3200 /  XXX
17                            (3) Dragons of the Sky  --- < > 3300 /  XXX
18
19      BOOK IV: CYTADEL  - : (1) Dragons of Power  ----- < > 4000 /  XXX
20                            (2) Dragons of the Sun  --- < > 4200 /  XXX
21                            (3) Dragons of Doom  ------ < > 4300 /  XXX
22
23      ADDITIONAL PROPOSALS:
24          The Dragonlance Iconograph ----------------- <+> 1212 / 1268
25          Dragonlords -------------------------------- <+> 1268 / 1322
26          Calendar ----------------------------------- <+> 1323 / 1363
27          Dragonseige -------------------------------- <+> 1364 / 1406
28          Novelization ------------------------------- < > XXX  /  XXX
29          Miniatures --------------------------------- < > XXX  /  XXX
30          Abstract Card Game ------------------------- < > XXX  /  XXX
31          Coloring Book ------------------------------ < > XXX  /  XXX
32          DRAGON(tm) Short Stories ------------------- < > XXX  /  XXX
33
34
35
36
37
38
39
40
41
42
43
```

This is page 1 of 20 pages

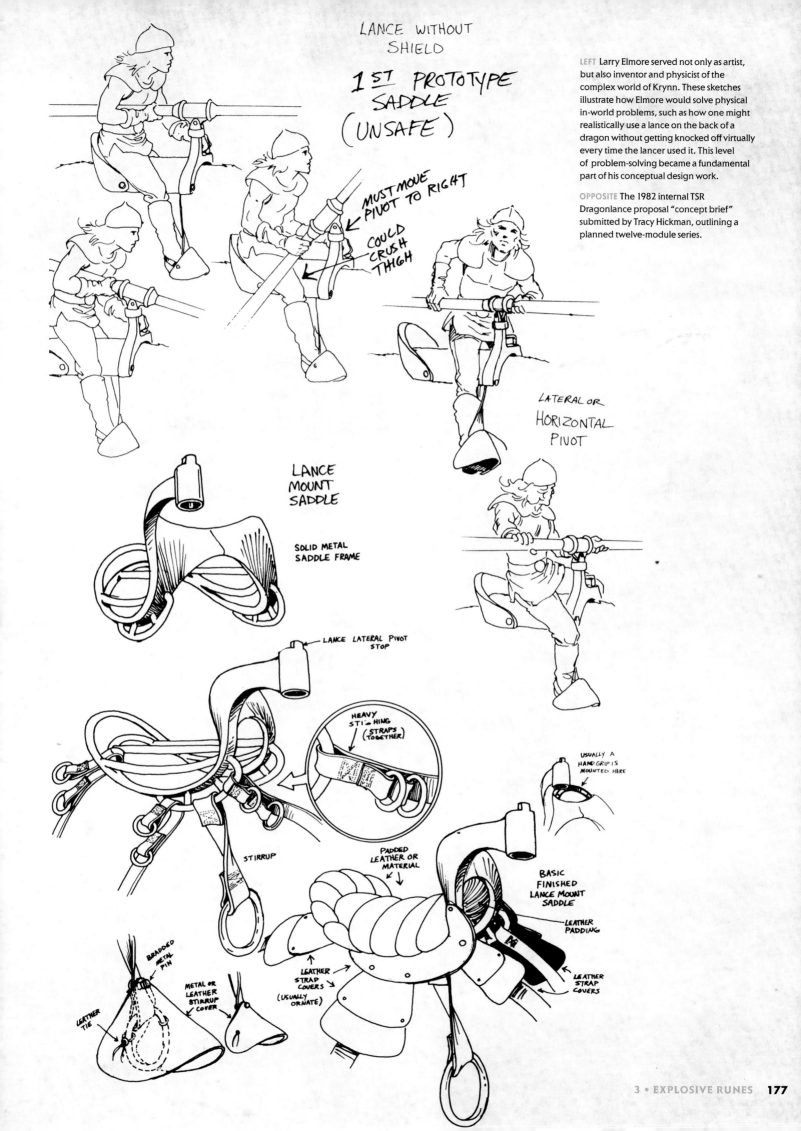

LANCE WITHOUT SHIELD

1ST PROTOTYPE SADDLE (UNSAFE)

MUST MOVE PIVOT TO RIGHT

COULD CRUSH THIGH

LATERAL OR HORIZONTAL PIVOT

LEFT Larry Elmore served not only as artist, but also inventor and physicist of the complex world of Krynn. These sketches illustrate how Elmore would solve physical in-world problems, such as how one might realistically use a lance on the back of a dragon without getting knocked off virtually every time the lancer used it. This level of problem-solving became a fundamental part of his conceptual design work.

OPPOSITE The 1982 internal TSR Dragonlance proposal "concept brief" submitted by Tracy Hickman, outlining a planned twelve-module series.

LANCE MOUNT SADDLE

SOLID METAL SADDLE FRAME

LANCE LATERAL PIVOT STOP

HEAVY STITCHING STRAPS (TOGETHER)

USUALLY A HAND GRIP IS MOUNTED HERE

STIRRUP

PADDED LEATHER OR MATERIAL

BASIC FINISHED LANCE MOUNT SADDLE

LEATHER PADDING

BRAIDED METAL PIN

METAL OR LEATHER STIRRUP COVER

LEATHER STRAP COVERS (USUALLY ORNATE)

LEATHER TIE

LEATHER STRAP COVERS

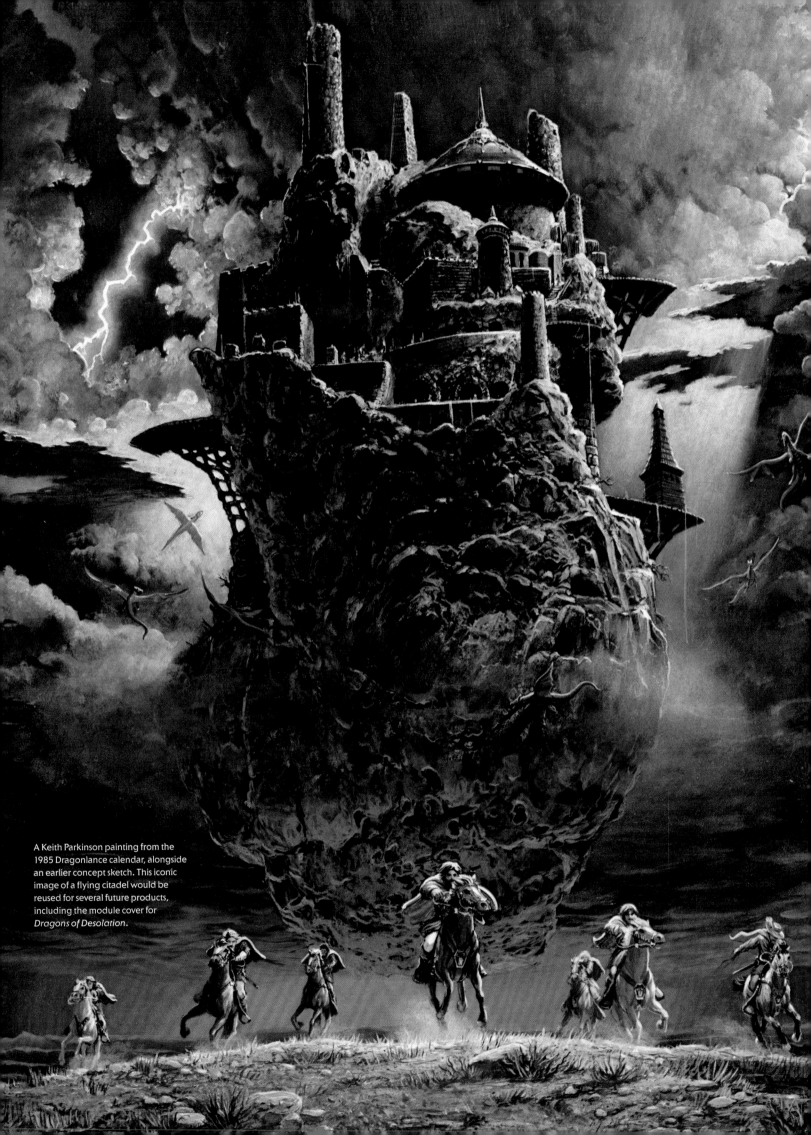

A Keith Parkinson painting from the
1985 Dragonlance calendar, alongside
an earlier concept sketch. This iconic
image of a flying citadel would be
reused for several future products,
including the module cover for
Dragons of Desolation.

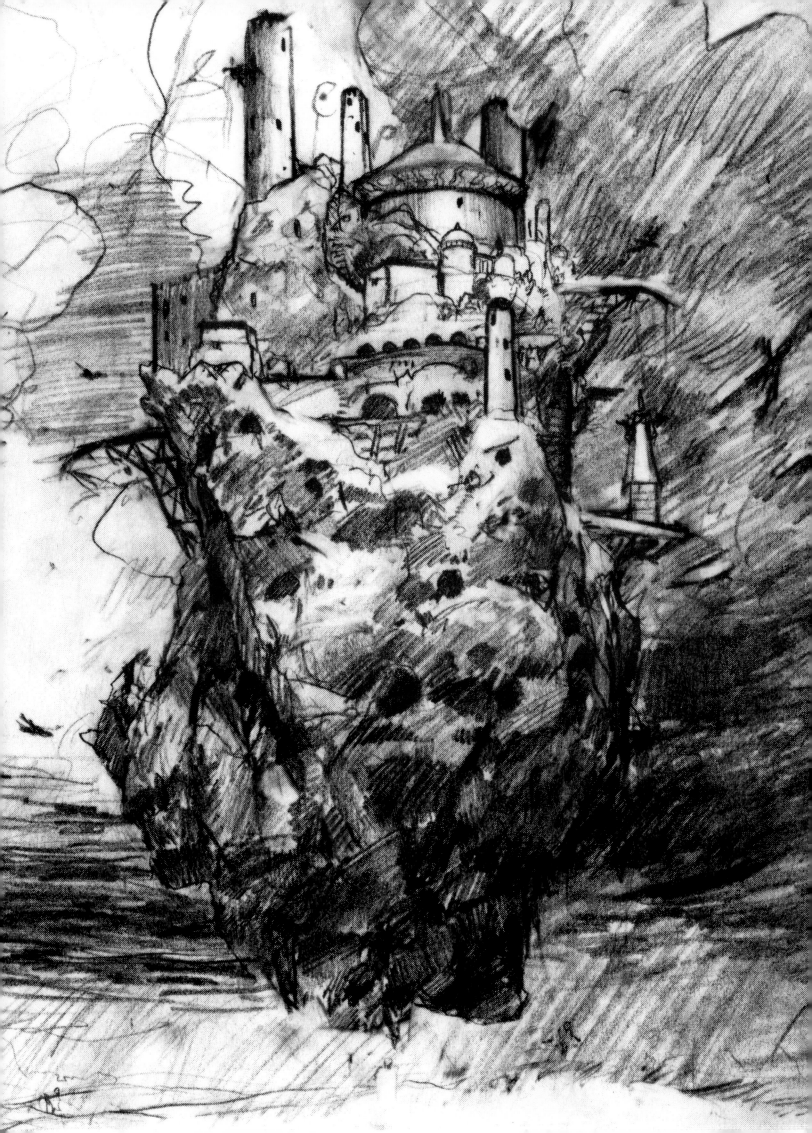

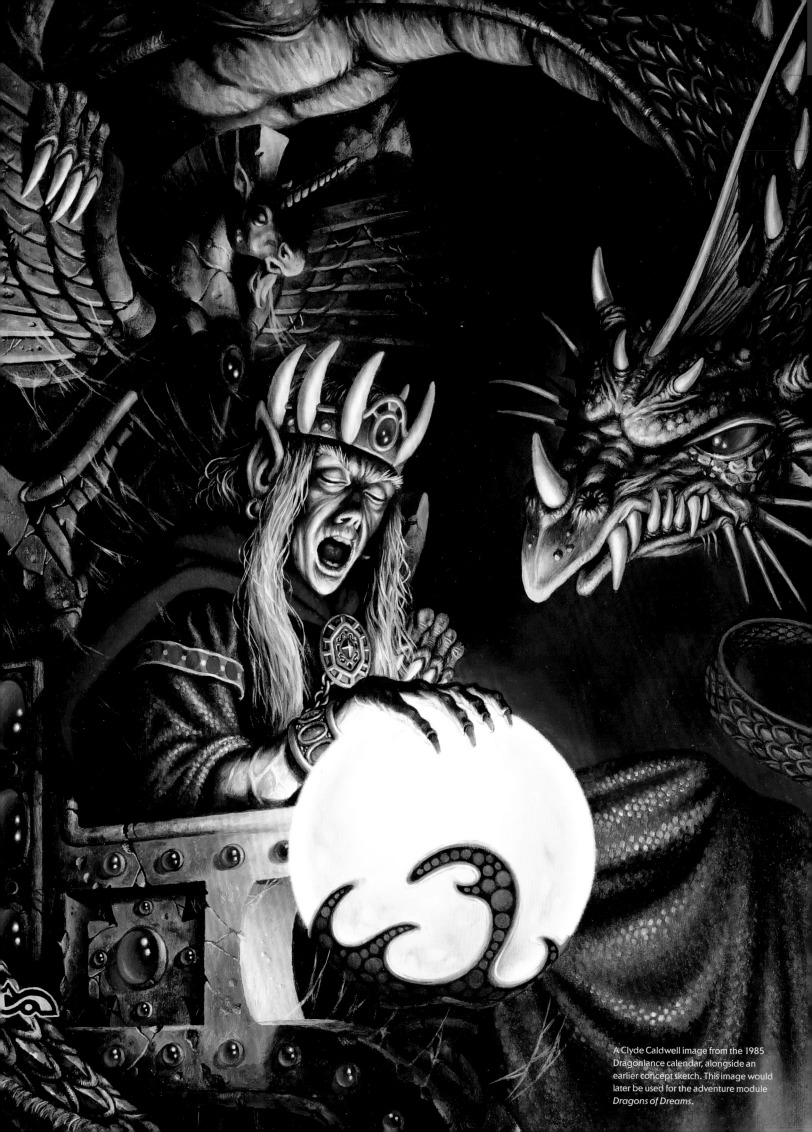

A Clyde Caldwell image from the 1985
Dragonlance calendar, alongside an
earlier concept sketch. This image would
later be used for the adventure module
Dragons of Dreams.

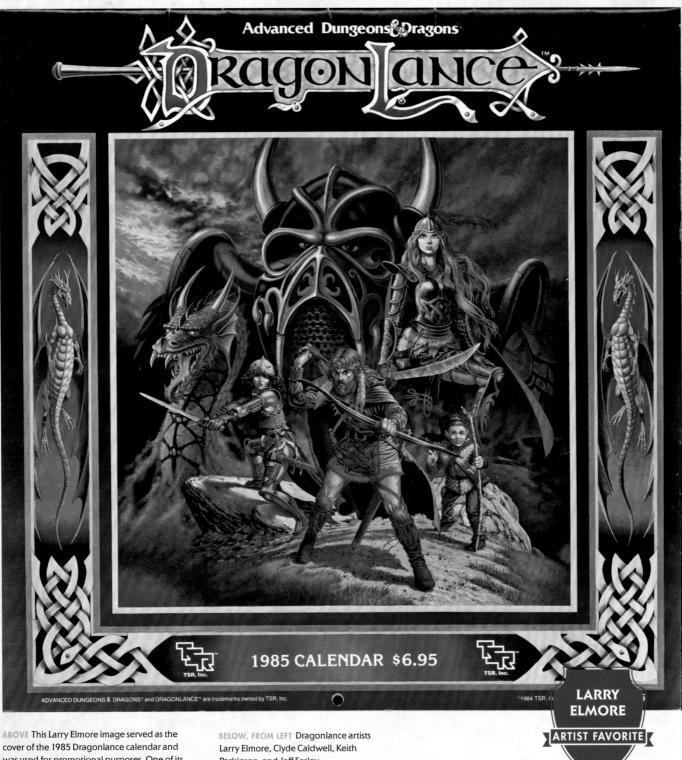

Advanced Dungeons & Dragons
DragonLance™

1985 CALENDAR $6.95

ADVANCED DUNGEONS & DRAGONS® and DRAGONLANCE™ are trademarks owned by TSR, Inc.

®1984 TSR, Inc.

LARRY ELMORE
ARTIST FAVORITE

ABOVE This Larry Elmore image served as the cover of the 1985 Dragonlance calendar and was used for promotional purposes. One of its most impressive features is that its Celtic-style border and the Dragonlance logo are part of the original painting and not applied later.

BELOW, FROM LEFT Dragonlance artists Larry Elmore, Clyde Caldwell, Keith Parkinson, and Jeff Easley.

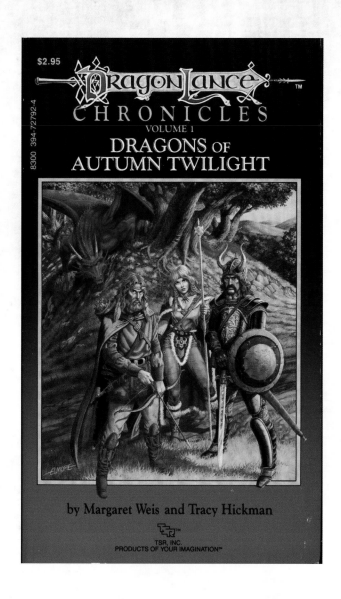

A steady stream of Dragonlance products followed soon thereafter: modules that eventually totaled sixteen, a new art calendar every year, a campaign sourcebook, dozens of ancillary products, and, of course, more novels, including *Dragons of Winter Night* and *Dragons of Spring Dawning* in 1985, rounding out the original Chronicles trilogy. Just as D&D art was instructional and helped orient new players, the Dragonlance novels introduced prospective players to the mechanics of the D&D universe.

The success of Dragonlance's pioneering multimedia approach redefined the way TSR thought about its gaming properties. A world that you could read about one day and play the next seemed to create a new level of player loyalty and engagement. Soon a second trilogy was developed with the team of Weis and Hickman, the Legends trilogy. By 1987, Dragonlance novels had sold more than two million copies, pulling in more than a half million module sales as well.

It wasn't only its marketing approach that made the Dragonlance franchise unique; the modules themselves broke new ground by letting players take over the iconic characters from the novels. You could become the incorruptible elf warrior Caramon, the conflicted half-elf Tanis, the mysterious and sinister sorcerer Raistlin, the pure-elf maiden Laurana, or the black-hearted dragon-lord Kitiara. Even ancillary characters like the menacing death knight Lord Soth would engender a fan base all their own.

Dragonlance has proven to be one of the most beloved and enduring of all D&D campaigns. Perhaps most important, it truly put the "dragons" into Dungeons & Dragons. To date, nearly two hundred novels have used the Dragonlance setting; dozens of modules and ancillary products have followed suit. Even a feature-length animated film starring Kiefer Sutherland and Lucy Lawless found its way to video in 2008. And while the dragons of Krynn have been sleeping as of late, with such a storied franchise, it seems only a matter of time before they awake.

TOP The best-selling 1984 Dragonlance novel, *Dragons of Autumn Twilight*.

LEFT The first twelve Dragonlance adventure modules, released between 1984 and 1986.

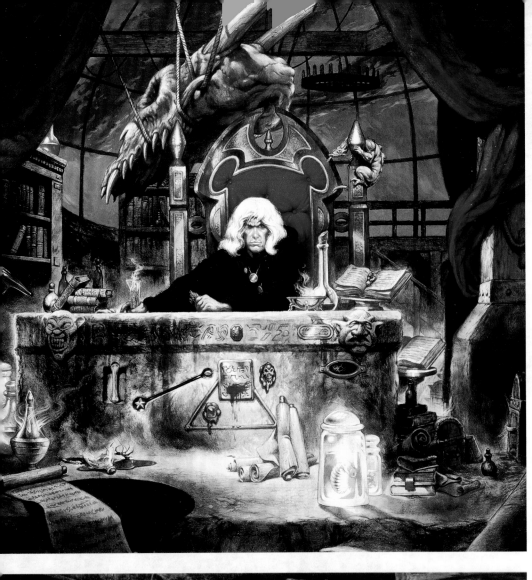
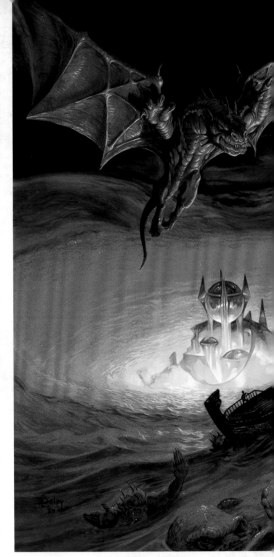
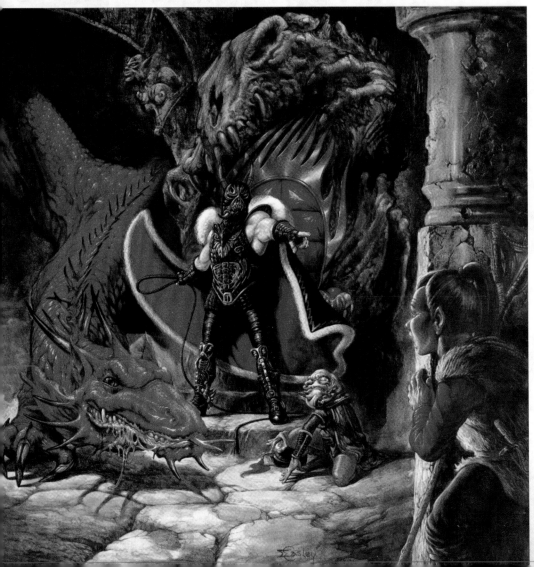
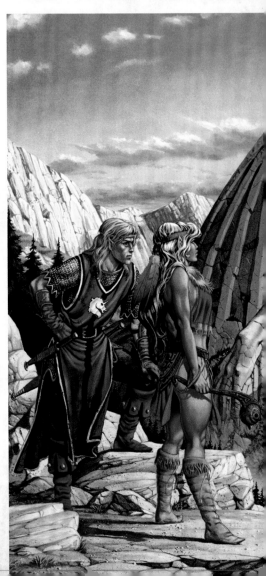

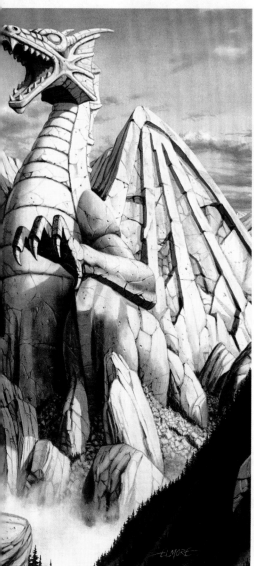

DragonLance

CHARACTER CARDS

CUT OUT CARDS

- -

TANIS *7TH LEVEL HALF-ELF FIGHTER*

STR 16 WIS 13 CON 12 THACO 14
INT 12 DEX 16 CHR 15 AL NG HP 55

AC 4 (*LEATHER ARMOR* +2, DEX BONUS)

WEAPONS *Longsword* +2 (1-8/1-12)
LONGBOW, QUIVER WITH 20 ARROWS (1-6/1-6)
DAGGERS (1-4/1-3)

EQUIPMENT AS SELECTED BY PLAYER;
500 STL/1000 GPW MAXIMUM.

LANGUAGES COMMON, QUALINESTI ELF,
HILL DWARF, PLAINSMAN

See back of card for more information.

- -

GOLDMOON *7TH LEVEL HUMAN CLERIC*

STR 12 WIS 16 CON 12 THACO 16
INT 12 DEX 14 CHR 14 AL LG HP 29

AC 8 (LEATHER ARMOR)

WEAPONS SLING +1 AND 20 BULLETS (2-5/2-7)

EQUIPMENT *MEDALLION OF FAITH*
AS SELECTED BY PLAYER; 500 STL/1000 GPW
MAXIMUM

ABILITIES Spell Use: 5 1ST LEVEL, 5 2ND LEVEL, 2
3RD LEVEL, 1 4TH LEVEL
LANGUAGES: COMMON, PLAINSMAN, HILL DWARF,
QUALINESTI ELF

See back of card for more information.

- -

CARAMON *8TH LEVEL HUMAN FIGHTER*

STR 18/63 WIS 10 CON 17 THACO 14
INT 12 DEX 11 CHR 15 AL LG HP 52

AC 6 (RING MAIL ARMOR AND SMALL SHIELD)

WEAPONS Longsword (1-8/1-12)
SPEAR (1-6/1-6)
DAGGER (1-4/1-3)

EQUIPMENT AS SELECTED BY PLAYER;
500 STL/1000 GPW MAXIMUM

LANGUAGES COMMON, PLAINSMAN

See back of card for more information.

- -

RIVERWIND *7TH LEVEL HUMAN RANGER*

STR 18/35 WIS 14 CON 13 THACO 14
INT 13 DEX 16 CHR 13 AL LG HP 42

AC 5 (LEATHER ARMOR AND SMALL SHIELD, DEX
BONUS)

WEAPONS *Longsword* +2 (1-8/1-12)
SHORT BOW, QUIVER OF 20 ARROWS (1-6/1-6)
DAGGER (1-4/1-3)

EQUIPMENT AS SELECTED BY PLAYER, 500 STL/
1000 GPW MAXIMUM

LANGUAGES COMMON, PLAINSMAN,
QUALINESTI ELF, HILL DWARF

See back of card for more information.

- -

RAISTLIN *5TH LEVEL HUMAN MAGIC-USER*

STR 10 WIS 14 CON 10 THACO 20
INT 17 DEX 16 CHR 10 AL N HP 15

AC 5 (*STAFF OF MAGIUS*, DEX BONUS)

EQUIPMENT *STAFF OF MAGIUS* (+3 PROTECTION,
+2 TO HIT, DAMAGE 1-8, CAN CAST *CONTINUAL
LIGHT* AND *FEATHER FALL* ONCE PER DAY.) AS
SELECTED BY PLAYER, 500 STL/1,000 GPW MAXI-
MUM.

ABILITIES Languages: COMMON, QUALINESTI ELF,
MAGIUS
Spell Use: 4 1ST LEVEL, 2 2ND LEVEL, 1 3RD LEVEL
PER DAY.

See back of card for more information.

- -

FLINT FIREFORGE *6TH LEVEL DWARF FIGHTER*

STR 16 WIS 12 CON 18 THACO 16
INT 7 DEX 10 CHR 13 AL NG HP 60

AC 6 (STUDDED LEATHER ARMOR AND SMALL
SHIELD)

WEAPONS 2 HAND AXES +1 (1-6/1-4)
DAGGER (1-4/1-3)

EQUIPMENT AS SELECTED BY PLAYER;
500 STL/100 GPW MAXIMUM

LANGUAGES COMMON, HILL DWARF

See back of card for more information.

- -

STURM BRIGHTBLADE *8TH LEVEL HUMAN FIGHTER*

STR 17 WIS 11 CON 16 THACO 14
INT 14 DEX 12 CHR 12 AL LG HP 47

AC 5 (CHAIN MAIL)

WEAPONS *Two-handed sword* +3 (1-10/3-18)
DAGGER (1-4/1-3)

EQUIPMENT AS SELECTED BY PLAYER; 500 STL/
1000 GPW MAXIMUM

LANGUAGES COMMON, QUALINESTI ELF,
SOLAMNIC

See back of card for more information.

- -

TASSLEHOFF BURRFOOT *6TH LEVEL KENDER*
(HALFLING) THIEF

STR 13 WIS 12 CON 14 THACO 19
INT 9 DEX 16 CHR 11 AL N HP 24

AC 5 (LEATHER ARMOR, DEX BONUS)

WEAPONS HOOPAK: TREAT AS COMBINATION
BULLET SLING (2-5/2-7) AND +2 JO STICK (1-6/1-4)
DAGGER (1-4/1-3)

EQUIPMENT THIEVES' TOOLS, LEATHER MAP CASE
AS SELECTED BY PLAYER, 500 STL/1000 GPW
MAXIMUM

See back of card for more information.

ABOVE Pre-generated character sheets from the 1984 module DL3: *Dragons of Hope* featuring heroes from the novels. Economy was key to these pre-developed characters, paired with a core rule system that was sparse enough to fit eight simplified characters on a single sheet.

OPPOSITE Clockwise (from top left) Raistlin depicted in the Tower of High Sorcery by Jeff Easley; Easley's painting that would adorn the adventure module *Dragons of Faith*; Larry Elmore's painting that would serve as the cover for *Dragons of Light*; the cover painting for *Dragons of Flame* by Jeff Easley.

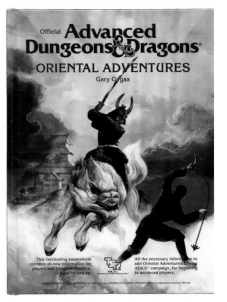

FEVER PITCH

At the end of 1984, corporate struggles had reached their boiling point. Despite numerous rounds of acrimonious layoffs, the company's balance sheet remained off-kilter, leading to the board's ouster of TSR president Kevin Blume. Waning sales of D&D paired with the company's overexpansion led to an even bigger loss than the year before, despite overall revenues that had increased to nearly $30 million. Worse still, the company had become mired in debt, creating new challenges when it came to freeing up enough cash flow to produce new products. D&D products had now sold perhaps eight million copies, but their future was in serious doubt.

In March of 1985, Gary Gygax exercised a stock option and took control of TSR. With few resources and a desperate need to market new products, the company took advantage of a wealth of untapped gaming material that had previously appeared only in *Dragon* magazine. This became the basis for the next AD&D hardcover, *Unearthed Arcana*, released that summer.

And TSR had other reasons for optimism. Gen Con, the company's longstanding gaming convention, then in its eighteenth year, had continued to grow so much that it had moved out of the modest spaces available in rural Wisconsin and into the Milwaukee Exposition Center. Unfortunately, optimism and public sentiment don't pay the bills, and TSR remained on a collision course with insolvency: for the first time in its history, the company was on route to decreased overall revenues and a net loss of nearly $4 million, five times the amount the year prior.

A wave of other fresh products followed including D&D's first campaign foray into Asian settings with its feudal Japan-inspired *Oriental Adventures*, a book that expanded D&D's use of non-weapon proficiencies; the long promised "mega-module" sequel to the popular *Village of Hommlet* called *The Temple of Elemental Evil*; and a new boxed set for high-level characters called the *Master Rules*, also known as the "black box," developed by Frank Mentzer.

Not only was the franchise losing money, but rumors of suicide and Satan worship hung like a black cloud over the game, pervading all parts of its public image. No longer was all press good press for a company that depended more and more on sales from school-aged children and teens. While TSR continued to pursue a softening of the brand, which included the reissuing and rebranding of products that were considered particularly occult—like it had done with *Deities & Demigods* becoming *Legends & Lore* the year before—it couldn't seem to do enough to purify its image. It didn't help that Gygax himself refused to stay on message; in the pages of *Dragon* he called the *Legends & Lore* change "a sop, or bowing to pressure from those who don't buy our products anyway." The continuous and unrelenting attacks from D&D's opponents finally culminated in the game's highest profile spot yet: a feature on CBS's *60 Minutes*. The game was clearly framed as the villain at the hands of BADD's Patricia Pulling and *60 Minutes* host Ed Bradley.

As for the company's leader, Gary Gygax, his problems didn't end with corporate debt and public controversies. He continued to tussle with TSR board members and the disenfranchised Blume brothers, who were still large stockholders, even as he tried to bring the company back to health by introducing new investors and executive leadership, such as newspaper heiress Lorraine Dille Williams. Things came to a head in October 1985: Gygax was ousted by the board of directors in a hostile takeover, which left his recent hire and former ally, Williams, in charge of TSR. Due to the company's dire financial situation, it only cost Williams around a half million dollars to acquire controlling interest. Gygax was devastated and made a desperate legal challenge to the stock transfer, but he lost the case, and with it, Dungeons & Dragons. He wrote an impassioned farewell that appeared in *Dragon* magazine in 1986, and went on to pursue other ventures in the gaming industry, but none that could take the place of D&D.

Now, separated from its creator, D&D's future belonged squarely to a second generation of designers, who would be tasked with taking the game in new directions. Would the game survive all of the turmoil? Only time would tell.

"The shape and direction of the
Dungeons & Dragons game system . . .
or that of the AD&D system, are now
entirely in the hands of others."

—GARY GYGAX, *DRAGON* #122

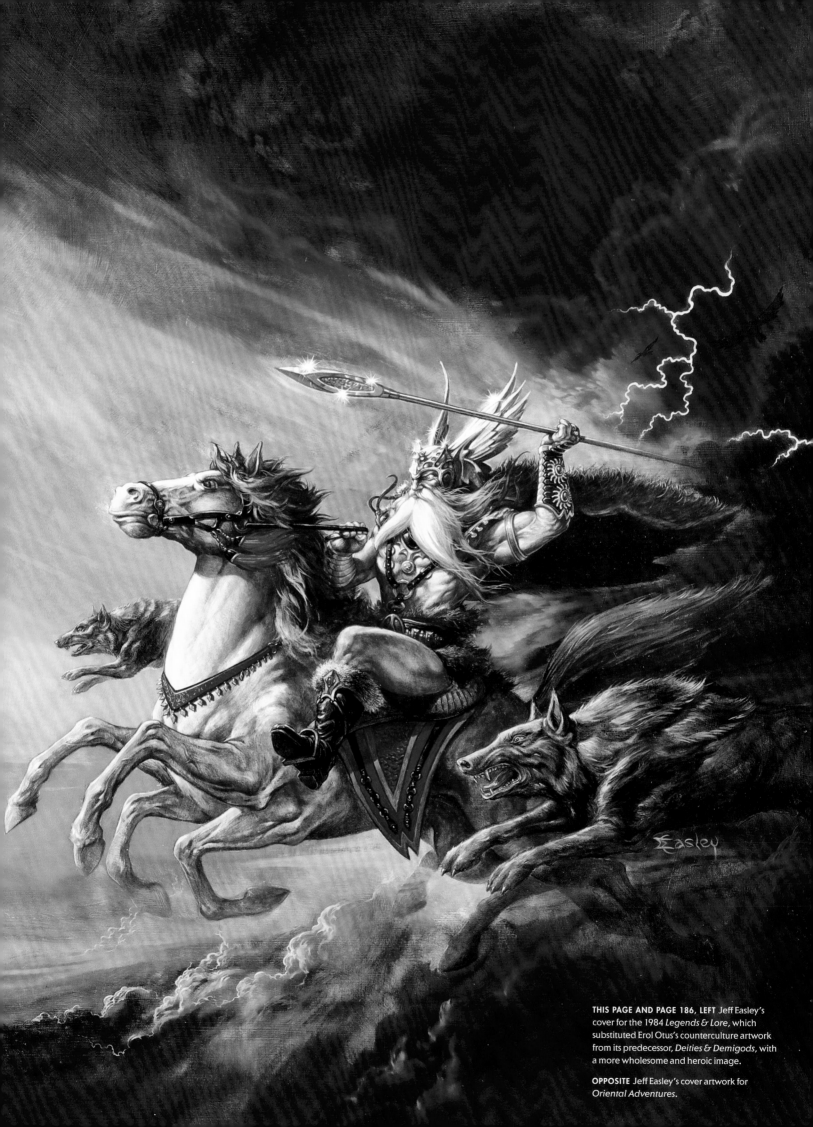

INTO THE FIRE — The legacy of a lost prince
THE DARK TOWER OF CABILAR — A deadly search for a crown
GRAKHIRT'S LAIR — At war with the norkers

Dungeon™

ADVENTURES FOR TSR® ROLE-PLAYING GAMES

ISSUE NO. 1 $3.75

0-88038-383-6

09

0 46363 19545 8

PARKINSON

NEW BEGINNINGS

While TSR entered 1986 embroiled in turmoil, the company was well positioned to recover under new leadership. It would no longer enjoy a growth market in the role-playing game space, but it was a stable and eminently viable climate. TSR had eliminated much of its costly overhead and had recently released a number of strong-performing products, most notably the best-selling Dragonlance novels. Despite the company's heavy debt load, its recent successes would allow for the development of a small but impactful series of products that would bring stability back to the brand. In an effort to engage the core D&D community with a steady dose of prepackaged adventures, TSR introduced the bi-monthly *Dungeon* magazine, which allowed *Dragon* magazine to focus more on the company's other gaming properties as well as fantasy fiction. On the gaming side, Gary Gygax's trusted lieutenant, Frank Mentzer, finally completed his five-part revision and expansion to the *Basic* game with his *Immortals Rules*.

Other strong-performing products rounded out the mix of D&D supplements, such as the *Dungeoneer's Survival Guide* and the *Wilderness Survival Guide*, which continued the trend toward character customization by introducing new non-weapon proficiencies. They even went back to D&D co-creator Dave Arneson and began publishing modules based on his campaign world, beginning with *Adventures in Blackmoor*. On the other side of all of the trials and tribulations over the last three years, D&D was finally on the mend.

As TSR continued to stabilize, new products and initiatives emerged from the design department that would fast-track D&D's journey back to health, like the new hardcover supplement called the *Manual of the Planes*. Meanwhile, a select team of designers had quietly begun to mull over ways to simplify the rules and create more campaign options. Most impactful to the D&D brand, though, was the release of the Forgotten Realms campaign setting.

Forgotten Realms would become one of the game's most popular settings. The inspiration for dozens of modules, novels, and computer games, the Forgotten Realms setting is surely the most famous example of cross-platform appeal. Lorraine Williams came from a background in managing media properties, and it is unsurprising that she drove TSR to develop campaign settings that could be aggressively marketed and licensed as tabletop game products, novelizations, computer games, and comic books.

THE TEMPLE OF ELEMENTAL EVIL

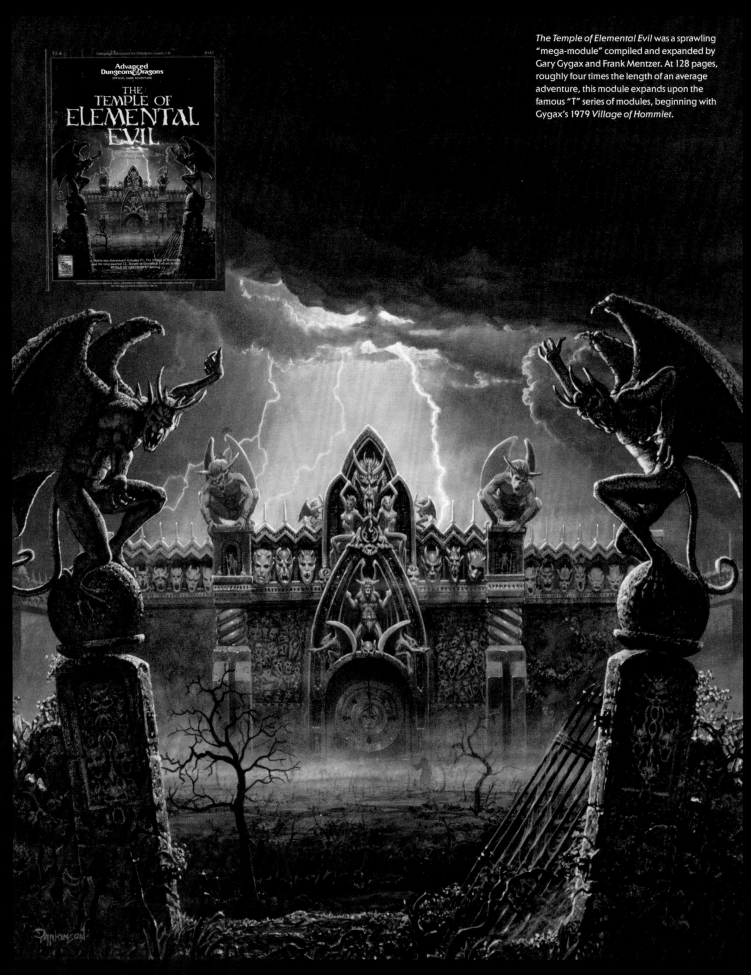

The Temple of Elemental Evil was a sprawling "mega-module" compiled and expanded by Gary Gygax and Frank Mentzer. At 128 pages, roughly four times the length of an average adventure, this module expands upon the famous "T" series of modules, beginning with Gygax's 1979 Village of Hommlet.

"A sinister force, long thought destroyed, stirs from the black hole that spawned it. Like an ebony darkness it prowls the land and safety is but an illusion, for it watches from every shadow and ponders possibilities.

"What began years ago with the introduction of the players to the quiet village of Hommlet and the amazing lands of Greyhawk, at last is complete. Here is the long awaited campaign adventure featuring the ruins of the Temple of Elemental Evil. Evil broods and grows beneath those blasted stones. This is your chance to drive it back and scatter its forces again."

— *THE TEMPLE OF ELEMENTAL EVIL, 1985*

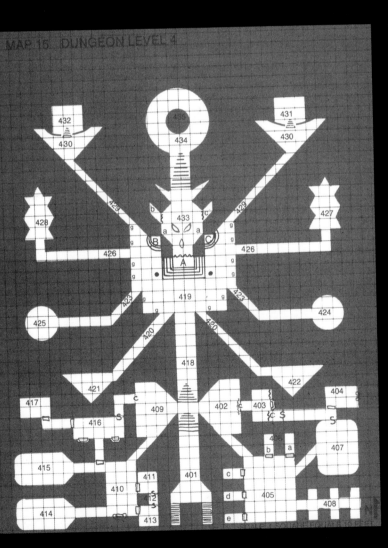

TO VERBOBONC

PASTURE

MILLER

TRADER

FAIR GROUNDS

PASTURE

PASTURE

FARMER

BARN

HERDSMAN

FARMER

FARMER

WEAVER

VILLAGE ELDER

TO NYR DYV +
TO TEMPLE

BLACK-SMITH

FARMER

WHEEL + WAIN RIGHT

INN OF THE
WELCOME WENCH

HERDS-MAN

BARN

WOODCUTTER

LEATHER WORKER

FARMER

SHRINE

VILLAGE PRIEST

FIELDS

BARN

FARMER

FIELDS

HOMLETT

FARMER

Gary Gygax's original 1976 hand-drawn
map of the legendary Village of Hommlet,
alongside his preliminary sketch of
the environs of the dreaded Temple
of Elemental Evil, both drafted by
the D&D co-creator years before they
were formally published.

WOODS

WOODS

OUT BLDGS

RUINS

T.D. DOWN

REFACTORY

BARRACKS

TEMPLE

STABLES

MAGICALLY
BARRED
GATE

MARSH

WOODS

TO HOMLETT

CHURCH

FIELDS

20

14 TEAMSTER

CHEESE

21 FARMER

FARMER

23

HERDSMAN

19

TRADER

13

MILLER

22

CABINET MAKER 16
& LIMNER

15

BARN

PASTURE

THE
OF

17

JEWELS
& MONEY
CHANGER

POTTER

PASTURE

12 FARMER

FARMER

BREWER

18

TAILOR

11

WEAVER

VILLAGE
ELDER

10

9

VILLAGE HALL

27

7

INN

OF THE

WELCOME

WENCH

BLACKSMITH

8

26

CARPENTER

WHEEL &

HERDSMAN

WAINWRIGHT

28

25 BARN

5

6

24

LEATHER

WORKER

WOODCUTTER

3

FARMER

DRUID

BARN

BARN

FIELDS

FARMER

FARMER

4

FARMER

2

1

FIELDS

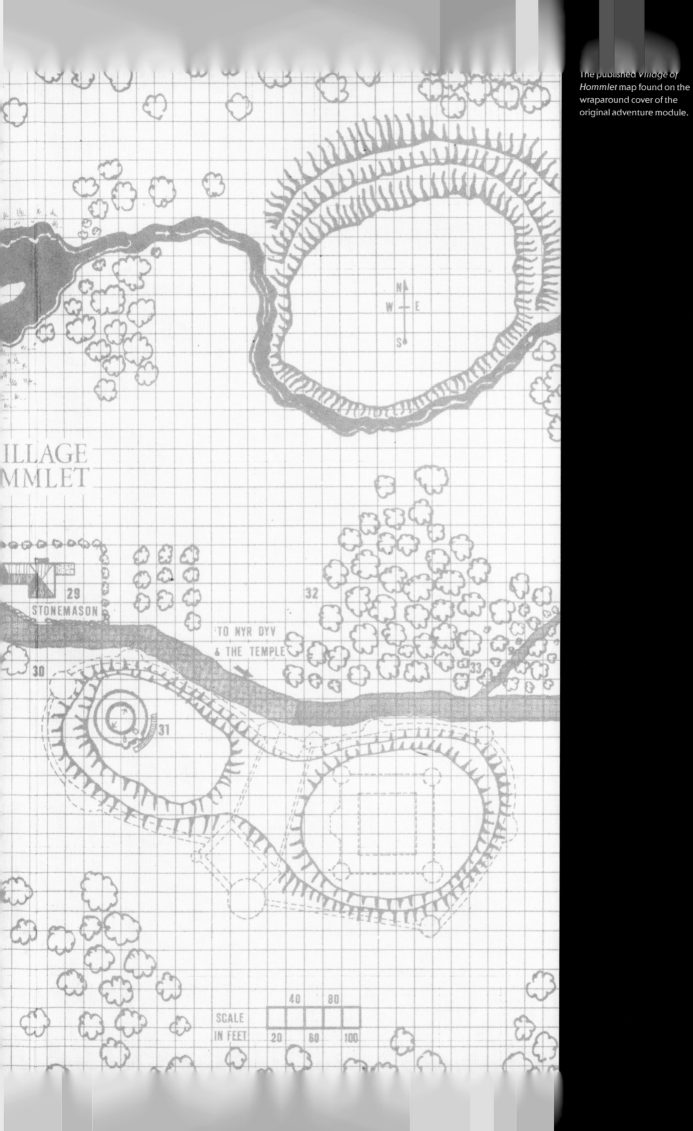

VILLAGE
HOMMLET

29
STONEMASON

30

31

32

TO NYR DYV
& THE TEMPLE

33

N
W · E
S

SCALE
IN FEET

20 40 60 80 100

The Realm of Fantasy Enters the World of Reality Via Bally Midway's Fantastic High-Profit-Return Dungeons & Dragons Pinball!

ABOVE A 1987 Bally Midway ad for the D&D pinball machine, a game that shed new (back)light on Larry Elmore's famous 1983 *Basic Rules* cover. With an aim toward luring game-minded adolescents, it was only a matter of time before D&D would invade 1980s arcades.

OPPOSITE Jeff Easley's original cover painting for the *Manual of the Planes*, which featured the first look at a terrifying creature called an ethereal (later "astral") dreadnought.

FORGOTTEN REALMS

LEFT The cover painting for the 1987 *Forgotten Realms* "grey box" by Keith Parkinson. The mounted Tuigan pictured, a tribesman of the Realms, instantly suggests a world full of danger and rich, exotic locales.

OPPOSITE Ed Greenwood's original hand-drawn map of the Forgotten Realms, featuring the Sword Coast, home to many of the most famous locations of D&D lore.

IN 1986, TSR WAS on the hunt for a new campaign setting for the Advanced Dungeons & Dragons game. One potential locale that caught the eye of TSR designer Jeff Grubb was Ed Greenwood's Forgotten Realms, or the Realms, as it is now often called. Greeenwood, who had crafted tales of his fictional Earth-like planet Abeir-Toril as far back as 1967 (it had been the setting for his homespun D&D campaigns since 1978), was writing official short stories about his fantasy world in the pages of *Dragon* magazine for years. Ironically, TSR's new setting had been sitting right under their noses.

The central focus of the setting is the continent of Faerûn, home to some of D&D's most iconic locations ranging from Neverwinter and Waterdeep to Baldur's Gate, to Candlekeep, all of which dot the famous Sword Coast—a haven for adventurers. It is an eclectic land, rich in history, that has witnessed the rise and fall of kingdoms,

forever baring the scars of centuries of war. The cultures are diverse, the magic is powerful, and the gods are unpredictable. It is, quite simply, Dungeons & Dragons to its very core.

The level of Tolkienesque history and detail that Greenwood had infused in his creation—an almost "real world" quality—granted the Realms an irresistible allure, providing players and Dungeon Masters alike with a seemingly endless trove of myths, religions, factions, locations, and plot hooks. While at its core the Forgotten Realms is a familiar, almost traditional, medieval-styled fantasy setting, it boasted unprecedented scope, offering ample room for growth, especially for future designers and storytellers. Within a year, around one hundred thousand Forgotten Realms boxed sets had sold, and nearly half as many sales followed the next year.

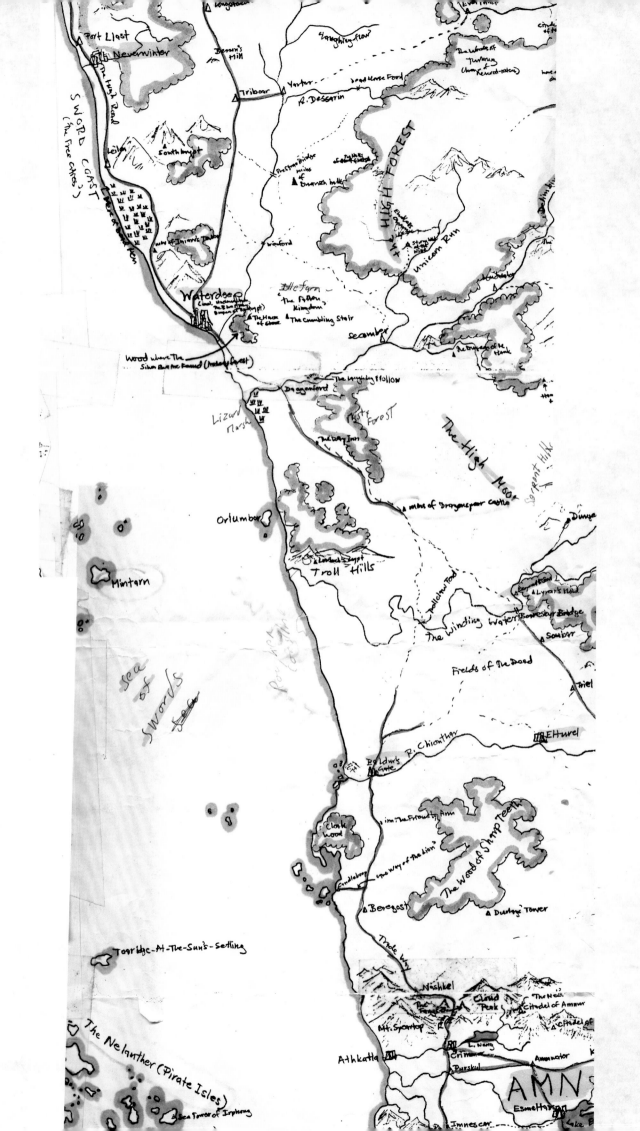

The *New York Times* bestselling author of *Sea of Swords*

FORGOTTEN REALMS

Book One: The Icewind Dale Trilogy

The Crystal Shard

R. A. Salvatore

DC

TSR

NO. 1 US $1.50
CAN $1.85
UK 80p
NEW FORMAT

APPROVED BY THE COMICS CODE AUTHORITY

FORGOTTEN REALMS

THE HAND OF VAPRAK!
PART 1 OF 4

JEFF GRUBB
RAGS MORALES
DAVE SIMONS

While the setting would become one of D&D's most enduring, spanning every subsequent edition through 5th edition and inspiring dozens upon dozens of modules, it is perhaps equally notable for the heroes it introduced into the fabric of greater D&D lore. *The Crystal Shard*, released in 1988, was the first novel to feature the fan-favorite drow Drizzt Do'Urden, who has since starred in countless *New York Times* best-selling novels, continuing where Dragonlance left off with an entirely new, ancillary stream of revenue for the brand. Soon Elminster, the Sage of Shadowdale; Volothamp "Volo" Geddarm, the renowned traveler; and Bruenor Battlehammer, King of Mithral Hall, were making the leap from specialized gaming shops to the storefront displays at major bookstore chains like Walden Books, B. Dalton, and Crown.

The grey boxed set would later be updated to the 2nd edition rules system with the release of a new *Forgotten Realms Campaign Setting* boxed set, which became the foundation of a massive supplement-based expansion, yielding a deeper dive into the setting's diverse regions, both culturally and geographically, with accessories such as *Volo's Guide to the North* and *Volo's Guide to the Sword Coast*, which contained "notes and commentary by the famous archmage and sage, Elminster," imbuing them with a unique conversational, in-world flavor.

A constant stream of modules, games, and novels followed throughout the 1990s. Even publishing titan DC Comics launched a Forgotten Realms series written by the setting's co-designer Jeff Grubb. Now renowned authors such as R.A. Salvatore, Troy Denning, Christie Golden, and dozens more were drafted into the D&D fold to reverentially expand on Greenwood's iconic foundation, adding depth and nuance to the already intricate universe. This explosion of new materials, spearheaded by a chorus of talented writers and designers, cemented the setting's status as one of the most successful shared-fantasy universes from the 1990s to today. Undeniably, Forgotten Realms publications like The Elminster Series, The Dark Elf Trilogy, The Moonshae Trilogy, *Spellfire*, and countless others have captured the imagination of fantasy readers worldwide, thereby inviting new players to join the Realms at the tabletop.

TOP R.A. Salvatore's first D&D novel, *The Crystal Shard*, introduced the world to drow Drizzt Do'Urden in 1988, with the help of Larry Elmore, who depicts the dark elf crouching on the cover.

LEFT Despite TSR's previous association with Marvel Comics, DC saw fit to capitalize on the exciting new Forgotten Realms setting with a twenty-five-issue run.

OPPOSITE Following the multipronged product strategy originally developed for Dragonlance, TSR sought to bolster the Forgotten Realms with a carefully phased selection of modules, supplements, and novels, as shown in this 1988 ad.

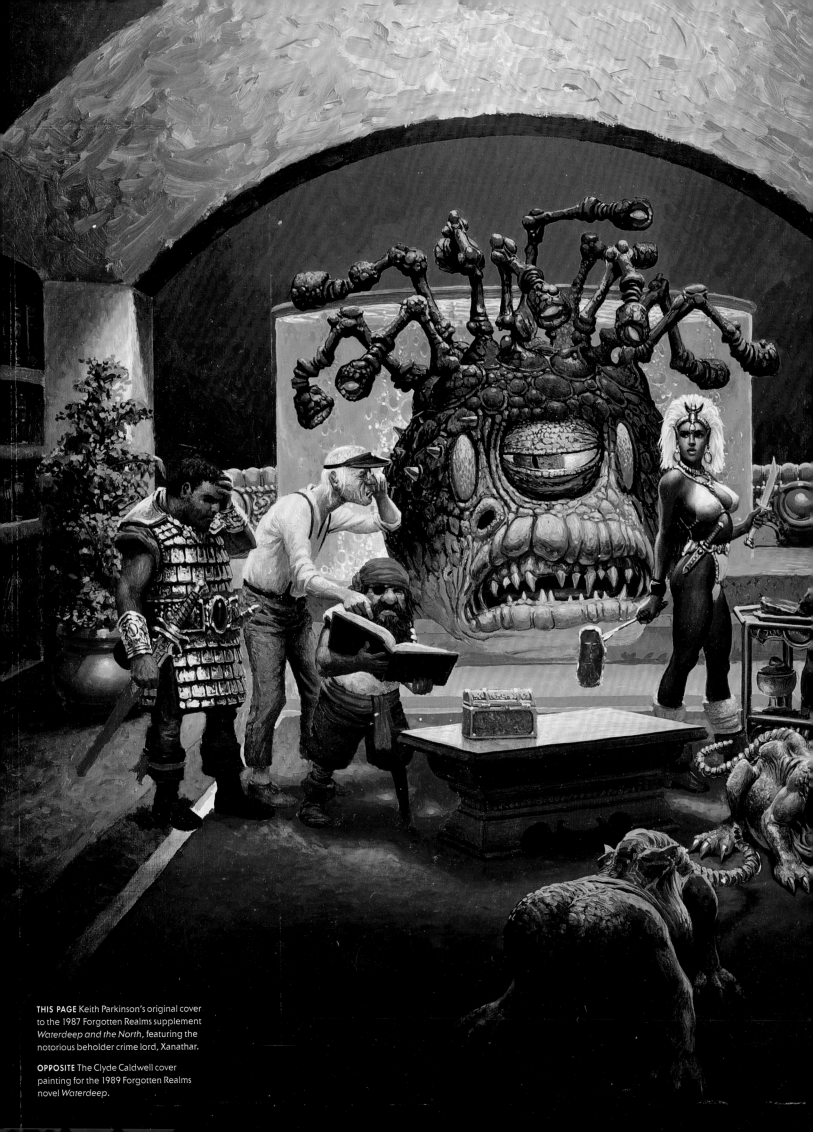

THIS PAGE Keith Parkinson's original cover to the 1987 Forgotten Realms supplement *Waterdeep and the North*, featuring the notorious beholder crime lord, Xanathar.

OPPOSITE The Clyde Caldwell cover painting for the 1989 Forgotten Realms novel *Waterdeep*.

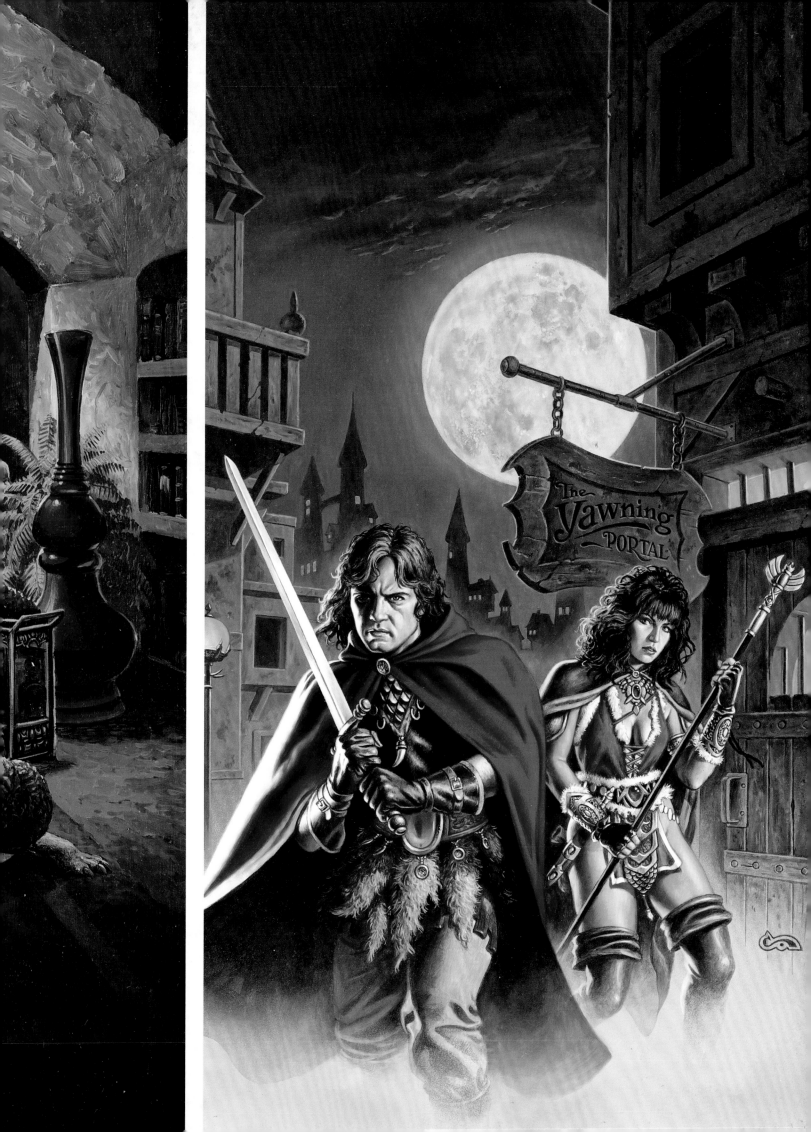

The Yawning PORTAL

ABOVE Fred Fields's iconic depiction of Elminster graced the cover of the 1993 AD&D 2nd edition *Forgotten Realms Campaign Setting* boxed set.

OPPOSITE John and Laura Lakey's cover art for the 1994 supplement *Volo's Guide to the Sword Coast*.

THE RUINS OF UNDERMOUNTAIN

Ed Greenwood's *The Ruins of Undermountain* featured one of the most extensive and dangerous D&D dungeons ever.

"Undermountain awaits you: the fabled and feared battleground of the realms—'The deepest dungeon of them all.'

"Dare you face . . . miles upon miles of deadly traps, glittering treasures, strange and cryptic rooms, and slithering, skulking, lurking monsters? They await you underneath Waterdeep!"

—THE RUINS OF UNDERMOUNTAIN, 1991

THE RUINS OF UNDERMOUNTAIN

LEVEL 1

Undermountain Encounter Tables

The Dungeon Level and NPC Party encounter tables given in Volume Two of the *Monstrous Compendium* will serve for Undermountain admirably, and the "Fresh Water Encounters: Temperate Water Depths" table can be used for encounters involving Sargauth, the River of the Depths.

These tables will soon become familiar to PCs exploring Undermountain for any length of time, however—so alternatives are given here. These tables are heavily based on monsters specific to the FORGOTTEN REALMS® campaign setting, and the wise DM will switch between these tables and the MC2 tables—or best of all, devise and customize tables of his own.

All of the monsters listed on these tables are detailed in this boxed set, or appear in the first three volumes of the *Monstrous Compendium*. In cases where two monsters are given, with an "or" between them, the DM should choose which type is encountered to best suit the surroundings and the current strength of the player character party.

WANDERING MONSTER ENCOUNTERS: 1ST LEVEL

d20 roll	Encounter
1	3-12 ogres or bugbears
2	2-8 huge spiders or wererats
3	4-16 orcs
4	2-12 giant centipedes or bookworms
5	3-18 stirges or giant bats
6	1-2 manticores or leucrotta
7	1 imp or giant constrictor snake
8	2-16 ghouls or curst
9	1-4 burbur or carrion crawlers
10	1-12 trolls or skeletons
11	1-20 crawling claws (roaming, as predators, by command)
12	1-8 living webs or skeletons
13	1-4 hmatova or monster zombies
14	2-4 giant toads or ghasts
15	4-16 goblins or giant wasps
16	2-12 zombies or trolls
17	3-12 orcs or fire beetles
18	2-4 wererats or jackalweres
19	1-3 rhaumbusun or cave fishers
20	2-8 skeletons or dopplegangers

ATTRACTED MONSTER ENCOUNTER TABLE

When there is an explosion, a large and noisy battle, or any other commotion, the DM should choose one or more "attracted monsters," to show up and make things even worse for the PCs. At best, these should be handpicked; failing that, use the table that follows. If a rolled monster is far too powerful for the PCs, roll again, or (better still) make the monster an injured specimen, minus key powers and with lessened hit points or damage dealt. These dangerous encounters teach the PCs one of the basic lessons of dungeon survival, in Undermountain and throughout the Realms: know when to *run away!*

d20 roll	Encounter
1	1 death kiss or gauth
2	1-4 xorn or umber hulks
3	1-4 curst or sharn
4	3-12 dopplegangers or gnolls
5	1-12 trolls
6	1-4 ettins or fomorians
7	1-6 carrion crawlers
8	2-12 land lampreys or drow
9	1-6 ghouls or adventurers (NPC party)
10	1 spectre or slithering tracker
11	3-30 orcs or hobgoblins
12	1-4 sharn or leucrotta
13	1 bulette or imp
14	1-6 ghouls or adventurers (NPC party)
15	2-8 hell hounds or mind flayers
16	2-20 shadows or (ordinary) rats
17	1-3 sharn or ochre jellies
18	1 trapper or gelatinous cube
19	12-48 jermlaine
20	1-3 spirit naga

Entry Well · START THOU HERE

FORGOTTEN REALMS

SCALE: ONE SQUARE EQUALS TEN FEET

DRIZZT

1988

"Drizzt Do'Urden trotted along silently, his soft, low-cut boots barely stirring the dust. He kept the cowl of his brown cloak pulled low over the flowing waves of his stark white hair . . . his violet-colored almond eyes, marvelous orbs that could rival an owl's at night, could not penetrate the blur of daylight. . . ."

—DRIZZT'S FIRST DESCRIPTIONS IN *THE CRYSTAL SHARD*, 1988

1992

1993

2012

1998

2007

BOXES OF GOLD

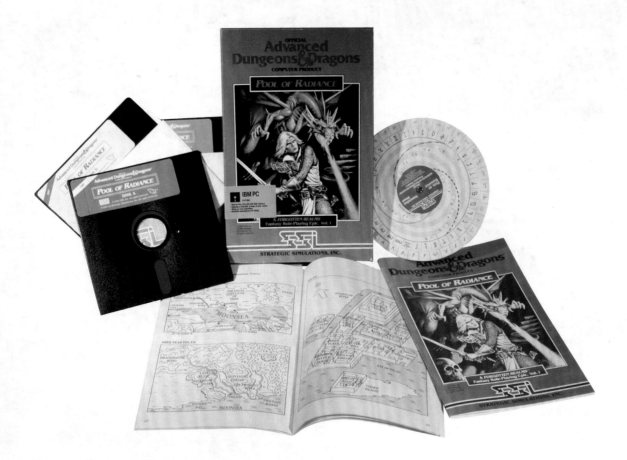

IN 1987, TSR SOLICITED new bids to license computer versions of D&D. Of the ten firms that competed fiercely to win this exclusive contract, TSR chose Strategic Simulations, Inc., already a respected publisher of fantasy adventure titles like *Phantasie* and *Wizard's Crown*. Not long before, TSR had allowed their former licensing partner, Mattel, to adapt D&D as the toymaker saw fit, but now they chose to work closely with SSI to develop games in the campaign settings of the Forgotten Realms and Dragonlance. The first of these titles would be the 1988 classic *Pool of Radiance*.

Chuck Kroegel, who ran research and development for SSI, would report that not only had TSR "carved out a space where our games will take place" within the Forgotten Realms, but also that "TSR staff is actually designing the first scenario for us." Under an in-house Creative Service team headed by Jim Ward, which included Zeb Cook, Steve Winter, and Mike Breault, TSR mapped the area of the city of Phlan, where adventurers would fight for glory. It became a joint venture because, as Kroegel explained, "They're going to be making paper modules of that same adventure as well," under the title *Ruins of Adventure*.

Pool of Radiance beat the *Ruins of Adventure* module to the market by a couple months, but the two products share the same Clyde Caldwell cover art and explicitly advertise their interconnection. *Pool of Radiance* shipped with an "Adventurer's

Journal" pamphlet that contained a blurb about *Ruins of Adventure* promising, "*Pool of Radiance* computer role-playing game players will find additional clues and background information in TSR's *Ruins of Adventure* module, to enhance their adventures in the computer version of this module." *Ruins of Adventure* gave a similar nod back to its computer counterpart, including a starburst advertisement for it on its cover.

With over one hundred units sold in the first year, a good head start toward eventual sales of nearly a quarter million copies— blockbuster figures for a computer game at the time—*Pool of Radiance* inaugurated a lucrative tradition of SSI games built on their game engine, which offered a more faithful implementation of D&D than prior efforts in the marketplace, from its artwork to its turn-based gameplay. The engine also enabled SSI to port games between Apple, Commodore, and IBM PC platforms—later ports would even reach Nintendo. The series of games they built on it, now famously known as the Gold Box titles, served as one of the primary ambassadors of the D&D brand in the late 1980s and early 1990s.

Within a year, TSR produced a novelization of *Pool of Radiance* as well, a harbinger of their emerging product strategy. The cross-platform sequel *Curse of Azure Bonds* shipped as an SSI computer game, a TSR paper module, and a novel, all jointly

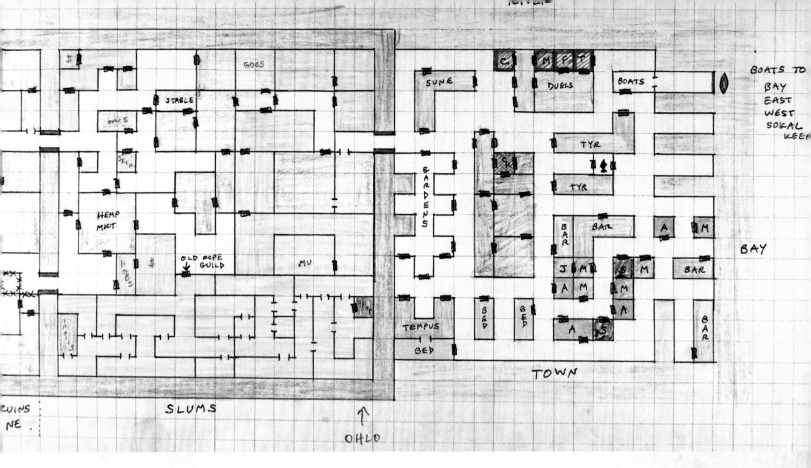

Labels on map: GOBS, STABLE, ORCS, SUNE, DUELS, BOATS, BOATS TO BAY EAST WEST SOKAL KEEP, TYR, TYR, HEMP MKT, GARDENS, BAR, BAR, A M, BAY, OLD ROPE GUILD, MU, HOBS, JIM, S M, BAR, A M, A M, BED, BED, BAR, TEMPUS, BED, A S, RUINS NE, SLUMS, OHLO, TOWN

ABOVE An original concept map for the *Ruins of Adventure's* starting area of Phlan.

RIGHT The TSR *Ruins of Adventure* module.

OPPOSITE Because disk space was at a premium for early computers, games such as *Pool of Radiance* would print accompanying story text, maps, and other information in a booklet to be referred to at key moments. The code wheel pictured was a copy protection method, used during each gaming session to generate a unique key input to unlock the game.

telling one adventure story in the Forgotten Realms. These releases marked the beginning of a transmedia platform for D&D, a shift from being simply a game into a broader media property that showcased TSR's campaign settings.

More subtly, the SSI releases marked the migration of the D&D brand away from a purely paper and pencil game. The *Dungeon Master's Assistant* software SSI released in 1988 was the first branded commercial product to provide computer tools to assist in tabletop play. The program could roll dice, randomly generate encounters for particular monsters or tables from the books, and even tabulate the resulting treasure and experience points. Although it got little traction in the market of the 1980s, it opened the door to many future computer-assisted versions of D&D, including the 1993 *Forgotten Realms: Unlimited Adventures* (*FRUA*) kit, which allowed computer-savvy Dungeon Masters to design their own Gold Box games. A pioneering D&D computer product that allowed users to express themselves creatively, *FRUA* provided perhaps the best approximation of D&D's original mandate to not let TSR do all of the imagining for you, inspiring a modding community that still exists today.

NAME	AC	HP
GLUM | 8 | 1
GRIMLIN | 8 |
GRETCHEN | 8 |
GRIMINIEN | 10 |
GUND | 9 |

14,7 S 00:04

YOU HAVE SURPRISED A PARTY OF KOBOLDS.

COMBAT WAIT FLEE PARLAY

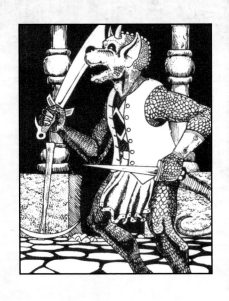

NAME	AC	HP
RESTAL | 2 | 30
TARRAN | 2 | 30
DIANE | 9 | 20
WILLIAM D'OR | 5 | 26

UP CLOSE, THE MONSTERS ARE FULL SIZE, ANIMATED, AND NASTY. THE ONLY WAY TO DEAL WITH BRUTES LIKE THESE IS IN DETAILED TACTICAL COMBAT.

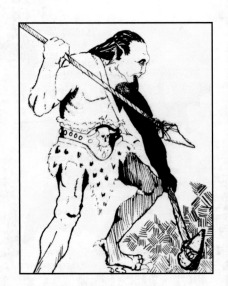

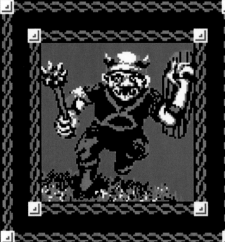

NAME	AC	H
GLUM | 8 | 10
GRIMLIN | 8 |
GRETCHEN | 8 |
GRIMINIEN | 10 |
GUND | 9 |

14,7 S 16:08

YOU HAVE SURPRISED A PARTY OF GOBLINS.

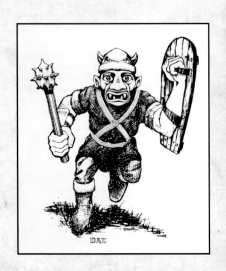

COMBAT WAIT FLEE PARLAY

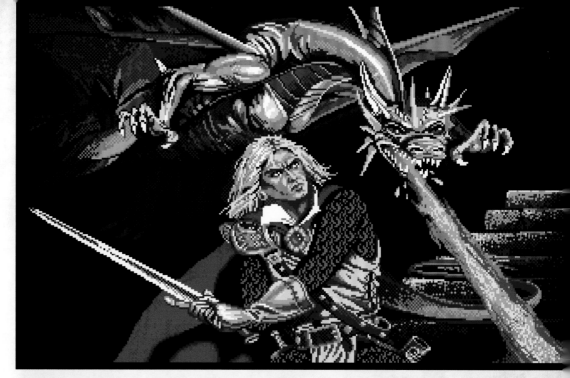

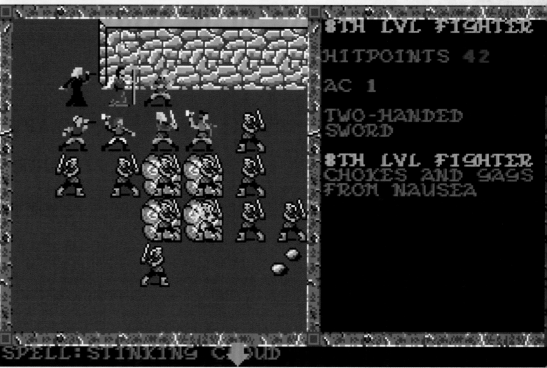

SPELL: STINKING CLOUD

8TH LVL FIGHTER

HITPOINTS 42

AC 1

TWO-HANDED
SWORD

8TH LVL FIGHTER
CHOKES AND GAGS
FROM NAUSEA

RIGHT Screengrabs from the Commodore Amiga version *of Pool of Radiance* including a digitized version of the Clyde Caldwell box cover art, the overhead combat interface in the wake of a wizard casting the notorious "stinking cloud," and the standard encounter screen.

OPPOSITE *Pool of Radiance*'s monster portraits shown during an encounter were digitized, colorized, and animated reproductions of the portraits from the 1st edition AD&D *Monster Manual*. Shown here are screengrabs from the DOS and Apple II editions of the game.

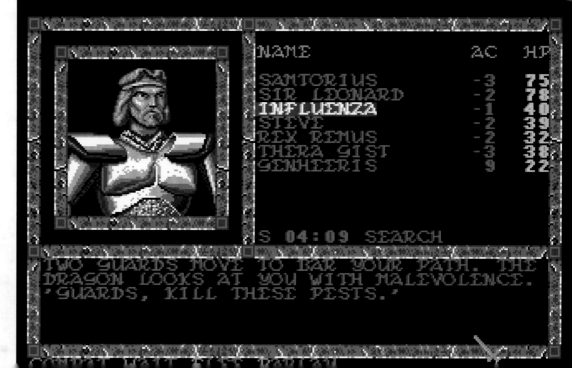

NAME	AC	HP
SAMTORIUS	-3	75
SIR LEONARD	-2	78
INFLUENZA	-1	40
STEVE	-2	39
REX REMUS	-2	32
THERA GIST	-3	38
GENHEERIS	9	22

S 04:09 SEARCH

TWO GUARDS MOVE TO BAR YOUR PATH. THE
DRAGON LOOKS AT YOU WITH MALEVOLENCE.
'GUARDS, KILL THESE PESTS.'

COMBAT WAIT CAST PARLAY

"WHEN THIS SPELL IS CAST, THE WIZARD IS ABLE TO
ASSUME THE FORM OF ANY CREATURE—FROM AS
SMALL AS A WREN TO AS LARGE AS A HIPPOPOTAMUS—
AND ITS FORM OF LOCOMOTION AS WELL."

4

POLYMORPH SELF

SELF

2ND EDITION

AROUND THE TIME of his ouster from TSR, Gary Gygax revealed in *Dragon* his plans for a second edition of Dungeons & Dragons, even speculating that there might be "a Third, and perhaps a Fourth someday." But work on a comprehensive revision would not commence until well after he left, and it departed radically from Gygax's original outline. It was a perilous endeavor, to reshape TSR's core product: after a decade on the market, the flagship *Players Handbook* had sold more than two million copies worldwide in numerous releases and languages; the *Monster Manual* traded in excess of a million and half copies; and the *Dungeon Masters Guide* yielded more than a million sales itself. Replacing them would mean potentially alienating legions of customers who had long since become set in their ways.

In the absence of guidance from the game's co-creator, TSR designers turned to the fans themselves. They sent out a questionnaire through *Dragon* magazine in the summer of 1987 and received some fifteen thousand responses. Lead designer and "TSR Million Dollar Club" member Zeb Cook famously wrung more data out of the audience with his article "Who Dies?" in *Dragon* #118, which teased the character classes that might be cut from a revised *Players Handbook*, arousing a much-intended uproar. In the beginning of 1989, after due consideration, TSR began releasing material from the long-awaited AD&D 2nd edition, starting with a thirty-two-page preview in the February issue of *Dragon* explaining the major design changes and the rationale behind them.

It had to be new, bright, and shiny, but still firmly in the tradition of Dungeons & Dragons that came before it. The design department argued endlessly about the concept of classes, and potentially even abolishing them all together, but as Steve Winter would put it, "Few things said 'AD&D' as loudly as the character classes." They made numerous fundamental changes, elevating THAC0 (a single number that indicated the roll a player character would need "To Hit Armor Class 0") and the skill system to central components in event resolution, and finally providing a mechanic for critical hits, something Gygax had resisted for years. But many things were too integral to the D&D brand to modify: "We wanted to change the order of armor class, making 1 the worst and going up," Cook recalled, but "it was decided that took things too far from where the players were accustomed to."

By Popular Demand!

You asked for it . . . it's almost here! After reviewing more than 15,000 letters in response to a player survey, the long-awaited release of TSR's AD&D® 2nd Edition game system is coming this Spring.

Can't Wait? The next issue of Dragon® Magazine will contain a 32-page "sneak preview" to the AD&D® 2nd Edition product line for 1989. This is a no-risk way for you to find out just what steps were taken to make the world's most popular role-playing game system "state of the art," *before* it hits the stores. Watch for it!

AD&D® 2nd EDITION

Previewing Next Month in Dragon® Magazine!

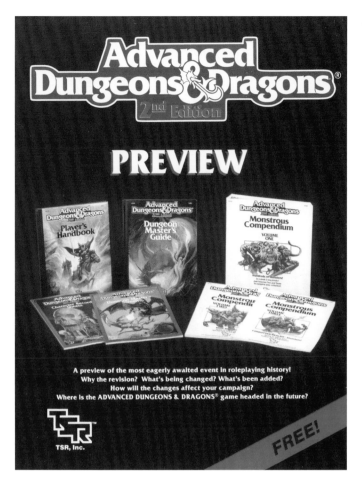

ABOVE AND OPPOSITE A series of 1989 ads for AD&D 2nd edition stressing a refined and simplified gaming experience that had been designed with player feedback in mind.

BELOW Beginning with *The Complete Fighter's Handbook* and *The Complete Thief's Handbook* in 1989, TSR's expanding series of "splatbooks" allowed players deeper character customization. While popular, these books offered modest advantages to each class, contributing to an effect known as "power creep," where classes slipped out of balance with each other until each class had its own book.

After two years of development, the goals of 2nd edition were manifold. Naturally, TSR hoped to simplify the rules and eliminate barriers to entry for new players; their advertising campaign stressed, "Your toughest opponent shouldn't be the rulebook." They also needed to create markets for future products, whether they be core books, campaign sets, modules, or other accessories. In this respect, 2nd edition was a bonanza, as it gave TSR the impetus to reinvent the product that had previously sold as *Monster Manual*. In its place, they released a loose-leaf notebook binder called the *Monstrous Compendium Volume 1* filled with some starting monsters, to which the company would later add numerous supplements, many tied in to their growing stable of campaign worlds. In addition, 2nd edition provided players a deeper dive into each class with the *Complete Fighter's Handbook* and *Complete Thief's Handbook*—a growing series of volumes often called "splatbooks." But another, more subtle goal of the edition had to do with reputation and redemption.

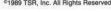

Advanced Dungeons & Dragons®
2nd Edition

PLAYER CHARACTER RECORD

Character __JACORD HAN-AZIZ__
Align. __CN__ Race __ELF__ Class __M/T__ Level __2/3__

Player's Name __STEVE WINTER__ Family __AZIZ__ Race/Clan __—__
Homeland __WATERDEEP__ Liege/Patron __NONE__ Religion __LEIRA__
Sex __M__ Age __119__ Social Class __LOW__ Status __NONE__
Ht. __60"__ Wt. __106 lbs.__ Birth Rank __4__ # Siblings __3__
Hair __BLOND__ Eyes __GREEN__ Appearance __AVG, EXCEPT DAGGER TATTOO ON RIGHT HAND__
Honor __—__ (Base Honor __—__) Reaction Adjustment __—__

ABILITIES

8	STR	Hit Prob —	Dmg Adj —	Wgt Allow 35	Max Press 90	Op Drs 5	BB/LG 1%				
15	DEX	Rctn Adj 0	Missile Att Adj 0	Def Adj -1							
10	CON	HP Adj 0	Sys Shk 70%	Res Sur 75%	Pois Save 0	Regen —					
16	INT	No of Lang 5	Spell Lvl 8	Lrn Sp 70%	Spells/Level 11	Spell Immun —					
11	WIS	Mag Def Adjus 0	Bonus Spells —	Spell Fail —	Spell Immun —						
12	CHR	Max No Hench 5	Loy Base 0	Rctn Adj 0							

MOVEMENT

Base Rate __12__

Light	36-50	8
Mod	51-65	6 -1
Hvy	66-80	4 -2
Svr	81-90	1 -4
Jog	(×2)	24
Run	(×3)	36
Run	(×4)	48
Run	(×5)	60

SAVING THROWS

Paralyze/Poison	13
Rod, Staff, or Wand	11
Petrify/Polymorph	12
Breath Weapon	15
Spells	12

Modifier __—__ Save

ARMOR

AC **9**

Adjusted AC
Surprised __10__
Shieldless __9__
Rear __10__

Armor Type (Pieces) __NONE__

Defenses _____

HIT POINTS
8

Wounds _____

WEAPON COMBAT

Weapon	#AT	Attack Adj/Dmg Adj	THAC0	Damage (SM/L)	Range			Weight	Size	Type	Speed
SHORT SWORD	1	+1	19	1d6 / 1d8				3	S	P	3
DAGGER	1		19	1d4 / 1d3	1	2	3	1	S	P	2
SHORT BOW	2/1	+1	19	1d6 / 1d6	5	10	15	2	M	P	7
			/								
			/								

Special Attacks _____

Ammunition: __ARROWS__ __ARROWS +1__ ☑☑☐☐
☑☑☑☑ ☐☐☐☐☐ ☐☐☐☐
☑☒☒☒☐ ☐☐☐☐☐ _____ ☐☐☐☐

Special Abilities

90% VS. SLEEP, CHARM
+1 W/BOW
+1 W/LONG, SHORT S.
-4 SURPRISE
IF SCOUTING
INFRAVISION 60'
1/6 NOTICE SECRET DOOR
1/3 FIND SECRET DOOR
1/2 FIND CONCEALED DOOR
+10% MAGE XP
THIEVES' CANT

PICK POCKETS 20
OPEN LOCKS 5
FIND/REMOVE TRAPS 15
MOVE SILENTLY 50
HIDE/SHADOWS 45
DET. NOISE 65
CLIMB WALLS 60
READ LANG. 0
BACKSTAB +4, x2

Proficiencies/Skills/Languages

SHORTSWORD (/)	READING/WRIT (I +1)
DAGGER (/)	SPELLCRAFT (I -2)
SHORTBOW (/)	ASTROLOGY (I 0)
(/)	ANCIENT HIS
(/)	(WATERDEEP) (I -1)
(/)	APPRAISING (I 0)
(/)	GAMING (CL 0)
(/)	ROPE USE (D 0)
(/)	STONEMASON (S -2)
(/)	COMMON (I 0)
(/)	(/)
(/)	(/)
(/)	(/)

ABOVE One of the biggest innovations of the 2nd edition rules was the wide adaptation of the concept of THAC0. Gone were "attack matrices" and "to-hit charts" of the past, replaced with a single number that could be used on the fly to determine the success of an attack.

LEFT 2nd edition design director Steve Winter at the TSR Hotel Clair location around 1981.

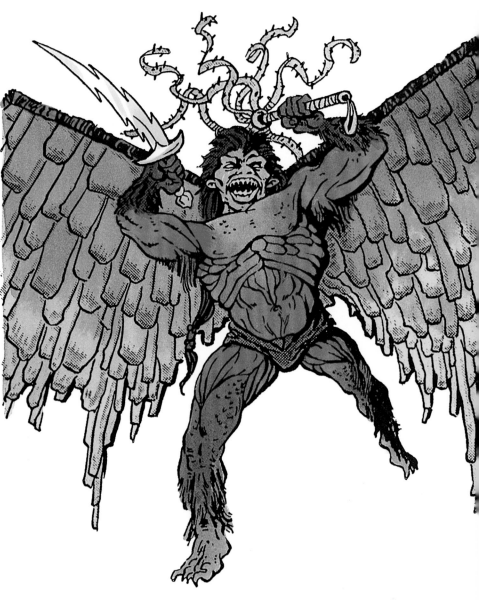

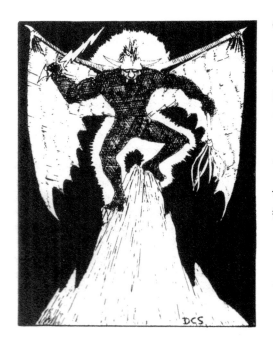

A 2nd edition balor (above, right) alongside Dave Sutherland's version from the 1977 *Monster Manual* (above, left). While the term "demon" had formally been removed from the game, some former demon types, including the balor and the marilith, were reintroduced within a couple of years of the debut of 2nd edition with little functional change except that they were now labeled "tanar'ri."

Nearly ten years after the James Dallas Egbert III incident and countless attempts to soften its image, D&D still had a dangerous— even occult—connotation in some circles. In a 1988 segment, NBC's *Unsolved Mysteries* had suggested the game served as gateway to dangerous cult activities. While no longer front-page news, the idea that the game was somehow an unhealthy diversion lingered in mainstream America. The newly released 2nd edition addressed these issues head-on with a strategic and deliberate softening of the content, which included the formal elimination of demons and devils, as well as the morally suspect assassin class. Even TSR Vice President Jim Ward admitted in the pages of *Dragon* magazine that many of these changes were made in response to "Angry Mother Syndrome." Paired with the success of Dragonlance and Forgotten Realms, which had steered the game toward more wholesome "high fantasy" along the lines of J.R.R. Tolkien and C.S. Lewis, D&D was again making a play for the family rooms of America. Skewing more toward Morley than Mephistopheles, 2nd edition provided the foundation for a series of successful new products that would sustain the brand for years to come.

"We knew from years of business experience that campaigns, worlds, and rules expansions were the biggest sellers. Anything that was targeted at players would sell more copies than something targeted solely at DMs."

— STEVE WINTER

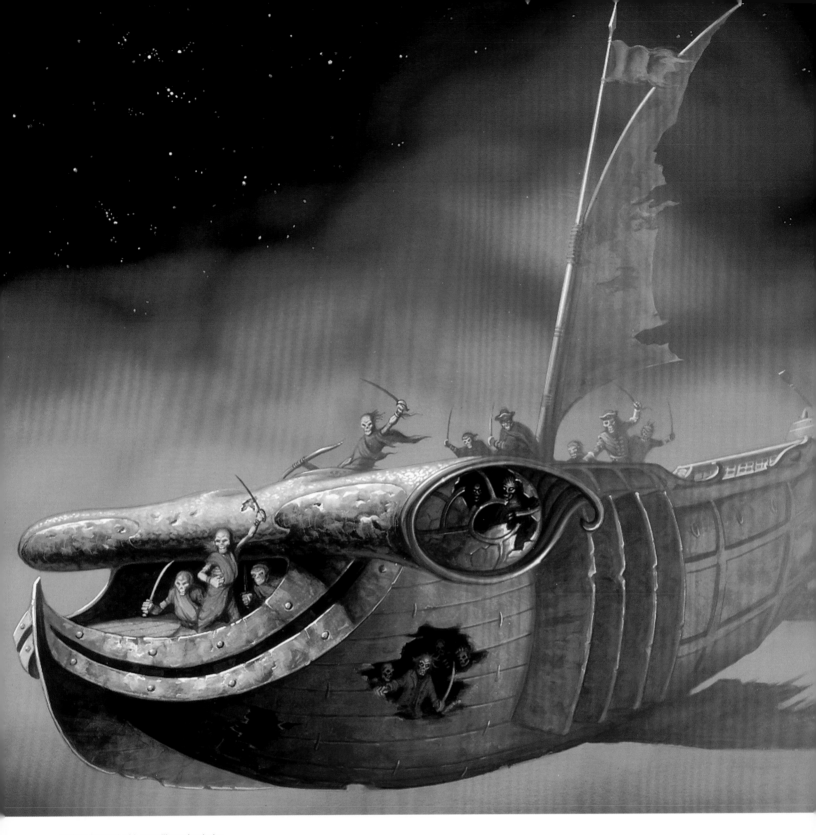

ABOVE A vessel with a spelljamming helm, allowing it to comfortably travel in terrestrial or outer-space environments. This was painted by a new TSR artist from the South who went simply by Brom.

OPPOSITE The alien aberrations known as the illithid, the race of the mind flayers, finally return home to space in this 1989 Spelljammer cover illustration by Jeff Easley featuring a logo by Doug Watson.

The innovations with 2nd edition didn't end with changes to the rules. Now more than ever, TSR observed a gaming landscape rife with competition, with new tabletop titles from budding publishers carving into the industry that D&D had not only birthed, but had historically dominated. To stay ahead of these rivals, TSR took a chance on a surprisingly bold setting: outer space.

With classic D&D races and rules at its core, Spelljammer, designed by Jeff Grubb, provided the sword-and-sorcery system with an exciting new backdrop. Powered by "spelljamming helms," ships could now travel through interplanetary space, visiting planets as well as planes. It wasn't uncommon to

witness a magically infused tall-mast ship navigate through a nebula pursued by a space schooner full of skeleton pirates. While Spelljammer was conceived as an entirely new way to experience D&D, it also appeared a brazen attempt to capitalize on the successful alchemic fusion of space and fantasy of *Star Wars*. Regardless of the fact that it was as much steampunk as it was "a galaxy far, far away," Spelljammer nonetheless elicited heavy comparisons to George Lucas's saga, and it would prove the first in a series of genre-bending campaigns that would support and expand the brand in the coming years.

MINDFLAYER

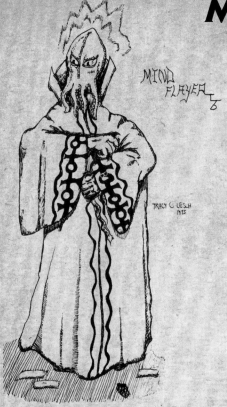

Original edition (1975)

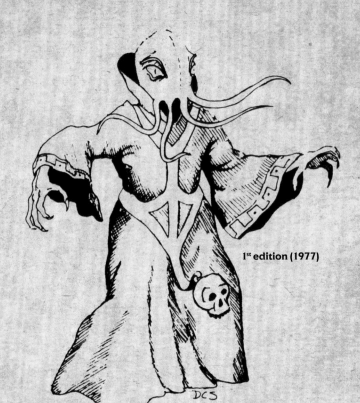

1st edition (1977)

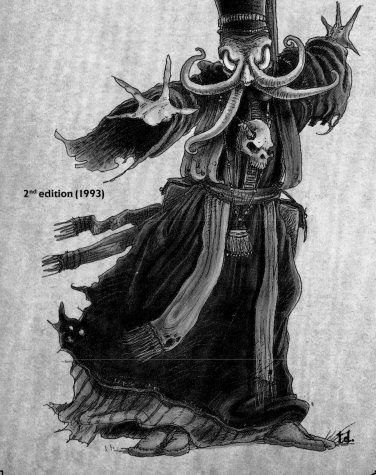

2nd edition (1993)

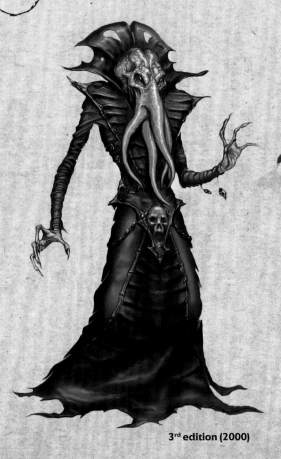

3rd edition (2000)

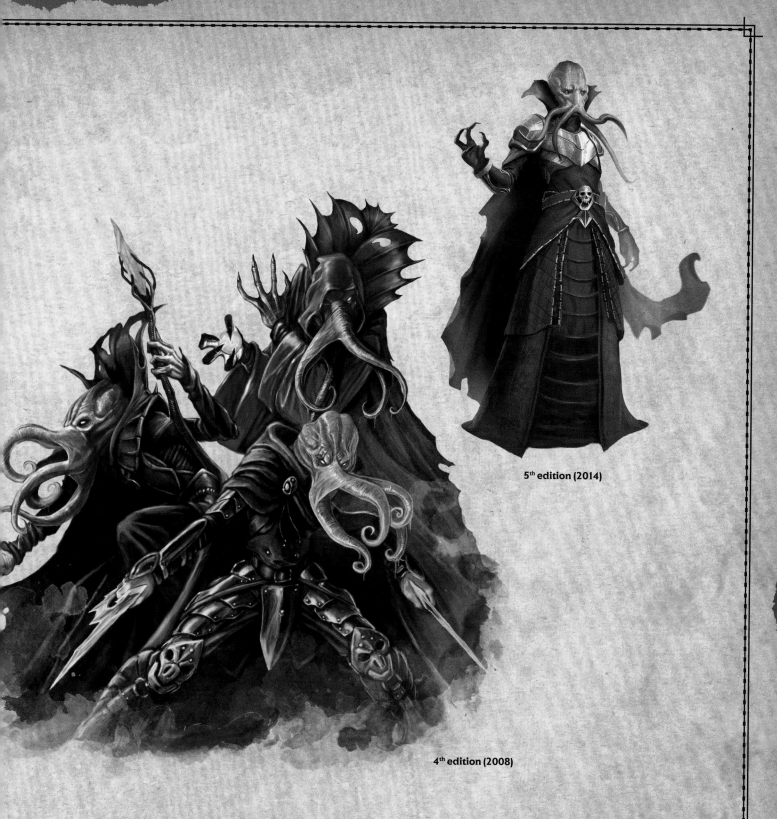

5th edition (2014)

4th edition (2008)

"Mind flayers are found only in subterranean places, as they detest sunlight. They are greatly evil and consider the bulk of humanity (and its kin) as cattle to feed upon. . . . The mind flayer's skin glistens with slime. Its skin color is a nauseous mauve, its tentacles being purplish black. A mind flayer's eyes are dead white, no pupil being evident. The three long fingers of each hand are reddish, but the hands are mauve."

— *MONSTER MANUAL*, 1977

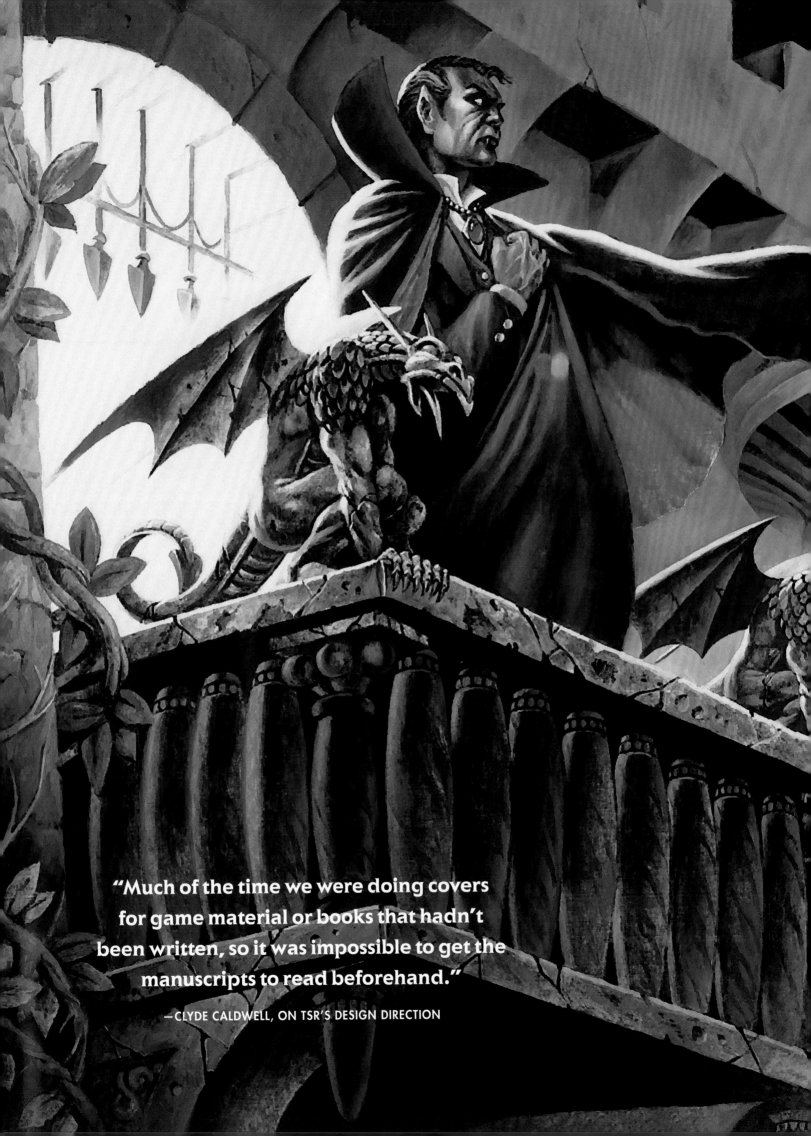

"Much of the time we were doing covers for game material or books that hadn't been written, so it was impossible to get the manuscripts to read beforehand."

—CLYDE CALDWELL, ON TSR'S DESIGN DIRECTION

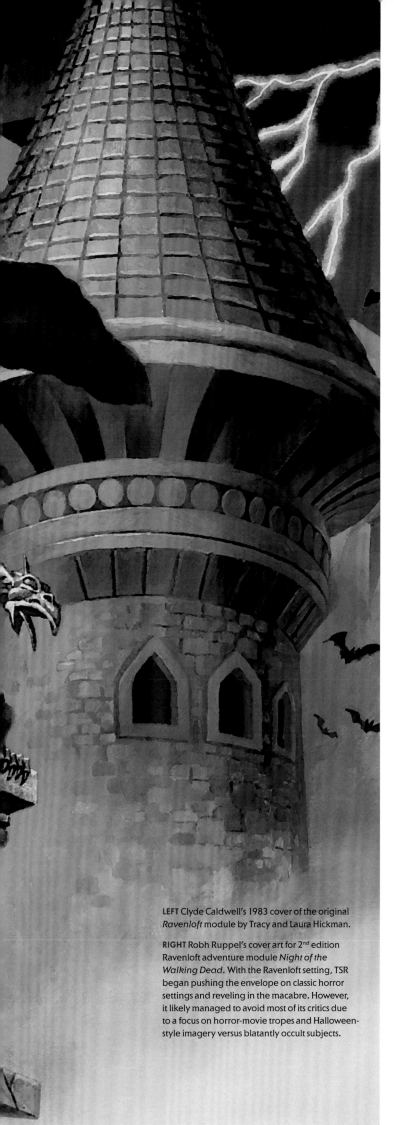

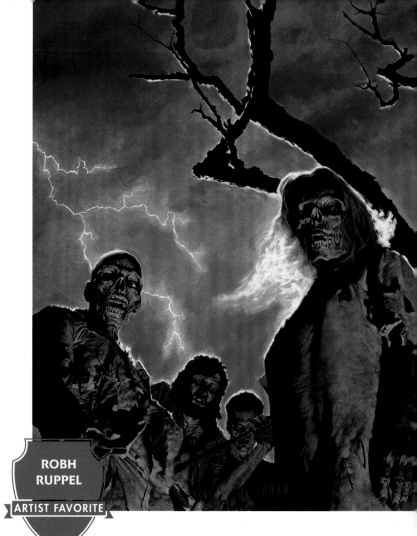

LEFT Clyde Caldwell's 1983 cover of the original *Ravenloft* module by Tracy and Laura Hickman.

RIGHT Robh Ruppel's cover art for 2nd edition Ravenloft adventure module *Night of the Walking Dead*. With the Ravenloft setting, TSR began pushing the envelope on classic horror settings and reveling in the macabre. However, it likely managed to avoid most of its critics due to a focus on horror-movie tropes and Halloween-style imagery versus blatantly occult subjects.

A MEDIA PLATFORM

TSR went into the 1990s feeling great confidence thanks to the success of Advanced Dungeons & Dragons 2nd edition. Early sales of the new core rulebooks were promising: in their first eight months on the market, the *Player's Handbook* sold more than three hundred thousand copies, and the *Dungeon Masters Guide* wasn't far behind at a quarter million copies. In their wisdom, the wizards of TSR weft and spun great sprawling tapestries of gaming content, as the products were so numerous and the execution in their visual presentation and production value had never been higher. No one could guess that TSR, and the role-playing game industry at large, was charging into a thick and deaf fog—a disruption created by the advent of the collectable-card game market. Before long, the very future of Dungeons & Dragons would be in question.

The start of the decade first saw TSR enter the foreboding lands of Barovia. The summer release of the Ravenloft campaign setting featured the vanquished (but unvanquished), dead (but undead) vampire, Strahd von Zarovich. The Ravenloft setting revolved around the iconic Strahd, who commanded ardor, respect, and fear. In this gothic-horror setting, players could brave lurking dooms in various domains of dread based loosely on the classic gothic tales of Edgar Allan Poe, Mary Shelley, and Bram Stoker. Players could test their moral fortitude, or sanity, in battles against the unholy forces of Strahd and a variety of other villainy, such as the undead wizard king Azalin.

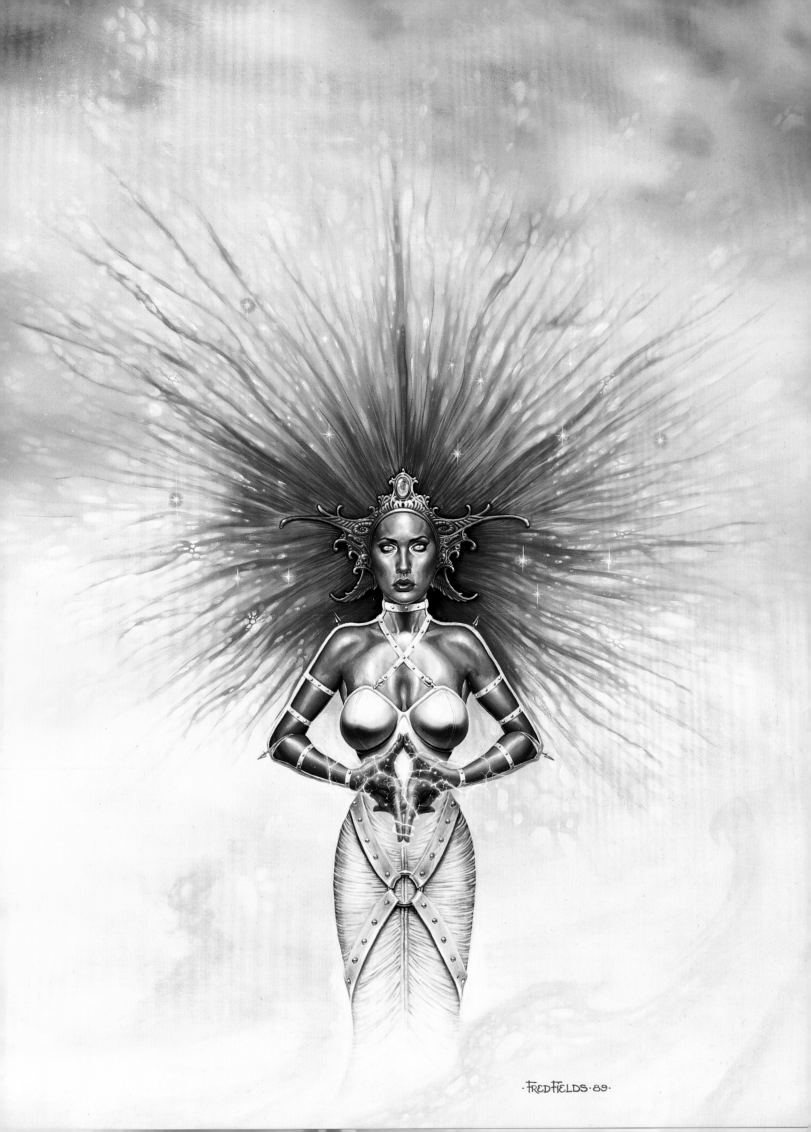

Without concern for breaking the dark mood of Ravenloft, in that same year TSR also published the *Hollow World Campaign Set*, which took a page from the rollicking adventures of Jules Verne, sending players under the surface of the "Known World" of Mystara. Lit by an internal sun, many prehistoric and extinct cultures based on Native American, Aztec, Viking, and ancient Rome thrived on the inside curve of this "Hollow World."

These two campaign boxed sets, along with their previous release of Spelljammer, exemplified a strategy at the company: no longer would they treat AD&D as a self-flavored game of medieval fantasy, but as a generic foundational ruleset, which TSR believed would support many campaign settings with different tones and flavors. In this, TSR would prove to be only half correct, as even the strongest foundations can support only so much weight.

Meanwhile, in the world of high tech, SSI continued the proud tradition of the now legendary Gold Box games in numerous titles set in the Forgotten Realms and the landscapes of Dragonlance—titles that had begun to rival sales of the printed books. In the 1990 *Champions of Krynn*—SSI's fourth foray into the Dragonlance setting—PC gamers could involve themselves in the War of the Lance, create an adventuring party of bold AD&D heroes that now included the ever mirthful kender, and charge into battle against ruthless draconians, some of whom dramatically exploded upon death. But SSI made a bolder move in conjunction with TSR and Stormfront Studios to bring Gold Box popularity and muscle to modern MUDs (Multi-User Dungeons), this time based on the Forgotten Realms setting. As this was well before widespread residential Internet access, *Neverwinter Nights* was released on America Online's dial-up modem service. It boasted a full graphical multiplayer Advanced Dungeons & Dragons experience. As in other early MUDs, *Neverwinter Nights* was a volatile and exciting place where your allies could be more dangerous than your enemies, as online players could be unpredictably treacherous to "freshmen," or "newbies," which evolved into the more commonly used "newbs." But loot was easy to come by, and players could be generous in provisioning newcomers, which helped ensure they would keep coming back in spite of the high AOL charges.

As *Neverwinter Nights* was primarily a licensing deal for TSR, the company never assumed great risk in its production, but it also viewed these arrangements as transmedia opportunities and relied on these efforts to complement its own core rulebooks, novels, and modules. Ironically, it was the low-risk/high-reward licensed products that increasingly granted D&D its greatest exposure during this period; licensed computer games would soon determine how the game was publicly viewed and visualized. Most important, they were forward-thinking. By continually inviting technology to the gaming table, a statement was made—one that would later grow into a full conversation some twenty years down the road and save the tabletop gaming industry from extinction in the face of video-game supremacy.

EVILUTION

THE DRAGON

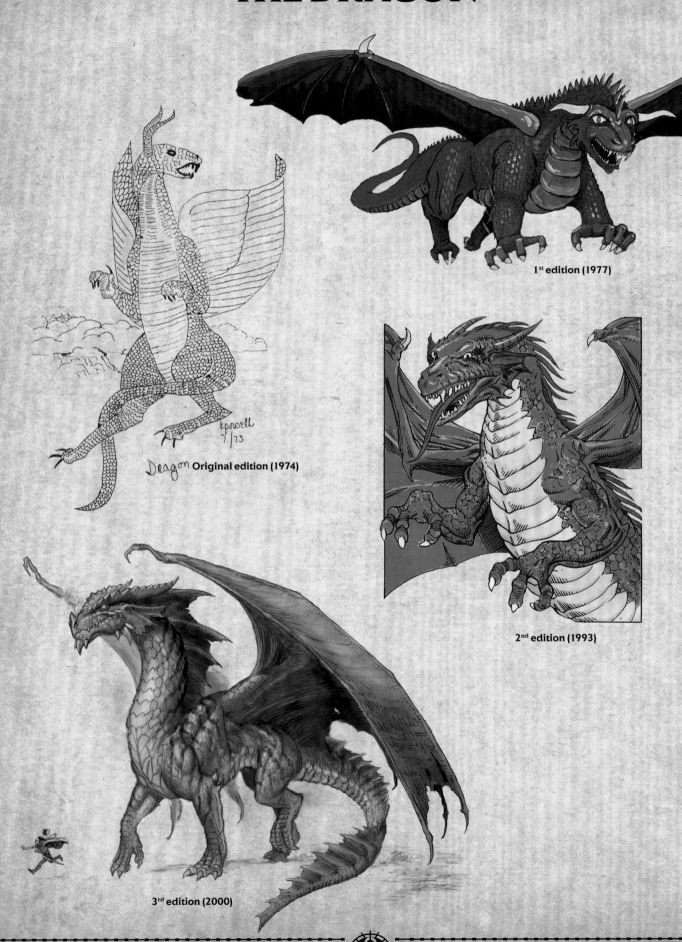

1st edition (1977)

Dragon Original edition (1974)

2nd edition (1993)

3rd edition (2000)

"Dragons come in many colors, sizes, shapes, and alignments. . . . The red dragon is usually found dwelling in great hills or mountainous regions. As with most others of this species, they make their lairs in subterranean caves and similar places. They are very greedy and avaricious. Of all evil dragons, this sort is the worst, save for Tiamat herself."

— *MONSTER MANUAL*, 1977

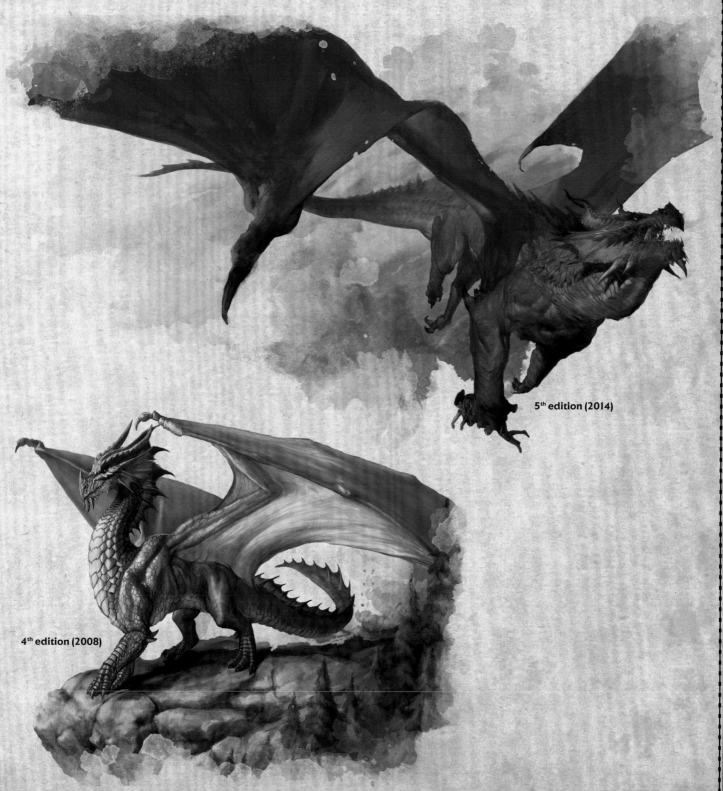

5th edition (2014)

4th edition (2008)

It's Coming!

In just a few months, you and your friends can experience adventure gaming unlike anything you have known before . . .

A medieval swordsman, powerful warrior or mystical wizard—this can be you in the new, easy-to-learn DUNGEONS & DRAGONS® game . . .

Learn to survive the deepest dungeons and the most horrible dragons . . . take the new DUNGEONS & DRAGONS game challenge . . . it's coming—soon!

TSR™
TSR, Inc.

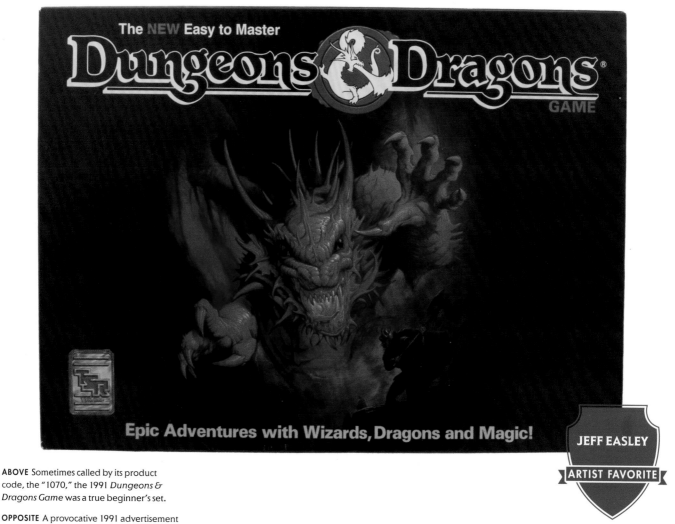

The NEW Easy to Master
Dungeons & Dragons®
GAME

Epic Adventures with Wizards, Dragons and Magic!

ABOVE Sometimes called by its product code, the "1070," the 1991 *Dungeons & Dragons Game* was a true beginner's set.

OPPOSITE A provocative 1991 advertisement for the forthcoming *Dungeons & Dragons Game* with art by Jeff Easley.

BY THE EARLY 1990s, everyone had to acknowledge that *Basic* D&D wasn't basic anymore. It had gone from a single rulebook in 1977 to the separate *Basic* and *Expert* boxed sets in 1981 to the five-part Frank Mentzer opus of the mid-1980s. So in 1991, TSR, Inc. ultimately capitulated and distilled the final form of the *Basic* game into the Dungeons & Dragons *Rules Cyclopedia*, compiled by Aaron Allston. This 304-page tome combined the *Basic*, *Expert*, *Companion*, and *Master* box set rules into an all-in-one game system, designed to be all things to all people. Intended for players and Dungeon Masters alike, the *Rules Cyclopedia* is still remembered by fans of the *Basic* Dungeons & Dragons series as the go-to book for the original game experience.

So what would starting players turn to, then, in the absence of a basic product? TSR designer and author Troy Denning produced "the new, easy to master" *Dungeons & Dragons Game* in 1991, a product that—at Lorraine Williams's direction—adopted the "Direct Instruction" approach popularized by Science Research Associates, reading cards to gradually indoctrinate novices into the concepts of D&D. It shipped in a long black box with a Jeff Easley dragon on its cover, which contained a slender rulebook and a folded poster game-board map called Zanzer's Dungeon

that cardboard figures would explore in a tutorial game. No doubt, its board-game structure owed a certain debt to the 1989 game *HeroQuest*, a popular dungeon crawl joint-venture between Milton Bradley and TSR's British rival, Games Workshop. This new "black box" version of D&D sold a half-million copies and inspired a series of "Adventure Pack" scenarios to supplement the initial game. It furthermore became the first in a new line of starter kits that would take the place of the *Basic* series for future editions of D&D. For example, to appeal to even younger consumers, TSR put out the hugely simplified *Dragon Quest* board game under the Dungeons & Dragons logo as way of introducing fundamental tabletop role-playing concepts.

Once consumers took to D&D, they could be steered to any one of many campaign settings to fit their tastes. Beginning in 1991, they could visit a parched world of extinction in the deserts of Athas: Dark Sun showed players a postapocalyptic Dungeons & Dragons world where gladiatorial-style savagery met traditional swords and sorcery. However, this was the third Advanced Dungeons & Dragons campaign box setting released in two years. For all the good ideas crammed into these three settings, the products themselves were in danger of competing with each other.

ABOVE, LEFT A 1991 ad for TSR's new introductory *Dungeons & Dragons* edition.

ABOVE A "Direct Instruction" card from the 1991 *New, Easy to Master Dungeons & Dragons* game.

BELOW The year 1991 was in the midst of the baseball-card boom, and TSR saw an opportunity to get a piece of the action by utilizing its vast archive of art to print and sell collectible trading cards.

OPPOSITE Jeff Easley's cover painting for the 1991 *Rules Cyclopedia*.

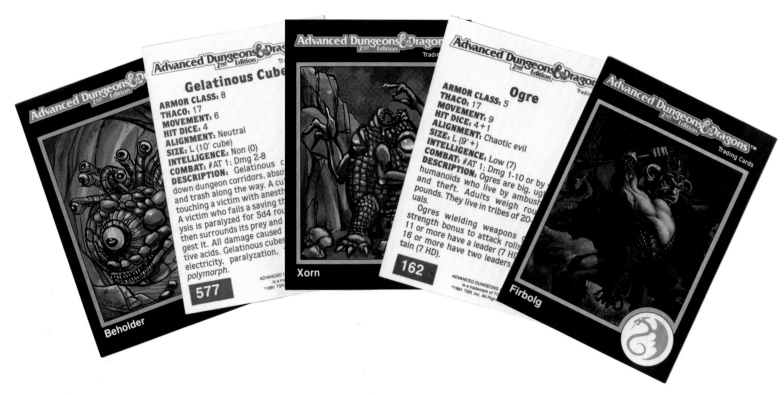

DARK SUN

IN 1990, AS SALES of Dragonlance were beginning to wane, TSR continued its push into new, nontraditional fantasy campaign settings in an effort to bolster and expand the Dungeons & Dragons brand. Spearheaded by key designers Timothy B. Brown and Troy Denning, and supervised by industry veteran Steve Winter, pre-production began on what was then called War World, a brash, postapocalyptic realm, devoid of all fantasy hallmarks.

Tasked with not only designing an exciting new world but also stimulating cross-product synergy, the team incorporated a few ideas resurrected from D&D's past, including mass-combat gameplay (via the *Battlesystem* second edition) as well as the psychic mental powers known as psionics, which just made their AD&D 2nd edition debut in the *Complete Psionics Handbook*. But with a largely blank canvas

before them, the team surprisingly drew much of their inspiration from a young painter named Gerald Brom (known professionally by his surname alone) who had been assigned to the story group. It quickly became apparent that TSR had a star in their midst.

Brom's richly detailed, mood-drenched concepts defined more than just the look of the universe—more poetically renamed Dark Sun. These illustrations directed every aspect of design, from character creation and landscape to the overarching narrative concept. "I pretty much designed the look and feel of the Dark Sun campaign. I was doing paintings before they were even writing about the setting. I'd do a painting or a sketch, and the designers wrote those characters and ideas into the story. I was very involved in the development process," Brom recalls.

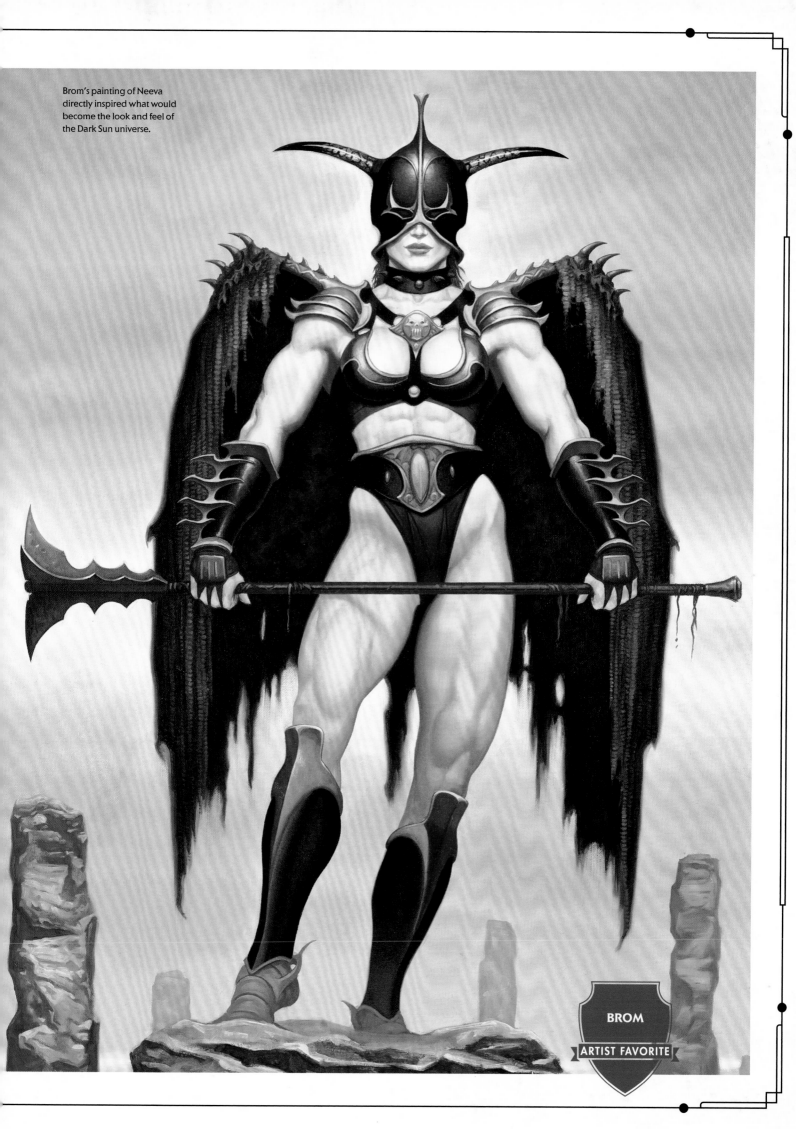

Brom's painting of Neeva directly inspired what would become the look and feel of the Dark Sun universe.

BROM

ARTIST FAVORITE

Brom's artwork for *Dragon's Crown* beside Frank Frazetta's cover illustration for *Conan: The Buccaneer*.

While early pulp fiction had inspired the imaginations of D&D's creators, it was later editions of these same pulp stories that set the visual bar for TSR artists, most notably Frank Frazetta's illustrations for the Conan editions of L. Sprague de Camp. Virtually all of D&D's key artists, from Erol Otus, Jeff Easley, and Larry Elmore to Keith Parkinson and Brom, have cited Frazetta's work as foundational to their style, bringing the game's pulp tradition full circle. Nowhere is Frazetta's influence felt more keenly than with Dark Sun.

By the time the game was released in 1991, Dark Sun had surged to life as a savage, magic-ravaged, desert realm named Athas. The scorched wastes of Athas saw player characters trade in blood and sand as conventional fantasy was dashed upon the rocky, yet perversely beautiful landscape. Weapons of bone splintered as players fought for survival in a resource-starved land where, ostensibly, most fantasy creatures such as elves and dwarves had long since died out. Metal was scarce, magic was terrifying, and players were enthralled.

In Brom's lush imagery, which adorned nearly every facet of the product line, one could feel the oppressive, radiating heat, and hear the thunderous approach of slave tribes across scorched earth. Although familiar fantasy races and character classes appeared in Dark Sun (despite early ambitions to omit them), they did so with dramatic aesthetic facelifts to properly mesh them with the setting's uniquely tenebrous tone. Nearly everything took a gladiatorial spin—warriors donning bone armor clash with leather-and-chain clad sorcerers. All told, Dark Sun was more *Mad Max* than Middle-earth.

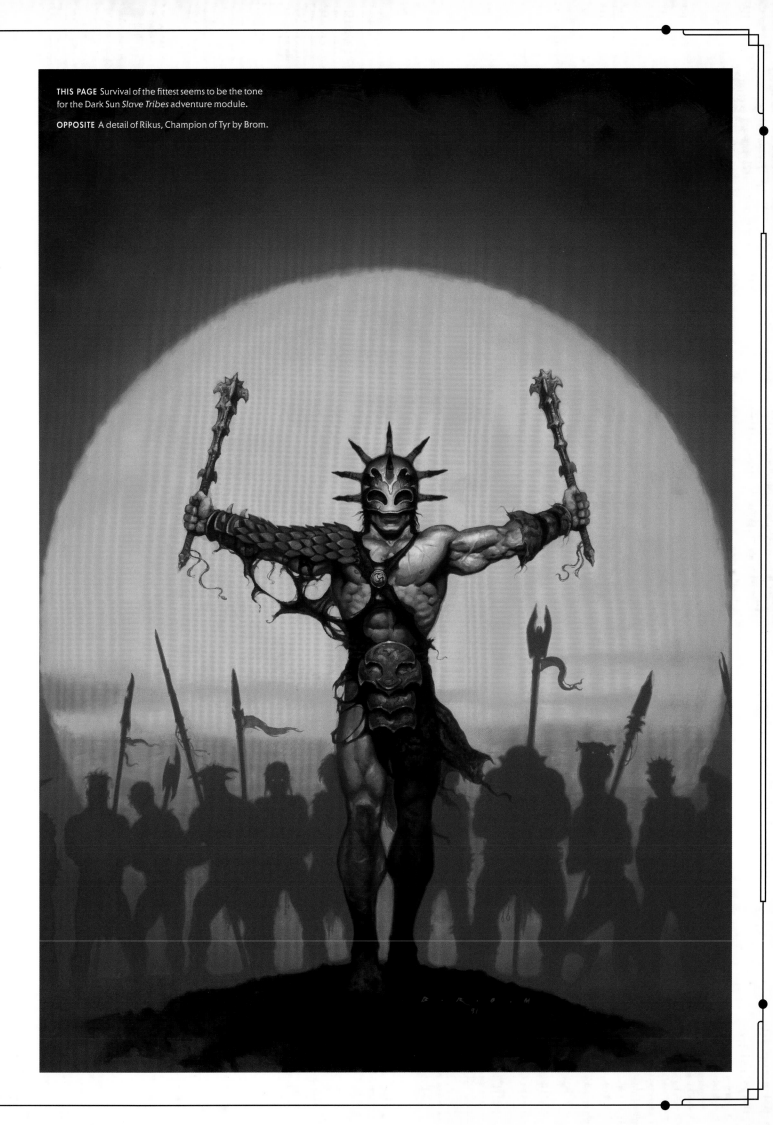

THIS PAGE Survival of the fittest seems to be the tone for the Dark Sun *Slave Tribes* adventure module.

OPPOSITE A detail of Rikus, Champion of Tyr by Brom.

The 1992 *Al-Qadim Land of Fate* boxed set with cover art by Fred Fields.

DOUBLING DOWN

The success and acclaim of the exotic Dark Sun campaign opened the door for new adventures in the sand with TSR's 1992 Al-Qadim campaign setting, themed around adventures of Middle Eastern legend, such as the Arabian Nights. Developed by veteran designer Jeff Grubb and based in the larger world of the Forgotten Realms, Al-Qadim detailed a peninsula of Faerûn called Zakhara, the Land of Fate. Having much more in common with early Hollywood depictions rather than hard historical fact, slashing scimitars cut through desert raiders, flying carpets zoomed over romantic sun-soaked landscapes, and carefully worded wishes were issued to djinn and efreet living inside, or sometimes outside, of magic lamps. It is through this campaign setting that the infamous, efreet-infested City of Brass is finally laid out in detail, by the same hand who had first depicted it for D&D audiences on the 1st edition *Dungeon Masters Guide* more than a decade earlier: Dave Sutherland. While Sutherland had long since left illustrations to TSR's stable of professional artists, he remained with the brand into the 1990s, leading the company's cartography efforts—an area to which he had always considered himself best suited.

Avencina
1 Gate of Ashes
2 Sultan's Renovation
3 Rebel's Rubble
4 Ghost District
5 Burnt Bean (famous coffeehouse)
6 Rabblerouser's Square

Arches
7 Slave Market
8 Chained Palazzo

Ashlarks
9 Zam-Zam (coffeehouse for slumming nobles)
10 Commoner's Market
11 Krak al-Tawil
12 Lookout Point
13 Shimmering Gate
14 Shimmerwaste

Castings
15 Duelist Row
16 Parade Grounds
17 Officers' Barracks
18 Armories and Stables
19 Gate of the Fallen
20 Firefist Alley (brawling site)
21 Embassy of the Brotherhood of True Flame
22 Ring of the Unquenchable

Char
23 Canal Docks
24 Phoenix Gate
25 Red Wyrm Smelter
26 Forge of Manacles
27 Locksmith's Row

Cindersweeps
28 Drydocks & Military Dock
29 Krak al-Zinad
30 Gate of the Simoom

Iskalat (docks)
31 The Lighthouse
32 Captain's Suq (ship's chandlers)
33 Magma Gate
34 The Octagon

The Foundry
35 Plaza of the Hunters
36 Plaza of the Silver Chariot
37 Gate of Glory
38 Fountain of Clearest Azure
39 Orangerie

The Furnace
40 Charcoal Palace
41 Red Pillar Halls
42 Breath of the Sultan
43 Barracks of the Ring of Fire
44 Eternal Flame Pavilion (Agni)
45 Mosque of Blistering Atonement (Imix)
46 Mosque of the Irreducible (Freyal)
47 Mosque of Kossuth (abandoned)
48 Flamesight Mosque (Hastsezini)
49 Guardians of the Three Flames Chapterhouse

Al-Qadim

SECRETS OF THE LAMP

to Obsidian Fields
1 Gate of Ashes
28
66
80

Street of Steel
53
3
Avencina
2
63 Golden Gate
Maidan
67
64
66 Street of
the
Last Houses
Krak al-Nayyiran
The Plume
68
Prism Gate
Krak al-Tawil
4
27 24
Phoenix
Gate
60
The Char
58
26
23
25
Furnace
46
47
45
21 20
Castings
59
Gate
78
74
70
48
40
Charcoal Palace
44
49
15
16
17
Red
Pillar
Halls
41
42
43
22
The
Chimney
smiths 73
Pyraculum
80
76
71 Street of Stelae
69 Gate of
the Fallen
19 18
61
Cindersweeps
77 79
37
Gate of the
Simoom
72
38
30
75
Naranj Canal
36
28
Naval
Yards
The Foundry
Krak
al-Zinad
39
The
Arches
8
Zinad Bridge
Sea of Fire
40
39
45
44
63

Poppy Fields

to Quarry

Keffinspires
50 Street of Steel
51 Golden Tower of the Azer Steel Guild
52 Cloud Palazzo (ramps to aerial walkways)
53 Basalt Palazzo (azer tower)
54 Diamond Gate
55 The Great Smithy

Marigate
56 Caravanserai District (warehouses)
57 Scorpion Alley (sparktail nests)
58 Dao Guard Drillgrounds

The Plume
59 Palazzo of Spears (general's palazzo)
60 Palazzo of Stamping Hooves (vizier)
61 Watchfire House (minister of security)
62 Krak al-Nayyiran
63 Golden Gate
64 Obelisk of the First Sultan
65 Prism Gate
66 Street of the Last Houses
67 Maidan
68 Ahsinat Bazaar (horse market)
69 Palazzo of Nine Black Pillars
70 Ebony Palazzo (baatezu embassy)
71 Blue Horse Palazzo (Sultan's physician)

Pyraculum
72 Mehara Bazaar (camels/saddle-makers)
73 Street of Craftsmen
74 Qahwa Suq (coffee/beans/spices)
75 Marabout Suq (preachers/books/holy items)
76 Dir al-Nasr Bazaar (hawks/hounds)
77 Hayyat Suq (cloth/tailors)
78 Edible Bazaar (vegetables/fruits)
79 Marakish Bazaar (leather goods)
80 Street of Stelae

Rookery
81 Seven Maidens Gambling Den
82 Kassar's Pleasure Garden
83 Arena of the Red Claw
84 Street of the Vine (wineshops)
85 Kalian (smoke vendors' bazaar)
86 Khat Market
87 Blue Feather Arena
88 Bridge of Delights
89 Gate of the Eternal Sun/Roumi Plaza
90 Maboul Fennec Square

The City of Brass

1 inch equals ½ mile

AL-QADIM is a trademark owned by TSR, Inc. ©1993 TSR, Inc. All Rights Reserved.

The 1993 City of Brass map from the *Secrets of the Lamp* boxed set by Dave Sutherland. This map of the hellish city is largely considered one of his finest, making the inscription on his 2005 gravestone all the more poignant: "Time to Map Heaven."

Advanced Dungeons & Dragons®
2nd Edition

Monstrous Manual™
Game Accessory

TSR

ON SALE NOW . . .
A first from R. A. Salvatore
The best-selling FORGOTTEN REALMS® novelist debuts in hardcover!

Don't miss the premier hardcover novel by R. A. Salvatore. *The Legacy* picks up where the FORGOTTEN REALMS® Dark Elf Trilogy left off. Drizzt Do'Urden thinks he has all of his problems solved until he finds himself caught in a web of hatred. The Spider Queen, Lloth, is out to poison his life with a vengeance!

In his best-selling tradition, R. A. Salvatore sets the stage for a new fantasy trilogy with *The Legacy*. Pick up this spellbinding tale today at book and hobby stores everywhere.

"There was a playfulness in the RPGs of the 1970s and 1980s, and I wanted to recapture a little bit of that."

—TONY DITERLIZZI, *MONSTROUS MANUAL* ARTIST AND CO-CREATOR OF *THE SPIDERWICK CHRONICLES*

Complementing the growth of TSR's gaming products, its publishing efforts also thrived in releases like R.A. Salvatore's hardcover D&D novel, *The Legacy*, which debuted in the top ten of the *New York Times* best-seller list. The company also endeavored to course-correct some of its more experimental rulebook ideas, such as going back to a single hardcover monster catalog, now called the *Monstrous Manual*, in lieu of continuing to support the unruly *Monstrous Compendium* binder strategy. Many of the illustrations in the new *Monstrous Manual* were completed in watercolor by a young TSR freelance artist named Tony DiTerlizzi, who added a flavor of fun and whimsy to each illustration. Meanwhile, Gen Con's twenty-fifth anniversary attendance shattered previous United States gaming convention records, indicating that the enthusiasm of the gaming community was strong. This no doubt emboldened the leadership of TSR, still the undisputed leader in fantasy role-playing games, to continue full steam ahead.

However, things were not as they were back in the heyday of TSR. In the 1970s and 1980s, Dungeons & Dragons was an innovative, one-of-a-kind product, and while there was some competition, none matched the art, story, quality, or reach of D&D products. TSR could largely dictate to its market. But now, other companies had become serious challengers to TSR's monopoly on the role-playing game concept. Titles like White Wolf's *Vampire the Masquerade* and West End Games' *Star Wars* role-playing game offered not just alternatives to Dungeons & Dragons, but vast departures in feel and genre. The core audience was no longer a monolithic, D&D-exclusive tribe. Nevertheless, these sorts of competitors were still playing on D&D's home turf—a more worrisome bid for gamers' attention came with the 1993 release at Gen Con of the card game *Magic: The Gathering* published by a small start-up called Wizards of the Coast. *Magic's* abrupt popularity and thematic resemblance to Dungeons & Dragons was noted with alarm by TSR leadership.

Ironically, a few years earlier when *Magic* creator Richard Garfield began circulating a prototype of his revolutionary new card game, he knew he wanted the cards to feature artwork and he turned to several sources, most notably Dungeons & Dragons. Many of the monsters in Garfield's prototype came directly from the 1977 *Monster Manual*: the djinn, ghoul, hydra, minotaur, basilisk, gargoyle, and many others were just imported creatures and their portraits on prototype cards. For other creatures, he found superior illustrations elsewhere in Dungeons & Dragons books: the Eye of Fear and Flame portrait from the *Fiend Folio* for the Lich, and its Sandman for the Doppleganger card.

But these borrowings did not stop with portraits of creatures. The prototype cards similarly used images from Dungeons & Dragons to depict items and even spell effects. The Rod of Ruin copied its artwork from the *Monster Manual*'s Wand of Orcus. The *Fiend Folio* furnished sources for the spell effects of the Animate Wall card, via the stunjelly portrait, and the Regrowth card, which took its artwork from yellow musk creeper. Even Starburst, the most notorious of the prototype cards—its ambiguous phrasing "Opponent loses next turn" having sown confusion throughout the playtesting community—took its depiction from the urchin in the *Monster Manual II*.

While *Magic: The Gathering*'s visual vocabulary began with Dungeons & Dragons, its instant success had disrupted the fantasy gaming market and created an uncertain future for its visual progenitor.

GEN CON:
WHERE IT ALL BEGAN

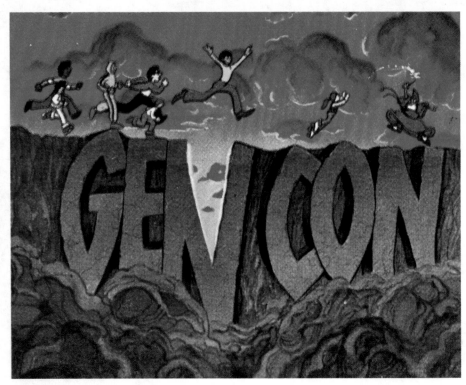

TOP Gary Gygax (second from left) sporting a mustache and contemplating his move.

ABOVE Dave Arneson (second seated from left) with his hand at his brow, at Gen Con in 1969.

RIGHT A still from a thirty-second animated short from 1980 featuring Morley, advertising Gen Con to a television audience.

IT WOULD BE NO exaggeration to call Gen Con the cradle of Dungeons & Dragons. Gary Gygax founded the convention in 1968 and met D&D co-creator Dave Arneson a year later at the second event. And while D&D may not have been released at Gen Con in 1974, the gamers who played it that summer under the tutelage of the original authors brought back with them an understanding that helped the game take hold throughout the Midwest and beyond.

In 1975, TSR quietly took over Gen Con from Gygax's local wargaming club, and from that point forward, it became deeply associated with TSR's flagship product. For some competitors, Gen Con and D&D were a little too close for comfort. The rival Origins convention, hosted by Avalon Hill, became a venue for more traditional wargame companies to check the ascendance of fantasy role-playing—though D&D tournaments flourished there from the very start. Rival wargame publishers still connected with customers at Gen Con, as did the many smaller players in the role-playing space, but they did so in the shadow of TSR's castle— literally, as TSR would erect imposing walls and ramparts around its own section of the convention floor.

Gen Con was the first place you could buy a *Players Handbook* in 1978, and in 1979, if you bought the new *Dungeon Masters Guide* at Gen Con XII, you might be one the lucky few to receive a copy signed by Gygax and cover-artist Dave Sutherland. The AD&D "open" tournaments that followed at Gen Con became the inspiration for numerous modules to come: in 1980, for example, it was the famous *Slave Lords* progressive tournament that would become modules A1–A4. A pilgrimage to Gen Con became a required demonstration of every true D&D fan's devotion.

Originally, Gen Con attracted a crowd of just one hundred to the Horticultural Hall a block away from Gygax's home in Lake Geneva, Wisconsin. By 1977, it had to relocate to a succession of larger venues: the local Playboy Club resort, then to nearby college campuses, and then to the city of Milwaukee, where it occupied a convention center that could hold the twenty-five thousand people who would attend Gen Con by the 1990s. It would be in that rich environment that the second great fantasy hobby game would debut in 1993, *Magic: The Gathering*.

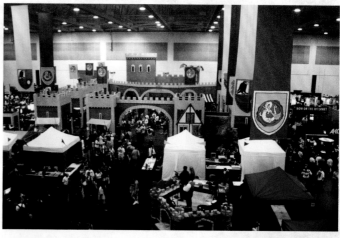

ANNOUNCING TWO IMPORTANT
NEW RELEASES FROM TSR

GAMMA WORLD*

*T.M. REG. APP. FOR

SCIENCE FANTASY ROLE PLAYING GAME

A complete boxed game of adventure on
a post atomic earth where mutants and
robots contend with the survivors
of the human race for
mastery of the
world!

AT ORIGINS
78
078

AT

GEN CON XI
ADVANCED
DUNGEONS & DRAGONS®
PLAYERS HANDBOOK

By Gary Gygax

The authoritative manual of character races, abilities, classes, alignments, and much more. A must for every D & D enthusiast.

TSR HOBBIES, INC.
P. O. BOX 756
LAKE GENEVA, WI 53147

TOP, LEFT Gary Gygax at Gen Con XI in 1978.

TOP RIGHT TSR's castle display at Gen Con in the early 1990s, which attracted gamers in droves to visit or play before its walls.

CENTER Fans at the TSR booth at Kenosha, and seated for game play.

LEFT Hobby gaming in the 1970s was a small and dispersed market, so gaming conventions such as Origins and Gen Con were the perfect places to announce and release new products.

SAVING THROW

TSR had, in 1994, watched the tiny hobby gaming company Wizards of the Coast achieve startling success within the span of just a year with its ground-breaking *Magic: The Gathering* collectible card game (CCG)—a narrative very different from the steady year-after-year growth of TSR two decades earlier. In an attempt to ride this wave of opportunity, TSR developed and published its own card-based game, *Spellfire: Master the Magic*, featuring the well-known names and campaign settings of the AD&D game: now you could fight the Forgotten Realms against Greyhawk! This release showed TSR very much playing the role of an established company predictably reacting to a winning gamble taken by a younger, more agile competitor. *Spellfire* was only the second CCG on the market, and it had the advantage of being able to harvest some of the most famous intellectual property in fantasy gaming; however, the game over time failed to capture a loyal fan base due to a marketplace dominated by *Magic*. Much like the many parallel plays that emerged in the wake of D&D itself, *Spellfire* could not topple the original and dominant instance of this new genre of game.

By the 1990s, few critics could single out D&D as dangerous and demonic. Other role-playing and video games, featuring content and themes far racier than the somewhat sanitized 2nd edition, began popping up. White Wolf's games relied heavily on adult themes, to the point where they eventually spawned a subsidiary brand, Black Dog, to carry content that might ordinarily come in an opaque wrapper. When the hyper-violent, gore-ridden first-person-shooter video game *DOOM* hit shelves at the end of 1993 to extraordinary success, parents and censors alike had found a new object of their collective dissension, and D&D largely fell off their radar.

RIGHT, TOP The box of the *Spellfire* deck from 1994, featuring some reused Dragonlance cover art by Keith Parkinson.

RIGHT Though long since ousted from TSR, Gary Gygax's personal D&D character, the legendary Mordenkainen, made an appearance in the game as one of the Greyhawk cards.

OPPOSITE Video game giant Capcom's 1993 *Tower of Doom*—a game that proved far less gory than another D&D-inspired game that shared a similar name released that same year, the seminal first-person-shooter, *DOOM*.

ダンジョンズ アンド ドラゴンズ
Dungeons & Dragons
Computer Game
タワー オブ ドゥーム
TOWER OF DOOM

物　語

ダロキン共和国、栄え豊かなこの国に不吉な暗雲が垂れ込める。
組織化された凶暴なモンスター達が群れをなして町を襲い始めたのだ。
町の有力者コーウィン・リントンは、君たちにこの異常の調査を依頼するだ
ろう。行く手には様々な困難と危険が口を開けて待っている。武器を取り、
呪文を唱え、恐怖を払え！　冒険の時は来た！……

コックピットの見方

職業とレベル ──

名前 ──

魔法、アイテムウインドゥ
(Dボタンで選択、Cボタンで使います。)

── 経験点(得点)

── ヒットポイント
hp

── 所持金
SP(シルバーポイント)

D&D941001

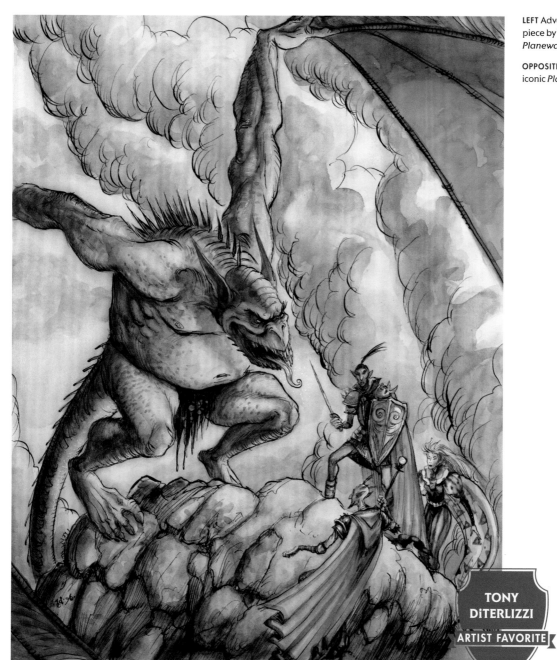

LEFT Adventurers in a tight spot in this piece by Tony DiTerlizzi from the 1996 *Planewalkers Handbook*.

OPPOSITE AND BELOW Robh Ruppel's iconic *Planescape* cover.

TONY
DiTERLIZZI
ARTIST FAVORITE

WHILE TSR HAD FAILED to take over the CCG market, they continued to be a prime mover in fantasy role-playing. TSR's newest contribution to the market would be a campaign set in the dark and richly evocative world of Planescape. Developed by Zeb Cook, *Planescape* allowed players to journey across the multiple planes of existence detailed in the 1987 *Manual of the Planes*. The campaign provided Dungeon Masters a bridge between the various Dungeons & Dragons campaigns, just as Spelljammer had tried previously. With its quirky design and the haunting visual dreamscapes created by Tony DiTerlizzi, Dana Knutson, and Robh Ruppel, Planescape won many devoted fans. Locations such as the City of Doors, otherwise known as Sigil, and characters like the Lady of Pain, the goddess-like protector and ruler of Sigil, were burned permanently into the lexicon of Dungeons & Dragons. While popular with fans, Planescape's gothic, bleak stylings proved oddly appropriate for a company with an uncertain future, seemingly lost in one of the Lady's magical mazes.

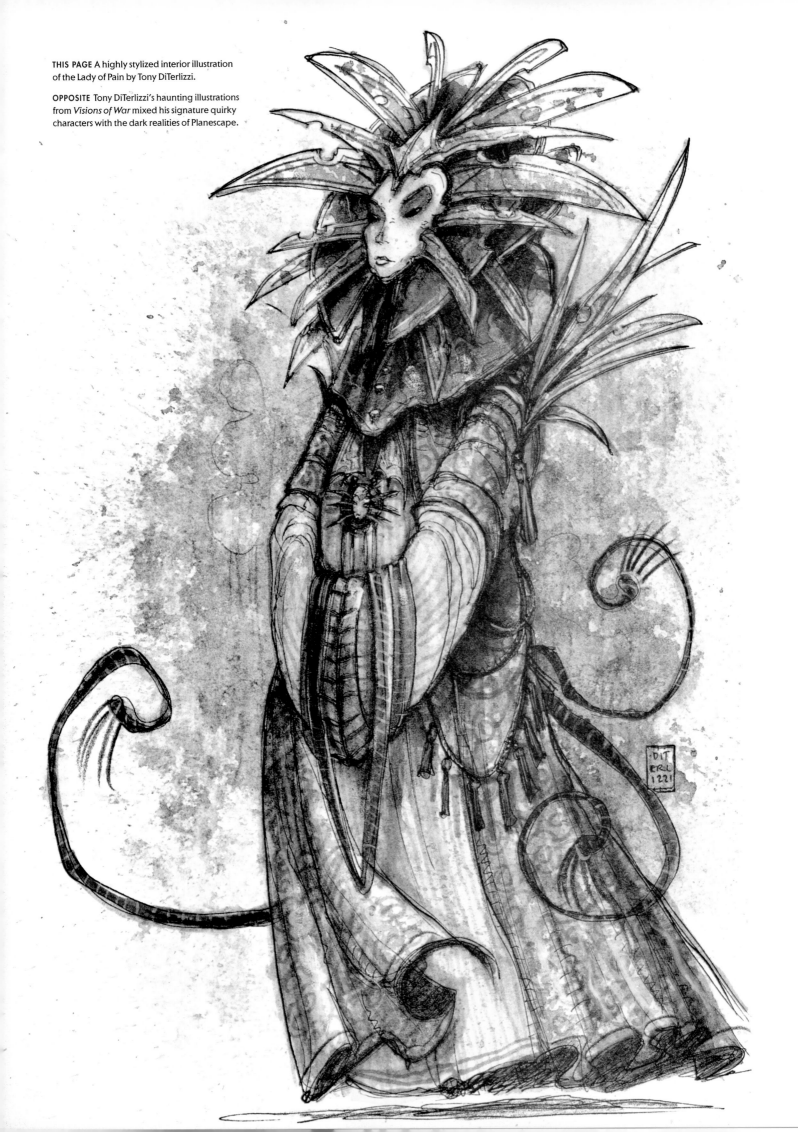

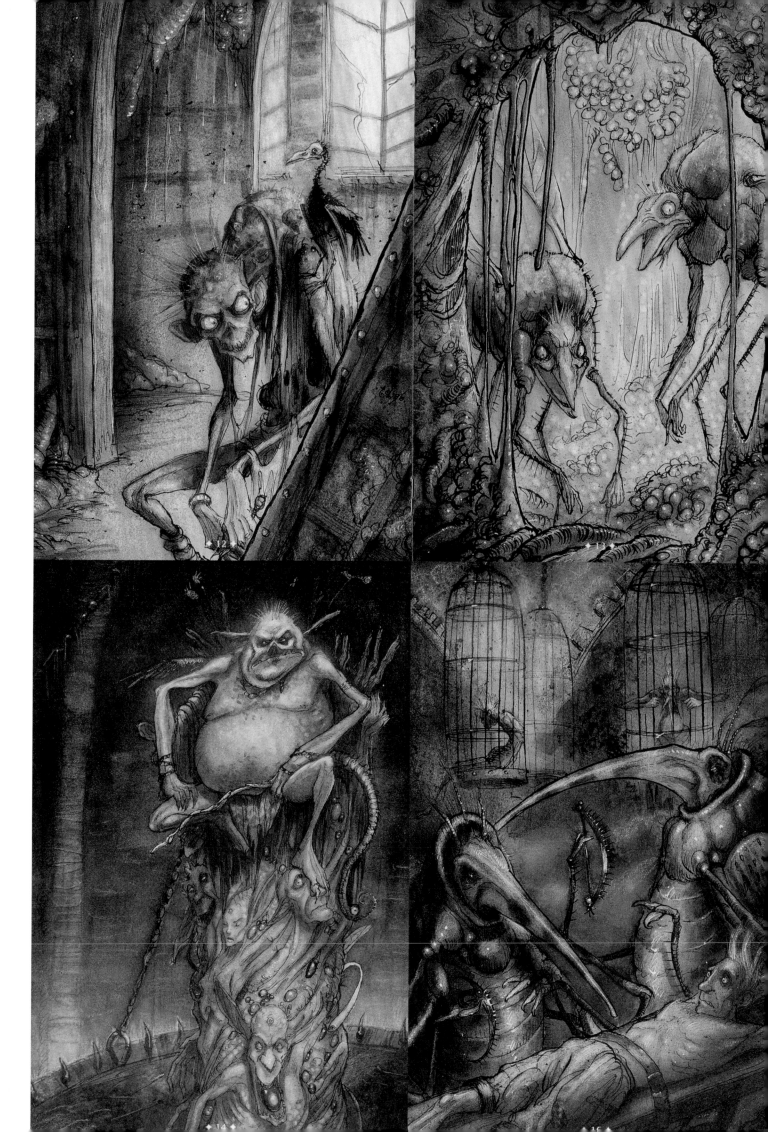

Planescape pushed D&D's aesthetic range, from the dreamy and whimsical to the bleak and outright hopeless.

THIS PAGE Robh Ruppel's cover art for the later Planescape box set *Hellbound: The Blood War*.

OPPOSITE rk post's cover art for the popular Monte Cook adventure module *Dead Gods*.

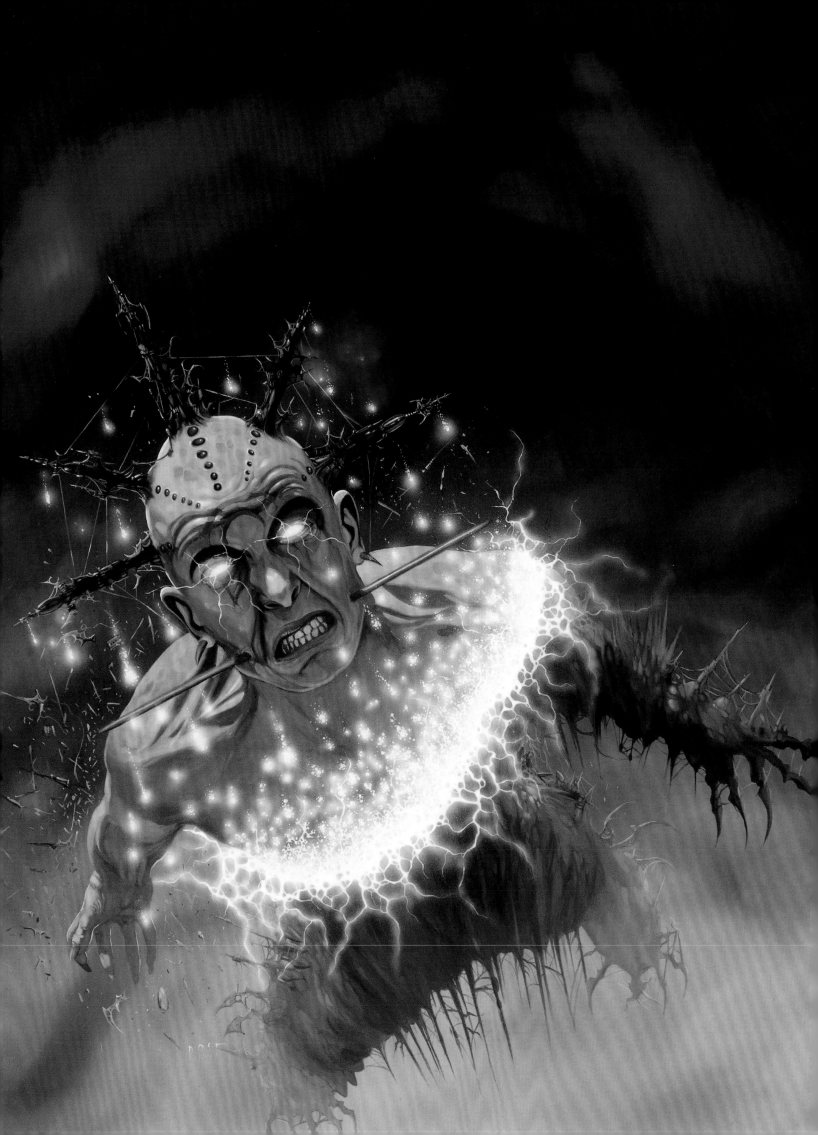

"THE BIGBY'S INTERPOSING HAND SPELL CREATES A MAN-SIZED TO GARGANTUAN-SIZED MAGICAL HAND THAT APPEARS BETWEEN THE SPELLCASTER AND HIS CHOSEN OPPONENT. THIS DISEMBODIED HAND THEN MOVES TO REMAIN BETWEEN THE TWO, REGARDLESS OF WHAT THE SPELLCASTER DOES OR HOW THE OPPONENT TRIES TO GET AROUND IT."

5

BIGBY'S INTERPOSING HAND

THE FALL OF TSR

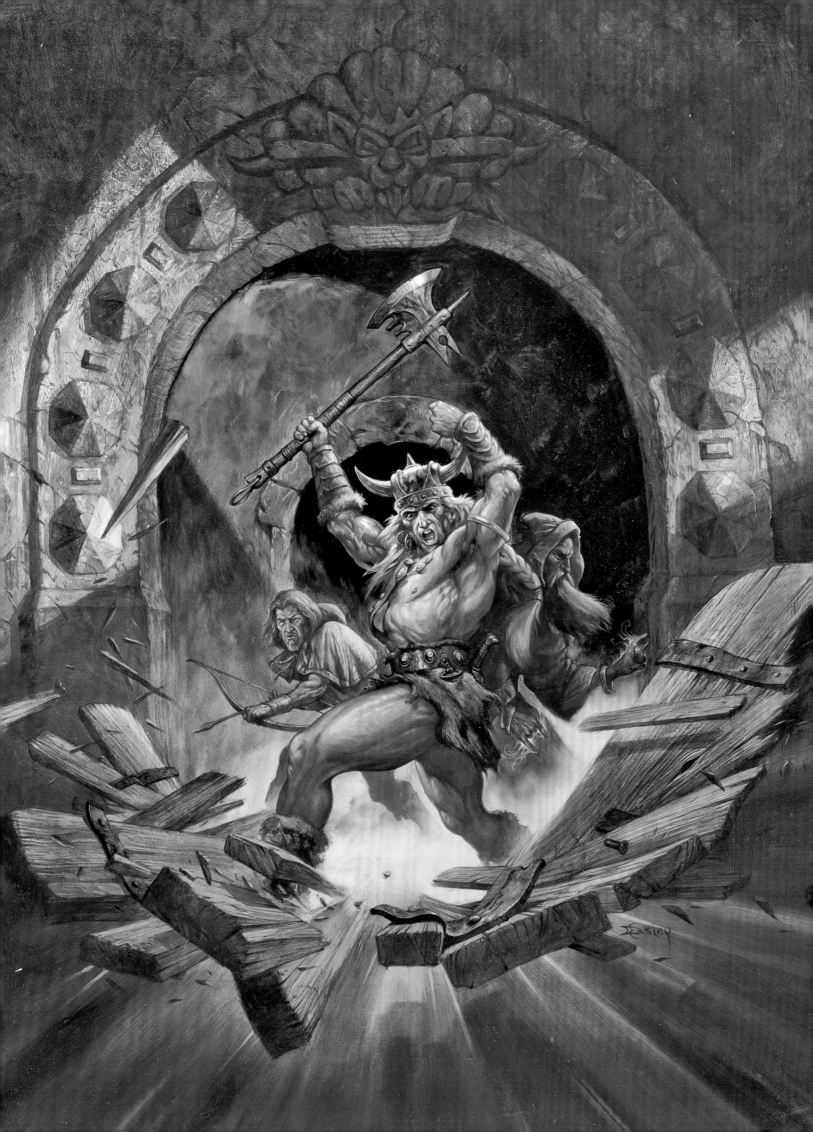

OPPOSITE Jeff Easley's cover art for the 1995 release of the 2nd edition Advanced Dungeons & Dragons *Player's Handbook*.

BELOW The 1995 AD&D 2nd edition core rulebooks featured new Jeff Easley covers and full-color interiors.

TSR MARKED ITS twentieth anniversary in 1995 with revised versions of the 2nd edition core AD&D rulebooks under new and more austere trade dress—the release not only dropped the term "2nd edition" from its emblem, but would have the dubious distinction of being the only version of the D&D logo after 1983 not to disguise a dragon breathing fire in its ampersand. This would prove the last publication of the Advanced Dungeons & Dragons ruleset as envisioned by Gary Gygax, but also the most lavishly executed, with its full-color art and expansive layout. The editions were substantially lengthier—about 25 percent for the *Player's Handbook* and 33 percent for the *Dungeon Master Guide*—but as Steve Winter's foreword observes of these extra pages, they "used them up just looking good," as the space went to lavish layout and illustrations rather than more text.

These books featured the artwork of Jeff Easley, Robh Ruppel, Dana Knutson, Roger Loveless, and others, and cleverly included reimaginings of the original "instructional art" scenarios from the AD&D 1st edition rule books, such as David Trampier's seminal *Player's Handbook* cover—this time from the perspective of those pesky thieves. With the establishment of additional gaming worlds in the Dungeons & Dragons pantheon, this ruleset now encompassed AD&D in its pure form. Much like the *Rules Cyclopedia* was for *Basic* D&D, it represented the last word in Advanced Dungeons & Dragons.

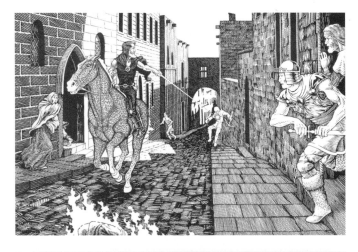

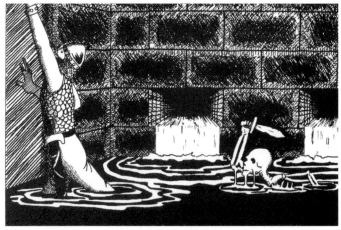

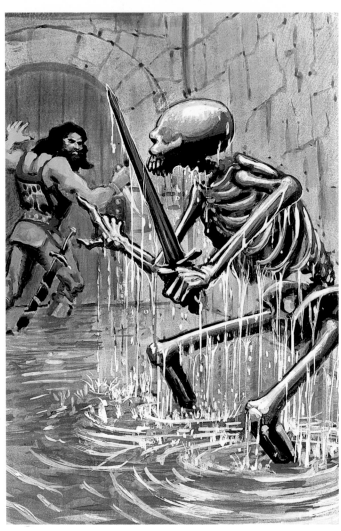

THIS PAGE AND OPPOSITE The 1995 *Player's Handbook* and *Dungeon Masters Guide* welcomed old players to a newly revised layout while assuring them that this was still the AD&D of old. To illustrate their point, many classic art pieces and scenarios that filled the pages of the AD&D 1st edition books of the late 1970s were re-created with a modern aesthetic.

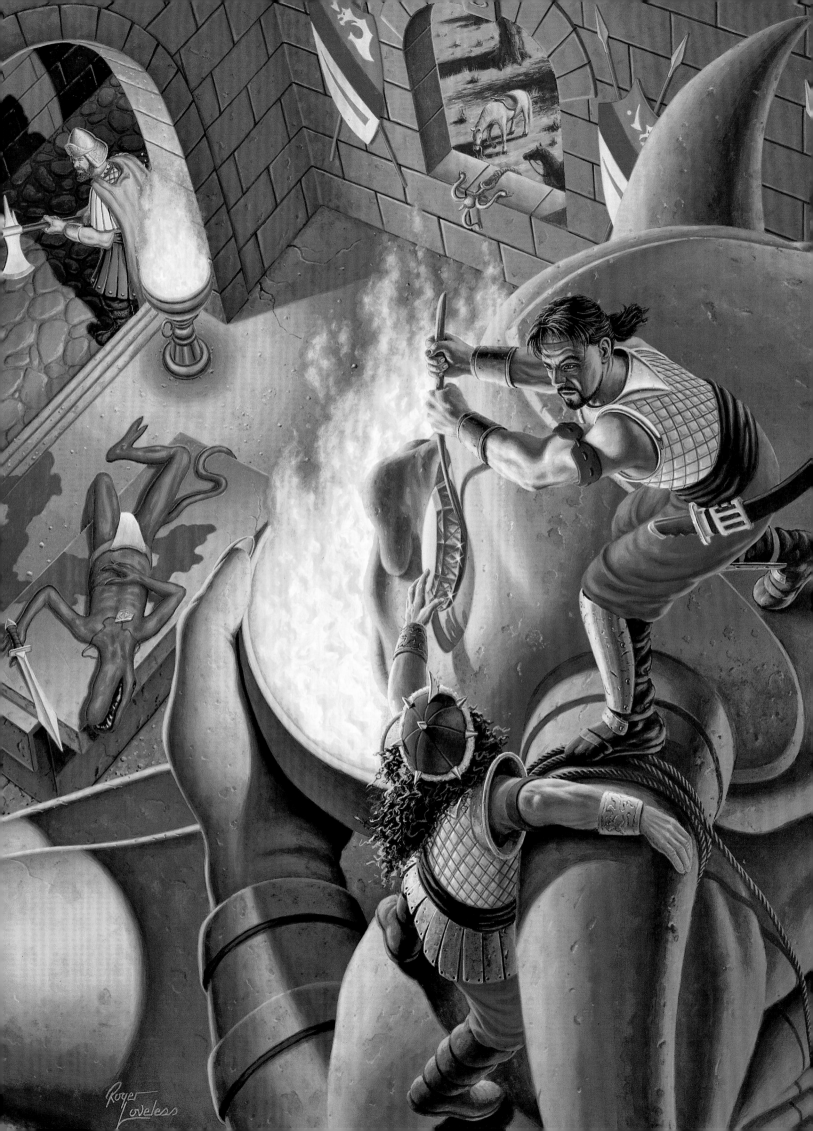

ABOVE, LEFT Reimaginings of the illusionist and cleric from the 1995 *Player's Handbook*.

ABOVE, RIGHT The hardcover *Player's Option* series added yet another dimension of à la carte customization to each game.

RIGHT Meant as a creative alternative to collectible card games, *Dragon Dice* tried to bring the same approach to collectible dice.

OPPOSITE Jennell Jaquays' cover art for the *Dragon Dice Battle Box* set.

JUST BECAUSE THE REISSUED AD&D books stayed quite close to the 2nd edition originals did not mean TSR was out of ideas. They quickly followed with a host of *Player's Option* and *Dungeon Master Option* books filled with variant rules reimagining character generation, combat resolution, spellcasting, and similarly fundamental aspects of the game. By making all of this optional, however, they effectively diluted the integrity of the core system. The confident production value of these new products belied the shaky ground that D&D balanced upon. Waning sales along with stiff competition meant that storm clouds were forming above TSR headquarters, causing the company to continue along new and highly speculative avenues, such as another expensive foray into the collectable gaming market with *Dragon Dice*.

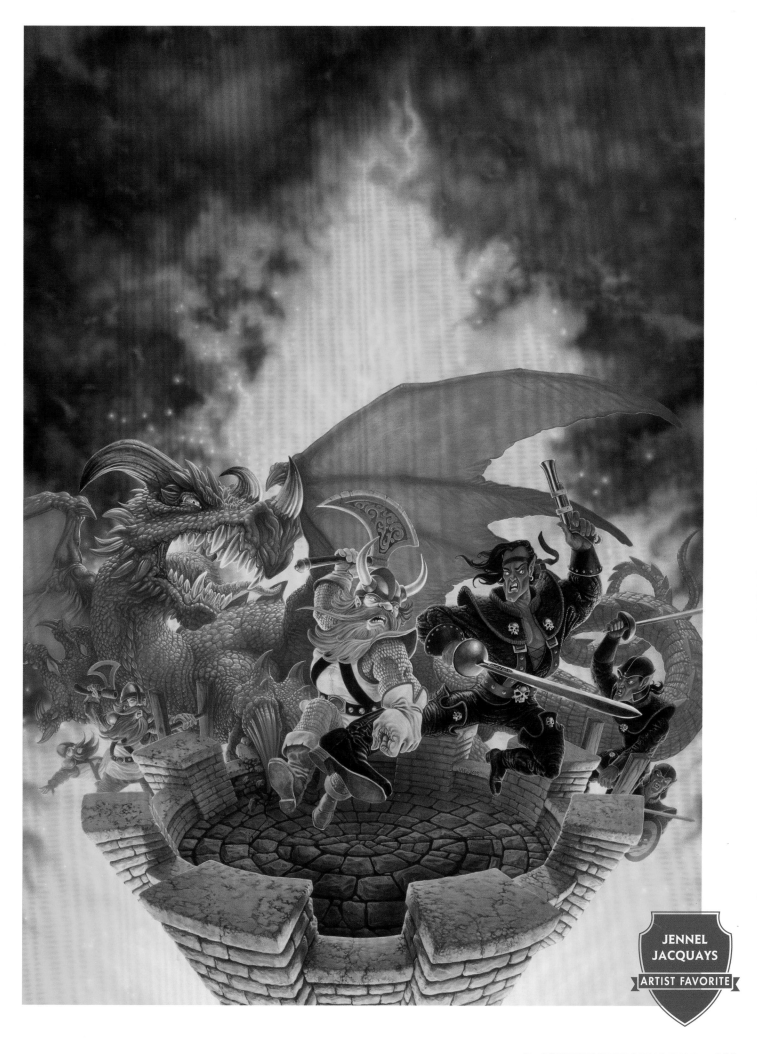

JENNEL
JACQUAYS
ARTIST FAVORITE

Twenty Years of TSR

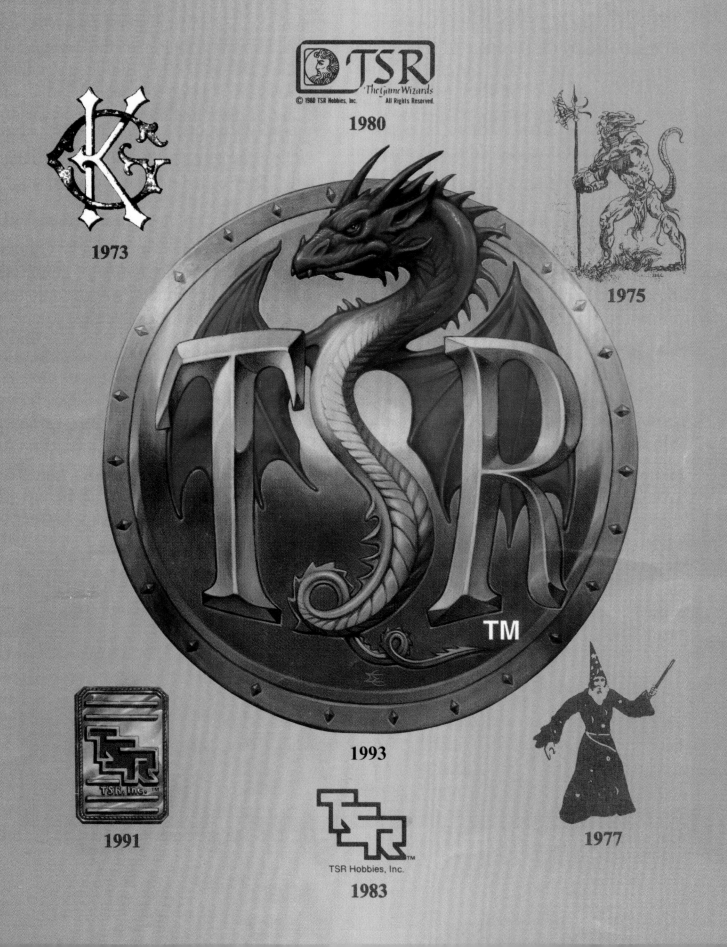

1973

1980

1975

1993

1991

1983

TSR Hobbies, Inc.

1977

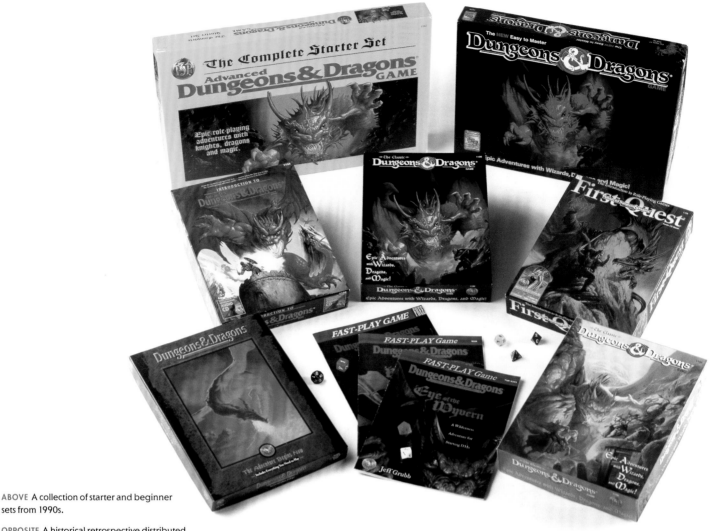

ABOVE A collection of starter and beginner sets from 1990s.

OPPOSITE A historical retrospective distributed to TSR employees to celebrate the company's twentieth anniversary, with a cover tracing the evolution of the company's logos. TSR had indeed grown away from its humble roots, so much so that it couldn't remember what year it began using the Wizard logo: 1978.

BELOW A set of polyhedral dice that came with the *Classic* Dungeons & Dragons game from 1994.

HOWEVER, ON THE OCCASION of the game's twentieth anniversary, TSR did not neglect the need to bring in newbie players. First, it reissued the 1991 "black box" set as the 1994 "classic" D&D game in a new size suitable for bookshelves. But then, it created a comparable product for AD&D initially marketed as *First Quest: Introduction to Role-Playing Games*, which shipped with an interactive audio CD to help guide novices through the process of running the game. Like the "classic" introductory game, it contained a dungeon map and figurines representing pre-generated characters, though instead of a consolidated rulebook it provided a new trilogy of the core three booklets—a *Rules Book, Monster & Treasure Book*, and

Adventure Book—along with separate spell books for wizards and clerics. Within a year, the item had been slightly rebranded as the *Introduction to Advanced Dungeons & Dragons* and given a bright new dragon by Jeff Easley on its cover, while replacing its one-off trilogy with slim paperback abridgments of the newly reissued *Player's Handbook, Dungeon Master Guide*, and *Monstrous Manual*. In short order, and just as abruptly, the item would then be repackaged in a yellow box and rebranded as the *Starter Set*. This frantic churn was symptomatic of the steadily mounting urgency of broadening the market for TSR products, a goal that seemingly remained forever out of reach.

We Introduced Mind-Blowing Experiences!

A pair of 1994 advertisements for D&D's introductory *First Quest* product, which promised "mind-blowing experiences," no doubt through the use of its interactive audio CD.

In 1994, the pioneers in fantasy role-playing games crossed the threshold onto a new level of gaming with audio CD technology. FIRST QUEST™, MYSTARA™, RED STEEL™ and TERROR T.R.A.X.™ interactive audio CD adventures to name a few. Watch for us in '95, we're taking *no* wimps, crybabies, wannabe's or wusses with our new games... Be prepared for TSR.

The Power of Interactive Audio CD Adventures.

AUDIO CD GAME

1 2 3

CAMPAIGN CRAZY

TSR continued to break new ground with the release of its Birthright campaign setting, which let players command the armies of nations, a nod back to D&D's wargaming roots. But as Birthright took its place in the pantheon of the increasingly multifaceted Dungeons & Dragons landscape, it was necessary to distinguish the setting with an artistic aesthetic that was further afield than any modern Dungeons & Dragons counterparts of the time. This compounded another problem that was brewing from a marketing perspective: the visual identity of the Dungeons & Dragons brand was growing inconsistent. Birthright, Planescape, Al-Qadim, Dark Sun, Hollow World, and Ravenloft all had distinctive visual styles and identities, to say nothing of earlier campaign settings such as Greyhawk, Mystara, Dragonlance, the Forgotten Realms, and Spelljammer. There were also many historically minded campaign sourcebooks TSR published in the early 1990s, which codified and gamified elements of real-world history and mythology, including books on the Vikings and Celts, on *Charlemagne's Paladins* and the Crusades, the *Glory of Rome,* and a gunpowder-era title called *A Mighty Fortress*. Now, even the real Earth had become another potential campaign setting. All this meant that products from different D&D campaign settings had little visual commonality, which set the identity of D&D as a brand somewhat adrift.

While this "something for everyone" approach serves many businesses well, hobby gaming was still a limited market, and TSR had managed to splinter the Dungeons & Dragons fan base into disparate groups that were playing, in essence, separate games. As a matter of course, when one gaming group committed itself to playing a campaign in Forgotten Realms, for example, it was naturally to the exclusion of playing a campaign in Dark Sun and buying the associated products. Advanced Dungeons & Dragons was competing not only with other gaming companies, but with itself. Moreover, players who yearned to create their own worlds, one of Gary Gygax's original guiding precepts of the game, had been neglected in his absence. Generalized Dungeons & Dragons products that emphasized tools for creators, or generic scenarios that would work in any given campaign, were given second priority next to the prepackaged campaign adventures that could fit into TSR's transmedia strategy of novelizations, computer adaptations, and comics. Worse still, the Internet brought together fans of its new nemesis, Wizards of the Coast, while TSR just barely established a presence on AOL by January 24, 1995—where they at least managed to make part of the February issue of *Dragon* available for download.

1

2

3

4

4 5

Here, Jeff Easley was saddled with the unenviable task of melding many of TSR's key campaigns into a single campaign for the TSR 1991 catalog. Even Buck Rogers makes an appearance in this strange amalgam of D&D and TSR campaign worlds.

LABYRINTH OF MADNESS

For characters of level 15 and above 9503

Advanced
Dungeons & Dragons

Labyrinth of Madness

For characters of level 15 and above

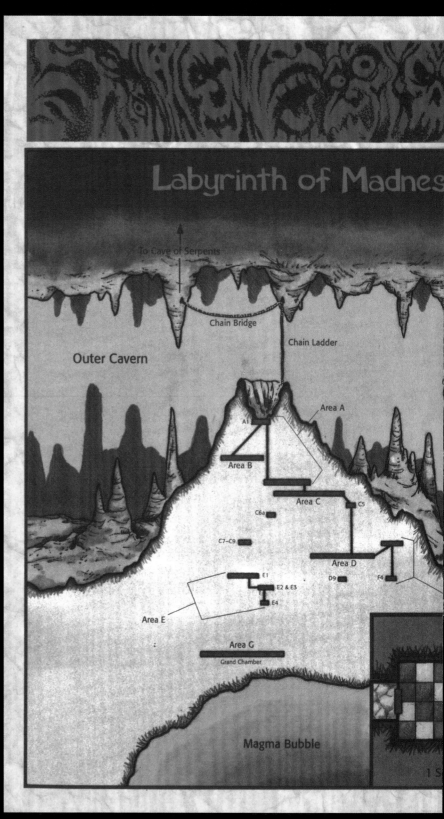

Labyrinth of Madnes

To Cave of Serpents

Chain Bridge

Chain Ladder

Outer Cavern

Area A

A1

Area B

Area C C5

C6a

C7–C9

Area D

E1 D9 F4

E2 & E3

E4

Area E

Area G

Grand Chamber

Magma Bubble

1 S

"Sinister twisting images. . . . Horrific
nightmares lurking at the corners of the
mind. . . . These are the descriptions used
to tell the tale of the Labyrinth of Madness.
But these tales of the labyrinth are only
legends, really, nothing more than stories
used to frighten children at night—until
a mysterious scepter is found, bearing
within its crystal head a visage of insanity
and terror, and also delivering a message:
'Disturb not the Labyrinth of Madness
again, and live a while longer.'"

— *LABYRINTH OF MADNESS, 1995*

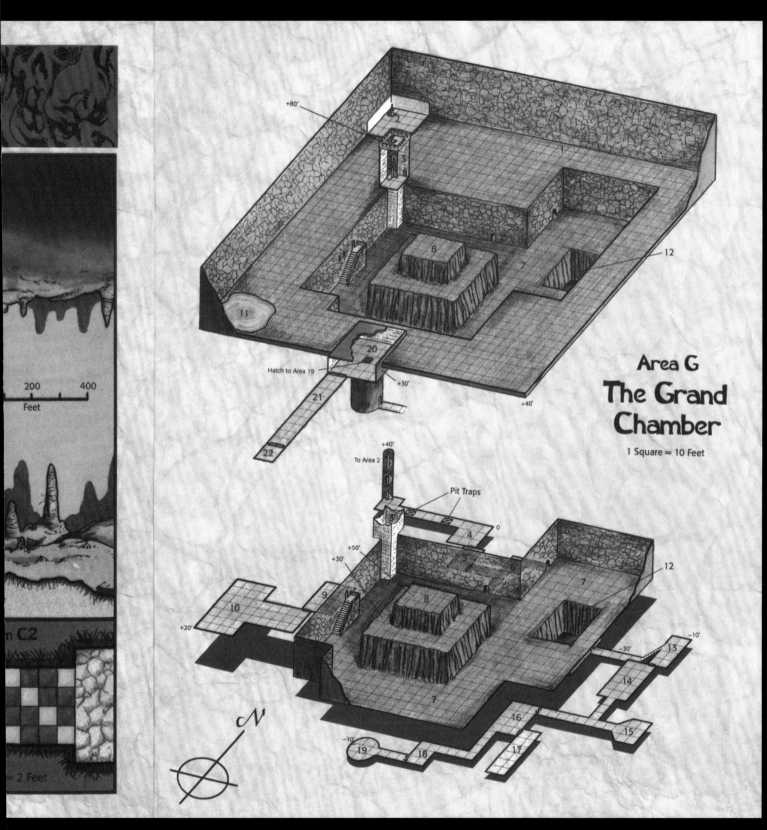

C2

= 2 Feet

+80′

+40′

+30′

Hatch to Area 19

20

21

22

11

8

7

3

12

Area G
The Grand Chamber

1 Square = 10 Feet

+40′
To Area 2

Pit Traps

+50′

+30′

4 0

5

6

9

10

+20′

8

7

7

12

−10′

−30′

13

14

−10′

19

18

17

16

15

N

Self-described as a "puzzle within a puzzle, that commemorates 20 years of gaming with TSR," Monte Cook's retro adventure module *Labyrinth of Madness* (1995) took D&D back to the deathtrap dungeons of old. Consistent with the company's strategy around major product rollouts, *Labyrinth of Madness* was a multimedia effort, this time publishing the module alongside a comic book of the same name.

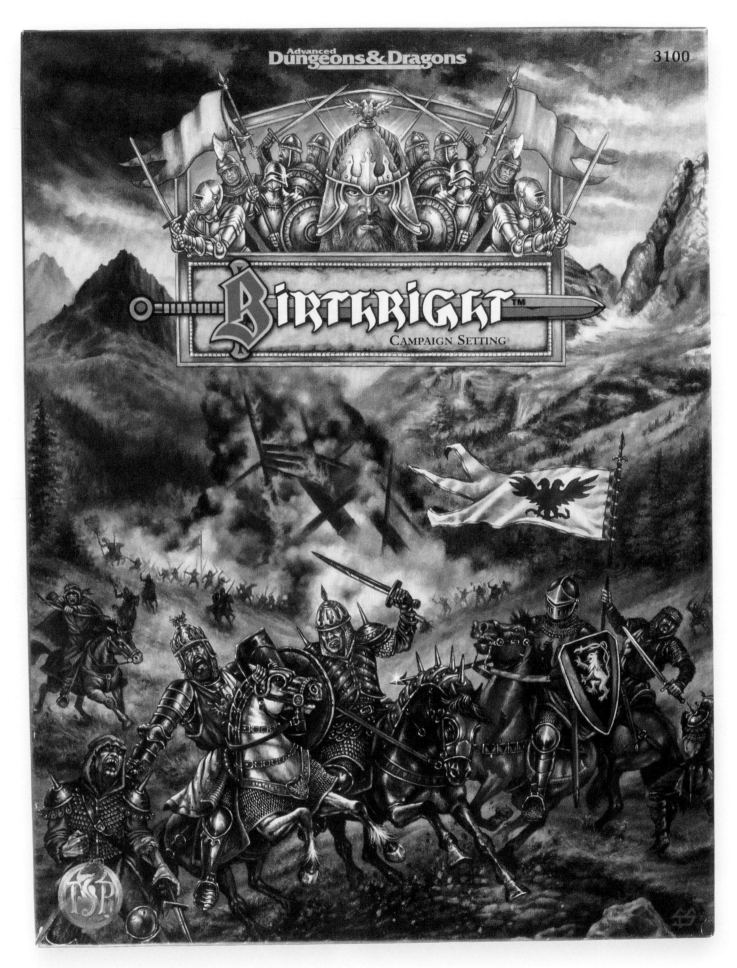

Tony Szczudlo's cover for the 1995 Birthright boxed set and his original cover painting for the 1996 *Rjurik Highlands* expansion set.

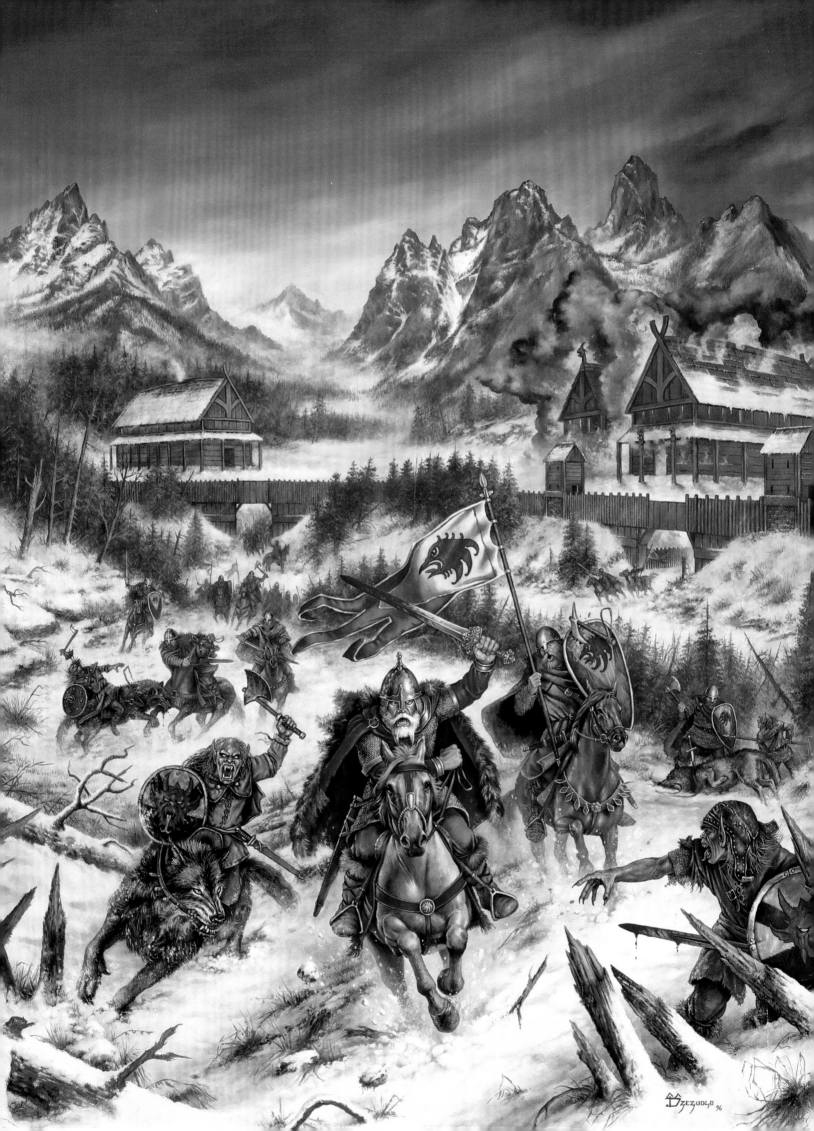

now in cyberspace on AOL

keyword: **TSR**

BY 1996, TSR WAS clearly suffering the effects of overexpansion— and this was not a rerun of 1984. With nearly a dozen campaign settings to support, as well as numerous ancillary products including an expanded number of hardcover novels and a wide array of gaming accessories such as its *Dragon Dice*, the company operated on razor-thin margins that were beginning to affect production. While TSR managed to break printing stalemates to support some of its core properties with the *Wizard's Spell Compendiums* and *SAGA System*-based Dragonlance: *Fifth Age*, new products slowed to a trickle. This trend was further exacerbated by a steady stream of returns of its hastily produced hardcover novels from TSR's book trade partner, Random House. Paradoxically, it was TSR's highest revenue year ever, but by the year's end, TSR was so broke that it had stopped publishing traditional games entirely. On the side, it still managed to push a few products through independent distribution, such as the AD&D *Core Rules* CD-ROM—a product with such high expectations that when it debuted at Gen Con XXIX, the first copy was carried on a black pillow to the TSR Castle exhibit, escorted by a kilted bagpiper.

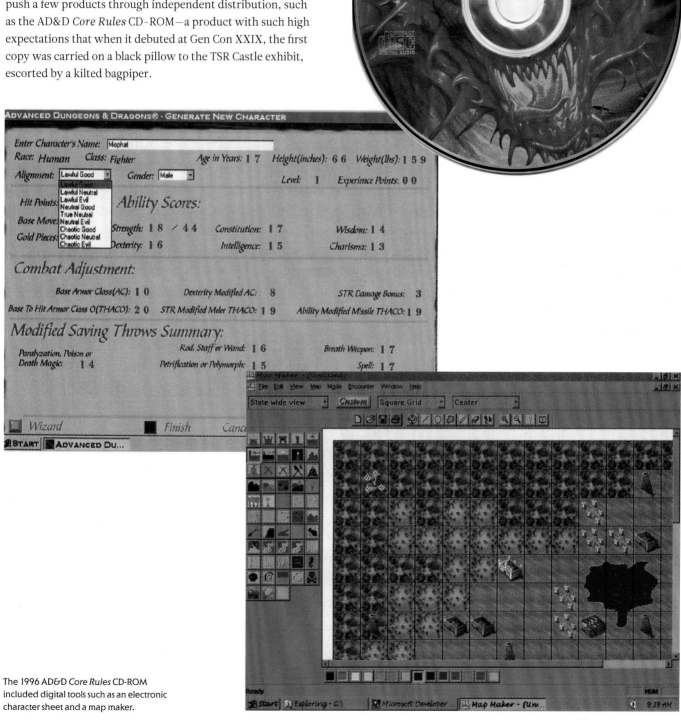

The 1996 AD&D *Core Rules* CD-ROM included digital tools such as an electronic character sheet and a map maker.

"Most of us wondered when we'd show up to locked doors, or maybe when our paychecks would bounce."

—ED STARK, TSR DESIGNER

The digital version of the *Core Rules*, implemented for Windows 95 by Evermore Entertainment in coordination with TSR, not only gave access to the 1995 editions of the core 2nd edition rulebooks in a searchable form, it also provided character management utilities that allowed players to generate and maintain a character sheet on their computers. The DM Toolkit in the *Core Rules* included utilities for randomly generating monsters and treasure, or non-player characters and encounters, as well as a mapping tool suitable for visualizing dungeon, overworld, and urban environments. It was a comprehensive digital offering, but perhaps late in one sense given TSR's financial situation, and a bit ahead of its time in terms of what its interface could achieve.

It was not a creative failure or lack of ideas that saw TSR collapsing in on itself. The market simply could not support all of the divergent products lines that were being produced at significant expense, especially when consumers flocked instead to the products of Games Workshop, who produced *Warhammer*, and Wizards of the Coast, whose game *Magic: The Gathering* was only gaining in popularity. The pages of *Dragon* magazine were filled with advertisements for competitive products such as *Magic* cards, *Warhammer* figurines, White Wolf games, and beyond—that was, until TSR was forced to stop printing even its flagship periodical at the end of 1996. Period accounts tell of a fulfillment warehouse loaded with millions of dollars' worth of unsold TSR product. The dreams outweighed the dreamers, and the foundation of Dungeons & Dragons cracked and faltered. Now a sleeping giant, the custom-built TSR offices on Lake Geneva's Sheridan Springs Road maintained operations, but at reduced capacity after crippling layoffs. Numerous employees reported to work with hopes that a solution could be found to bring the company back to solvency.

Unfortunately for TSR, its staff, and its flagship product, 1997 brought little in the way of promise, at least in the marketplace. Behind the scenes, however, Wizards of the Coast, producer of the wildly popular *Magic: The Gathering*, was about to interpose its hand. Under the direction of the company's founder and CEO, Peter Adkison, Wizards of the Coast made preparations to purchase TSR along with all its intellectual property with the singular purpose of saving the Dungeons & Dragons brand.

Adkison would remember, "I had approached TSR several times about the possibility of us working together," and in particular, "of publishing *Magic: The Gathering* expansions based off D&D campaign settings." But because *Magic* was obviously starving TSR out of the marketplace, he received a cold reception: "Not with you guys." So it comes as no surprise that the deal between TSR and Wizards of the Coast would ultimately be brokered through an intermediary. Although TSR's financial problems were obvious to everyone, Lorraine Williams expressed her willingness to sell to the managers of the Five Rings Publishing Company, a spin-off of the Alderac Entertainment Group. As Five Rings could not cover this transaction themselves, they shared the term sheet with Adkison—a document now remembered as the "million-dollar fax"—which induced Wizards to acquire both Five Rings and TSR in a three-way transaction. The deal closed in June 1997, and involved an approximate $30 million expenditure to cover TSR's assets and debts.

With an infusion of new capital, D&D surged back to life. *Dragon* returned in July 1997 with new monthly issues picking up where suspended subscriptions had left off. The following issue outlined a bustling release schedule across a dozen TSR product lines.

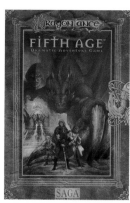

FAR LEFT A "thank you" card presented to Peter Adkison, founder and CEO of Wizards of the Coast, by TSR staffers after Wizards of the Coast bought the company in 1997.

LEFT Dragonlance: *Fifth Age* (1996) introduced a new card-based rule system called the *SAGA System*. This, paired with a rebooted "fifth age" companion world, proved unpopular among the Dragonlance faithful.

OPPOSITE Dana Knutson's cover painting for the *1996* AD&D *Monstrous Arcana: I, Tyrant* supplement.

BELOW Some of TSR's much diminished staff at its Lake Geneva, Wisconsin, headquarters circa 1997.

THE INFINITY ENGINE

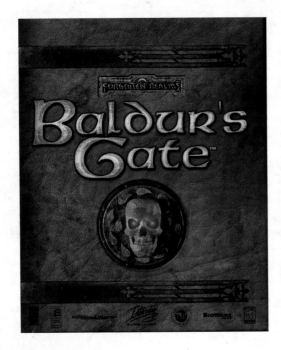

IN 1998, A NEW chapter opened for Dungeons & Dragons with the release of a landmark Advanced Dungeons & Dragons game experience for personal computers. *Baldur's Gate*, the first in a series of AD&D video games produced by developer BioWare for Interplay Entertainment, was unleashed upon the public to great fanfare and critical acclaim. Based on AD&D 2nd edition rules, *Baldur's Gate* transported gamers to the Sword Coast of the Forgotten Realms to oppose the forces of Bhaal, the God of Murder. Much like the Gold Box series before it, *Baldur's Gate* would prove so successful and surefooted that it spawned an entire series of games that employed the same gameplay engine, which solidified BioWare as a leading producer of computer role-playing games.

By the mid-1990s, TSR had effectively reorganized the D&D product line around its growing stable of campaign settings. Each setting became its own media property, and thus TSR licensed each independently for computer adaptation. While SSI held the rights to the Dark Sun setting and generic AD&D games, Interplay acquired the license to adapt the popular Forgotten Realms as well as one of the newer settings, Zeb Cook's otherworldly Planescape. As a first step, Interplay repurposed its *Descent* game engine, largely designed to accommodate three-dimensional aerial dogfighting games, for an action game based on a dungeon crawl through the Undermountain, the mega-dungeon of the Forgotten Realms, in the aptly named but poorly received *Descent to Undermountain*.

The computer role-playing game market had become white-hot following the monumental success of two games released around the beginning of 1997: Blizzard's *Diablo* and Squaresoft's *Final Fantasy VII*. Interplay also shook up the genre that year with its first *Fallout* game, which came out while the external BioWare development team built a new Forgotten Realms game.

That project became the first application for BioWare's famous Infinity Engine, which borrowed from *Fallout* and *Diablo* a two-dimensional overhead diagonal view—as it came to be called, an isomorphic perspective—where parties of characters gradually reveal area maps by navigating at the click of a mouse.

BioWare set their Forgotten Realms adventure on the Sword Coast and named it after a key location, Baldur's Gate. They developed around ten thousand area maps to represent the locales where the adventure transpired, and expressive dialog trees—reminiscent of *Fallout*—allowed for a bit of role playing. Although *Baldur's Gate* proudly featured a Forgotten Realms logo on its box, you have to squint at the fine print on the bottom to see the black-on-gray Advanced Dungeons & Dragons logo. The game's development cycle inauspiciously coincided with the lowest ebb in the D&D brand, culminating in the sale of TSR to Wizards of the Coast—but *Baldur's Gate* became an immediate sensation, selling more than two million copies.

Baldur's Gate and its successors were the most popular and visible manifestation of D&D in this dark era for TSR. Interplay tapped the Black Isle Studio group to adapt the Infinity Engine for its other licensed campaign setting, leading to the title *Planescape: Torment*. Its unconventional narrative, which follows the Nameless One as he struggles with the nature of identity in an afterlife encompassing many possible pasts, subverted the usual genre stereotypes and won lavish critical praise. The augmentations Black Isle made to the Infinity Engine contributed to the depth and flexibility of BioWare's *Baldur's Gate II: Shadows of Amn*, which itself went on to sell two million copies for Interplay. Both *Baldur's Gate II* and *Planescape: Torment* are routinely included in lists of the top-ten computer role-playing games of all time.

TOP The menu screen for 1999's *Planescape: Torment* developed by Black Isle Studios.

ABOVE Interplay advertisements from 2000 for *Baldur's Gate II* and *Icewind Dale*.

OPPOSITE, LEFT The box cover for the 1998 smash hit video game *Baldur's Gate*.

OPPOSITE, RIGHT A screenshot of *Baldur's Gate* featuring its Infinity Engine isomorphic perspective and dialog choices.

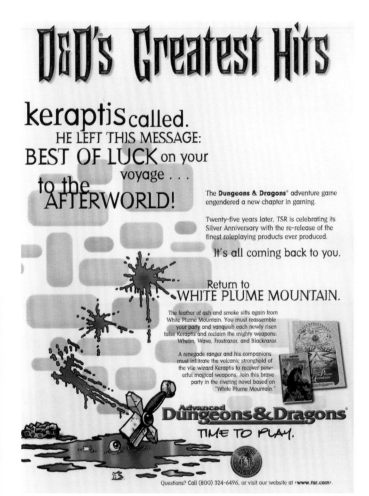

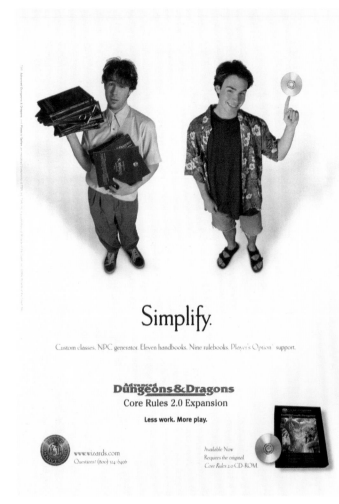

Simplify.

Custom classes. NPC generator. Eleven handbooks. Nine rulebooks. Player's Option™ support.

Advanced Dungeons & Dragons

Core Rules 2.0 Expansion

Less work. More play.

www.wizards.com
Questions? (800) 324-6496

Available Now
Requires the original
Core Rules 2.0 CD-ROM

TOP, LEFT With reprints and reimaginings of classic modules, the *Silver Anniversary Retrospective Boxed Set* was not only a celebration of the game's heritage, but an invitation for AD&D 1ˢᵗ edition players to come home.

TOP, RIGHT A 1999 ad for *Return to White Plume Mountain*.

ABOVE A bit of mixed messaging from the new owner of the franchise, Wizards of the Coast. While CD-ROMs were the newest, hip thing, books were still what payed the bills as far as D&D was concerned.

OPPOSITE The module cover for *Return to White Plume Mountain*.

AS THE 1990s DREW to a close, the dust settled and D&D products again began to roll out in earnest. However, Wizards was looking for an opportunity to show fans just how important the D&D brand was to them. This opportunity emerged in the form of D&D's silver anniversary in 1999. The game's twenty-fifth birthday was commemorated with an elaborate, ten-city Silver Anniversary Tour, which was as much a celebration of Dungeons & Dragons as it was a good-will outing to prove how genuinely excited Wizards of the Coast leadership was to be steering the TSR, Inc. ship. The *Silver Anniversary Retrospective Boxed Set* opened with a foreword by Wizards CEO Peter Adkison, which related his euphoria and good fortune to be sitting at the helm of a game that he had played for many years, adding that when the deal to acquire Dungeons & Dragons was finalized, it marked "one of the greatest days of my life." This boxed set included faithful reproductions of the original printing of various classic modules, including B2: *The Keep on the Borderlands*, the *Against the Giants* series (G1, G2, and G3), and I6: *Ravenloft*, along with a replica of the 1977 *Basic Set* rulebook. In some cases, Wizards not only reprinted but also revisited these module settings: as a part of the anniversary celebration, they made a new module, *Return to White Plume Mountain*, to accompany the reprint of the classic 1979 module in the boxed set. That same year, Wizards released the *Dragon Magazine Archive*, another affectionate nod to the past, that for the first time offered a scanned digital archive of the entire run—more than 250 issues. It's clear that Wizards felt that before it could move the brand forward, it had to take inventory of the game's past.

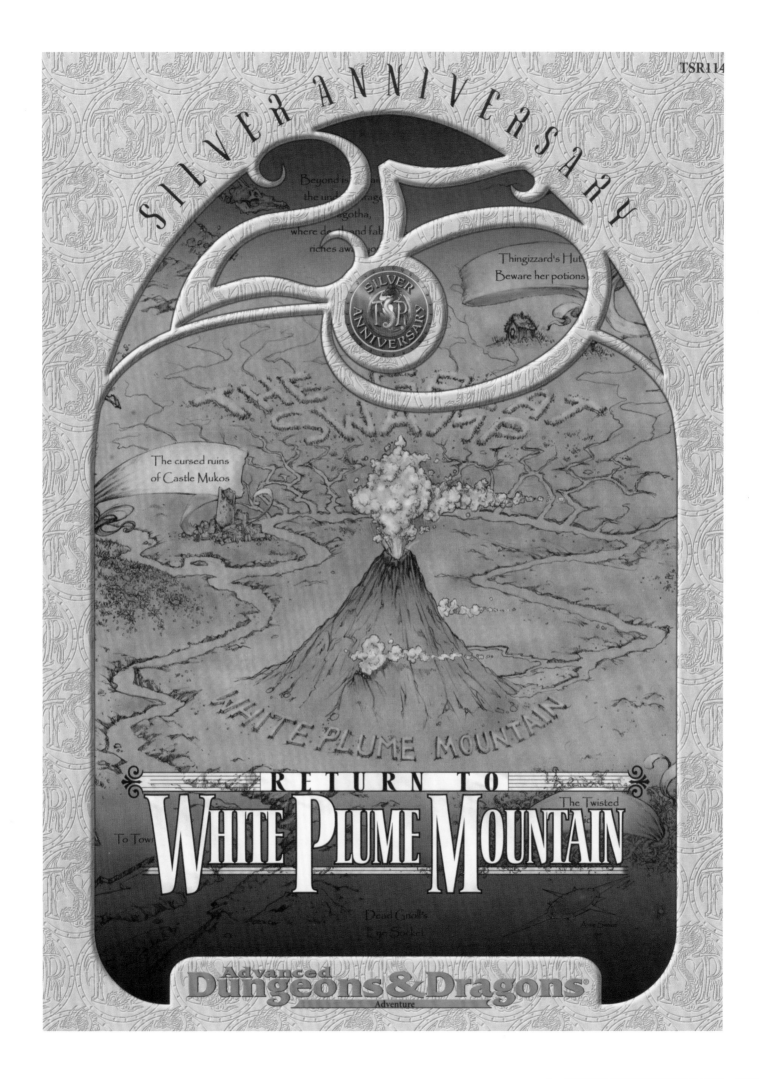

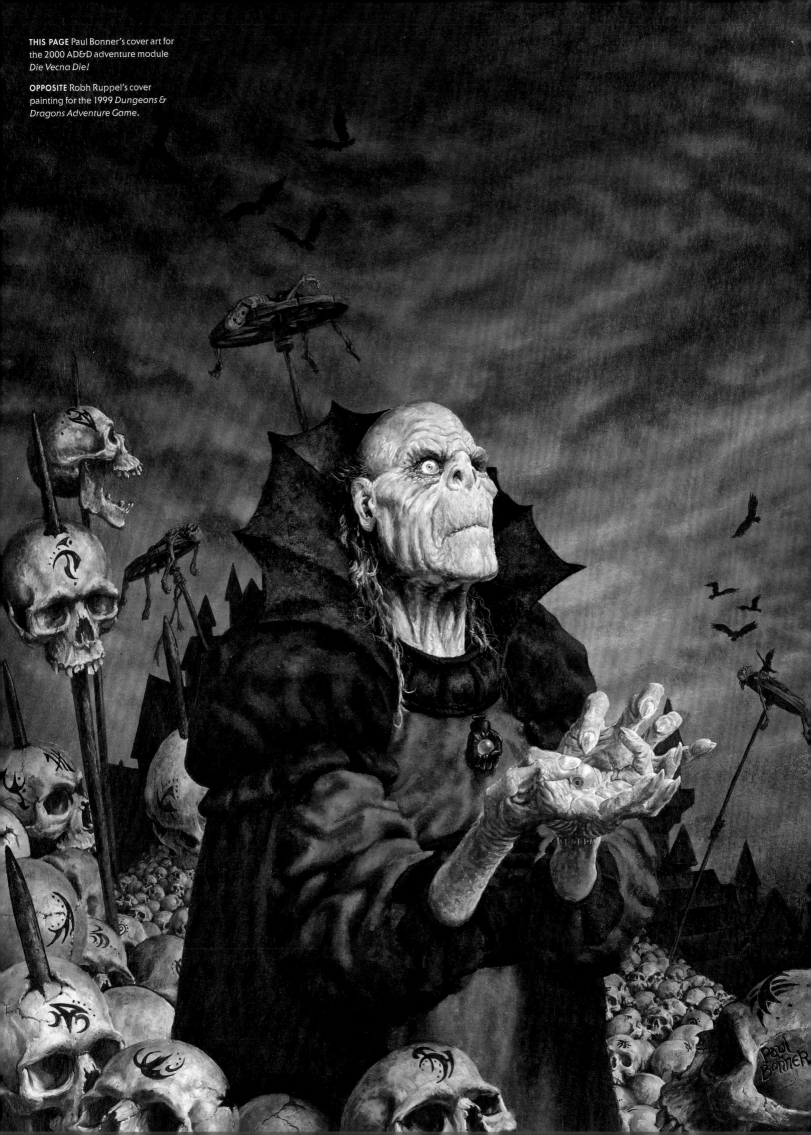

"WITH THIS SPELL, THE CHARACTER BRINGS BACK A DEAD CREATURE IN ANOTHER BODY, PROVIDED DEATH OCCURRED NO MORE THAN 1 WEEK BEFORE THE CASTING OF THE SPELL AND THE SUBJECT'S SOUL IS FREE AND WILLING TO RETURN."

6

REINCARNATION

3RD EDITION

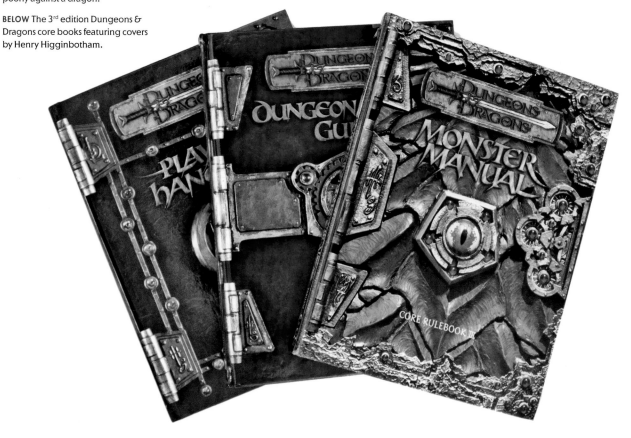

BY THE TIME Wizards relocated D&D development from Lake Geneva, Wisconsin, to their headquarters near Seattle, Washington, Advanced Dungeons & Dragons 2nd edition had been on the market for nearly a decade—as long as 1st edition had been on the market before it was replaced. TSR had long hoped to create a revised third edition in the 1990s, but its financial difficulties had rendered that unfeasible. Now, with motivated new ownership in place, the time for a fresh approach had finally come. In 2000, after several years of intense development, Dungeons & Dragons 3rd edition was released by Wizards of the Coast, under a carefully selected, veteran design team. Peter Adkison named Wizards staffer Jonathan Tweet the lead for the project. Tweet came to D&D with a long background in innovative design, beginning with *Ars Magica* more than a decade before.

The core design team became a triumvirate, encompassing Tweet and two employees who made the transition from TSR: Monte Cook and Ralph "Skip" Williams. Cook had joined TSR in the 1990s to work on edgier TSR properties like Planescape; Williams had been around the company since the 1970s, and he had long furnished the wisdom behind the "Sage Advice" column in *Dragon* magazine. The three of them spanned the eras of D&D development, and brought to the project a mix of the old and the new. True to tradition, totally new versions of the *Player's Handbook, Dungeon Master's Guide,* and *Monster Manual* comprised the core 3rd edition rulebook launch.

Wizards' groundbreaking new version of D&D featured many changes, starting with its very name. By no longer referring to these flagship releases as "Advanced," Wizards shed a moniker that adorned the "holy trinity" for decades. Adkison reached out to both Gygax and Arneson to secure any lingering rights needed to let the company use the name "Dungeons & Dragons" without stepping on any toes. This simplification granted the game a fresh start in the marketplace as a single, unified product.

From a system perspective, the design team at Wizards dared to go places TSR feared to tread. Zeb Cook had wanted to break with long-held tradition and align armor class with the game's other numerical categories where high scores were advantageous, but the TSR 2nd edition design team feared it would be too radical. Now the 3rd edition made armor class start low and improve as it went up, as did virtually every additive property of characters in the new d20 System of action resolution, where system events are resolved by the throw of a twenty-sided die. Tweet's multi-classing design, where at every advance in level, players could choose which class they want to take a level in, struck a compelling compromise between the necessity of preserving the core class mechanic and the flexibility of allowing characters to grow in the directions players desired. To ease die-hard 2nd edition players into the new system, Wizards circulated a free *Conversion Manual* pamphlet drafted by Skip Williams that gave experienced players the gist of the transition, while other products such as *The Apocalypse Stone* adventure module sought to "scour your campaign world and pave the way for Third Edition."

REMOVE
UNWANTED SPOTS

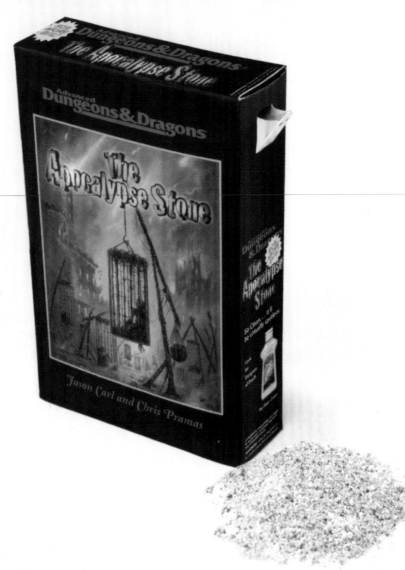

Stuck looking at the same mucky swamp, ruin, or back-alley?
Well say no more! The *Apocalypse Stone* adventure is
designed specifically to scour your campaign world and pave
the way for Third Edition.
It's time to level the playing field. Literally.

Advanced
Dungeons&Dragons®

TIME TO PLAY.

Both the *Apocalypse Stone* module (opposite) and the free *Conversion Manual* (above) were products designed to aid in the transition from past D&D campaigns into the new 3rd edition game.

RIGHT A conceptual, pre-release 3rd edition logo alongside the final tradedress that adorned all 3rd edition products.

BY 2000, COMPUTER USERS could no longer afford to be neglected in a tabletop gaming customer base. Wizards of the Coast, with more computer savvy than TSR ever mustered, shipped the *Player's Handbook* with a free CD tucked into the back cover, a demo version of a set of software tools for character generation. While the program was a little buggy, it was an early expression of the direction Wizards would take to align its products with a generation of gamers who were increasingly unaccustomed to paper and pencil, preferring instead digital tools.

LEFT, TOP Wizards of the Coast founder Peter Adkison (left) and 3rd edition principal designer Jonathan Tweet (right) today.

LEFT Wizards of the Coast's headquarters.

OPPOSITE A 2000 ad announcing the coming of D&D's 3rd edition, the originator of the legendary d20 System. It did indeed challenge the gaming world's perceptions.

BELOW With the transition to 3rd edition, Wizards of the Coast put a new emphasis on digital tools like this character generator from 2000.

"It took me about thirty seconds to decide, we've got to do a third edition of Dungeons & Dragons."

— PETER ADKISON

CHALLENGE YOUR PERCEPTIONS

DUNGEONS & DRAGONS®

8.10.00

www.wizards.com/dnd

IN-WORLD DESIGN

Both the wraparound covers by Henry
Higginbotham (opposite) and parchment-print
interiors (above) of the 2000 3rd edition core
books suggested in-world tomes versus the
dramatic adventure scenes that characterized
D&D books of the past.

> "Until now *D&D* art,
> while great art, didn't
> really reflect what
> *D&D* characters would
> look like. *D&D* art was
> too 'clean.'"
>
> —PETER ADKISON

IN A STARK DEVIATION from D&D tradition, Henry Higginbotham's
covers of the 3rd edition core books lacked anything like the customary
fantasy art of Jeff Easley, Dave Sutherland, or Dave Trampier.
Perhaps this was Wizards of the Coast's form of brand differentiation
since they, after all, built their entire empire on the back of *Magic:
The Gathering*, a collectible card game business that relied heavily
on providing dynamic scenes of fantastic art. Whatever the reasons,
this was no doubt a conscious decision made by a company that
boasted many of the industry's best fantasy artists.

While the exteriors of these rule tomes had broken with convention,
opting for an in-universe leather-bound look, the interior art became
a sepia feast of imagery inspired by the freshly revamped gameplay.
And, as with each edition prior, this new version brandished an entirely
different visual identity. Titans of D&D's visual past all made way for
new artistic voices with fresh interpretations of the brand.

THE KEY TO ENDLESS ADVENTURE!

by Jonathan Tweet, Monte Cook, and Skip Williams

Here is the indispensable manual of fantasy roleplaying. The *Player's Handbook* includes everything you need to create and play your ideal DUNGEONS & DRAGONS® character.

Pick up this book and join the millions of other players who have made the D&D® game the world's most popular fantasy roleplaying game!

DUNGEONS & DRAGONS

PLAYER'S HANDBOOK

CORE RULEBOOK I

PLAYER'S HANDBOOK

d20 System
Wizards

Visit our website at www.wizards.com/dnd

ISBN 0-7869-1550-1
9 780786 915507
52995
U.S. $29.95 CAN $41.95
Printed in U.S.A. TSR11550
EAN

WORLDS OF INSPIRATION!

by Monte Cook, Skip Williams, and Jonathan Tweet

You've got the DUNGEONS & DRAGONS® *Player's Handbook*, but you need more—you're the Dungeon Master, and it's up to you to create adventures and worlds for your friends' characters to experience, explore and conquer.

This book contains everything you need—from special high-level classes to magic items, artifacts and more! You're the Dungeon Master, and all the DUNGEONS & DRAGONS® secrets are yours!

DUNGEONS & DRAGONS

DUNGEON MASTER'S GUIDE

CORE RULEBOOK II

DUNGEON MASTER'S GUIDE

d20 System
Wizards

Visit our website at www.wizards.com/dnd

ISBN 0-7869-1551-X
9 780786 915514
52995
U.S. $29.95 CAN $44.95
Printed in U.S.A. TSR11551
EAN

ABOVE Artists Sam Wood (left), Todd Lockwood (center), and Jon Schindehette (right), along with Dawn Murin (not pictured), were the core team responsible for 3rd edition's radical new look.

RIGHT 3rd edition conceptual drawings by Todd Lockwood, showing an aesthetic shift toward characters that seemed lived-in and practical from an in-world perspective, above finished panels from the *Player's Handbook* by Lockwood (bottom, center, and right) and David Martin (bottom left).

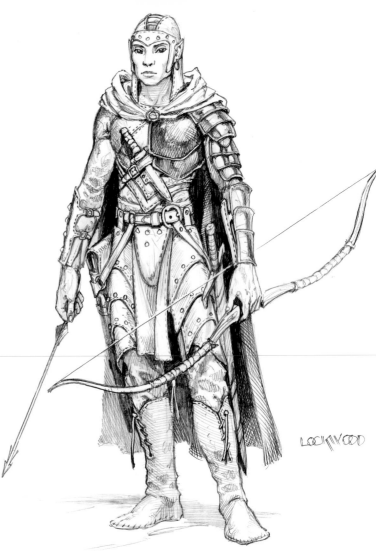

"In all cases we were looking to find the mean between historical medieval and something new and unseen."

—TODD LOCKWOOD, DUNGEONS & DRAGONS
3RD EDITION ARTIST

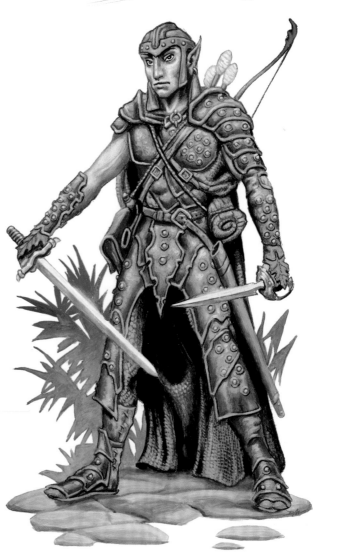

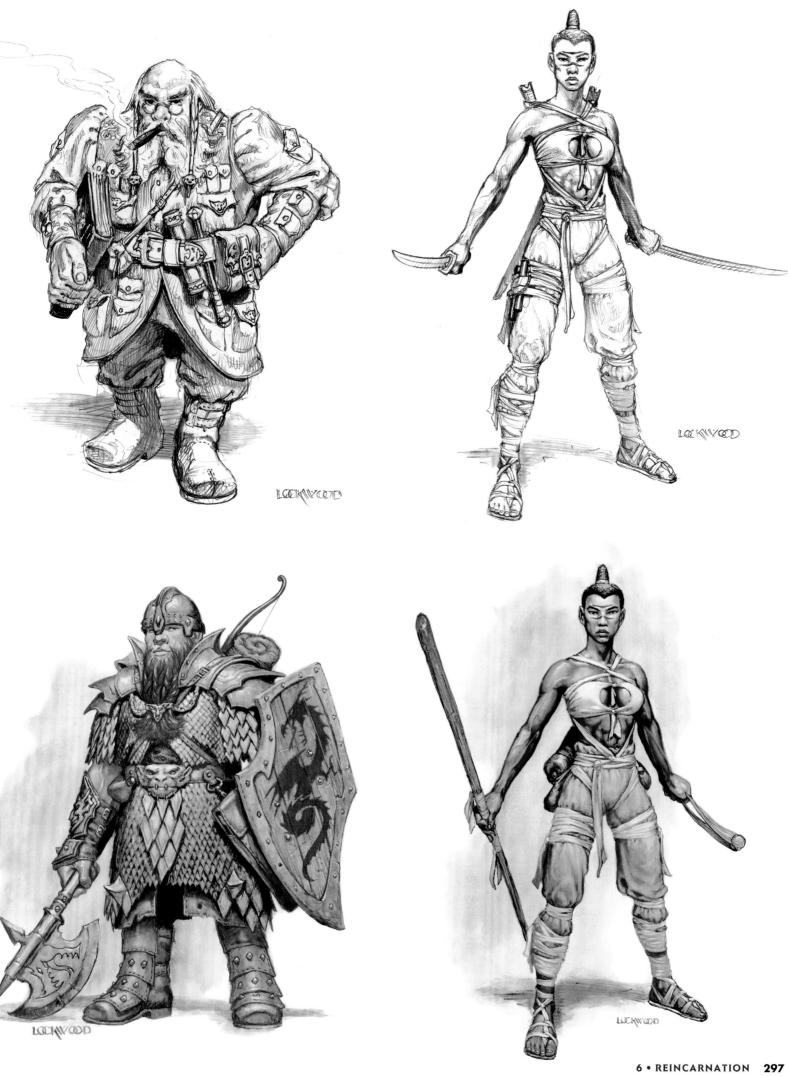

EVERY GOOD ADVENTURER NEEDS THE RIGHT EQUIPMENT

A 2002 ad that shows off 3rd edition's in-world stylings, while perhaps also serving as an invitation to live-action role-playing gamers to come to the table.

The sorcerer, a purveyor of wild magic, and a staple class in later editions, first graced the pages of the 3rd edition *Player's Handbook* in this depiction by Sam Wood.

THE RADICAL 3RD EDITION heralded the introduction of new character classes and options, including the rogue (the updated thief class) and the all-new sorcerer—granting players a more intuitive spell-caster option. The sorcerer, liberated from the burden of relying on a spell book, could innately harness magical power, though from a much smaller pool of spells than a wizard, and was afforded more combat flexibility, often prompting more offensive magic builds by players.

One of the most striking aspects of Dungeons & Dragons 3rd edition's new visual identity was the inclusion of a cast of now-iconic, named, and developed characters that were fully integrated in the pages of its rulebooks. The sorcerer shown wasn't just any sorcerer; his name was Hennet. Lidda the thief could often be found sneaking around, disarming traps or launching a surprise attack. Ember the monk wore her hair in a bun and wielded a quarterstaff. The development of these iconic characters by artists Todd Lockwood and Sam Wood was a major part of redesigning the look of D&D for its third edition. All of these characters adorn the 3rd edition *Dungeon Master's Screen*, and appear throughout the rulebooks to help illustrate the use of class powers and the way that adventurers go about their business. It wasn't long before Wizards made them protagonists in a new series of D&D novels and rendered them in three dimensions for the first branded D&D 3rd edition miniatures.

THE ORC

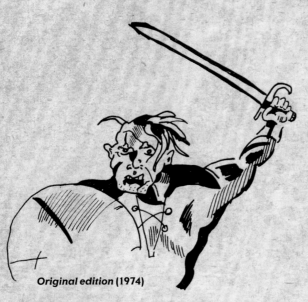

Original edition (1974)

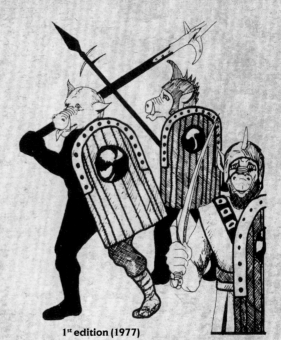

1st edition (1977)

2nd edition (1989)

3rd edition (2000)

"Orcs are cruel and hate living things in general. . . . Orcs appear particularly disgusting because their coloration—brown or brownish green with a bluish sheen—highlights their pinkish snouts and ears. Their bristly hair is dark brown or black, sometimes with tan patches. Even their armor tends to be unattractive—dirty and often a bit rusty."

—*MONSTER MANUAL, 1977*

5th edition (2014)

4th edition (2008)

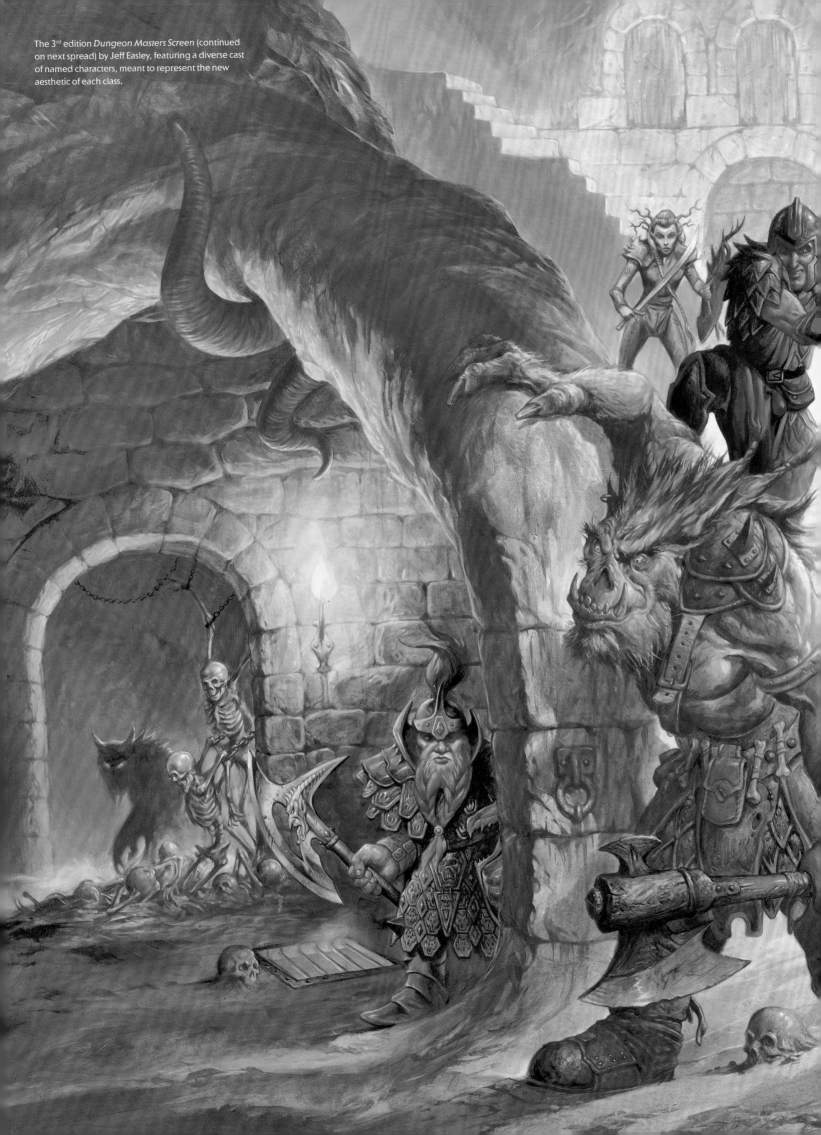

The 3rd edition *Dungeon Masters Screen* (continued on next spread) by Jeff Easley, featuring a diverse cast of named characters, meant to represent the new aesthetic of each class.

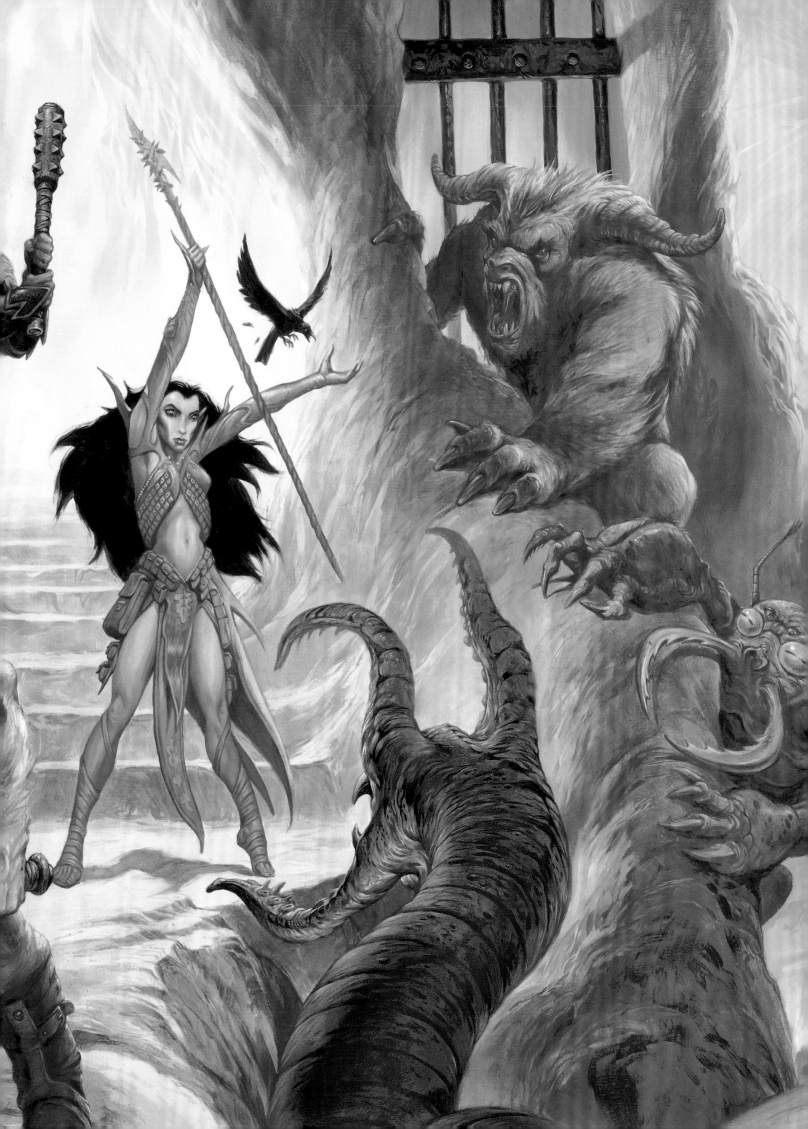

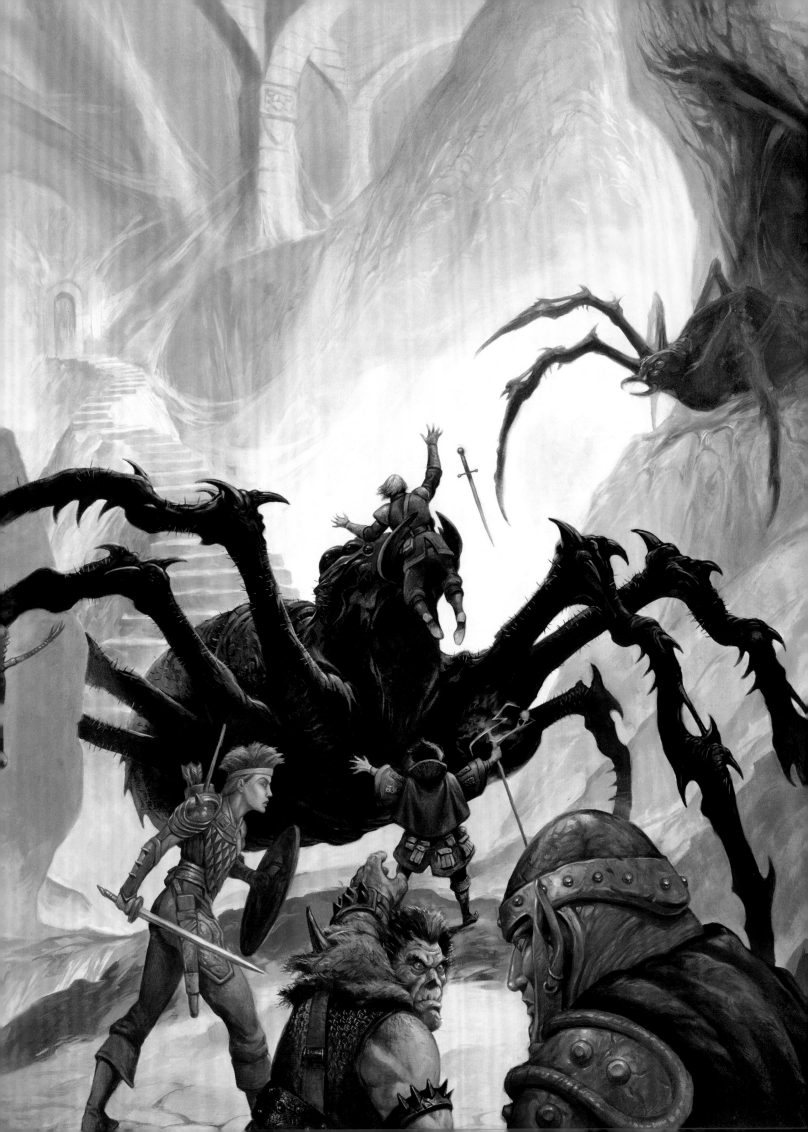

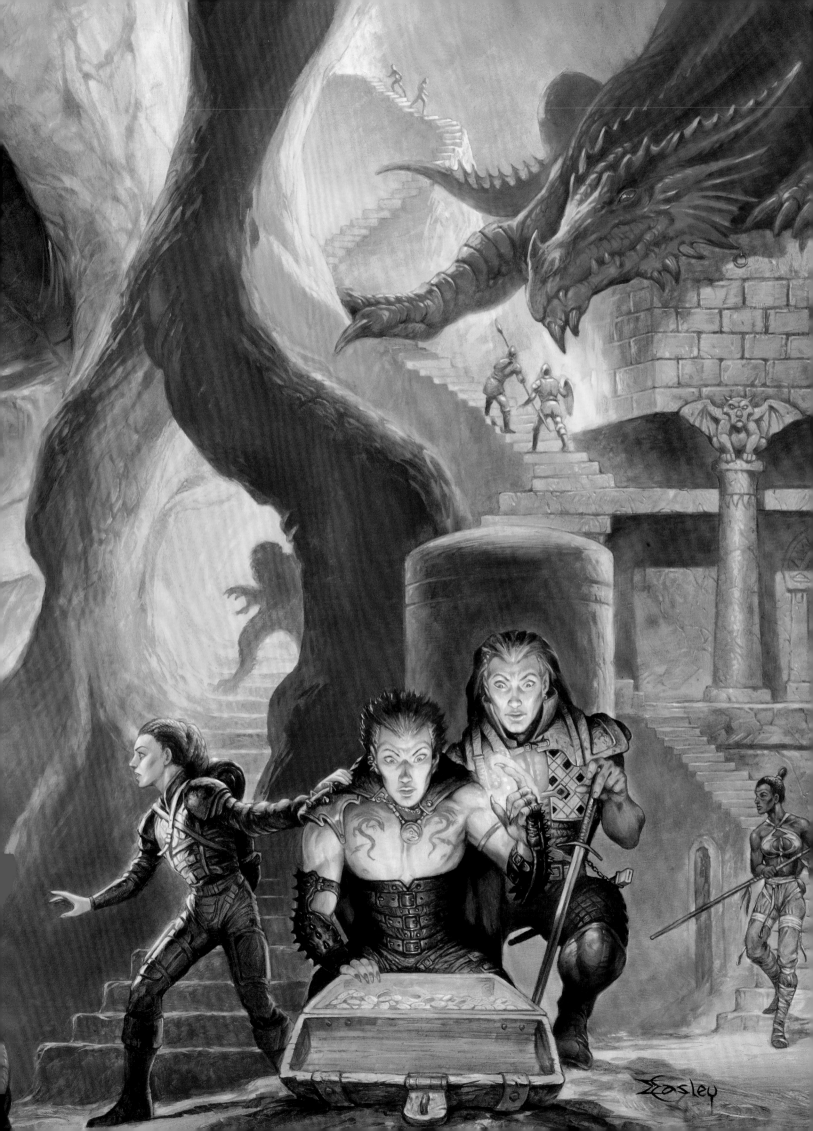

CHARACTER RACE TABLE II.: CLASS LEVEL LIMITATIONS

Character Class	Racial Stock of Character						
	Dwarven	Elven	Gnome	Half-Elven	Halfling	Half-Orc	Human
CLERIC	(8)	(7)	(7)	5	no	4	U
Druid	no	no	no	U	(6)	no	U
FIGHTER	9[1]	7[2]	6[3]	8[4]	6[5]	10	U
Paladin	no	no	no	no	no	no	U
Ranger	no	no	no	8[4]	no	no	U
MAGIC-USER	no	11[6]	no	8[7]	no	no	U
Illusionist	no	no	7[8]	no	no	no	U
THIEF	U	U	U	U	U	8[9]	U
Assassin	9	10	8	11	no	U	U
MONK	no	no	no	no	no	no	no

[1] Dwarven fighters with less than 17 strength are limited to 7th level; those with 17 strength are limited to 8th level.

[2] Elven fighters with less than 17 strength are limited to 5th level; those with 17 strength are limited to 6th level.

[3] Gnome fighters of less than 18 strength are limited to 5th level.

[4] Half-elven fighters of less than 17 strength are limited to 6th level; those of 17 strength are limited to 7th level.

[5] Halfling fighters of **Hairfeet** sub-race, as well as all other types of sub-races with strength of under 17, are limited to 4th level. **Tallfellows** of 17 strength and **Stouts** of 18 strength can work up to 5th level. **Tallfellows** that somehow obtain 18 strength can work up to 6th level.

[6] Elven magic-users with intelligence of less than 17 are limited to 9th level; those with intelligence of 17 are limited to 10th level.

[7] Half-elven magic-users with intelligence of less than 17 are limited to 6th level; those with intelligence of 17 are limited to 7th level.

[8] Gnome illusionists with intelligence or dexterity under 17 are limited to 5th level; those with both intelligence and dexterity of 17 are limited to 6th level.

[9] Half-Orc thieves with dexterity of less than 17 are limited to 6th level; those with dexterity of 17 are limited to 7th level.

Notes Regarding Character Race Table II:

Numbers in Parentheses () indicate that this class exists only as non-player characters in the race in question.

Numbers — not in parenthesis — indicate the maximum level attainable by a character of the race in question.

U appearing in a race column indicates that a character of the race in question has no limitation as to how high the character can go with regard to level in the appropriate class.

Penalties and Bonuses for Race:

Certain racial stocks excel in certain ability areas and have shortcomings in others. These penalties and bonuses are applied to the initial ability scores generated by a player for his or her character as soon as the racial stock of the character is selected, and the modified ability scores then are considered as if they were the actual ability scores generated for all game purposes. These penalties and bonuses are shown below:

Race	Penalty or Bonus
Dwarf	Constitution +1; Charisma -1
Elf	Dexterity +1; Constitution -1
Half-Orc	Strength +1; Constitution +1; Charisma -2
Halfling	Strength -1; Dexterity +1

There are certain other disadvantages and advantages to characters of various races; these are described in the paragraphs pertaining to each race which follow.

LEFT The Class Level Limitations table from the 1st edition *Players Handbook*, which stifled the long-term advancement of non-human races in exchange for starting advantages.

OPPOSITE The 2000 3rd edition adaptations, now featuring both male and female versions.

FOLLOWING SPREAD This Mark Zug depiction of a half-orc paladin for *Dragon* #275 was a groundbreaking indicator of how the tropes of the game were expanding under the watch of Wizards of the Coast.

BELOW Dave Sutherland's original depiction of races from the 1978 *Players Handbook*.

THE 3RD EDITION ALSO marked the inclusion of "prestige classes," a series of sub-class options that players could only access at high character levels after fulfilling specific in-game goals. Subsequent products even included "epic-level" options for characters seeking advancement above the already lofty twentieth level. Non-weapon proficiencies made way for "skills" and "feats," neatly defined and often-extraordinary abilities characters could perform, which afforded players even greater customization. But most important, 3rd edition removed the restrictions of prior versions on class and race combinations, granting access to totally new character hybrids, something unthinkable in the days of TSR. These many modifications naturally yielded a tangible new look for the game at large across its entire product range.

The release of 3rd edition was important for many reasons, but none more so than for its new rule system: no previous D&D edition had deviated so far from the original ruleset. During the 1970s, Gary Gygax spent years refining and tinkering with the rules, always in an effort to bring balance to the game, sometimes overcompensating where he thought there was potential for unfair advantage, as with supernatural races. For example, in AD&D a dwarven fighter could not advance beyond ninth level, and certain class combinations, such as a half-orc paladin, were not allowed. In this way, the original game steered player characters away from the seductive, short-term bonuses of non-human characters, always in favor of . . . bland humanity. The removal of class and race restrictions in 3rd edition set a tone for exciting new combinations, but also sent a strong social message: this game is for everyone, and you can be whatever you want to be. The iconic characters themselves form a very pronounced call for diversity. The advent of skills and feats, on the other hand, became a foundational mechanic for the later "talent tree" systems of many computer games.

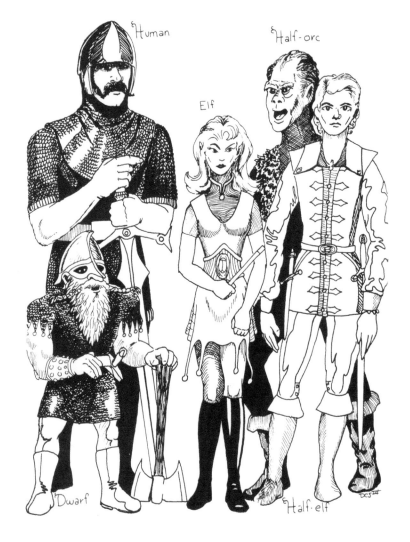

Human Half-orc
Elf
Dwarf Half-elf

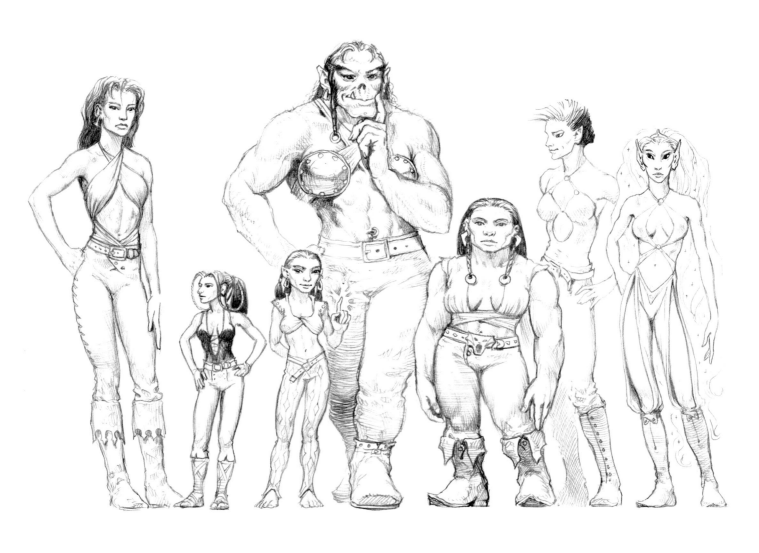

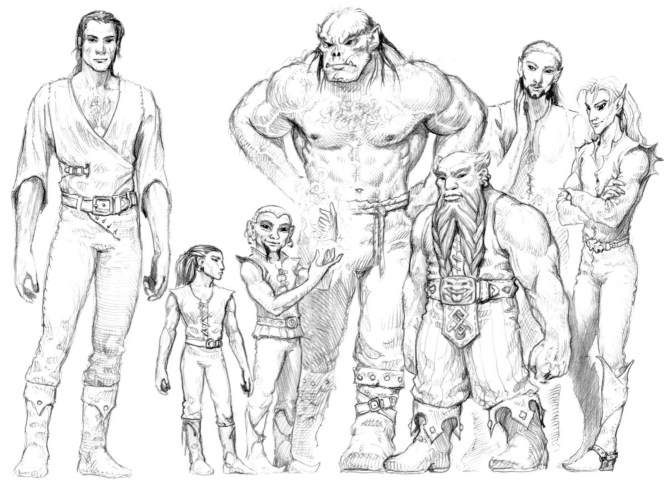

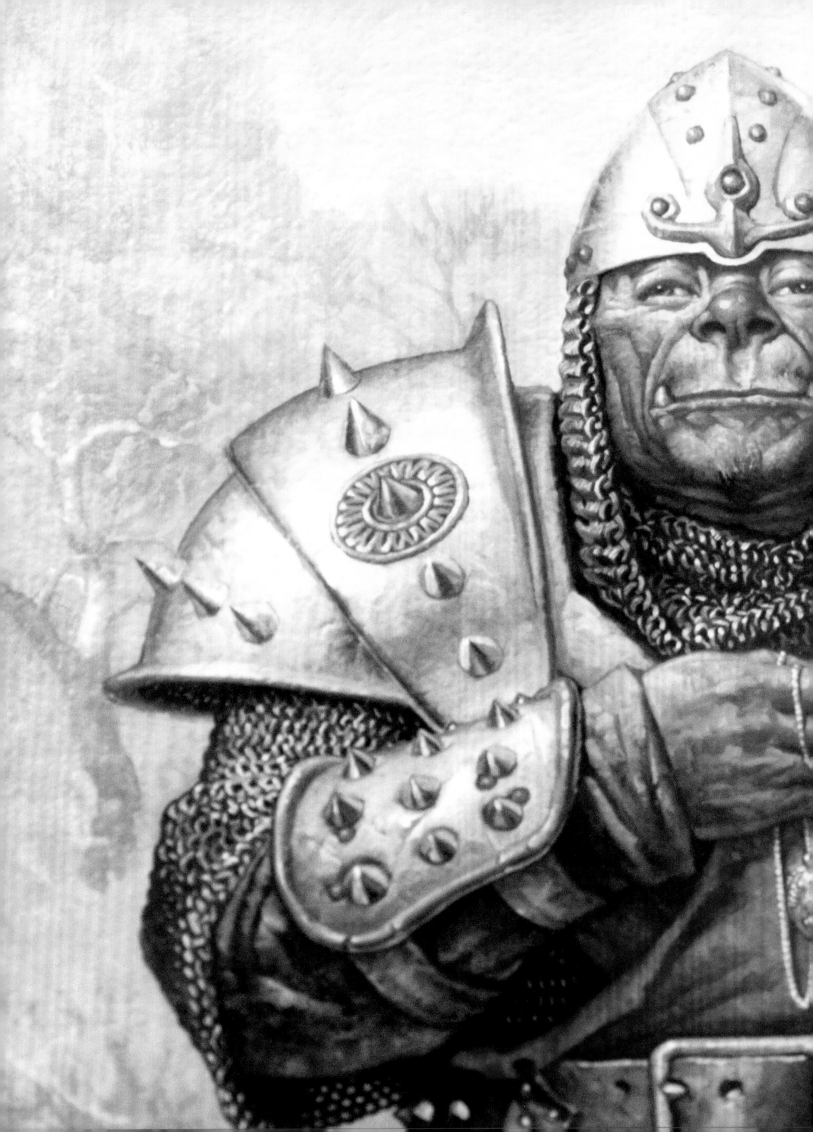

> ## "We couldn't understand why the owner of the company and the brand manager of the world's most successful role-playing game line would want to give away the ruleset that made *D&D* such a success in the first place."
>
> —ED STARK, TSR/WIZARDS OF THE COAST GAME DESIGNER

WIZARDS OF THE COAST'S risk-taking also stretched beyond in-game design. In a bid to entice the greater role-playing game community back to the D&D sandbox, the Wizards brand team, and in particular brand head Ryan Dancey, published the 3rd edition game under a legal framework known as the Open Game License (OGL), which was modeled on similar open-source licenses in the software industry. This effectively transformed the industry by generating opportunities for third-party companies and designers to produce generic d20 System-branded products based on D&D 3rd edition rules, royalty-free. The floodgates were opened for new proprietary material created by independent voices, much to the consternation of TSR employees who viewed the D&D system as a competitive advantage. Now rather than flooding the market with campaign settings, Wizards could let other companies publish as many campaigns and historically low-margin modules as the market would tolerate. A gold rush ensued. For example, White Wolf, by any measure a veteran publisher, immediately created a subsidiary imprint called Sword & Sorcery Studios to publish its own d20 sourcebooks, which you would find on the gaming-store shelf right next to official Wizards products. Even digital game company Blizzard Entertainment used the OGL to make a tabletop role-playing game version of their classic computer wargaming franchise, *Warcraft*.

The combined assets of Wizards of the Coast provided an irresistible target for an acquisition. Boasting *Magic: The Gathering*, Dungeons & Dragons, and the meteorically successful *Pokémon* card-game franchise, Wizards would have to command a spectacular valuation, and it did: Hasbro acquired Wizards for $325 million in September 1999. Now, for the first time, D&D had a global corporate parent. The original managers of TSR had shepherded D&D successfully for about a decade before they needed to be rescued by an outside investor, who in turn ran the company for another decade before requiring the intervention of Wizards. D&D would not need to fear another recurrence of this troublesome pattern.

RIGHT The inclusion of the d20 logo on a given product assured consumers of compatibility with D&D 3rd edition.

FAR RIGHT A trio of popular Open Game License (OGL) products developed by outside publishers: Kenzer & Company's *Kingdoms of Kalamar*, Sword & Sorcery Studios' *Arcana Unearthed*, and the combined Wizards of the Coast, Sword & Sorcery, and Blizzard Entertainment *Warcraft* book—the last appearing a year before the debut of *World of Warcraft*.

OPPOSITE Publishers such as Kenzer & Company developed licensed ancillary products such as comic books to support their new OGL product lines.

THIS SPREAD D&D's new band of heroes weren't limited to the pages of the rulebooks; they were generously featured across a whole line of supplements, accessories, novels, and ancillary gaming products.

AS *D&D* WAS NOW part of the Hasbro family (Wizards of the Coast's parent company), the D&D brand and its iconic characters could begin to infiltrate the Parker Brothers back catalog. A 2001 version of the classic murder-mystery board game *Clue* featured the iconic characters and a magical makeover of the rules: Did Regdar do it in the Dragon's Den with the Staff of Power? Gamers across the Atlantic would play these characters in the *Dungeons & Dragons Fantasy Adventure Board Game*, another attempt to bridge the gap between D&D and the children's board-game market. And true to the prior strategy, novelizations based on D&D 3rd edition made these iconic characters their protagonists.

3RD EDITION DRAGONS

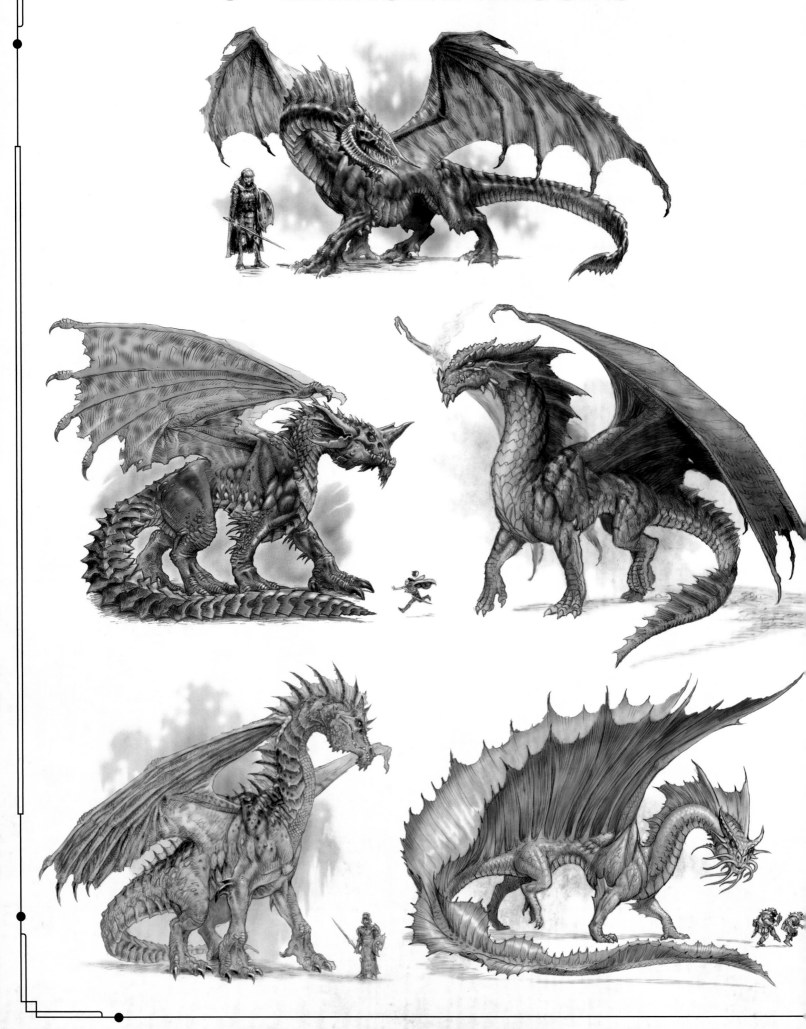

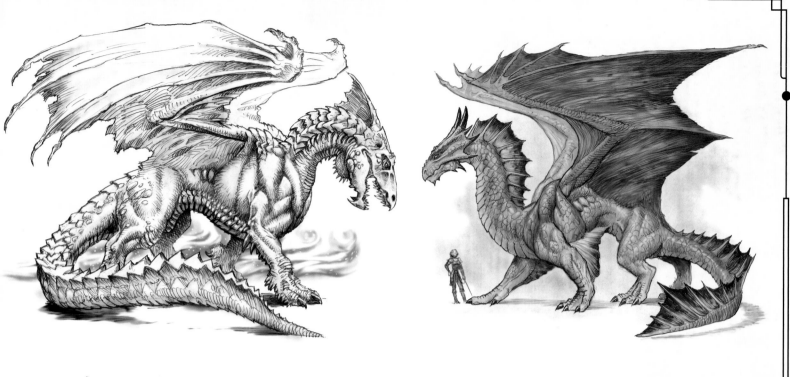

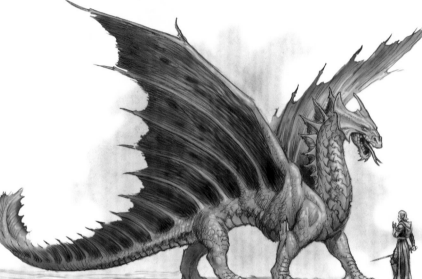

3RD EDITION'S IMPRESSIVE CHROMATIC and metallic dragons, developed by Todd Lockwood and Sam Wood, offered what Wizards designers now consider the "definitive" representations of these monsters. According to Lockwood, he and Wood had two goals during the design process: "give them anatomy that made sense, particularly regarding wing musculature; and honor the original designs that Dave Sutherland created for the 1st edition *Monster Manual*. His dragons were an anatomical mess, but they were very inventive."

Lockwood went on to add, "Along the way we followed the idea that no two dragons would have identical wings. Their color and facial characteristics were obviously distinctive, so we wanted their wings to be distinctive too. . . . Whatever the King of Beasts has that makes him royalty, dragons have in surplus."

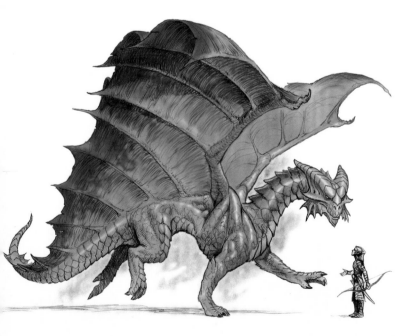

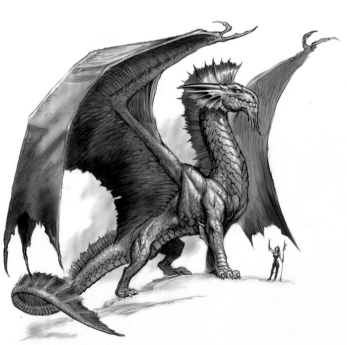

OPPOSITE Stephen Daniele's seminal depiction of Laveth, the daughter of Lolth, for the Monte Cook–penned adventure "The Harrowing" in *Dungeon* magazine. Chris Perkins, the art director of the piece, notes, "I like the stylized face of Lolth filling the background and the danger it represents."

ABOVE This gothic Brom illustration from *Dungeon* magazine shows the Priestess of Loviatar controlling a devourer, a creature new to 3rd edition.

THE LAND BEHIND THE SILVER SCREEN

"I found no single redeeming feature in the *D&D* movie. Even the special effects weren't special.

—GARY GYGAX

THE 1999 ACQUISITION OF Wizards of the Coast by toy-giant Hasbro set the stage for an exciting new era in Dungeons & Dragons and a fresh foray into the mainstream in the form of a big-budget movie adaptation. Five years earlier, the exclusive motion picture rights for Dungeons & Dragons had been acquired by Courtney Solomon's production company, Sweetpea, from a struggling TSR for a measly $15,000. Released in 2000, the Solomon-directed film was a relatively safe showcase of classic archetypes and tropes from the tabletop's past (untethered to any specific edition). While the filmmakers tried to be reverential to the source material, they were intent on emulating other successful fantasy franchises from the genre's recent history, such as *Hercules: The Legendary Journeys* and *Xena: Warrior Princess*, matching their levels of cheap special effects and camp.

Despite an eclectic list of stars, from Marlon Wayans to Academy Award–winner Jeremy Irons, coupled with a wide theatrical release on more than two thousand North American screens, the $45 million New Line Cinema–distributed adaptation flailed in its attempt to bridge the gap between game and cinema, and the movie subsequently fizzled globally with fans and critics alike.

Nominated in seven categories at the 2000 Stinkers Bad Movie Awards, including Worst Picture of the year, the film was a financial failure as well, recouping only $33 million of its budget. The low-budget TV movie sequels *Wrath of the Dragon God* (2005) and *The Book of Vile Darkness* (2012) fared even worse, doing more harm than good to the brand's reputation, trending the franchise even more toward campy and leaving many to muse that the property was cursed when it came to the silver screen.

In almost every attempted incarnation, the spirit of the game is barely existent. Certainly, the freeform nature of *D&D*, with players and DMs joining forces to weave a collaborative tale, is a challenge to what the medium of narrative cinema can offer. But with the tabletop games more popular than ever, there is still hope for a last-ditch resurrection spell to grant a potential movie new life.

A MAINSTREAM COMEBACK

The promotional efforts and early success of 3rd edition came as D&D increasingly surged back into the mainstream media. Fans who had grown up playing the game, honing their storytelling craft with homebrewed campaigns, were now in positions of power and influence. Dungeons & Dragons had naturally become the subject of reverence (and occasional ridicule) on pop culture–heavy 1990s shows like *The Simpsons* that boasted many former players among their creative ranks. A character in a 1996 *X-Files* episode could quip unselfconsciously, "Hey, I didn't spend all those years playing Dungeons & Dragons and not learn a little something about courage."

The following year, satirical newspaper the *Onion* published under the headline "Bill Gates Grants Self 18 Dexterity, 20 Charisma" a crudely drawn character sheet for "Bilbo of the Gatespeople," an overpowered chaotic evil half-elf. The 1999 cult classic *Freaks and Geeks* featured the game in its series finale, where the too-cool-for-school "freak" played by James Franco joins the geeky protagonists in a D&D game session, leaving them to wonder, "Does him wanting to play with us again mean that he's turning into a geek, or we're turning into the cool guys?" This was a symbolic moment for the show's creators, both D&D players and future writer/director superstars Judd Apatow and Paul Feig,

who proved beyond any doubt that the answer was the latter. In an episode of the Matt Groening–created animated series *Futurama* titled "Anthology of Interest" released in 2000, Gary Gygax himself guest-starred alongside a select group of culturally significant icons from the late twentieth century, including Vice President Al Gore and Stephen Hawking. Because Al Gore's wife, censorship advocate Tipper Gore, had been among D&D's biggest critics during the 1980s, the show served as an ironic and poignant reminder about how far the game's public image had evolved.

D&D was becoming a fad again, but this time the novelty of its past became chic. The tabletop was finally shedding some of the long-standing stigmas that had been placed on it by outsiders. In 2001, the Dungeons & Dragons *Chainmail* miniatures game was released in both a nostalgic attempt to return gameplay to its roots of fantastic medieval wargaming and to compete against the success of *Warhammer* by Games Workshop, which had attracted a dedicated fan community that was spending exorbitant sums of money on metal miniatures. Under Wizards of the Coast's stewardship, the Dungeons & Dragons brand had become even more agnostic to format, with the name itself carrying immediate awareness as well as a geek cachet.

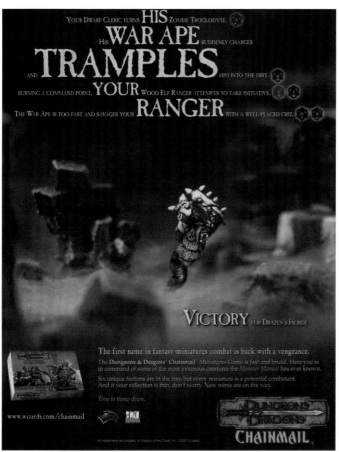

ABOVE RIGHT A 1997 image from the satirical newspaper the *Onion*.

ABOVE A 2001 ad for *Chainmail*, an attempt to return to the miniatures wargaming space.

RIGHT Gary Gygax as depicted on *Futurama* in 2000.

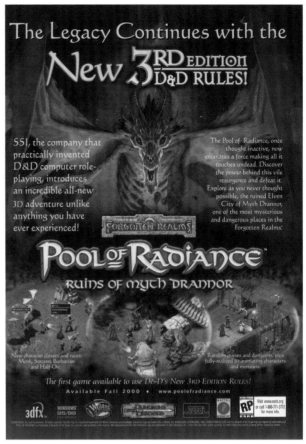
THE VISIBILITY OF THE brand was continually buoyed by computer D&D products, which could now easily sell in a year more copies than their tabletop equivalents would in a decade. The *Pool of Radiance* computer game series made the leap back to the PC with the Ubisoft-produced sequel *Ruins of Myth Drannor* in 2001. The following year saw BioWare's release of an all-new *Neverwinter Nights* computer game. The system, based on 3rd edition rules and set in the Forgotten Realms, included an Internet-based multiplayer mode, a novel feature that again allowed fans to experience the game with a global community, as well as the Aurora toolset, an integrated module-building system that placed greater control and creativity into the hands of fans, to the extent that they could host their own server full of player-created content. Technology, driven by widespread Internet accessibility, was finally able to emulate some of the creative platform offered by the tabletop game. The game was a hit and quickly followed by Obsidian Entertainment's *Neverwinter Nights 2* and additional titles from Interplay. Thanks to Hasbro's relationship with Atari as its former owner, more computer games quickly followed.

To a whole new generation of fans, these digital games, and numerous others like them spanning various consoles, provided the solitary gateway into a brand with its identity firmly rooted in a bygone era of pencil and paper. However, the majority of the D&D video game titles hitting the marketplace were often more referential than reverential incarnations of their esteemed namesake. As advanced as video games had become, the format itself was still hard-pressed to do justice to the full breadth of the tabletop role-playing game experience. Despite the fact that role-playing game

publishing was again on the rise, digital gaming was now bigger than ever, meaning that these licensed visualizations of D&D had become the prominent and definitive "look" of the brand.

On all fronts, Dungeons & Dragons was succeeding, further underscoring the brilliant business move that Wizards of the Coast made just a few years prior. Novelizations continued to flow from the Dragonlance and Forgotten Realms settings, including the 2002 releases *Dragons of a Vanished Moon: The War of Souls, Vol. III* and *The Thousand Orcs*, both of which debuted on the *New York Times* best-seller list. The books, and the branded characters emerging from within their pages, provided fresh intellectual property and seemingly endless ancillary opportunity for expansion.

Along with forward progress came upheaval, too: the *Pokémon Trading Card Game* had been a huge money maker for the company over the last couple of years, but when the craze subsided, there were layoffs at Hasbro, and Wizards of the Coast shed a number of core assets that had been with D&D since its infancy. In 2002, Wizards licensed the rights to publish both *Dragon* and *Dungeon* magazines to Paizo, a start-up led by Wizards alum Lisa Stevens. Paizo took over just in time to publish the three-hundredth issue. Wizards founder Peter Adkison, who had left the company at the end of 2000, made a separate deal in 2002 to purchase fan-favorite institution Gen Con. By that point, Wizards had already decided to relocate the convention from Wisconsin to Indianapolis, Indiana, as of 2003. Despite uncertainty from the community, the more central location and increased show-floor space proved to be a positive boon, as the convention was outgrowing some of its longest standing traditions. Changes were definitely afoot, and more were sure to come.

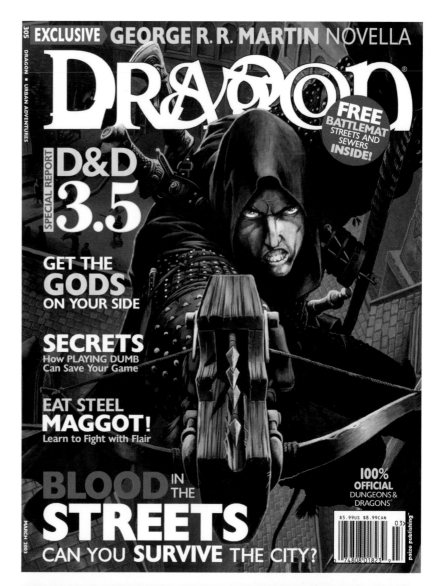

OPPOSITE, LEFT A 2002 ad for *Dragon* magazine, now produced by Paizo Publishing as a licensing partner, celebrated the publication's 300th issue.

OPPOSITE, RIGHT An ad for the 2000 reboot of the beloved *Pool of Radiance*.

RIGHT Wayne Reynold's popular cover of *Dragon* #305, which featured a special report on another revision to D&D rules: edition 3.5.

BELOW Even early computer role-playing games became objects of nostalgic reboots, like Bioware's 2002 reimagining of the 1991 MMO *Neverwinter Nights*.

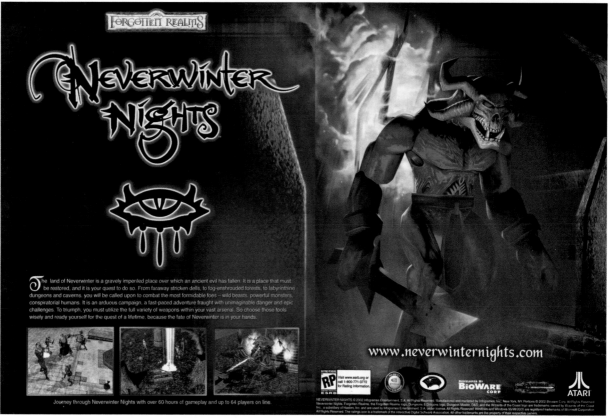

3rd edition heroes Hennet, Mialee, and Nebin show us that lightning can strike not just twice, but three times.

LOCKWOOD

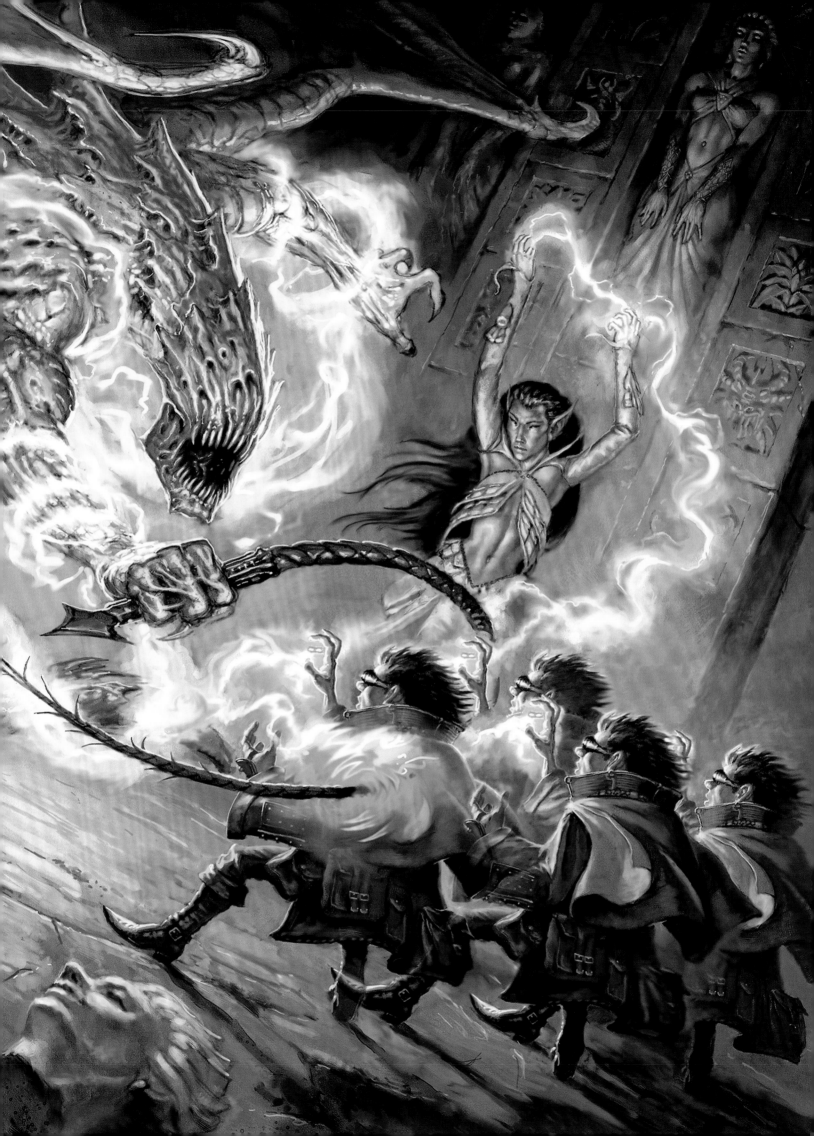

"SIMULACRUM CREATES AN ILLUSORY
DUPLICATE OF ANY CREATURE."

7

SIMULACRUM

v3.5 and DDM

DUNGEONS & DRAGONS 3rd edition had

been a success by virtually any measure, but within six months of its debut, Wizards began to realize that baked into the radical new system was a problem: new player acquisition. After a fast and furious rollout, new player growth had slowed to a trickle, likely caused by a combination of complex new rules, which created barriers to entry, and the myriad competitive options promulgated by the Open Gaming License. As a result, the year 2003 saw the debut of a revision to 3rd edition, which, in a nod to software versioning, was called Dungeons & Dragons v3.5. Its updated incarnations of the core rulebooks implemented some needed fixes to game mechanic glitches, but its arrival so soon after 3rd edition aroused suspicions that Wizards of the Coast might be trying to monetize the same product a second time. Under the hood, however, this upgraded system came with new ways to play D&D and a bold expansion into adjacent markets.

In the wake of the *Pokémon* crash, Wizards decided on a new direction for D&D that depended heavily on the Dungeons & Dragons *Miniatures Game*, or *DDM*, a collectible miniatures game for tactical combat. The "organized play" strategy that had proven so successful in acquiring and cultivating players for *Magic: The Gathering*, with seasonal releases of new card expansions coinciding with large tournaments, could only apply to Dungeons & Dragons if it could somehow duplicate those structures for manufacturing and distributing collectible playing pieces. A whole industry of collectible plastic tactical miniatures games had already spread in the wake of the WizKids *Mage Knight* system; its success had marginalized Wizards' own *Chainmail* offering. *Mage Knight* had spun off several variants and sequels including *HeroClix*, with former D&D design staffers Monte Cook and Jeff Grubb both contributing design work, which suggested there could be room for the Dungeons & Dragons brand

DUNGEONS & DRAGONS

Get Ready for the Next Round

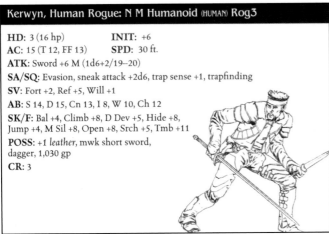

Kerwyn, Human Rogue: N M Humanoid (HUMAN) **Rog3**

HD: 3 (16 hp) **INIT:** +6
AC: 15 (T 12, FF 13) **SPD:** 30 ft.
ATK: Sword +6 M (1d6+2/19–20)
SA/SQ: Evasion, sneak attack +2d6, trap sense +1, trapfinding
SV: Fort +2, Ref +5, Will +1
AB: S 14, D 15, Cn 13, I 8, W 10, Ch 12
SK/F: Bal +4, Climb +8, D Dev +5, Hide +8, Jump +4, M Sil +8, Open +8, Srch +5, Tmb +11
POSS: +1 *leather*, mwk short sword, dagger, 1,030 gp
CR: 3

D&D QUICK REFERENCE Illus. Stephen Tappin

Kerwyn, Human Rogue

7 POINTS

CG

LVL: 3	**SPD:** 6
AC: 15	**HP:** 15

MELEE ATTACK: +6 (5)
RANGED ATTACK: —
TYPE: Humanoid (Human)

SPECIAL ABILITIES: Unique. Hide;
Mobility (+4 AC against attacks of opportunity);
Sneak Attack +5

22/60 ◆ DUNGEONS & DRAGONS ©2003 Wizards

to enter the market—and leverage it to steer fans of collectible miniatures games toward D&D.

So, effectively the D&D brand was cloned into a collectible miniatures game. Wizards began distributing three or four expansions of new collectible miniatures for *DDM* every year, starting with the 2003 *Harbinger* set. Within the *DDM* entry packs and boosters, players could find pre-painted plastic miniatures of their favorite monsters and character types. Each miniature shipped with a character sheet card with statistics for the simplified *DDM* "Skirmish Rules" on one side and "D&D Quick Reference" on the other, so that the miniatures could readily transition from use in one game to the other, thereby removing barriers to entry for the new v3.5 role-playing game.

TOP A 2003 advertisement for v3.5.

ABOVE Two-sided character cards that came with packs of *Dungeons & Dragons Miniatures*. One side was for use with the 3.5 D&D role-playing rules and the other was for use with standalone *DDM* combat.

OPPOSITE Repurposing an approach they used successfully with *Magic: The Gathering*, Wizards began to release randomized "booster packs" with pre-painted D&D miniatures, complete with associated character cards.

EASIER

No glue. No paint. Open a box and jump into battle. With **DUNGEONS & DRAGONS**® Miniatures, you get pre-assembled, pre-painted, randomized plastic minis, all statted up and ready for action. So you know where you stand—and where your enemies will fall.

Pick them up and roll for initiative.

DUNGEONS & DRAGONS
PLAY MORE 3.5

The *Miniatures Handbook* included a head-to-head skirmish system, but could also be easily adapted to support combat for traditional role-playing games.

BY REUSING *DDM* FIGURES on a "battle grid" terrain of one-inch squares, each representing five feet of space, those miniatures became a core part of D&D and a key to the game's visual identity at the time. With the new *Dungeon Tiles* configurable map segments—the latest iteration of the venerable idea of *Dungeon Geomorphs*—Wizards of the Coast granted players tools far superior to the spoken word to visualize a deterministic tactical situation. A large battle grid and a few cardstock terrain tile sheets shipped in every *Harbinger* entry pack. Wizards made the link to *DDM* officially part of the D&D v3.5 system in their Dungeons & Dragons *Miniatures Handbook*, not coincidentally designed by a team led by 3rd edition lead designer Jonathan Tweet, who had moved over the miniatures division, along with staffer Rob Heinsoo, who had worked on the 3rd edition *Forgotten Realms Campaign Setting*. Even the v3.5 *Player's Handbook* heavily reoriented combat around the battle grid, and the *Dungeon Master's Guide* shipped with a detachable grid map in the back suitable for D&D miniatures. This emphasis on the exact visualization of tactical combat with miniatures on a battle grid would become a signature feature of D&D in this era.

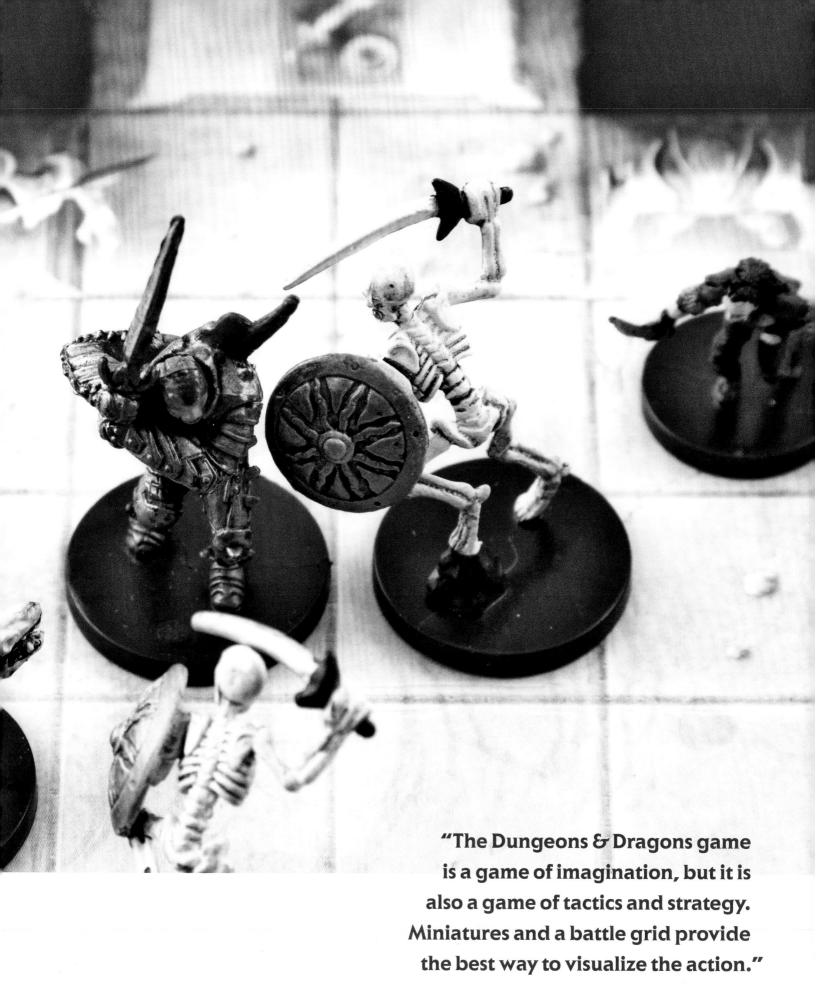

"The Dungeons & Dragons game
is a game of imagination, but it is
also a game of tactics and strategy.
Miniatures and a battle grid provide
the best way to visualize the action."

—DUNGEONS & DRAGONS V3.5

THE ROPER

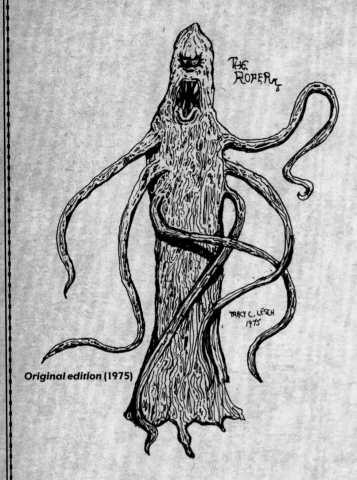

Original edition (1975)

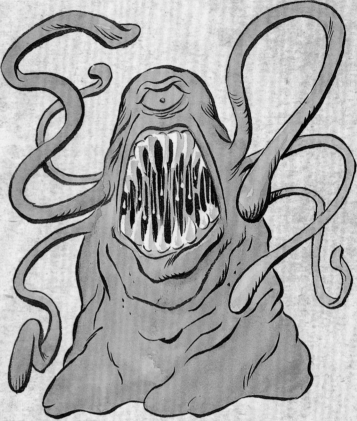

2nd edition (1993)

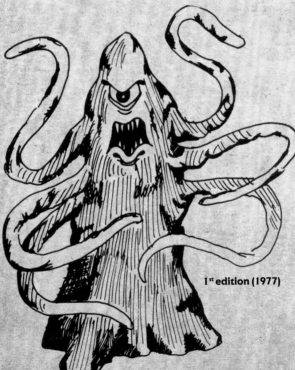

1st edition (1977)

"Ropers inhabit subterranean caverns. They prey upon all forms of creatures, but humans are their favorite form of food. . . . The roper has six strands of strong, sticky rope-like excretion which it can shoot. . . . This yellowish gray monster appears to be a mass of foul, festering corruption. The roper is cigar-shaped, about 9'-long, with a diameter of some 3'."

—*MONSTER MANUAL*, 1977

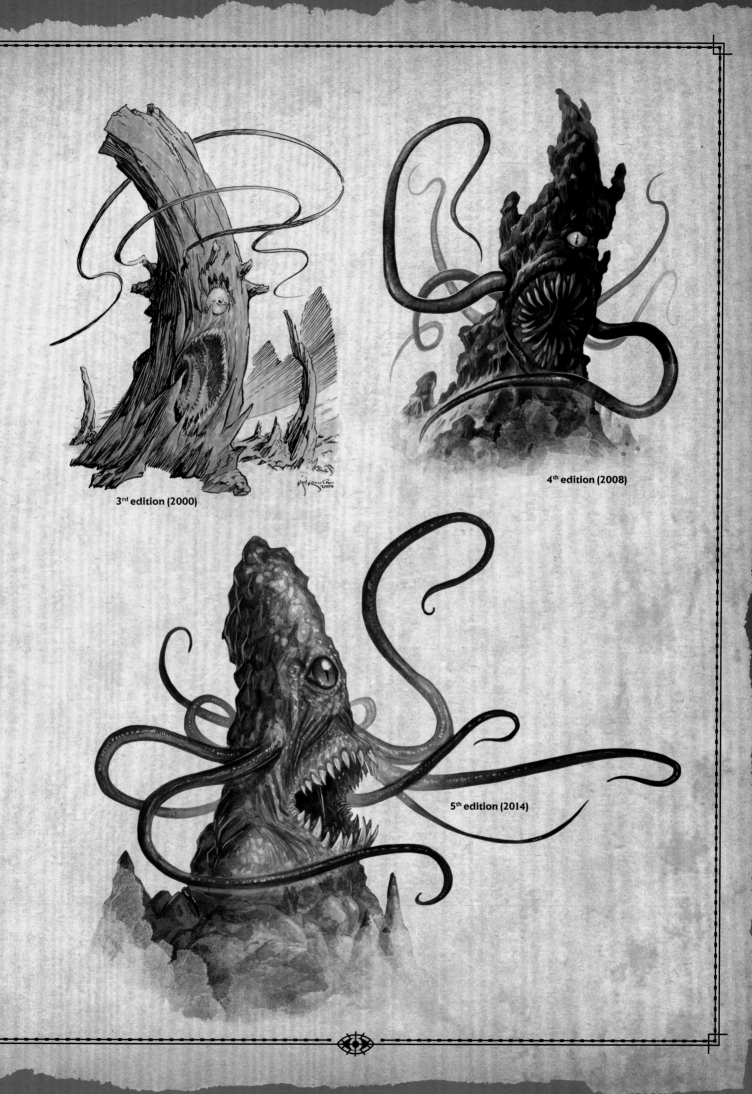

3rd edition (2000)

4th edition (2008)

5th edition (2014)

Bar fight! A key Todd Lockwood marketing image from the
3rd edition era celebrating the thirtieth anniversary, showcasing
a multitude of iconic D&D creatures and character archetypes
in the Yawning Portal tavern, the continuation of a longstanding
D&D tradition depicting character-laden tavern scenes.
According to Lockwood it was "the most fun I've had working
on a D&D-themed image, which is saying something."

TODD
LOCKWOOD
ARTIST FAVORITE

Eberron was the sole new campaign setting introduced by Wizards during the 3rd edition era. Perhaps no artist became more synonymous with this era than a young artist from Leeds, England, named Wayne Reynolds. Pictured here is the original wraparound cover alongside the published product.

> "In my opinion, Wayne Anthony Reynolds is the defining artist of Eberron."
>
> —KEITH BAKER, EBERRON CREATOR

NEW WORLDS

In 2004, the game had turned thirty years old, and Wizards estimated that four million people played Dungeons & Dragons on a monthly basis. The first Worldwide Dungeons & Dragons Game Day was held on October 16 in celebration of the game's thirtieth anniversary, giving fans a good reason to go to the local game store to buy or join a game. Despite all of the recent changes to the system, the fan community remained a deeply valued component of the brand's identity, a fact that Wizards of the Coast both recognized and respected. Just a year earlier, Wizards had challenged role-playing game fans around the world to come up with a new campaign setting, promising that the winner's

creation would be turned into an entirely new playable realm of Dungeons & Dragons—along with a $100,000 prize. From more than eleven thousand entries, the winner was Eberron, the brainchild of author and game designer Keith Baker.

The *Eberron Campaign Setting*, developed by Baker, Bill Slavicsek, and James Wyatt, was designed to accommodate standard D&D races within an entirely fresh campaign world. Set in a post-war environment on the fictional continent of Khorvaire, Eberron wove dark adventure elements into a classic fantasy tone that included atypical technologies such as skyships, trains, and mechanical beings—all of which were powered by magic.

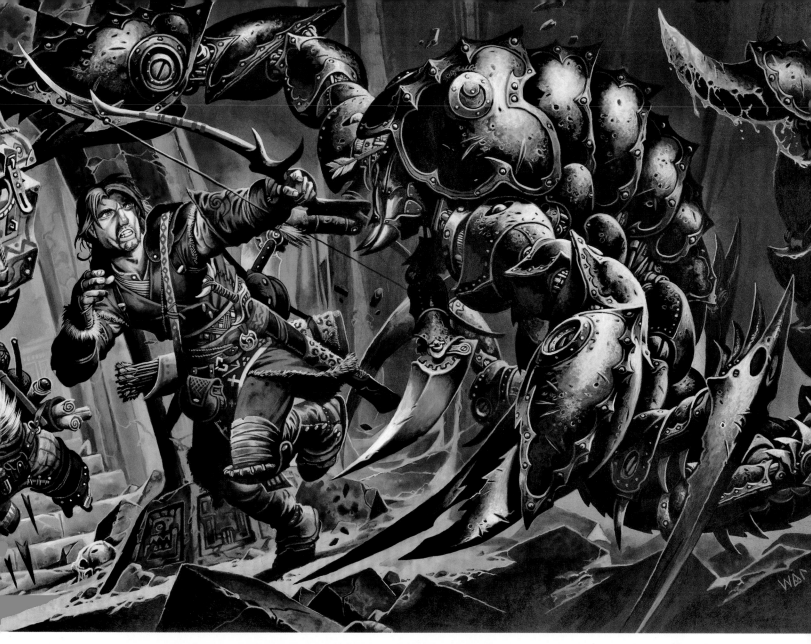

TOP *Sharn: City of Towers* by Wayne Reynolds. According to Eberron creator Keith Baker, this cover "captures the pulp flavor and incorporates new elements such as the Warforged," something of a reimagined golem that is a race option for player characters in Eberron.

BOTTOM Original *Forge of War* wraparound cover by Wayne Reynolds.

WAYNE REYNOLDS

ARTIST FAVORITE

FOR A GAME THAT was thirty years old, D&D was showing no signs of its age, touting a young fan base and a briskly selling catalog of books. A new Dungeons & Dragons *Basic Game*, designed by Jonathan Tweet, hit shelves in 2004 to help ease new players into the fold. As a template for character development, it included pre-generated sheets for iconic 3rd edition characters—and inevitably, it incorporated *Dungeon Tiles* and *DDM* figure movement on a simplified version of the battle grid.

Although the printed version of D&D was revered as an institution, there was still room for the industry as a whole to grow. Wizards of the Coast ceded the emerging digital markets to competing brands, companies who transformed the innovations of D&D into online phenomena. *Everquest*, *Ultima Online*, and *World of Warcraft* attracted hordes of fans, all in the form of monthly paying subscribers, much to the notice, and sometimes chagrin, of the Wizards boardroom.

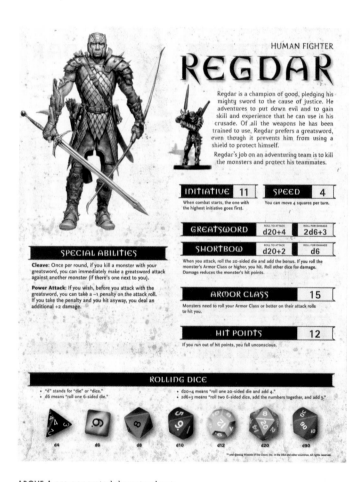

HUMAN FIGHTER

REGDAR

Regdar is a champion of good, pledging his mighty sword to the cause of justice. He adventures to put down evil and to gain skill and experience that he can use in his crusade. Of all the weapons he has been trained to use, Regdar prefers a greatsword, even though it prevents him from using a shield to protect himself.

Regdar's job on an adventuring team is to kill the monsters and protect his teammates.

INITIATIVE	11	SPEED	4

When combat starts, the one with the highest initiative goes first.

You can move 4 squares per turn.

		ROLL TO ATTACK	ROLL FOR DAMAGE
GREATSWORD		d20+4	2d6+3
SHORTBOW		d20+2	d6

SPECIAL ABILITIES

Cleave: Once per round, if you kill a monster with your greatsword, you can immediately make a greatsword attack against another monster (if there's one next to you).

Power Attack: If you wish, before you attack with the greatsword, you can take a –1 penalty on the attack roll. If you take the penalty and you hit anyway, you deal an additional +2 damage.

When you attack, roll the 20-sided die and add the bonus. If you roll the monster's Armor Class or higher, you hit. Roll other dice for damage. Damage reduces the monster's hit points.

ARMOR CLASS	15

Monsters need to roll your Armor Class or better on their attack rolls to hit you.

HIT POINTS	12

If you run out of hit points, you fall unconscious.

ROLLING DICE

- "d" stands for "die" or "dice."
- d6 means "roll one 6-sided die."
- d20+4 means "roll one 20-sided die and add 4."
- d6+3 means "roll two 6-sided dice, add the numbers together, and add 3."

d4 d6 d8 d10 d12 d20 d90

** and ©2004 Wizards of the Coast, Inc. in the USA and other countries. All rights reserved.

ABOVE A pre-generated character sheet from the 2004 *Basic Game*.

LEFT Wayne Reynold's cover painting for the 2004 *Basic Game*. With a renewed focus on the miniatures market, D&D's newest iteration of the basic game now featured them standard.

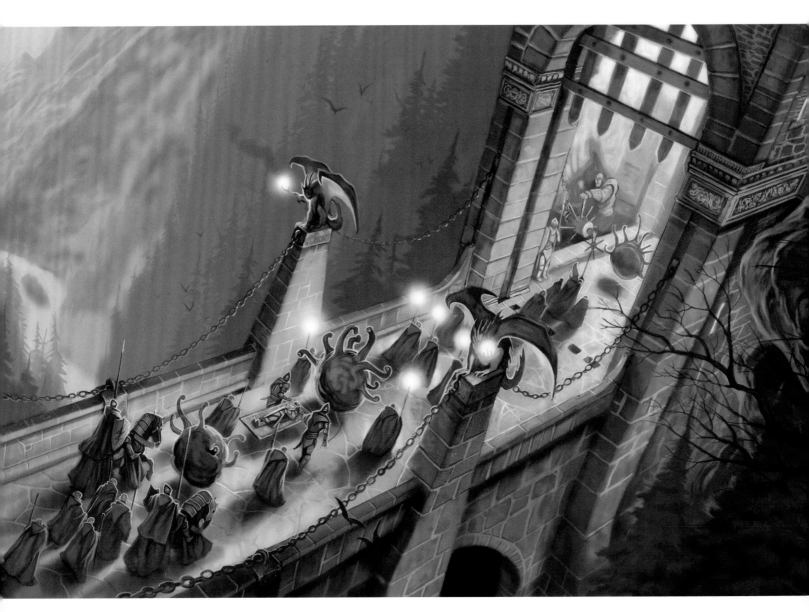

The full, cinematic painting for the 2005 Forgotten Realms product *Mysteries of the Moonsea* by William O'Connor was a wraparound cover, a common feature in the 3rd edition era. It's hard to ignore the very significant influence Peter Jackson's blockbuster *Lord of the Rings* trilogy had on all things fantasy in the early 2000s: this piece clearly draws inspiration from a scene in *Return of the King* (2004) at Minas Morgul.

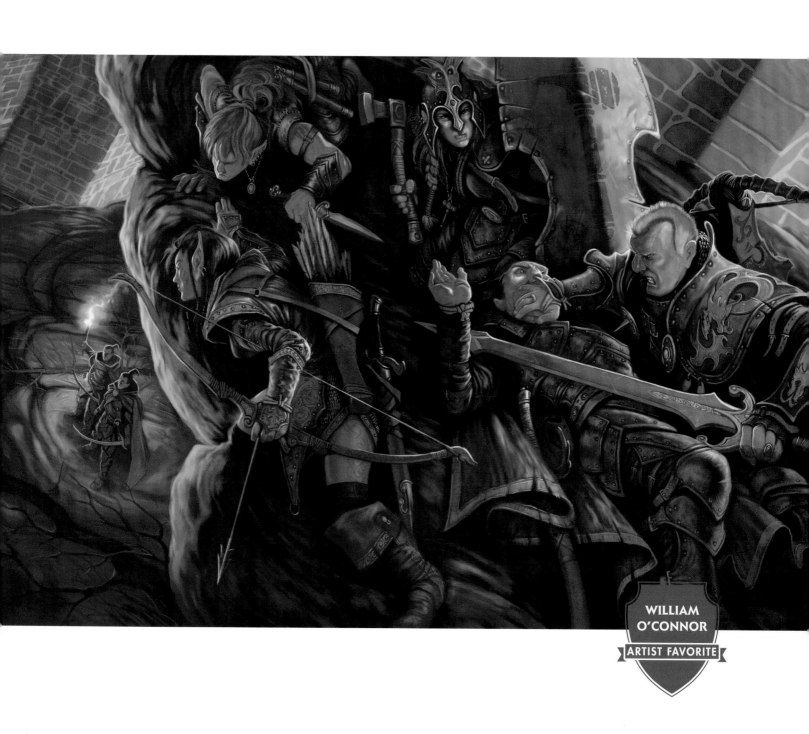

WIRED FOR ADVENTURE

"My vision for D&D, at the time, was doing an MMO.
We started a studio and had 30 people working on
code and art. It was when Hasbro decided to not do
that I realized I didn't have another idea."

—PETER ADKISON

SINCE THE 1970S, COMPUTER programmers have sought to reproduce the thrilling, open-ended world of Dungeons & Dragons as a computer game. Early technological hurdles meant that graphics and gameplay were decidedly primitive. But all this changed around the turn of the millennium, when talented artists could finally see their worlds come to life on the computer screen.

Among the most significant developments in early computer gaming was the evolution of the MUD (Multi-User Dungeon), a homebrew system by which a computer connected dozens of players to a single, persistent gaming world that they could explore through a textual interface together via an "avatar," or "player character." Digital thieves, mages, fighters, and priests began to plumb the depths of silicon labyrinths in an attempt to capture the magic of gathering around a tabletop, rolling a few jeweled dice, and spinning a Dungeons & Dragons yarn together. However, these MUDs evolved to include more players than could ever be accommodated by even the largest dining room table.

More polished commercial offerings like Origin Systems' *Ultima Online*, Sony's *Everquest*, AOL's *Neverwinter Nights*, and Mythic Entertainment's *Dark Age of Camelot* all garnered audiences of their own on systems that could accommodate thousands of players at once. People who'd never played Dungeons & Dragons took to these addictive experiences, and with each new iteration, the technology, the design, and, indeed, the art style, became more vivid and alluring. Soon these digital kingdoms were home to millions of avid players and rabid fans of their particular milieu.

It was in this frenzy that a new computer-generated world emerged—the undisputed victor of these massively multiplayer online role-playing games (MMORPGs, or MMOs for short). In 2004, Blizzard Entertainment released *World of Warcraft*, and the face of online gaming changed forever.

World of Warcraft (*WoW*) quickly became the most successful MMO of its time, with a large part of its success owing to its design-over-technology approach to the art of the game. Beautiful graphics were selling. However, with *WoW*, a decision was made to forgo the more realistic style of other games, which demanded faster computer hardware, in favor of a simpler, hyper-stylized, wildly colorful universe that would run fast and look beautiful on a much wider range of personal computers. Combined with a killer game engine, it was unstoppable.

The result? *World of Warcraft* boasted more than twelve million monthly subscribers at its height. This victory sent a shockwave through the entire entertainment industry. Other MMOs responded by seeking to emulate *WoW*'s success, but nowhere was this wave more keenly felt than in the offices of Wizards of the Coast, which estimated a D&D player base of four million—only a third of *WoW*'s subscription. *WoW* also saw more hours, sessions, and dollars out of each player. Whether the subscribers of *WoW* knew it or not, Wizards of the Coast hierarchy saw that just over that proverbial hill, in a valley next to the Hobbit Holes containing the tabletops of yesteryear, there were twelve million Dungeons & Dragons players—most of whom didn't even know they were playing Dungeons & Dragons.

```
> look
The Church

    You are in the main church of Realmsmud.
    You see a set of stairs that go down to the healing waters of
    the Realms. There is a huge pit in the center, and a door in
    the west wall. There is a button beside the door.
    There is a clock on the wall.

    THE GRAVEYARD TO THE EAST IS NOW OPEN FOR LEVELS 6-15!
    This church has the service of reviving ghosts. Dead
    people come to the church and pray.
+---------------------------------------------------------------------+
|      ******DON'T CAST SPELLS OR FIGHT IN THE CHURCH!*****           |
+---------------------------------------------------------------------+
A new graphics command is now available. Try typing 'graphics vt100'
and then look at this room again. You should see the box around
the text above as a perfectly drawn box. If this doesnt work
with your terminal program, you can disable it by typing
'graphics dumb'. Or just type 'graphics' for a list of other
supported terminal types.  -James

There are exits south, north, up, arena, east, down and wedding.
    A magic portal, leading to many houses.
    REALMS players rules.
    A newspaper.
> s
Village green ( w e s n up )
    The Dream Post.
    A dazzling sapphire.
    An important Newbie Signpost.
```

TOP An example of the textual interface typical of MUDs.

ABOVE Screen shot from the 2006 *Dungeons & Dragons Online*.

RIGHT *World of Warcraft* would occasionally name-drop Gary Gygax or Dave Arneson as a wink and a nod to tabletoppers who had made the switch to online.

Delvar Ironfist

DELVAR IRONFIST
Well it's about time ye showed up. I'm done slumming around with these new recruits.

Me blade is sharp, me armor is spit shined and I combed me beard this mornin'.

I've been ready for battle since me grandpa Gygax first put an axe in me wee lil hand.

So whad'ya say, commander?

REWARDS
You will gain this follower:

Delvar Ironfist
91

You will also receive: 11 40
Experience: 10,450

Complete Quest

BY THE TIME THE massively multiplayer online role-playing game *Dungeons & Dragons Online* was released by Turbine Entertainment in partnership with Wizards in 2006, the MMO market had become firmly established. Although fans were now able to log in and play alongside (or against) a community of players from around the globe, many potential buyers were already deeply invested in rival titles. Regardless, *Dungeons & Dragons Online* remained steadfast to the spirit of the classic role-playing game, and despite the format being an obvious rethink of mechanics and design, it offered an entirely new and immersive way of experiencing the game, ingratiating new fans to the brand and granting loyal tabletoppers a world to escape to on their "off nights." As an olive branch to tabletop loyalists and a tribute to the game's creators, Turbine even invited both Gary Gygax and Dave Arneson to record voiceover narratives for *Stormreach* adventures.

ABOVE, LEFT AND RIGHT With the rising popularity of online games, Wizards sought to remind players of the joys of good old-fashioned live role-playing.

OPPOSITE The game was originally marketed as *Dungeons & Dragons Online*: *Stormreach* before being rebranded as simply *Dungeons & Dragons Online*, with the introduction of Forgotten Realms content.

AS WIZARDS HAD DISCOVERED, the creative landscape was rapidly changing and the entire industry along with it. Computer role-playing game releases were becoming bigger hits than even the most epic Hollywood blockbusters, raking in hundreds of millions per top title. Consequently, many Dungeons & Dragons fans were tempted away from the tabletop, toward the desktop and the console.

Wizards had to counterattack—an ambition that would ultimately manifest in the 4th edition project, which kicked off internally in 2005, just as the adjacent market of MMOs had exploded. When the project was finally announced at Gen Con 2007, revamped editions of D&D rules had been flowing fast and furiously all decade—but people got the hint that something

more fundamental was in the works when Paizo's license to publish *Dragon* and *Dungeon* magazines expired and was not granted renewal. With a revitalized focus on digital media, Wizards signaled that the brand's flagship periodicals would later resume as digital-only downloads available through its new multimedia service: *D&D Insider*, which went live on the first day of that same Gen Con.

The concept of *D&D Insider* was simple—a subscription-only Internet portal that provided an array of helpful tools to play D&D on the tabletop. For a $14.95 monthly fee, a tithe familiar to any *World of Warcraft* player, subscribers could access a character builder, a rules library, and downloads of the digital versions of *Dungeon* and *Dragon* magazines. But most of the promised value in the *D&D Insider* portal was in its online interface for remote play—a "virtual table" halfway between the Aurora toolset of *Neverwinter Nights* and the *D&D Miniatures Game*, which in 2007 Wizards still pushed with new expansions like the recent *Night Below*. This would not be a licensed product or a one-off, but part of the core implementation of Dungeons & Dragons. The visual identity of the game was poised to jump from print to the screen. With all of these innovations, one thing was clear: Wizards was reorganizing D&D for the digital age.

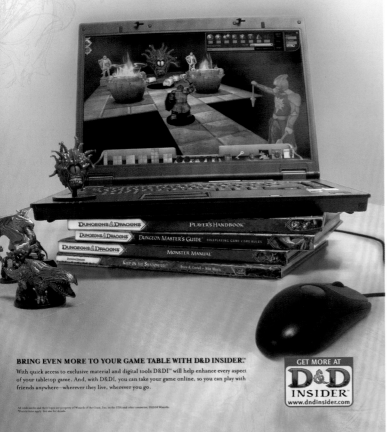

Combat Improves When You Add a Mouse

BRING EVEN MORE TO YOUR GAME TABLE WITH D&D INSIDER.
With quick access to exclusive material and digital tools D&DI™ will help enhance every aspect of your tabletop game. And, with D&DI, you can take your game online, so you can play with friends anywhere—wherever they live, wherever you go.

GET MORE AT
D&D INSIDER
www.dndinsider.com

ABOVE Digital avenues had so much become the focus of D&D strategy that players could only wonder what to do with all of those expensive books. This ad seems to offer an unintentionally symbolic suggestion.

RIGHT Dan Scott's recasting of the Dave Trampier *Players Handbook* painting for the cover of *Player's Handbook II* for v3.5.

OPPOSITE In an echo of the distant past, Erol Otus's iconic *Dragon* #55 cover painting (1982) is repurposed for this 2007 ad for the v3.5 *Monster Manual V*.

"YOU BANISH A CREATURE THAT YOU CAN SEE
WITHIN RANGE INTO A LABYRINTHINE DEMIPLANE.
THE TARGET REMAINS THERE FOR THE DURATION
OR UNTIL IT ESCAPES THE MAZE."

8

MAZE

4TH EDITION

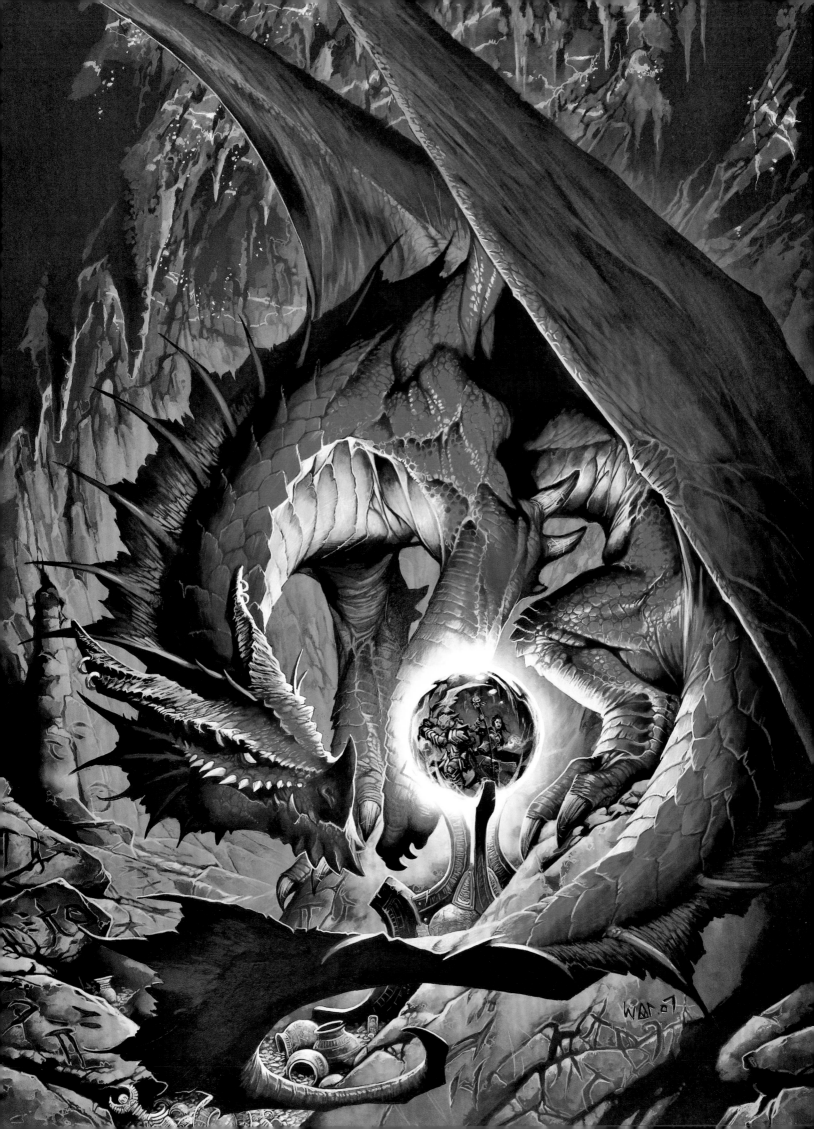

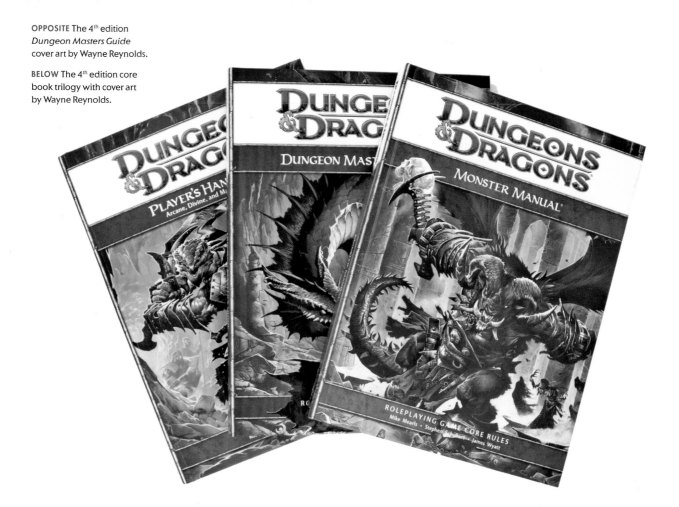

OPPOSITE The 4th edition *Dungeon Masters Guide* cover art by Wayne Reynolds.

BELOW The 4th edition core book trilogy with cover art by Wayne Reynolds.

IT HAD BEEN only eight years since the publication of Dungeons & Dragons 3rd edition, and only five years since the bug-fix point release of v3.5, when Wizards of the Coast unveiled the 4th edition. This dramatic intervention followed seismic shifts in the marketplace caused by the monumental popularity of MMOs, but it also flowed from Wizards' ongoing difficulties in acquiring new players for D&D—a challenge that v3.5 failed to solve—causing them to push harder on integrating the collectible *Dungeons & Dragons Miniatures Game* into the core D&D product. Whereas computer game developers like SSI and BioWare had to transform the earlier freeform D&D rules for digital play, 4th edition was designed from the ground up to run as a tight tactical game, which let computers be part of its core realization.

The 4th edition design was led by Rob Heinsoo, a veteran designer for the *DDM*. The rules for 4th edition combat resolution assumed access to both those miniatures and the *Dungeon Tiles* product. While v3.5 had made the battle grid integral to resolving combat, now, in 4th edition, all movement and ranged effects were measured in terms of squares familiar from the *Dungeon Tiles* grid. You could hardly cast a spell without knowing which squares it might affect—but in the grand scheme of things, even that was a comparatively minor change. Where previous revisions approached the brand with cautious reverence, the 4th edition team boldly transformed D&D to its very core.

As Gen Con was no longer a Wizards property, 4th edition did not wait for a grand release at that summer convention: instead, the new version of "holy trinity" core books began to appear on Wizards' annual D&D Day, June 6, 2008. The month before, however, they released *The Keep on the Shadowfell* module with a quick-start package geared to get people quickly

off the ground. But in some respects, the system innovations it presented had long been telegraphed in v3.5 releases; the 2006 *Book of Nine Swords*, for example, had already previewed ways to restructure fighting classes around the spell-like abilities in the v3.5 framework the 4th edition design team explored.

The 4th edition rules were to offer each class such a menu of preloaded powers, some of which could be used at-will, while others required a cooldown period before reuse—a system familiar to MMO players at the time, and for spellcasting classes, a stark break from traditional D&D memorization requirements. Now a starting wizard who took Magic Missile could cast it every round nonstop, though Sleep could only be cast once daily. Coupled with a boost to starting hit points, this meant that classes that had historically started out weak now had viable offensive and defensive capabilities from the get-go. Other nods to MMO design included quick health and ability recovery during downtime between encounters and the division of character classes into the "roles" of controllers, defenders, leaders, and strikers; this enabled MMO-like defensive tactics for concentrating enemy fire on resilient characters with support from healers while damage-dealers whittle down the adversaries. These rigid mechanics would have been ideal for play on the "virtual table," an "online meeting space, allowing players that can't gather together the means to play D&D," that was promised to accompany 4th edition—but that project was delayed soon after launch, leaving early adopters to keep track of these things the old-fashioned way, on the tabletop. Not that it would have looked much different: even the vaporware screenshots of the "virtual table" prototypes bear an uncanny resemblance to a computer rendering of *DDM* and *Dungeon Tiles*.

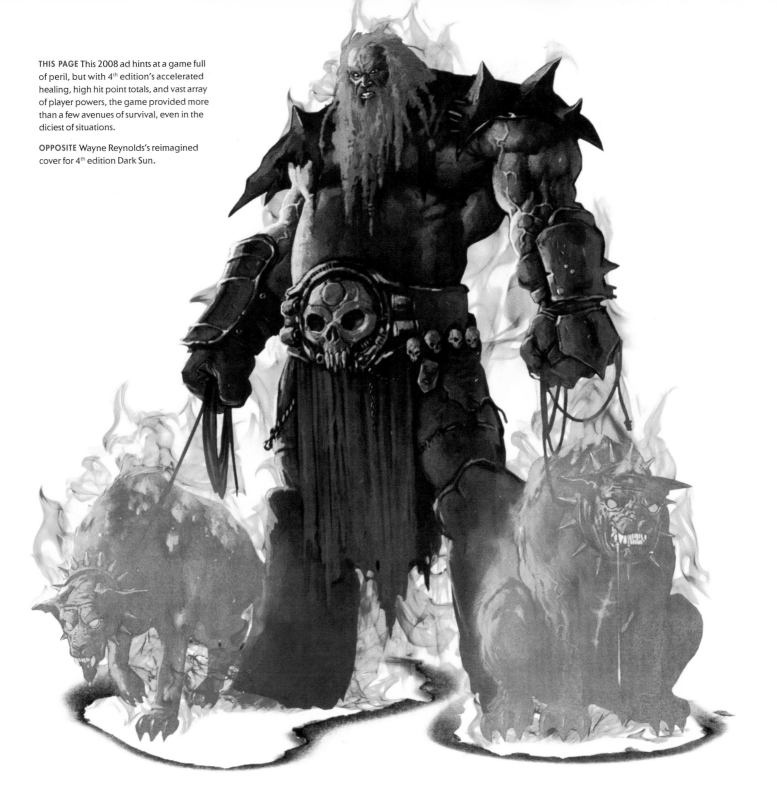

THIS PAGE This 2008 ad hints at a game full of peril, but with 4th edition's accelerated healing, high hit point totals, and vast array of player powers, the game provided more than a few avenues of survival, even in the diciest of situations.

OPPOSITE Wayne Reynolds's reimagined cover for 4th edition Dark Sun.

THESE GUYS SPENT THE LAST THREE YEARS GETTING READY FOR THEIR NEXT FIGHT.

In the name of making 4th Edition, we've offered up countless of our own characters for use as punching bags and chew toys. Now it's your turn.

So, be ready to throw down when you pick up all three Core Rulebooks.

You know where to get 'em.

AVAILABLE JUNE 6TH

CREATE AN ACCOUNT AT:
DNDINSIDER.COM

"One of 4th edition's advances is to rethink half of 3rd edition's biggest advances."

—ROB HEINSOO, 4TH EDITION LEAD DESIGNER

DUNGEONS & DRAGONS®

DARK SUN® CAMPAIGN SETTING

ROLEPLAYING GAME SUPPLEMENT

Richard Baker · Robert J. Schwalb · Rodney Thompson

THIS PAGE 4th edition conceptual designs, including some experimentation with "dwarven designs" and a new race available to characters known as the "dragonborn," with art by William O'Connor, and a reimagining of the iconic beholder by David Griffith.

OPPOSITE A freshened up view of the fabled Temple of Elemental Evil by Howard Lyon.

"As much as I love the art from each edition, it needs to be refreshed with a new style for a new gamer just like the mechanics."

—WILLIAM O'CONNOR, 4TH EDITION LEAD CONCEPTUAL ARTIST

JUST AS THE BOOKS departed from the game's heritage, exploring new mechanics and emphasizing tactical miniature combat, it was impossible to ignore the hyper-stylized rebranding similarly occurring in the art. Under the guidance of art director Stacy Longstreet, who relied heavily on William O'Connor for concept art, 4th edition steered D&D in a brash new direction—one loaded with unbridled action, exaggerated poses, and extreme, often distorted, angles. "[The style guide] demanded a visual branding to be developed that had never been a consideration in previous editions," says O'Connor. "It allowed the game to be visually designed . . . from the ground up to work as an online game, video games, books, minis, and toys." Accordingly, isometric perspectives and first-person point-of-views, all common in video games, became signature vantages in 4th edition art. Frames were often overcrowded, sometimes conveying a veritable feast of adrenalized information. It was fresh, it was dynamic, and it was a decided step away from the past.

Dungeons & Dragons had been reforged into a game system that MMO fans would find familiar. Just as previous editions of the D&D tabletop game tethered their identity to their visual style, a clear decision was made to skew 4th edition toward a more fantastical, super-heroic, *World of Warcraft*-infused experience. Giant shoulder pauldrons, impossibly large weapons, and incredible splashes of bright color illustrated a new ruleset that leapt far beyond the foundational, brand-defining look that Dave Sutherland's or Dave Trampier's illustrations conveyed back in 1978. The game had once again entered a new era, and yet, strangely, it was no longer the trendsetter.

Where Sutherland's art advised caution, 4th edition commanded bold action; where Trampier depicted scruffy bearded men wearing threadbare tunics, 4th edition's armor gleamed and robes billowed; where Erol Otus hinted at a broader world controlled by lascivious and uncaring gods, 4th edition gave player characters reason to expect to be godlike themselves with abilities like leaping, flipping, and teleporting directly to the shimmering, sylvan glades of the Feywild or the oppressive, suffocating mists of the Shadowfell. The baseline rules even provided the opportunity to play as one of the dragonborn—humanoids descended from an ancient dragon god.

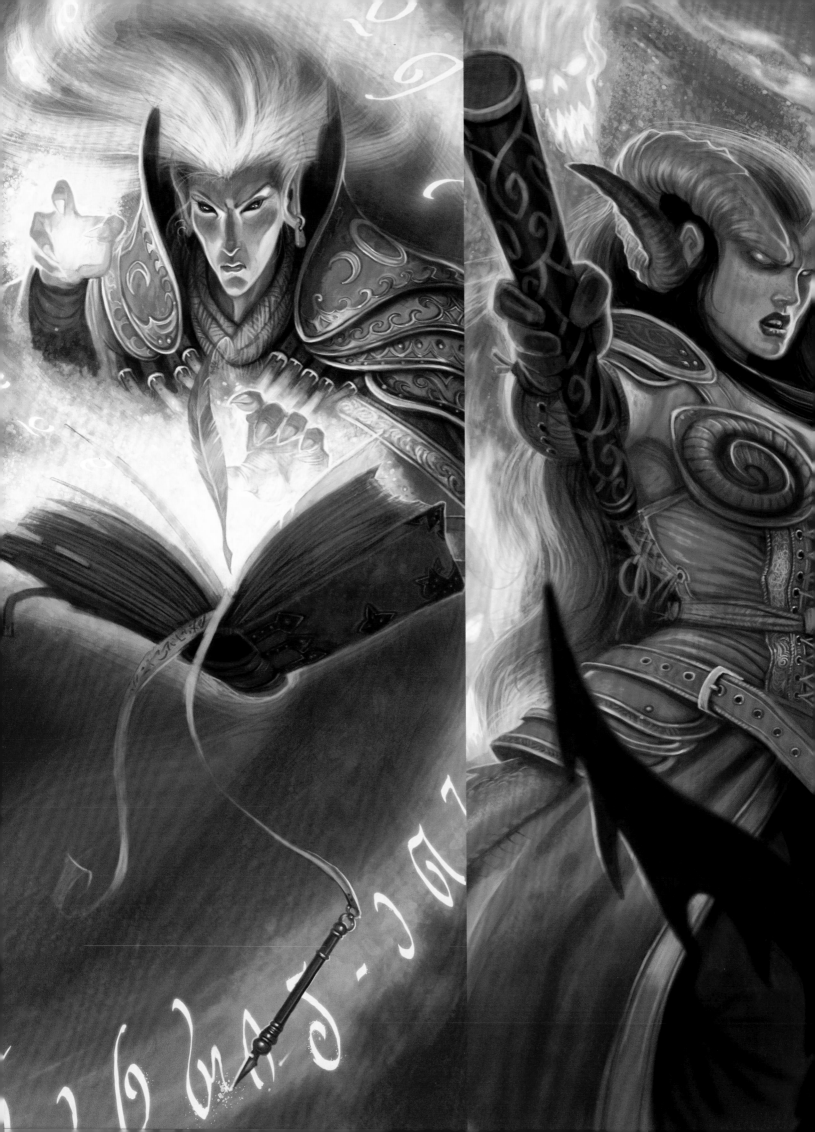

Art by William O'Connor:

LEFT The mystical, high-elven eladrin.

CENTER The demonic and oft-cursed tieflings, which first appeared in 2nd edition's Planescape.

RIGHT The dragonborn, a race of humanoids with dragon-like characteristics, not unlike the half-man, half-dragon abominations known as draconians originally introduced in Dragonlance.

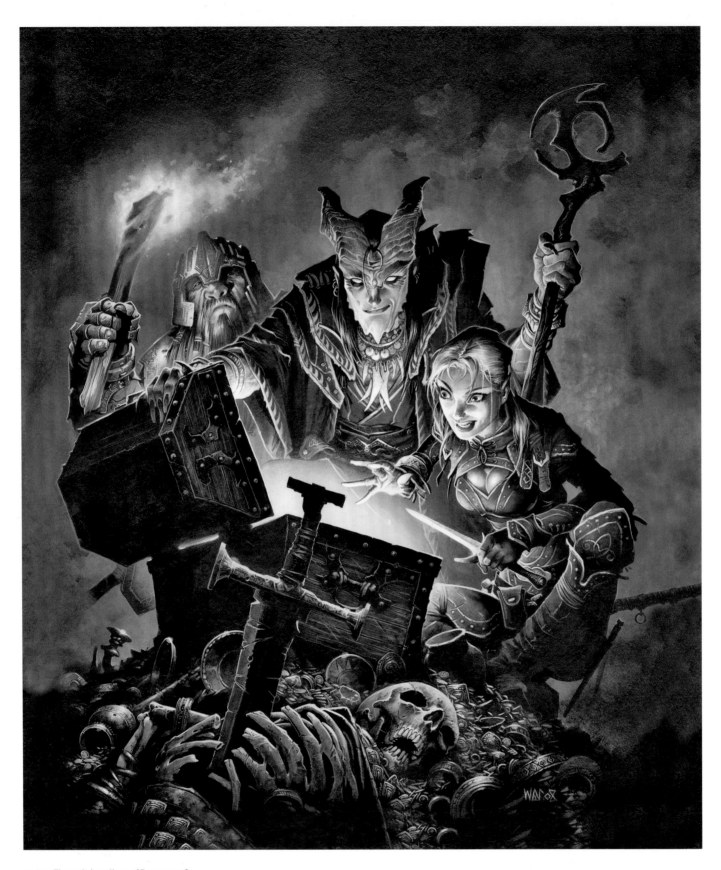

ABOVE The artistic stylings of Dungeons &
Dragons 4th edition were decidedly a departure
from traditional D&D artwork, yet there were
occasional nods to the past, as with Wayne
Reynolds's cover art for *Adventurer's Vault 2*.

OPPOSITE An iconic Dave Trampier panel from the
original AD&D *Monster Manual*.

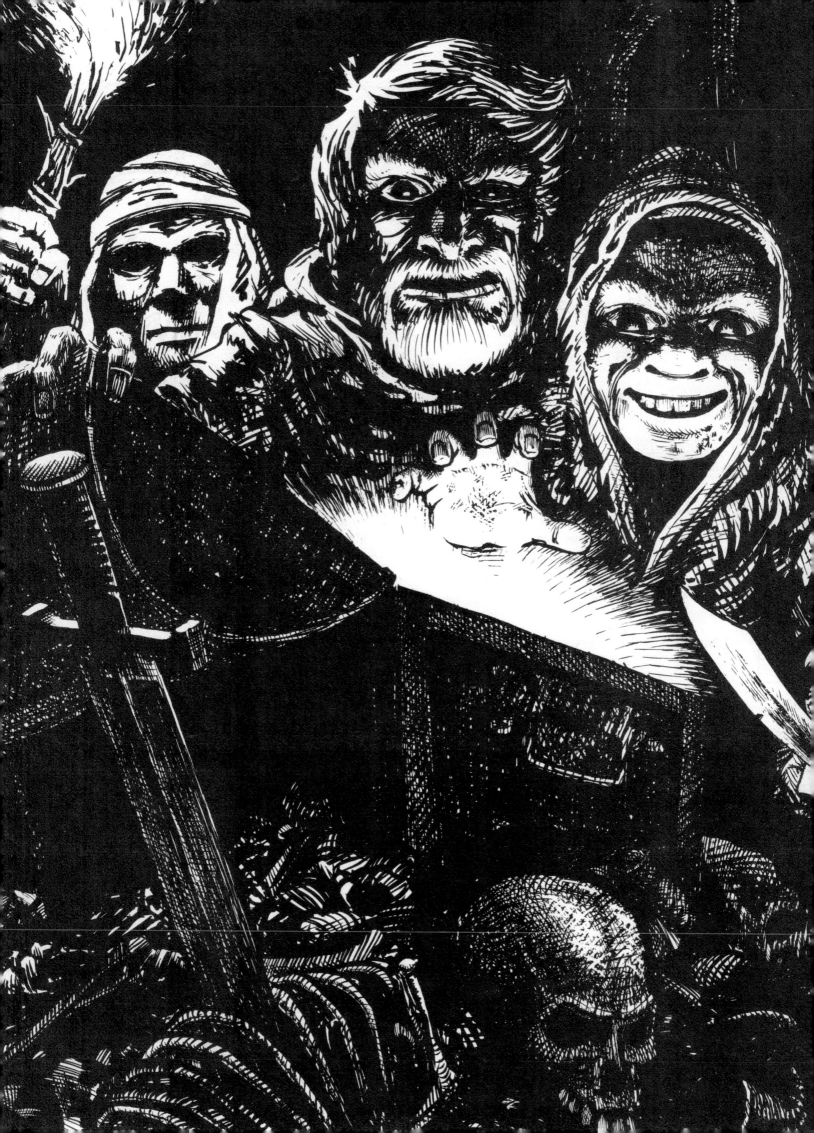

FRESH EYES

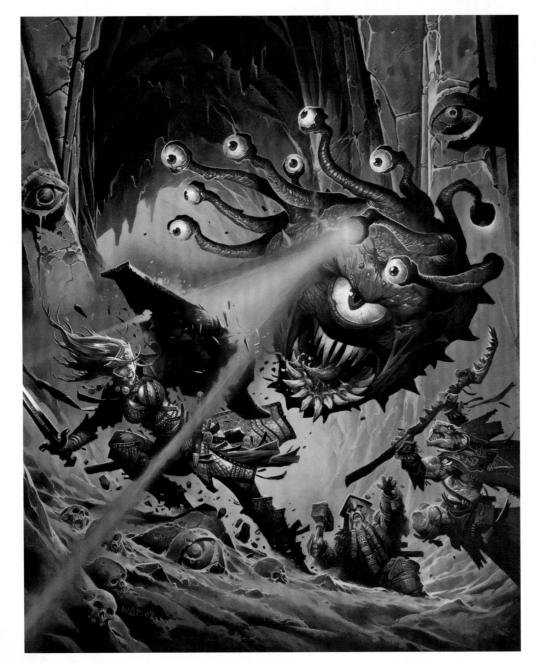

Wayne Reynold's "eye of flame beholder" (above) used as the design inspiration for the art study.

WAYNE REYNOLDS'S ICONIC DEPICTION of the all-new eye of flame beholder appeared on marketing ads, miniature packaging, and beyond. It quickly became among the most iconic images of D&D 4th edition, so much so that Wizards of the Coast senior art director Jon Schindehette administered a widely publicized art segmentation study, challenging artists to render alternative versions of Wayne Reynolds's landmark illustration. This effort demonstrated Wizards' openness and interest in continually pushing the artistic envelope.

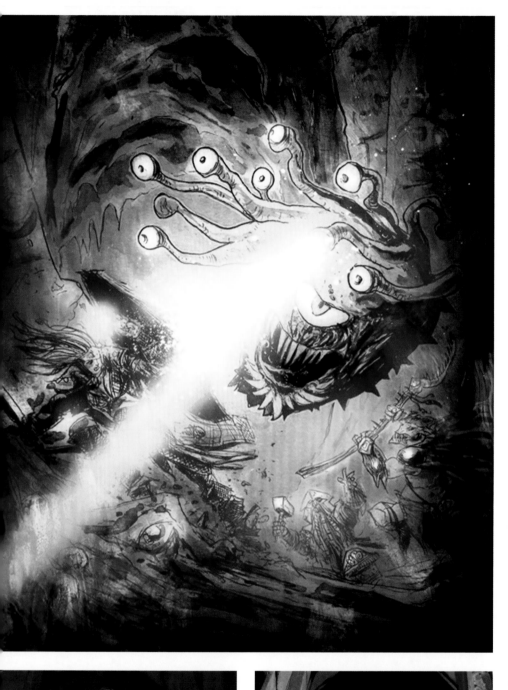
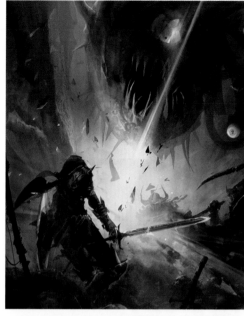
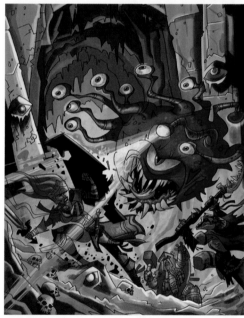
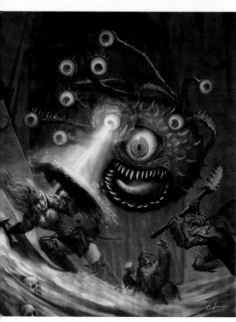
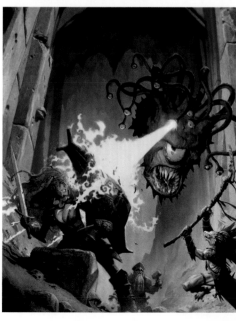
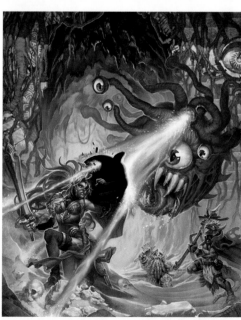

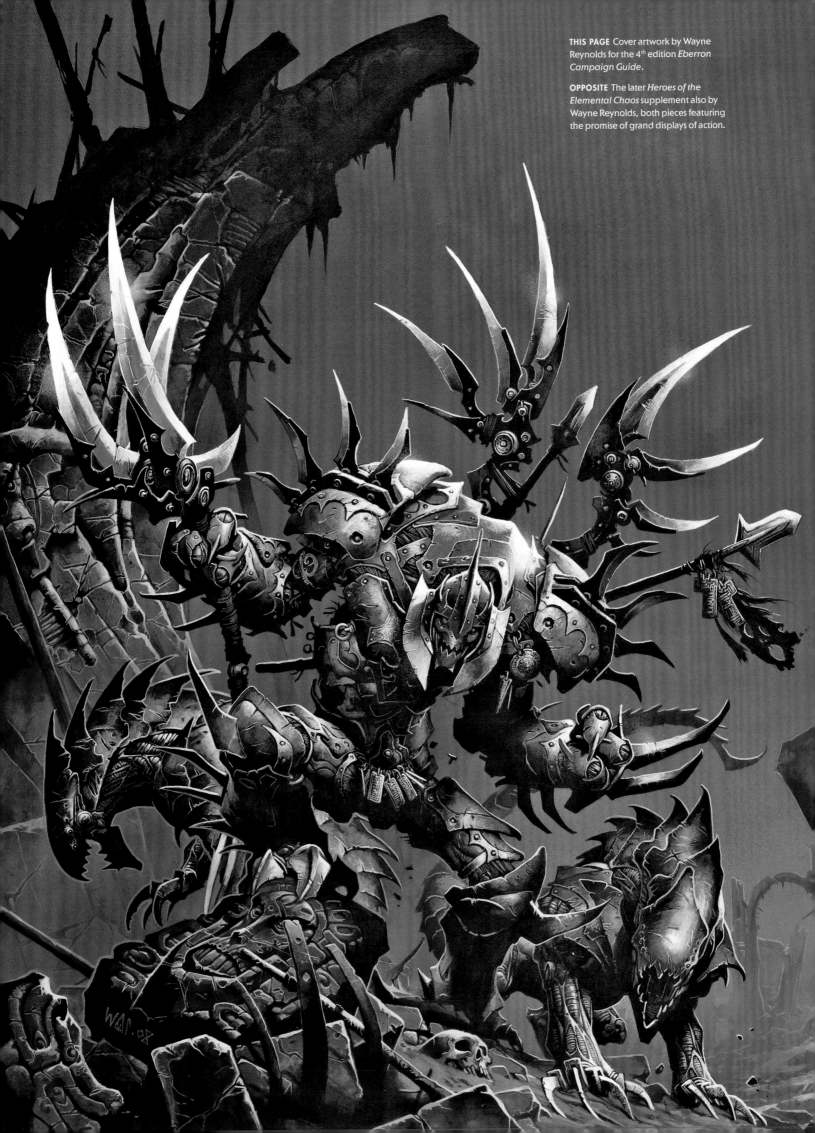

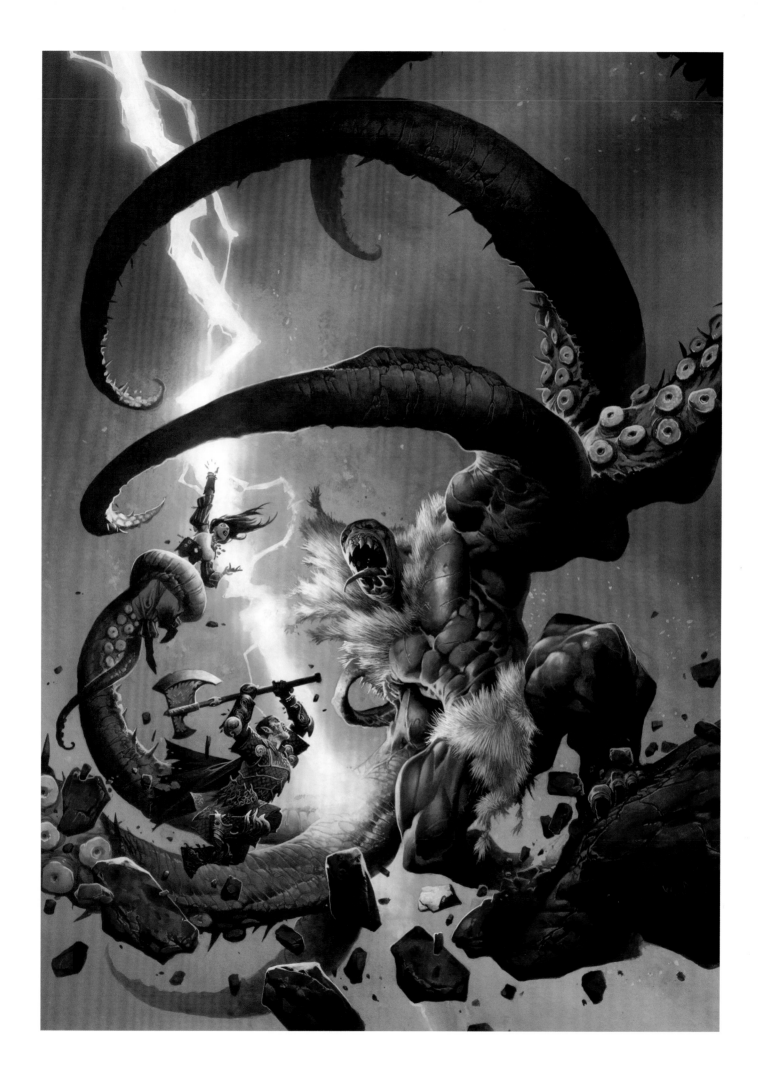

EVILUTION
THE OWLBEAR

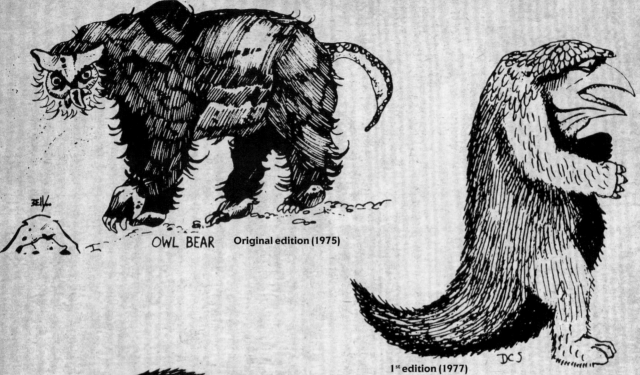

OWL BEAR — Original edition (1975)

1st edition (1977)

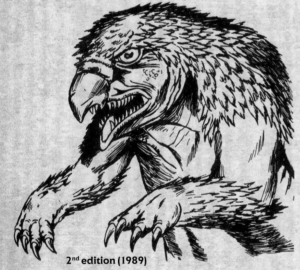

2nd edition (1989)

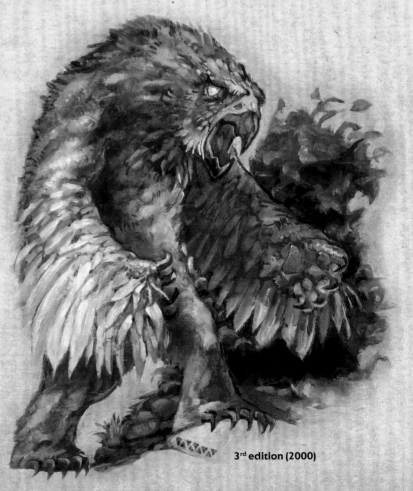

3rd edition (2000)

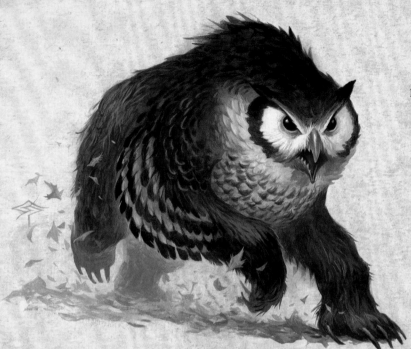

"The horrible owlbear is probably the result of genetic experimentation by some insane wizard. These creatures inhabit the tangled forest regions of every temperate clime, as well as subterranean labyrinths. They are ravenous eaters, aggressive hunters, and evil tempered at all times. They attack prey on sight and will fight to the death. . . . Owlbears have brownish-black to yellow brown fur and feathers. . . . The beaks of these creatures are yellow to ivory. The eyes are red-trimmed and exceedingly terrible to behold."

— *MONSTER MANUAL*, 1977

5th edition (2014)

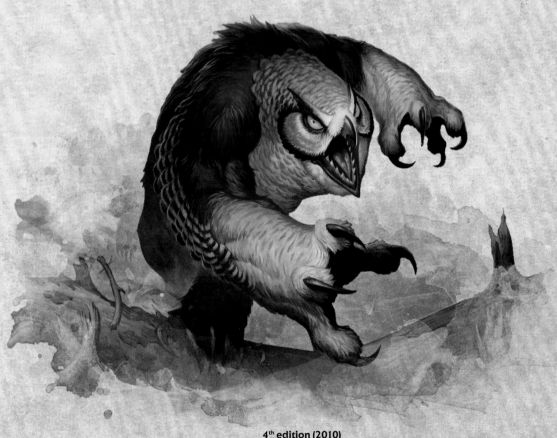

4th edition (2010)

An advertisement for *D&D Insider*, an online subscription service for players and dungeon masters.

THE BRAND WAS MOVING fast, eager to keep pace with an industry undergoing dramatic shifts. The allure of digital markets was irresistible, but beyond adjusting mechanical and graphical elements, how could a game fundamentally meant to be played at the tabletop adapt to a world of keyboards and computer screens? Due to competition from more established social media sites and existing online communities surrounding games like *World of Warcraft*, Wizards of the Coast found itself faced with the unenviable task of reinventing the wheel in technological spaces where they had little experience. For a time, it seemed like D&D might become lost in a maze of its own creation.

Its proposed "virtual table" would not enter beta until 2010, but by this point, after six years of growth, even *World of Warcraft* was now suffering a steady decline in subscription. *D&D Insider* was released to a modest response from customers;

it would be discontinued in 2014. With *D&D Insider*, Wizards was again asking the right questions but coming up with the wrong answers. These digital projects depended on the success of 4th edition, which they pushed aggressively, releasing dozens of mostly hardcover products in only two years' time. But 4th edition had dictated a narrow, and sometimes cumbersome, style of play, and even in year one, the game struggled to find support from the 3rd edition and v3.5 community.

The difficulties with the digital strategy made it more important than ever for Wizards of the Coast to get new players to the tabletop. Building on the organized play framework of the *Dungeons & Dragons Miniatures Game*, they unveiled the idea of a monthly dungeon crawl adventure series called "Delve Night," each installment of which was structured as four encounters to be played weekly that would take an hour or two to complete.

New adventures every month in your local retail stores.

Embark on a new adventure starting July 2009

Ask your friendly game store owner for more details

LEFT Facing increasing delays and challenges on the digital front, *Delve Night* was an effort to get players back to the tables and into game shops. While period ads were encouraging online engagement with browser bookmarks, it was only paper bookmarks like this one that could actually be used with the 4th edition game so far.

BELOW The *D&D Insider* virtual tabletop failed to move past development/beta stages. The resemblance of the environment to *Dungeons Tiles* and *Dungeons & Dragons Miniatures* is not coincidental.

By joining the Wizards Play Network, you would receive the full-color cardstock sheets necessary to run the encounters at sanctioned locations. They billed it as "a great way to have a weekly D&D game without a large time commitment," though of course the Dungeon Masters were expected to bring their own *Dungeon Tiles* and *D&D Miniatures*. The first installment, the Tower of Maraj, shipped in September 2008. Wizards furthermore re-tasked the RPGA with sponsoring events in the "Living Forgotten Realms," starting with an inaugural "Weekend in the Realms" slated for October. Adventure releases like these continued through 2009, but in 2010, Wizards replaced this series with the more longstanding "D&D Encounters" adventures, short encounters that were distributed to retailers in particular to support and encourage play at game stores.

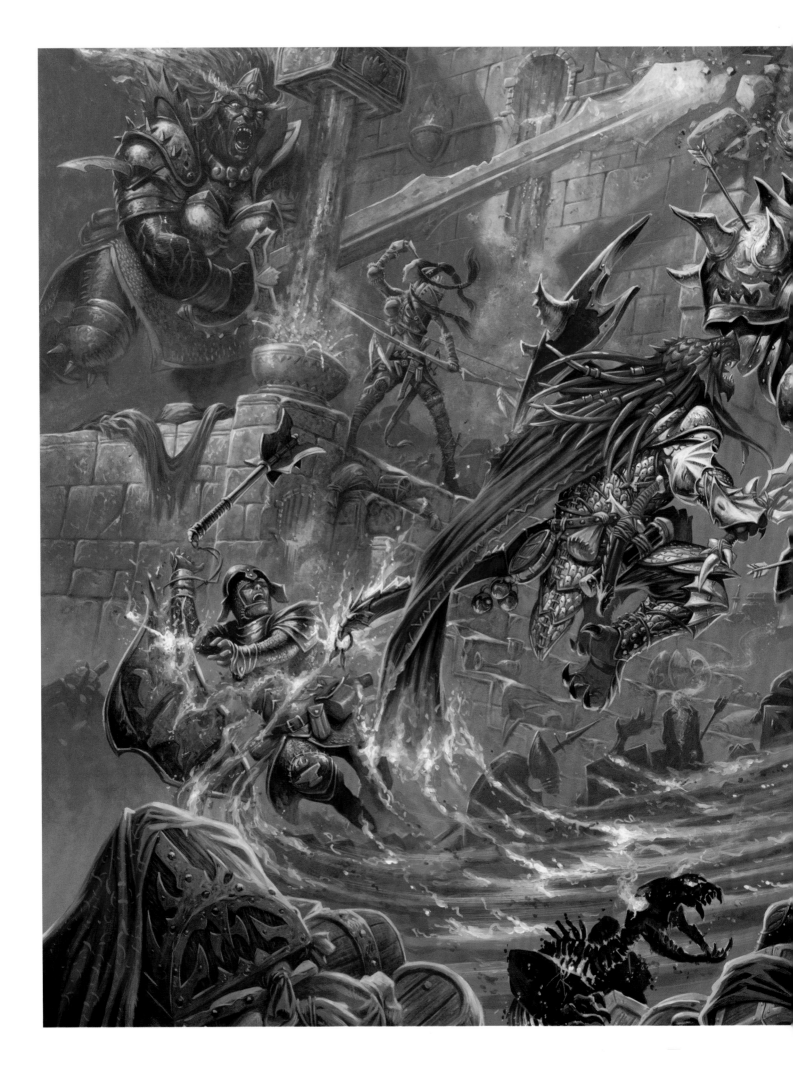

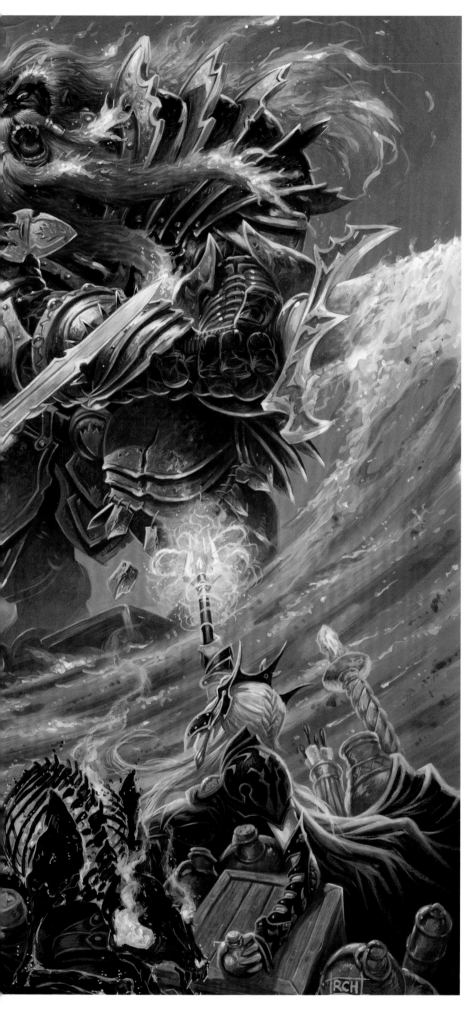

A 4th edition *Dungeon Master's Guide 2* interior illustration by Ralph Horsley of a fearless dragonborn and companions facing off against some nasty fire giants. The over-exaggerated, Michael Bay–style chaos of the scene well represents the kind of in-world gameplay that could be expected of 4th edition mechanics.

BUT WIZARDS COULD NO longer take for granted that fans would flock to its events. The traditional tabletop market had shifted dramatically in the years leading up to 4th edition, thanks largely to the Open Gaming License and competition it necessarily created. Eager to reorient the hobby around its new flagship game, Wizards rebooted everything, even the *Dungeons & Dragons Miniature Game*, to integrate with 4th edition rules. While some third-party publishers had experienced great success under the OGL, many others contributed to a glut of low-quality d20 products that diluted the market, undermining consumer confidence in non-Wizards products, such as adventure modules that were essential to supporting the brand. So, Wizards began to rethink the nature of this licensing agreement and subsequently introduced the Game System License (GSL), which enabled third-party publishers to produce 4th edition compatible products but under reworked, and slightly more restrictive, guidelines. But competition within the marketplace between 4th edition and third-party expansions of D&D's own previous editions provided the Wizards team with the unexpected and deeply ironic challenge of differentiating its products from, essentially, itself.

The biggest threat came from the popular *Pathfinder* game from Paizo Publishing, which appealed to a contingent of fans who felt abandoned by the shift to 4th edition. Paizo effectively reclaimed the abandoned official v3.5 game rules under the terms of the OGL and supported them in the existing market, one it knew inside and out as the former *Dungeon* and *Dragon* magazine license holder and a developer of d20 supplements. By some industry metrics cited at the time, *Pathfinder* may have even outsold D&D. They even engaged Wayne Reynolds to do their covers, capturing the visuals of that v3.5-era feel.

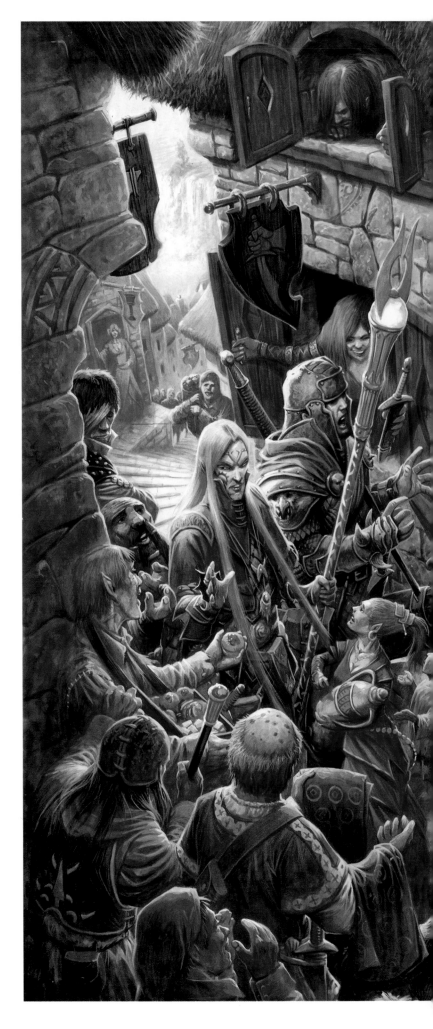

Where's Warlock? An acrylic illustration by Ralph Horsley, from the 4th edition *Dungeon Master's Guide*, which packs many characters into a dynamic town scene. Like Wayne Reynolds, Horsley hails from Leeds, England.

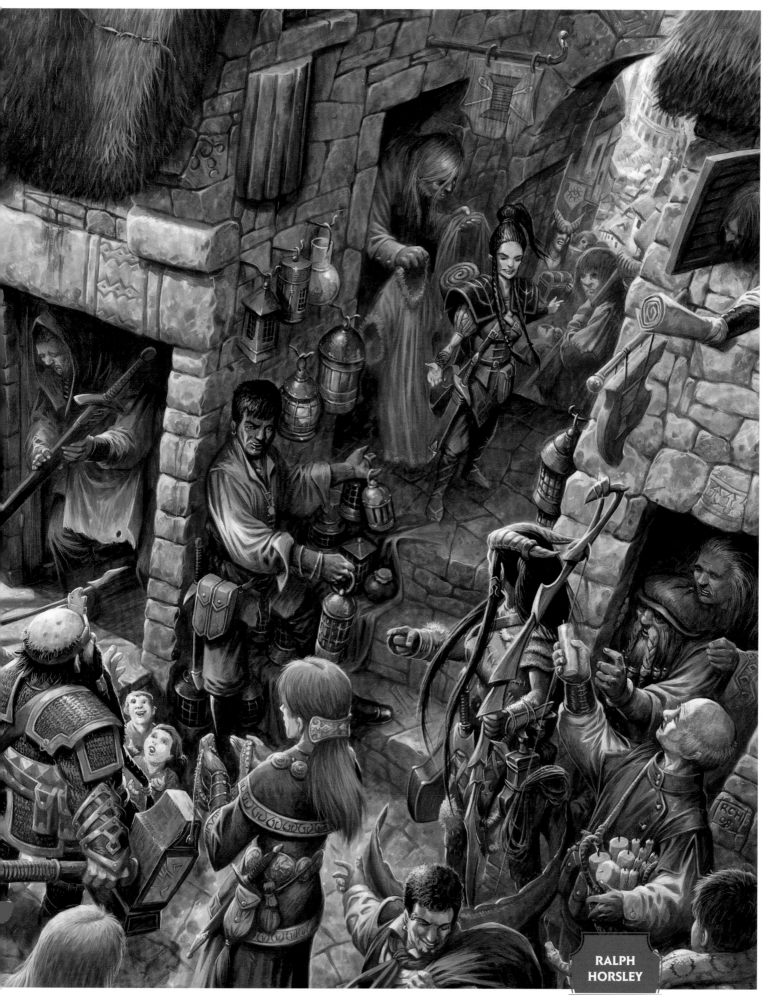

RALPH
HORSLEY

ARTIST FAVORITE

MONSTER MANUAL

ADVANCED DUNGEONS & DRAGONS™

By Gary Gygax

DUNGEON MASTERS GUIDE

ADVANCED DUNGEONS & DRAGONS™

By Gary Gygax

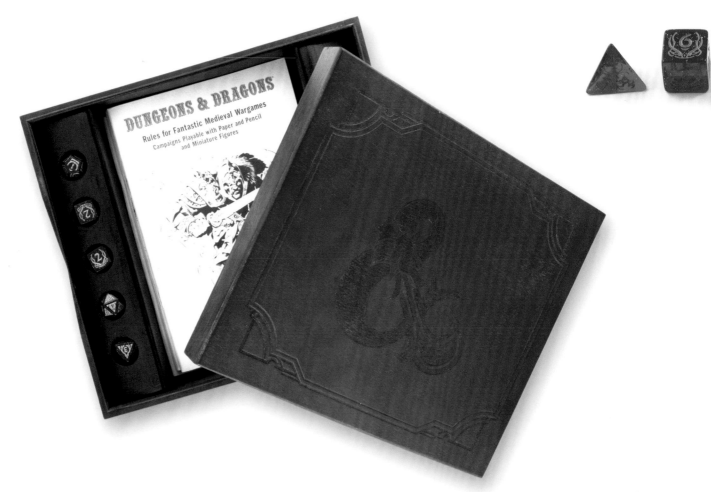

DUNGEONS & DRAGONS

Rules for Fantastic Medieval Wargames
Campaigns Playable with Paper and Pencil
and Miniature Figures

TOP AND LEFT With an unmistakable nod to the past, Wizards of the Coast published commemorative reprints of the original D&D and AD&D books of the 1970s in 2012 and 2013.

ABOVE While the commemorative original Dungeons & Dragons boxed set, released in 2013, reproduced and celebrated what were among the most crude and primitive D&D materials, the dice they included did have a bit of flair.

RETRO

After a decade of rapid-fire modifications, new editions, and copycat legacy games, industry insiders began referring to these turbulent times as the edition wars. While edition wars were nothing new to D&D and often represented welcome change, longtime players were becoming fatigued. Fans on the Internet organized themselves into informal communities like the "Old School Renaissance," a group of originalists seeking a return to the foundational Advanced Dungeons & Dragons 1st edition and original Dungeons & Dragons editions. This movement, which had gathered momentum throughout the 2000s, was fueled by disillusionment with 4th edition and granted new urgency by the passing of Gary Gygax in 2008 and Dave Arneson in 2009. How can one recapture D&D as it was originally played? Or, perhaps more accurately, as it should have been played: the many omissions and ambiguities in the original rules encouraged many to roll their own "retro-clones" of early D&D editions, some of which became small-press hits by their own rights. Numerous web forums emerged catering to vintage games. Sites like Dragonsfoot for fans of AD&D 1st edition, the Acaeum for collectors of early D&D products, and many others provided support networks for players who wanted to explore the game as it was originally published. The power of social media let fans organize themselves and promote work they found valuable, like the One-Page Dungeon Contest event held every year since 2009. The Internet even became a path to crowdsourced funding in this period, as Kickstarter started letting audiences bankroll their own role-playing games in 2009.

Wizards clearly recognized this growing nostalgia market. As they rolled out the D&D *Essentials* series in 2010, even the *Starter Kit* that Wizards published cloned the look of the Frank Mentzer "red box" *Basic Rules*—including the iconic Larry Elmore dragon—as a sly call to "old school" players who might have neglected 4th edition. As a fundraising effort for the creation of a Gary Gygax memorial in Lake Geneva, Wisconsin, Wizards even released reprints of the earliest AD&D 1st edition books, donating proceeds to the foundation; more reprints and digital editions of older books would follow. And when the fortieth anniversary of Dungeons & Dragons neared, Wizards showed their support for these retro enthusiasts by releasing a deluxe boxed set of the original D&D game in an homage to the digest-sized pamphlets— this time not just in a woodgrain-patterned cardboard box, but in a sturdy wooden miniature chest with a removable lid.

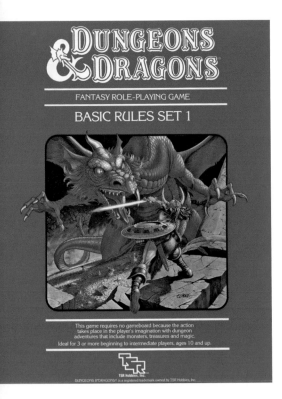

DUNGEONS & DRAGONS

FANTASY ROLE-PLAYING GAME

BASIC RULES SET 1

This game requires no gameboard because the action takes place in the player's imagination with dungeon adventures that include monsters, treasures and magic. Ideal for 3 or more beginning to intermediate players, ages 10 and up.

TSR Hobbies, Inc.

DUNGEONS & DRAGONS® is a registered trademark owned by TSR Hobbies, Inc.

Spot the difference! The 1983 *Basic Rules* (above) shown next to its 2010 counterpart (right) and ostensible near-clone. Of course, what's inside each box is anything but similar. Even at a glance, the 1983 version promises, "This game requires no gameboard," whereas the 2010 version based on the complex 4th edition rules depends heavily on miniatures and grid maps. One area the 4th edition did find simplicity was with its dice—just black.

OPPOSITE IDW collaborated with D&D designers, often providing uniquely successful interpretations of stories that felt as if they could have even come directly out of dynamic role-playing game sessions.

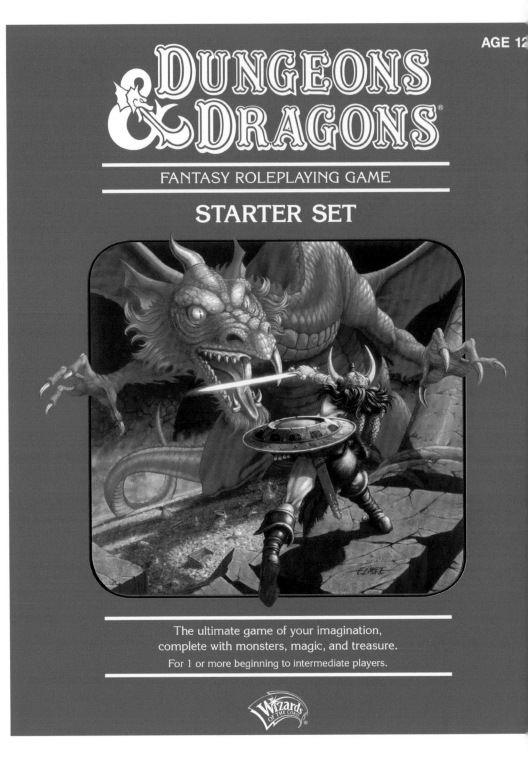

AGE 12

DUNGEONS & DRAGONS®

FANTASY ROLEPLAYING GAME

STARTER SET

The ultimate game of your imagination, complete with monsters, magic, and treasure.
For 1 or more beginning to intermediate players.

Wizards OF THE COAST®

LEFT Greendale Community College student Pierce Hawthorne, played by Chevy Chase, discovers secrets that are sure to give him an unfair advantage in a game of Advanced Dungeons & Dragons on NBC's *Community*.

BELOW, LEFT Top collector and "old schooler" Bill Meinhardt stands in front of "the wall," a veritable library, custom-built to keep his collection safe from the white walkers of dust, sunlight, and oxidation. Collectors such as Meinhardt compete furiously in live and online auctions to obtain unused, mint-condition product—what Meinhardt refers to as "God's copy."

BELOW, RIGHT Kickstarter has not only become the go-to place to fund specialized role-playing game materials to suit any tastes, but its own staff members hold a regular game of D&D, hosted by Kickstarter Head of Games Luke Crane.

OPPOSITE This player map of the Caves of Chaos by Kickstarter staffer Carly Goodspeed is evidence of the group's engagement in the game.

DUNGEONS & DRAGONS ALSO reinforced its connection to its longstanding campaign settings through novelizations and comics. Around fifteen Forgotten Realms books were published by Wizards in 2010 alone, including works by usual suspects such as Ed Greenwood, R.A. Salvatore, and Doug Niles. Decades after his earliest successes, Salvatore still resonated with fans: his 2010 *Gauntlgrym* debuted at number thirteen on the *New York Times* best-seller list. These books shared shelf space with novelizations of newer campaign settings, like Keith Baker's Eberron books, and occasional visits to Krynn courtesy of Tracy Hickman and Margaret Weis. IDW brought both D&D and the Forgotten Realms back to graphic narratives with its new line of comic books starting in 2010.

At the end of the 2000s, "nerd culture" was inescapable. Everywhere you looked it was in the news, heavily influencing content outputted by both Hollywood and the computer game industry. Mainstream mentions of the fabled role-playing game were now commonplace, popping up regularly on hit television shows like Joss Whedon's *Buffy the Vampire Slayer* and *The Big Bang Theory*—another notable entry by the producer of the 1983 animated series, CBS. Even rock-and-roll legend Alice Cooper famously played D&D on an episode of sitcom *That '70s Show*. The show *Community*, created by known D&D fanatic Dan Harmon, sat its characters around the tabletop for an episode called "Advanced Dungeons & Dragons," and followed it up with another called "Advanced Advanced Dungeons & Dragons." Dozens of other influential players, such as *Transformers* executive producer Tom DeSanto and Emmy Award–winning *Veep* writer and showrunner David Mandel, began to occupy and infiltrate Hollywood. Dungeons & Dragons fans could finally hold their heads high. Consequently, Wizards went all in on their new product line, despite mixed reaction, releasing sequels to each of the 4th edition core books as well as several rebooted campaign guides—more than three dozen products in all.

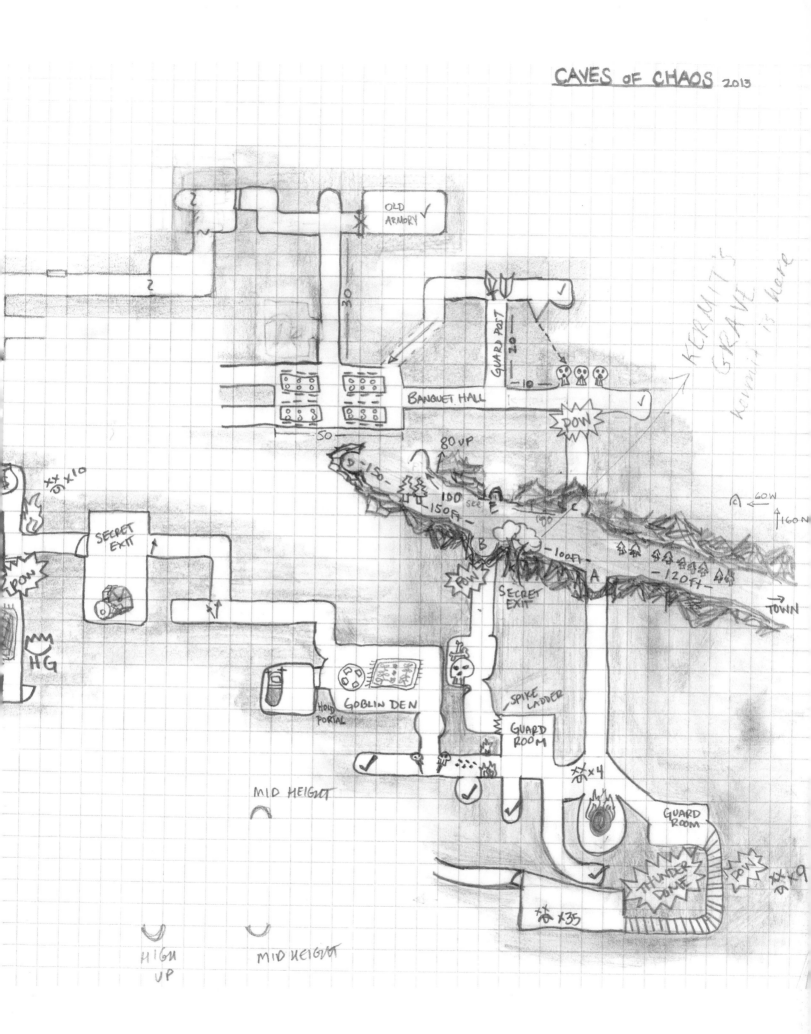

CAVES OF CHAOS 2013

OLD ARMORY ✓

30

GUARD POST
20
10

KERMIT'S GRAVE
keryit is here

BANQUET HALL
50

POW ✓

XX x10

80 UP
150
100 sec
150 FT

SECRET EXIT

POW

HG

MID HEIGHT

GOBLIN DEN

HOLY PORTAL

SECRET EXIT

60 W
160 N

100 FT
120 FT

B
A
C

TOWN

SPIKE LADDER

GUARD ROOM

XX x4

GUARD ROOM

HIGH UP

MID HEIGHT

THUNDER DOME

POW

XX x9

XX x35

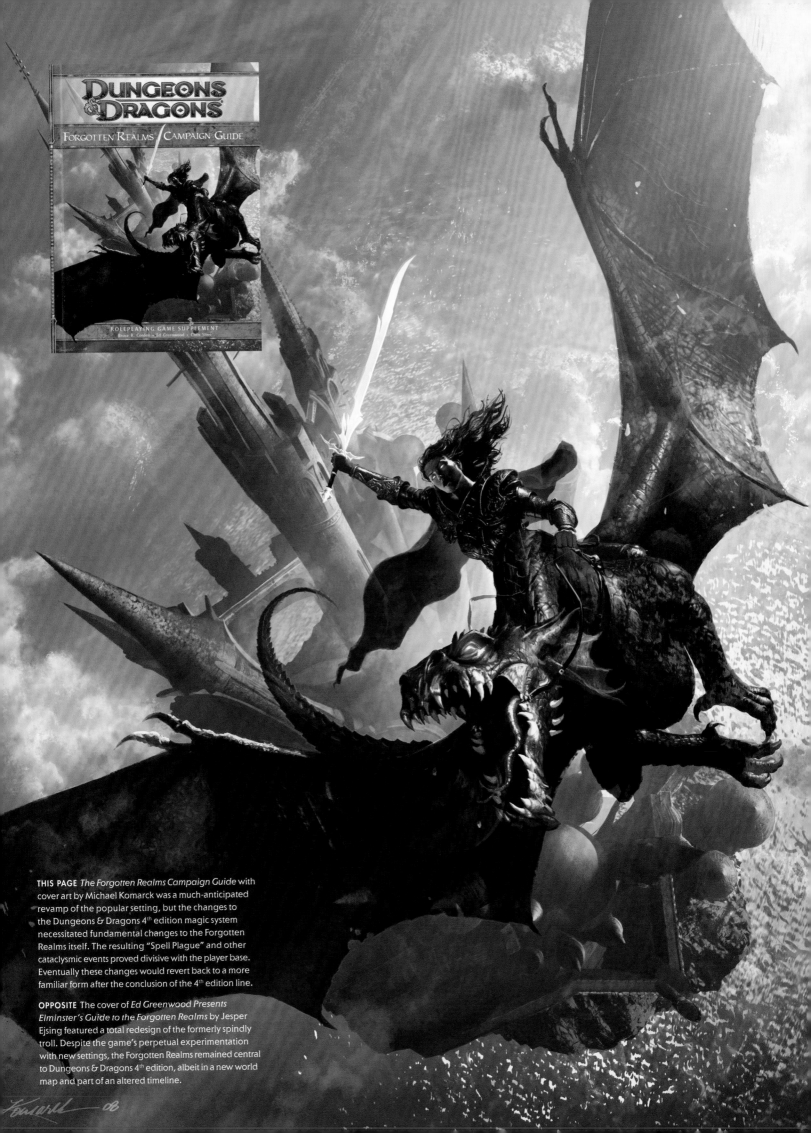

DUNGEONS & DRAGONS

FORGOTTEN REALMS / CAMPAIGN GUIDE

ROLEPLAYING GAME SUPPLEMENT
Bruce R. Cordell • Ed Greenwood • Chris Sims

THIS PAGE *The Forgotten Realms Campaign Guide* with cover art by Michael Komarck was a much-anticipated revamp of the popular setting, but the changes to the Dungeons & Dragons 4th edition magic system necessitated fundamental changes to the Forgotten Realms itself. The resulting "Spell Plague" and other cataclysmic events proved divisive with the player base. Eventually these changes would revert back to a more familiar form after the conclusion of the 4th edition line.

OPPOSITE The cover of *Ed Greenwood Presents Elminster's Guide to the Forgotten Realms* by Jesper Ejsing featured a total redesign of the formerly spindly troll. Despite the game's perpetual experimentation with new settings, the Forgotten Realms remained central to Dungeons & Dragons 4th edition, albeit in a new world map and part of an altered timeline.

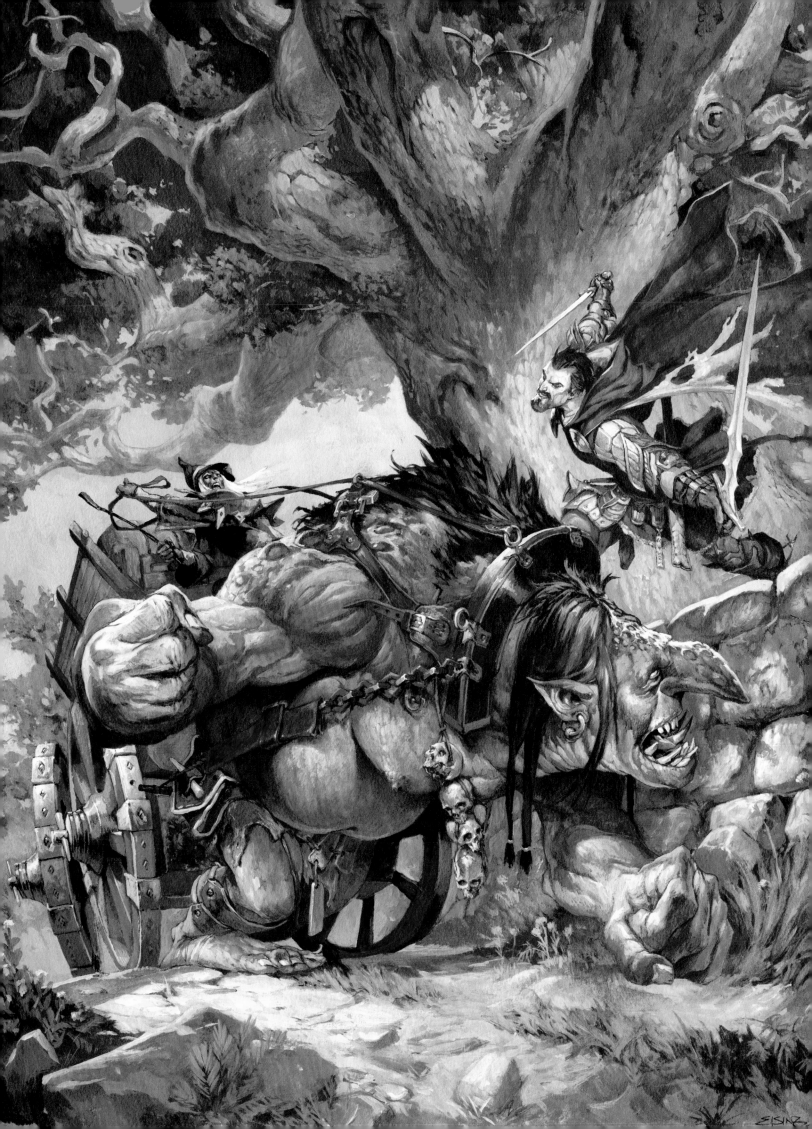

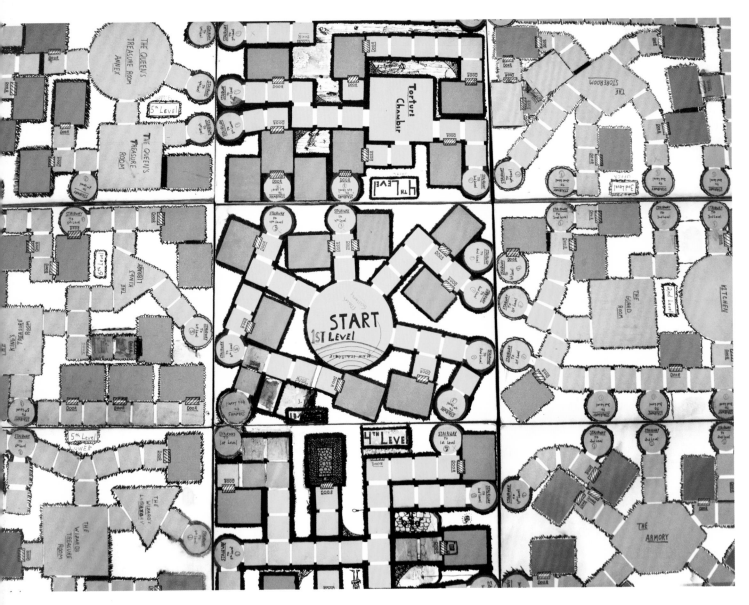

ABOVE Dave Megarry's prototype *DUNGEON!* game board from around 1973.

OPPOSITE The published *DUNGEON!* board from 2010 with art by Franz Vohwinkel.

WITH THE RISING CHICNESS of D&D, the widespread popularity of "Eurogames" like *Settlers of Catan*, and the distribution power of Hasbro, Wizards returned aggressively to the board game market in the 2010s with deeper D&D branded offerings than the *Clue* or the *Fantasy Adventure Board Game* of the previous decade. The cooperative D&D Adventure System Board Game family, beginning with *Castle Ravenloft* in 2010, used random terrain tiles and encounter cards to allow parties to explore classic D&D settings and play signature characters: later installments let you take on the role of Drizzt, or pursue quests in the Temple of Elemental Evil. Peter Lee, who worked on the design of the Adventure System games, also helped bring the Forgotten Realms setting to the board game market with *Lords of Waterdeep*. Its

popularity on the tabletop, including winning Best Board Game at the 2012 Origins Awards, led to a mobile app version for touchscreen tablets. Rodney Thompson, the other co-designer of *Waterdeep*, spearheaded a familiar Wizards initiative in this period: courting the tactical miniatures community. The D&D branded *Dungeon Command* product integrated *Magic: The Gathering* concepts, like shuffled "order cards" drawn from a deck by each player and "tapping" creature cards, with the warbands and connecting tiles familiar from the *Dungeons & Dragons Miniature Game*. With its expansion-based business model and extensive use of *Magic* mechanics, *Dungeon Command* perhaps achieved the closest synergy between Wizards's two greatest products.

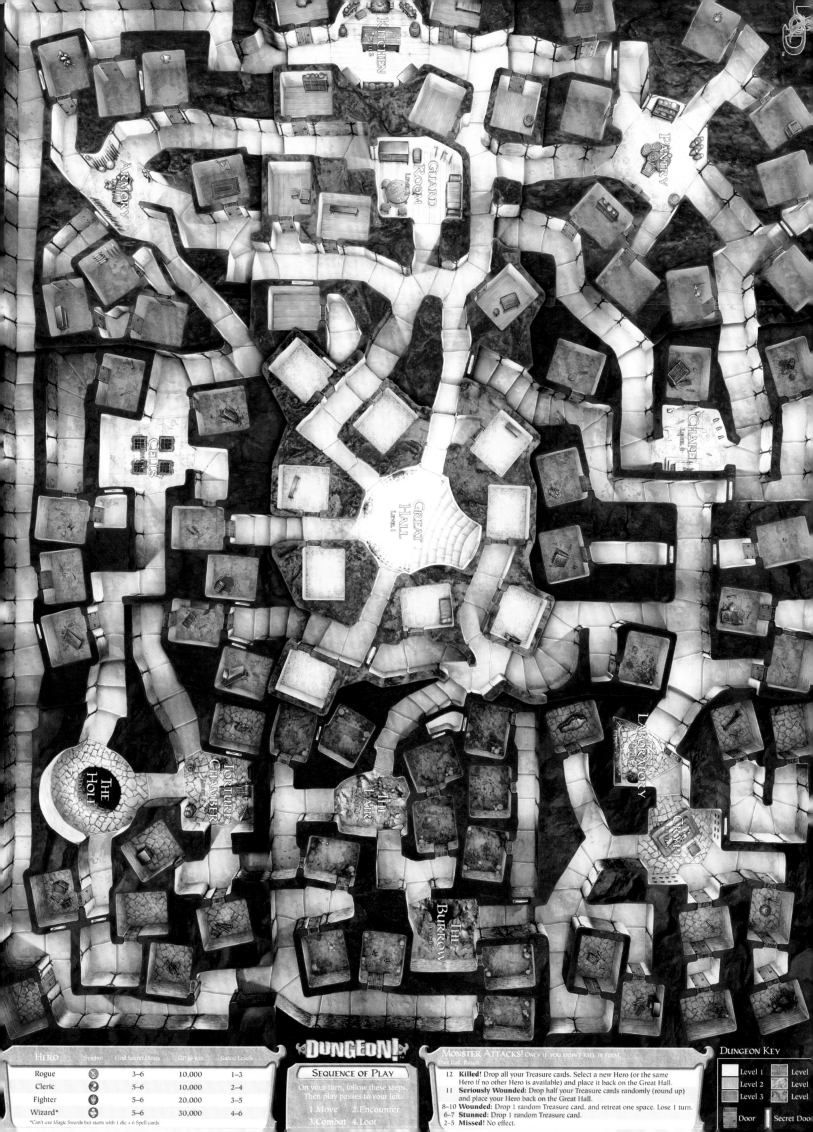

DUNGEON!

Room Labels (on map)

- KITCHEN — Level 2
- ARMORY
- GUARD ROOM — Level 1
- PANTRY — Level 2
- CELLS
- CHAPEL — Level 4
- GREAT HALL — Level 1
- THE HOLE — Level 6
- TORTURE CHAMBER — Level 3
- THE LAIR — Level 3
- LABORATORY — Level 5
- CRYPT — Level 6
- THE BURROW — Level 5

HERO	Symbol	Find Secret Doors	GP to win	Safest Levels
Rogue	✗	3–6	10,000	1–3
Cleric	☥	5–6	10,000	2–4
Fighter	✋	5–6	20,000	3–5
Wizard*	⚡	5–6	30,000	4–6

*Can't use Magic Swords but starts with 1 die + 6 Spell cards

SEQUENCE OF PLAY

On your turn, follow these steps.
Then play passes to your left.

1. Move 2. Encounter
3. Combat 4. Loot

MONSTER ATTACKS! ONLY IF YOU DIDN'T KILL IT FIRST.

Dice Roll Result

- **12 Killed!** Drop all your Treasure cards. Select a new Hero (or the same Hero if no other Hero is available) and place it back on the Great Hall.
- **11 Seriously Wounded:** Drop half your Treasure cards randomly (round up) and place your Hero back on the Great Hall.
- **8–10 Wounded:** Drop 1 random Treasure card, and retreat one space. Lose 1 turn.
- **6–7 Stunned:** Drop 1 random Treasure card.
- **2–5 Missed!** No effect.

OPEN ANOTHER ADVENTURE

PULSE-POUNDING EXPLORATION. BACK-STABBING INTRIGUE. MIND-BENDING STRATEGY.
THERE'S A DUNGEONS & DRAGONS® BOARD GAME FOR EVERY MOOD.

Legend of Drizzt®
Cooperative exploration
with a new dungeon
every game.

**Dungeon Command™:
Blood of Gruumsh™**
Tactical battles featuring
D&D's classic foes:
orc raiders.

Dungeon!™
Classic family
D&D® exploration.

**Clue: Dungeons
& Dragons**
Beloved family game
of heroic investigation.

Lords of Waterdeep®
Shadowy intrigue using strategic
construction and loyal adventurers.

Scoundrels of Skullport™
Dual expansion set for
Lords of Waterdeep.

DUNGEONSANDDRAGONS.COM

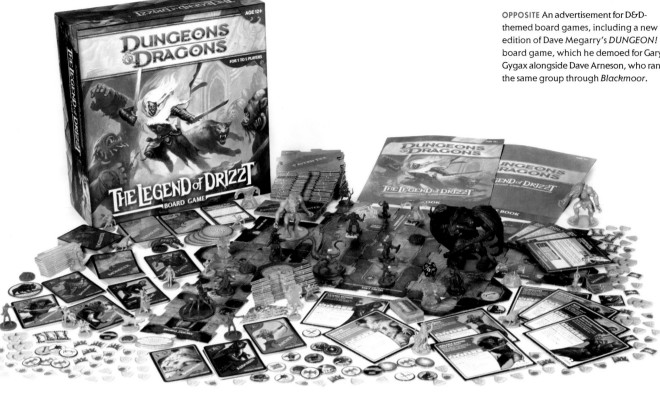

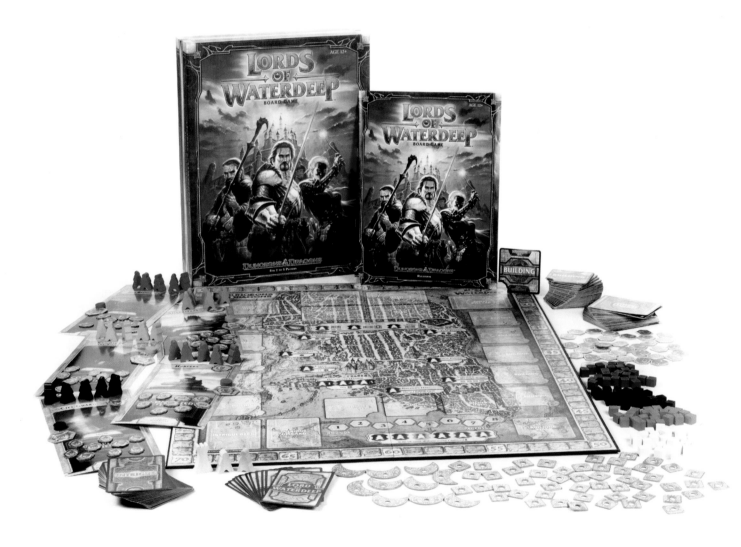

BELOW *The Legend of Drizzt* board game from 2010.

BOTTOM *Lords of Waterdeep* from 2012.

OPPOSITE An advertisement for D&D-themed board games, including a new edition of Dave Megarry's *DUNGEON!* board game, which he demoed for Gary Gygax alongside Dave Arneson, who ran the same group through *Blackmoor*.

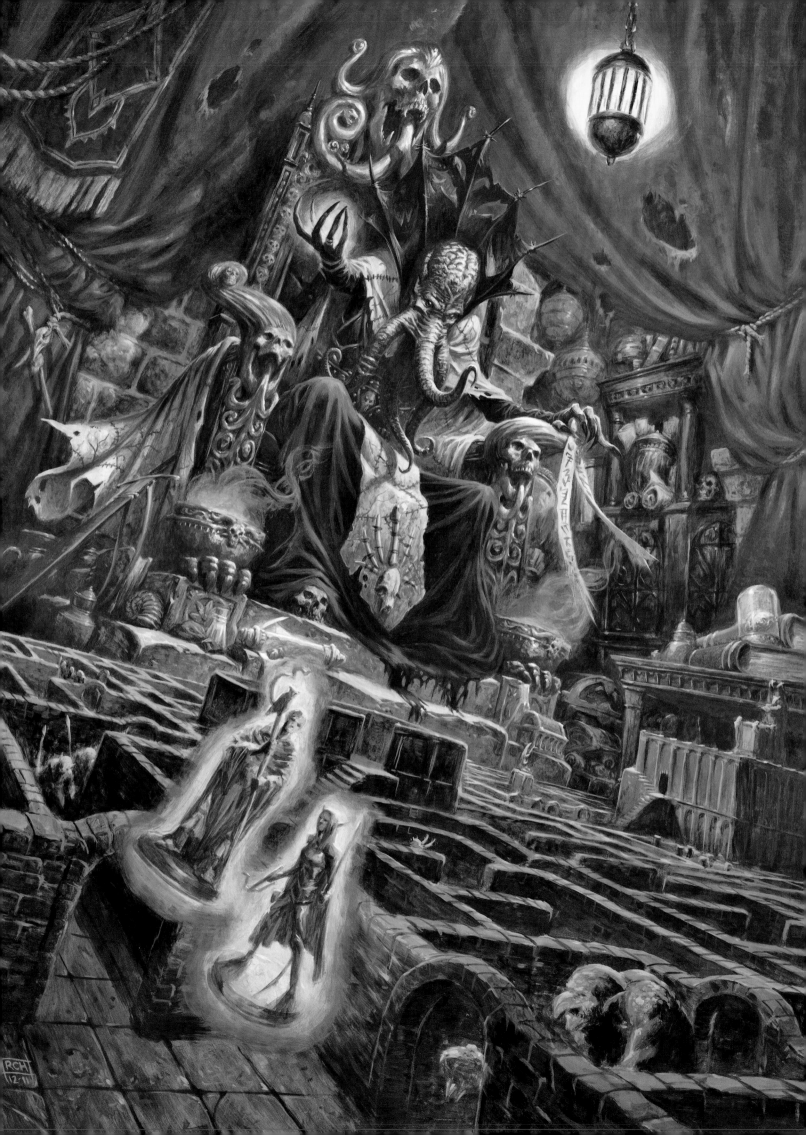

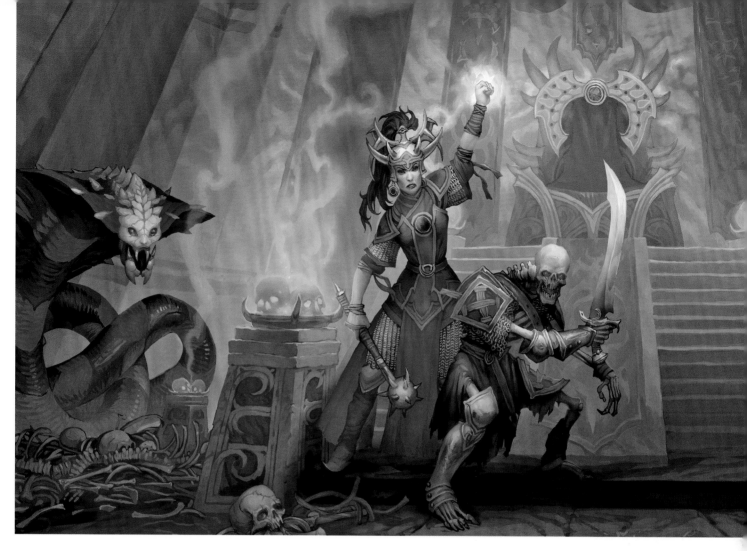

THESE HIGHLY VISIBLE ADAPTATIONS of the D&D brand might sometimes have overshadowed the core game. While 4th edition boldly committed to very distinct design choices both in content and in art direction, "there was market saturation for that style of game," lead designer of the 4th edition *Monster Manual* Mike Mearls asserted. "Much of D&D's fantasy world approach to gaming, once so fresh and original, had been commoditized and digitized over the course of decades." It was only a matter of time until the brand took a hard look in the mirror—and the mirror of Dungeons & Dragons has always been its fan community.

On January 9, 2012, Wizards announced a massive playtesting initiative to decide the future direction of a new edition of Dungeons & Dragons. "Your Voice, Your Game," the announcement of *D&D Next* read. The first testable system documents became available to the community in May, and as of early 2013, the "D&D Encounters" series began to incorporate some provisions from the *D&D Next* rules, starting with the season twelve *Against the Cult of Chaos* adventure—players could go to the Wizards website to get the current state of the playtest rules to plug into the games.

Over the next two years, Wizards took the design process on the road, at their own Dungeons & Dragons events, at shows like the San Diego Comic-Con, PAX, Gen Con, and anywhere else that D&D fans congregated. In all, more than 175,000 players participated. They recruited hordes of Dungeon Masters to run small groups through playtesting adventures, gathering feedback, uncovering bugs, and readying the community for a new approach to the game.

ABOVE Alexey Aparin's cover art for the 2013 *Against the Cult of Chaos.*

OPPOSITE Whatever grievances aired about D&D's 4th edition system, its art usually found itself exempted: this edition featured some of the most richly illustrated products in the game's history. Shown here is an interior illustration by Ralph Horsley from the 2012 4th edition supplement *Into the Unknown.*

BELOW A button distributed to participants in the *D&D Next* playtests—by far the largest such effort in the game's history.

"WISH IS THE MIGHTIEST SPELL A MORTAL CREATURE CAN CAST. BY SIMPLY SPEAKING ALOUD, YOU CAN ALTER THE VERY FOUNDATIONS OF REALITY IN ACCORD WITH YOUR DESIRES."

9

WISH

5TH EDITION

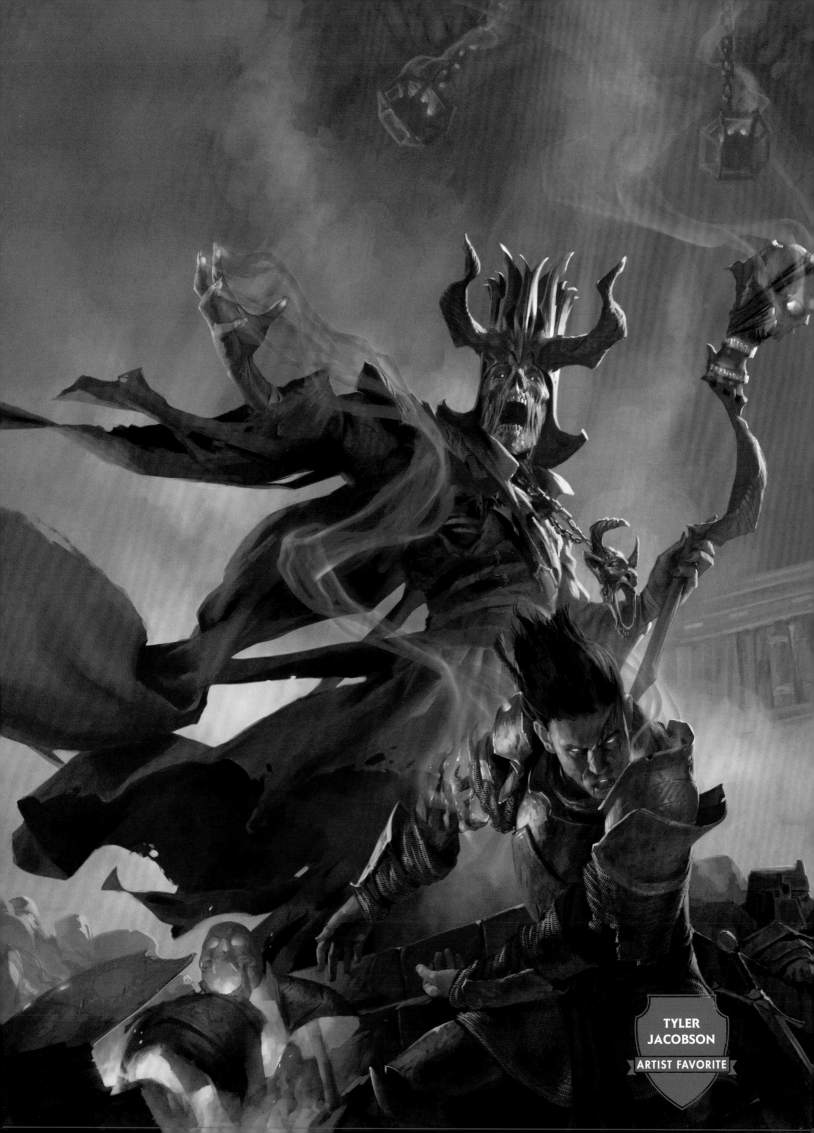

THE YEAR 2014 marked the fortieth anniversary of D&D and the release of the 5th edition of Dungeons & Dragons. Arriving only six years after the polarizing 4th edition, this sleeker version of the world's most famous RPG is something of an optimized fusion of all the most beloved features and mechanics from the previous four versions, with a refreshed game design intended to attract new and veteran fans alike.

During the golden days of 2nd and 3rd editions, D&D spawned countless competitors all eager to steal its title as the premier RPG system. This kept designers on their toes, forcing them to visually reinvent the brand every few years with distinct new settings, including Spelljammer, Mystara, Planescape, Dark Sun, and Ravenloft. The resultant business philosophy led to flooding the market with an excess of supplements and modules in a retail smash and grab. The frequently misunderstood 4th edition was released deep in the middle of a boom of both console video games and desktop computer games that left Dungeons & Dragons grappling with its identity. As a result, D&D not only struggled to compete with other formats, but also was desperate to justify its existence to the digital consumer.

To say that the 5th edition is a reaction to what came before would be a massive understatement. The rules are now simpler, streamlined for quicker play. They reduce a great number of different circumstances that might affect event resolution into the simple mechanism of advantage and disadvantage: rolling a pair of d20s and taking either the higher (if you have an advantage) or the lower (if you have a disadvantage). Now, both skill checks and saving throws are anchored to the six character abilities; rather than having to look up a specific saving throw value for petrification, as you would in the original game, or calculating a Fortitude save as 3rd edition would have it, now characters make a Constitution save with the standard modifier for that ability. We also find in 5th edition encouragements to role-playing from familiar indie RPGs, like the specification of ideals, bonds, and flaws for characters, and an inspiration mechanism that lets Dungeon Masters reward players for playing to their characters' natures.

To even call the game "5th edition" perhaps goes against the intended branding of its creators, who label the game simply "Dungeons & Dragons," only referring to a version number when absolutely necessary. Its release schedule is structured around a handful of marquee products issued each year rather than a glut of minor and inexpensive works shipping monthly or even weekly, which allows Wizards of the Coast designers to be more deliberate in their approach. They even have made some basic rules for the game available as a free download, in all almost two hundred pages covering the fundamentals of how to generate characters and run adventures. Everything about the business plan is a clear and thoughtful pivot from the past.

ABOVE A 2014 print ad for "D&D Encounters," the continuing initiative that promotes organized play at local game stores.

OPPOSITE A refreshingly understated interior illustration from the 5th edition *Dungeon Master's Guide* by William O'Connor. One can feel the danger increase with each step down into what promises to a massive and perilous dungeon.

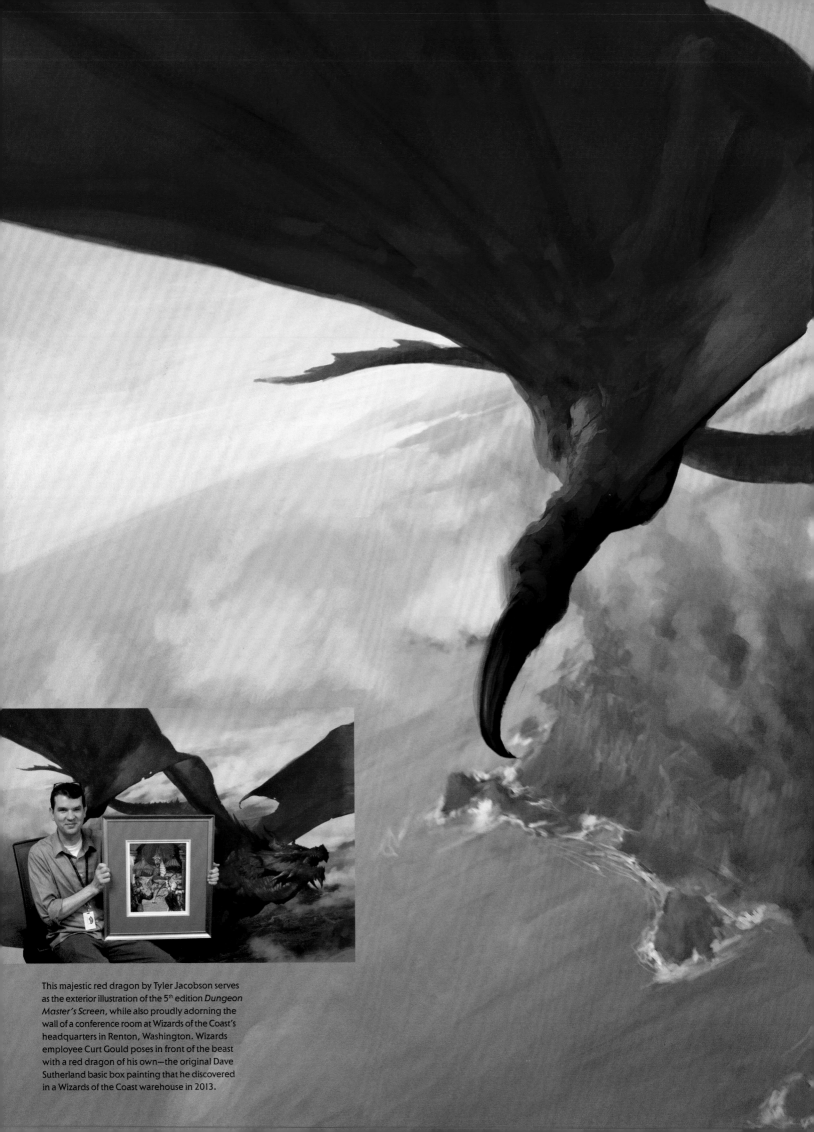

This majestic red dragon by Tyler Jacobson serves as the exterior illustration of the 5th edition *Dungeon Master's Screen*, while also proudly adorning the wall of a conference room at Wizards of the Coast's headquarters in Renton, Washington. Wizards employee Curt Gould poses in front of the beast with a red dragon of his own—the original Dave Sutherland basic box painting that he discovered in a Wizards of the Coast warehouse in 2013.

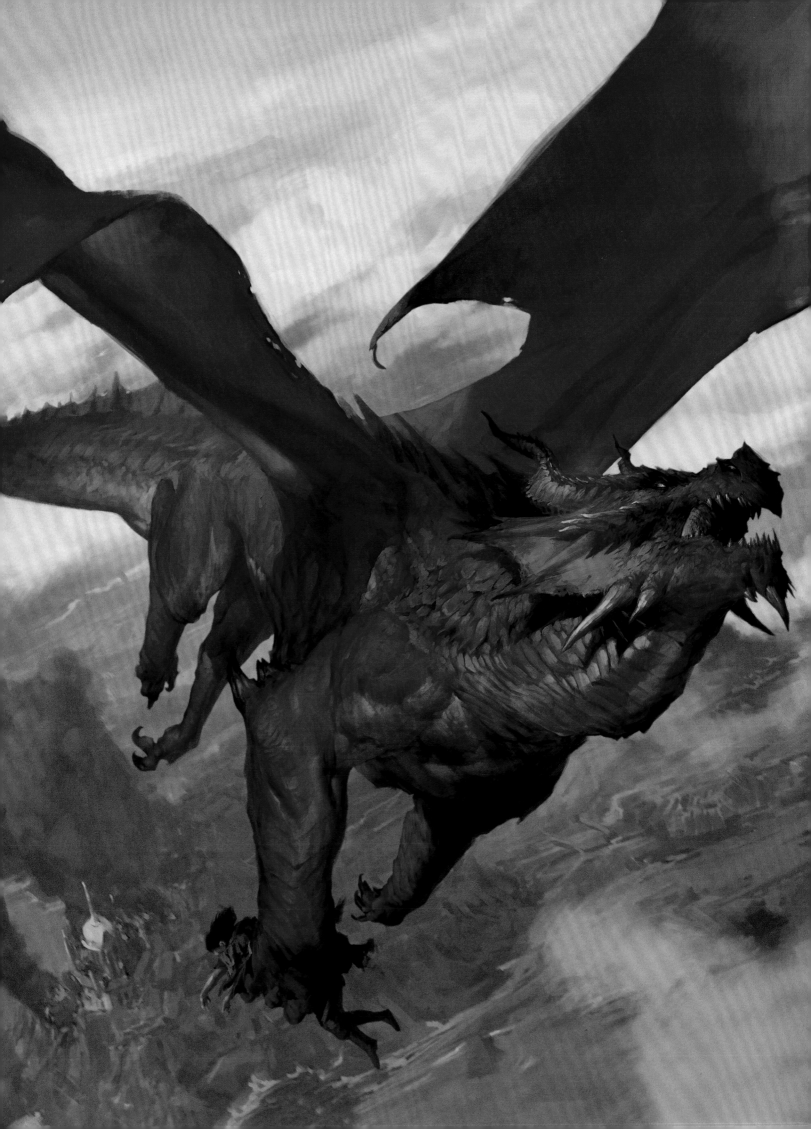

WHAT'S OLD IS NEW AGAIN

While earlier editions were reactive to an ever-changing marketplace, 5th edition strives to stand on its own, with the powers that be exuding refreshing confidence. In fact, 5th edition seems as indifferent to the video game industry as it does to its copycat tabletop competitors. It's as if Wizards of the Coast finally embraced Dungeons & Dragons' status as the Zeus of all modern gaming; after all, the majority of the industry's most innovative concepts were birthed straight from its head.

This liberated approach grants the creative team of Jeremy Crawford, Mike Mearls, and Chris Perkins the freedom and impetus to mine Dungeons & Dragons' own storied past. *The Curse of Strahd*, *Princes of the Apocalypse* (aka *Elemental Evil*), *Tales of the Yawning Portal*, *Tomb of Annihilation*, and others, which revive classic adventures from assorted realms, all look inspirationally to the past while still striding confidently toward the future. "We try to use iconic D&D elements in our stories.

I like to take things that have existed in D&D for a while and put new spins on them—for example, taking the Underdark and blending it with themes from *Alice in Wonderland*. For *Curse of Strahd*, we really just wanted to reintroduce a classic," Perkins reveals.

The 2016 *Tales from the Yawning Portal*, named for the tavern in Waterdeep that houses the entry well to the treacherous Undermountain dungeon, brings classics back to life. Adventure modules like *The Sunless Citadel*, *The Hidden Shrine of Tamoachan*, *White Plume Mountain*, *Dead in Thay*, and the legendary *Against the Giants* are all given thoughtful 5th edition conversions. Ultimately, this updated fusion of classics makes up a mega-module meant to take player characters from the beginning of their adventuring careers to, quite possibly, the bitter end—the last module is a 5th edition revamp of the most lethal dungeon of them all: *Tomb of Horrors*.

> ## "We leaned on iconic elements of fantasy and streamlined the process to build archetypes that are familiar to players."
>
> **–MIKE MEARLS ON 5TH EDITION DESIGN**

ABOVE Wizards of the Coast's current headquarters in Renton, Washington.

LEFT Mike Mearls (left), Jeremy Crawford (center) and Chris Perkins (right) discuss game mechanics during a 5th edition design meeting.

OPPOSITE The 1983 *Ravenloft* is widely considered one of the greatest AD&D adventure modules of all time. The 2016 *Curse of Strahd* is a lovingly retold 5th edition version, with loads of new content and chilling new twists by lead designer Chris Perkins, with input from the 1983 module's original authors, Tracy and Laura Hickman.

WHAT ARE YOU AFRAID OF?

D&D
CURSE OF STRAHD

DUNGEONS & DRAGONS®

Unravel the mysteries of Ravenloft' in this dread adventure
for the world's greatest roleplaying game

From lead writer Chris Perkins
in consultation with Tracy and Laura Hickman

A 256-page fantasy-horror campaign
Inspired by the original Ravenloft adventure

Official Release
March 15

ORDER
NOW

Designed for
levels 1–10

STRAHD

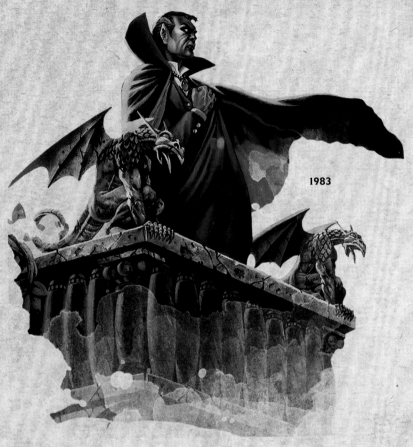

1983

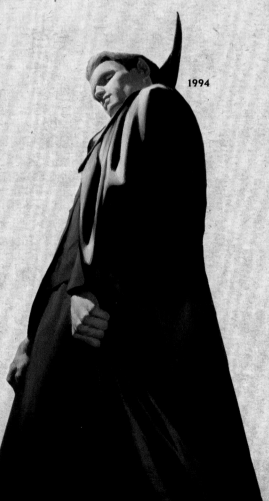

1994

"Under raging stormclouds, a lone figure stands silhouetted against the ancient walls of castle Ravenloft. Count Strahd von Zarovich stares down a sheer cliff at the village below. A cold, bitter wind spins dead leaves around him, billowing his cape in the darkness. Lightning splits the clouds overhead, casting stark white light across him. Strahd turns to the sky, revealing the angular muscles of his face and hands. He has a look of power and of madness. His once handsome face is contorted by a tragedy darker than the night itself."

—*RAVENLOFT*, 1983

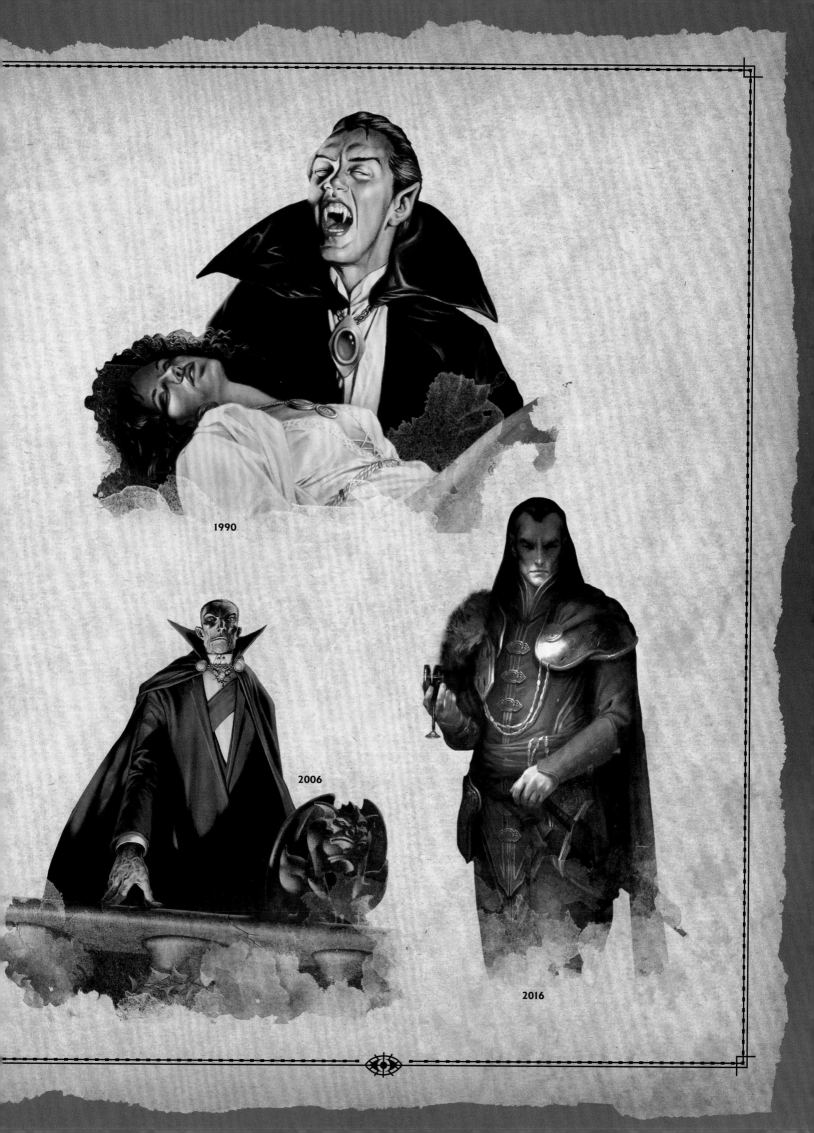

1990

2006

2016

THE DOOMVAULT

AGE 12+

DREAMS OF THE RED WIZARDS™

DEAD IN THAY™
AN ADVENTURE FOR CHARACTERS OF 6TH – 8TH LEVEL
SCOTT FITZGERALD GRAY

FORGOTTEN REALMS®
THE SUNDERING

THE DOOMVAULT, ORIGINALLY A feature of *Dead in Thay* (2014) and rolled out during *D&D Next*, was reprinted for the *Tales from the Yawning Portal* anthology of historic adventures. While the Doomvault was a relatively new creation, it certainly didn't feel like it, featuring deadly traps, fire pits, and foes that could make even the notoriously brutal AD&D modules of the late 1970s jealous. A self-professed "tribute to *Tomb of Horrors*, *The Ruins of Undermountain*, and other killer dungeons," it was a perverse, yet light-hearted nod to all that has come before . . . perhaps that's why it's called the Doomvault.

"Near the village of Daggerford on the Sword Coast, the Red Wizards of Thay have plotted to extend the evil reach of their land and its master—the lich lord Szass Tam . . . Kazit Gul, a crazed demilich, built the Doomvault to siphon the souls of those who perished within. Szass Tam and his followers enslaved Gul and repurposed the Doomvault as a monstrous menagerie and arcane laboratory . . . Szass Tam and his followers have reshaped the Doomvault's magic, creating laboratories in which the divine power of the Chosen can be extracted and funneled into the lich lord's phylactery to fuel his pursuit of godhood."

— *DEAD IN THAY*, 2014

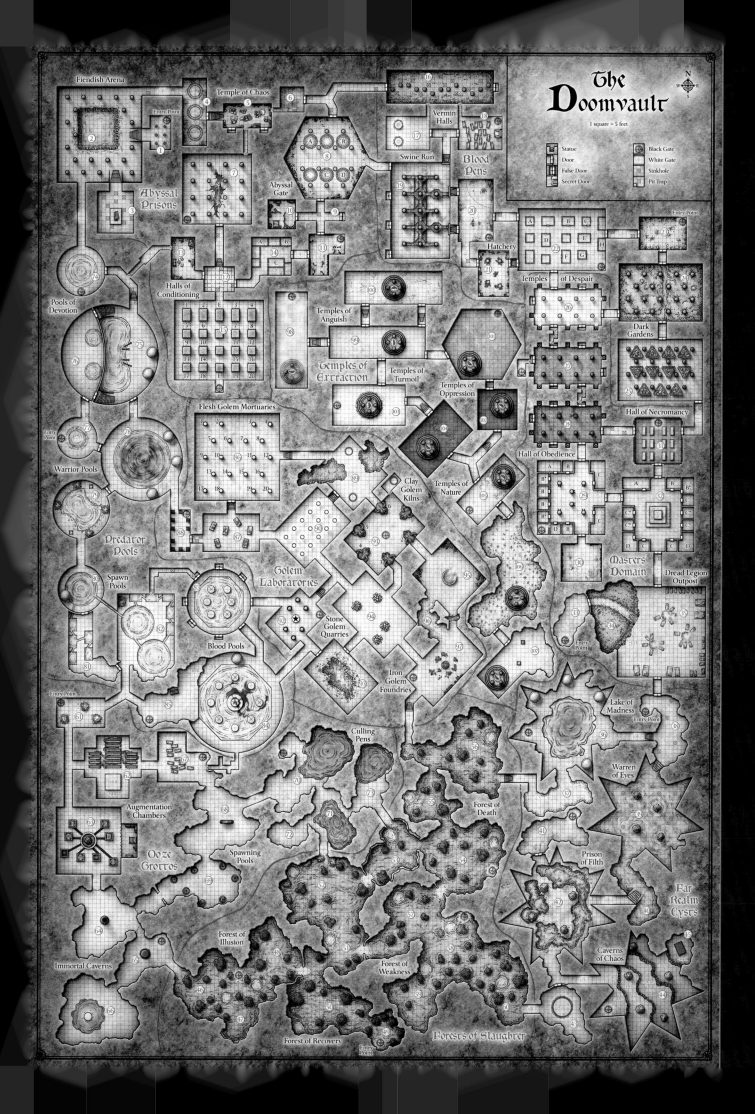

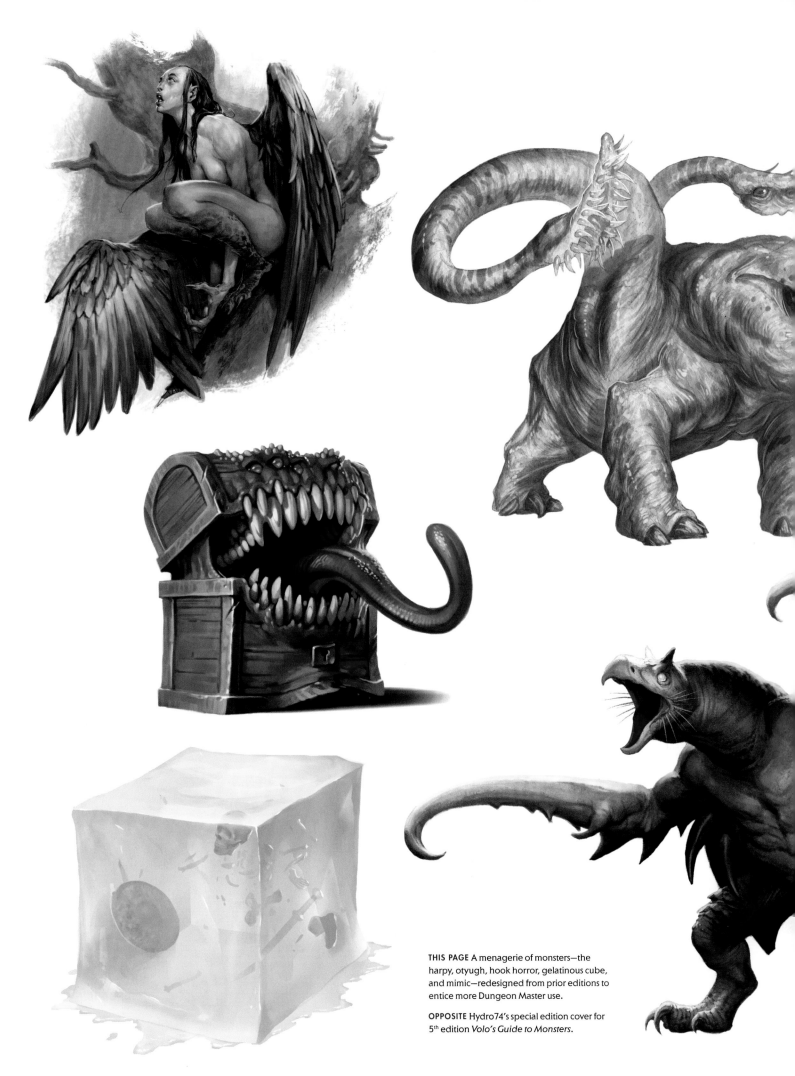

THIS PAGE A menagerie of monsters—the harpy, otyugh, hook horror, gelatinous cube, and mimic—redesigned from prior editions to entice more Dungeon Master use.

OPPOSITE Hydro74's special edition cover for 5th edition *Volo's Guide to Monsters*.

THE 5TH EDITION HAS not only brought with it a refreshing philosophy toward the game's storied past, but it also has overhauled the visual aesthetics of the brand. The art has become a manifestation of the mandate, with a clearly updated approach for how to visualize D&D. The story has taken center stage, demanding new levels of emotion, humor, and drama in each piece. And, more so than any previous edition, the imagery flows from page to page, chapter to chapter, and book to book, a testament to this unified tone and direction.

Under the guidance and stewardship of D&D's senior art director Kate Irwin, the art in 5th edition embraces all that came before with a unified language, even finding room for neglected creatures from the game's past, albeit with an artistic facelift. As Chris Perkins, 5th edition's principal story designer, elaborates, "Monsters were pulled from every previous edition, even some oddball ones that capture the more polarizing aspects of the game, including its sense of humor and whimsy. . . . However, our main goal was to make sure that the illustrations 'sold' the monsters enough that Dungeon Masters would actually use them in their games." Wizards of the Coast moreover tells the story of these monsters through in-universe guidebooks like *Volo's Guide to Monsters*.

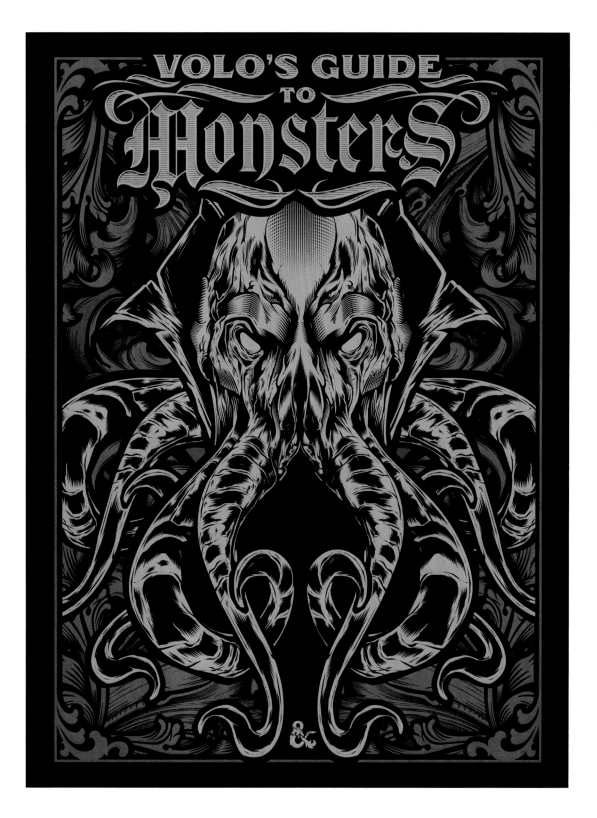

ABOVE Even fan-favorite drow Drizzt Do'Urden made the leap to 5th edition with a refreshed look by Tyler Jacobson.

LEFT The grounded art common in 5th edition, like this piece by Kieran Yanner, reflects a commitment to visualizing the full range of emotions associated with combat and adventuring.

OPPOSITE The Sword Coast of the Forgotten Realms, redrawn by Jared Blando for 5th edition in the 2014 supplement *Horde of the Dragon Queen*.

THE FORGOTTEN REALMS, THE world at the center of all 5th edition storytelling, has always been steeped in history, even predating its inclusion in official D&D lexicon when Ed Greenwood developed it as the backdrop for his short stories. But now in the 5th edition, the look of the universe is layered, grounded, and lived-in, with an emphasis on the continent's diverse, multiethnic regions. Once a player entered this world, it feels like anything and everything is possible—distinct sensations stimulated by the rich art.

And while everything is possible, 5th edition conveys the subtle message that not everything is *probable*. In 4th edition, characters were capable of super-heroic feats almost from the outset of creation. Heroes flipped trippingly past ruthless death traps, hacked enemies to bits with impossibly massive axes, and tirelessly rained colorful death down on foes with hugely destructive and demonstrative magic. However, 5th edition returns a sense of gravity into the game, reintroducing the characters' feet to the ground. And, true to form, every panel of art illuminates this change of philosophy.

Armor now looks as if real people could actually wear it. Weapons are once again proportionate to the hero, as if capable of being wielded by mortals. And wizards have clearly gone back to school rather than to the gym. While these aren't quite the hairy, grubby mercenaries depicted on Dave Trampier's 1st edition *Players Handbook* cover, these new adventurers look like they could, at least, share a frame with those same scoundrels. In short, this new iteration is more congruent with the earliest iterations of the game than anything prior, as if a sense of mortality, or at least humanity, has returned to the game.

The Endless Ice Sea

Reghed Glacier

ICEWIND DALE

THE SPINE OF THE WORLD

MIRABAR

LUSKAN

River Mirar

The Crags

The Lurkwood

The Glimmerwood

MITHRAL HALL

NESME

CITADEL FELBAR

CITADEL ADBAR

ICE MOUNTAINS

SILVERMOON

RAUVIN MOUNTAINS

LONGSADDLE

NEVERWINTER

Neverwinter Wood

The Evermoors

EVERLUND

NETHER MOUNTAINS

TRIBOAR

YARTAR

The Lost Peaks

The Star Mounts

The High Forest

The Far Forest

Anauroch

The High Road

WESTBRIDGE

LEILON

Kryptgarden Forest

SWORD MOUNTAINS

RED LARCH

Westwood

The Long Road

Dessarin River

Mere Dead Men

WATERDEEP

Ardeep Forest

LOUDWATER

GREYPEAK MOUNTAINS

The Black Road

SECOMBER

South Wood

LLORKH

PARNAST

DAGGERFORD

The Trade Way

The High Moor

Serpent Hills

Marsh Chelimber

Forgotten Forest

The Lonely Moor

GREY CLOAK HILLS

Sea of Swords

Tollbark Forest

DRAGONSPEAR

Serpent's Tail Stream

THE SHAERADIM

THE TROLL HILLS

Mintarn

Winding Water

Coast Way

Najara

HILL OF LOST SOULS

BATTLE OF BONES

TROLLCLAWS

The Coast Way

Forest of Wyrms

SOUBAR

Skull Gorge

WELL OF DRAGONS

The Fields of the Dead

Trielta Hills

TRIEL

DARKHOLD

SUNSET MOUNTAINS

BALDUR'S GATE

Chionthar River

SCORNUBEL

ELTUREL

Marsh of Tun

Cloakwood

Coast Way

The Reaching Woods

N

CANDLEKEEP

The Wood of Sharp Teeth

BERDUSK

BEREGOST

IRIABOR

EASTING

GREENEST

THE SWORD COAST

·To Amn·

BLANDO

MARVELOUS MAPS

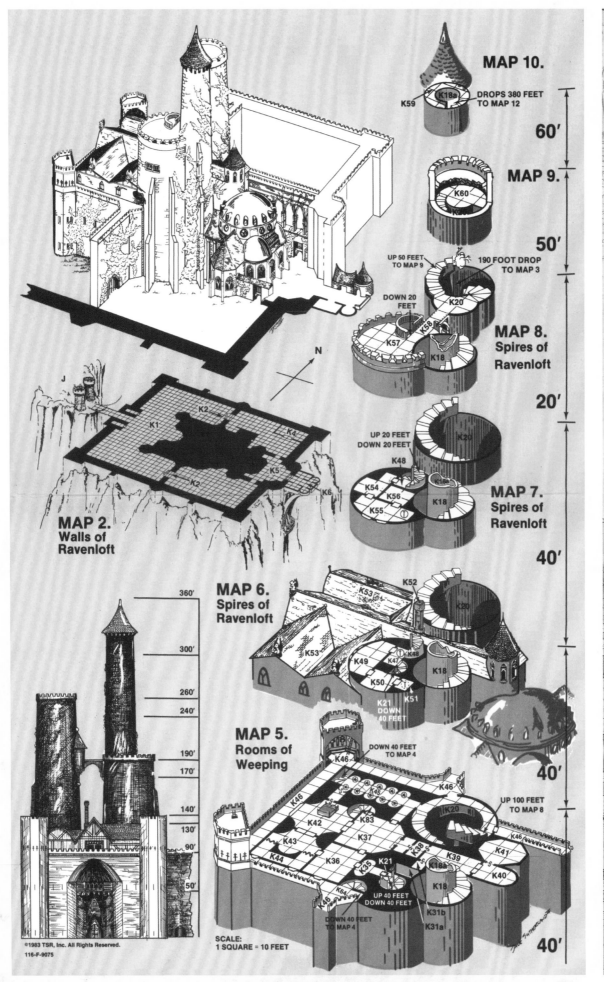

MAP 10.

K18a
K59
DROPS 380 FEET
TO MAP 12

60'

MAP 9.

K60

50'

UP 50 FEET
TO MAP 9
190 FOOT DROP
TO MAP 3

DOWN 20
FEET
K20
K58

K57
K18

MAP 8.
Spires of
Ravenloft

20'

UP 20 FEET
DOWN 20 FEET
K20

K48
K54
K18a
K56
K18
K55

MAP 7.
Spires of
Ravenloft

N

MAP 2.
Walls of
Ravenloft

K2
K1
K4
K5
K2
K6

J

MAP 6.
Spires of
Ravenloft

K52
K53
K20
K53

K49
K47
K48
K50
K18
K51
K21
DOWN
40 FEET

40'

360'
300'
260'
240'
190'
170'
140'
130'
90'
50'

MAP 5.
Rooms of
Weeping

DOWN 40 FEET
TO MAP 4
K46
K46
K45
K42
K83
K20
UP 100 FEET
TO MAP 8
K43
K37
K46
K44
K36
K35
K21
K38
K39
K41
K18a
K40
K64
K18
UP 40 FEET
DOWN 40 FEET
K46
K31b
DOWN 40 FEET
TO MAP 4
K31a

40'

40'

SCALE:
1 SQUARE = 10 FEET

THE CITY OF
UR DRAXA

Copper Gate
Ramund Gate
Iakong Gate
Forest
Grassland
Crops
Buildings
Lake

NUMOL
NORTH HARROD

UETH
FIRST HARROD

KAIRAS
SECOND HARROD

0 1 2 3
MILES

THE EARLIEST D&D MAPS were of the most simple and utilitarian design. Primarily a tool for Dungeon Master consumption, in the 1970s function always superseded form, without much in the way of aesthetic consideration. But by the 1980s, D&D maps began to undergo significant artistic treatments, partly to improve their function, but also to better match the industry-leading fantasy art that adorned D&D modules and gamebooks of the time, often prepared by an overlapping group of artists. Such innovations ranged from the full-color terrain maps of Greyhawk to three-dimensional, isometric layouts of Ravenloft to the dynamic plan and elevation combo maps often featured in 2nd edition campaign settings.

LEFT A 1992 Dark Sun map of the City of Ur Draxa, located in the sun-scorched Valley of Rust and Fire, by Diesel LaForce and Steve Beck. Today, maps, whether generated for Dungeon Master or player consumption, are as much a part of the art and look of the game as they are part of the game itself.

FAR LEFT The haunted towers of Strahd von Zarovich's Castle Ravenloft by Dave Sutherland.

WATERDEEP
City of Splendors

THE DEMONWEB

| | First Level | | Second Level | | Third Level | | Fourth Level |

1-12 and a-i are Doors A, B, C are Teleportation arrival points

106-M-9035

GUARDROOM

ILLITHID QUARTERS

COMMON ROOM

CLEANSING CHAMBERS

ELDER BRAIN CHAMBER

BRAIN LIBRARY

RESTING POOL

TRANSFORMATION CHAMBER

PRISON

TADPOLE CHAMBERS

LIBRARY/DISSECTION CHAMBER

ESCAPE SHAFT

GUARDROOM

MIND FLAYER COLONY

50 FEET

UNDERCAVERN

BLANDO

ABOVE A sample mind flayer colony map from *Volo's Guide to Monsters.* So far, maps from the 5th edition have managed to strike a successful balance between aesthetics and functionality.

OPPOSITE, TOP A bird's-eye view of the bustling City of Waterdeep from the 1988 *Forgotten Realms City System* accessory by Dennis Kauth and Frey Graphics.

OPPOSITE, BOTTOM The interior cover map from the 1980 adventure module *Queen of the Demonweb Pits.*

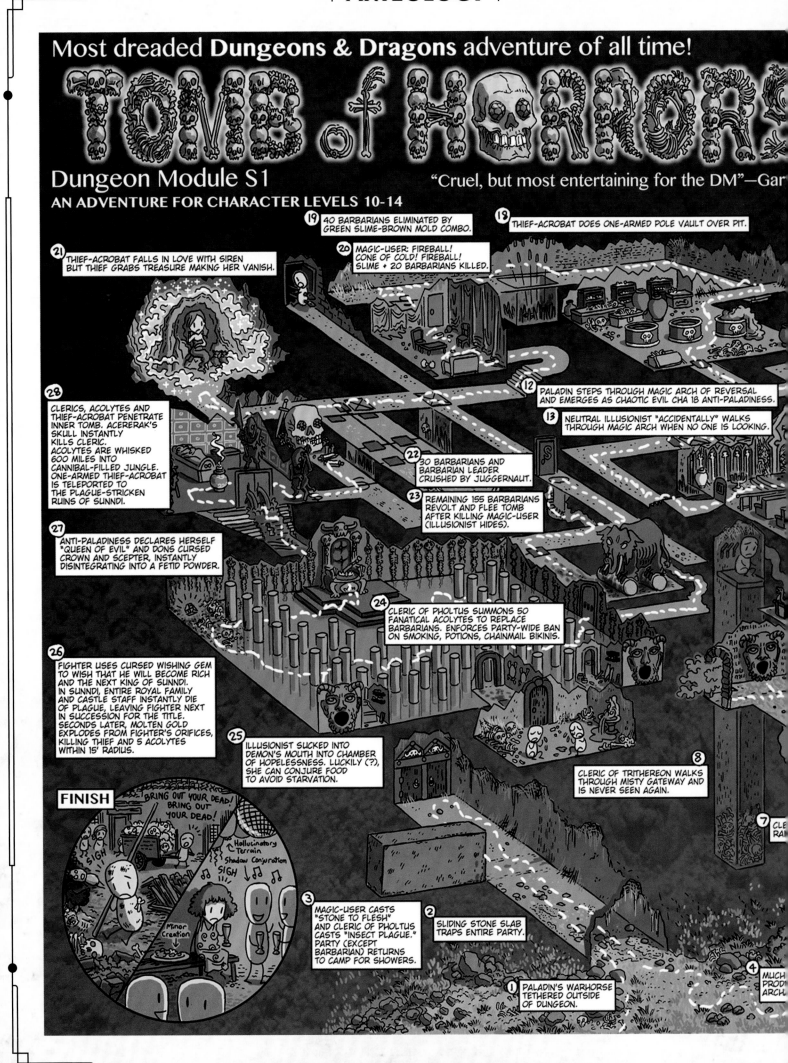

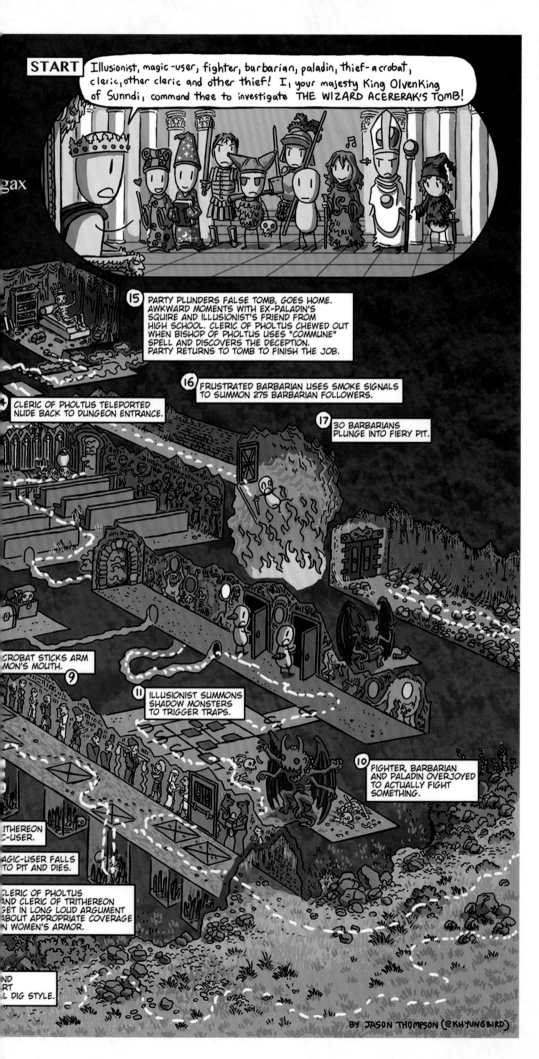

A 2014 map by Jason Thompson, shedding light on, and making light of, one of the most dreaded dungeons in D&D history.

It was the self-determined mandate of the Wizards of the Coast Research and Development team to play every version of the Dungeons & Dragons rules before setting pencil to paper for 5th edition: original D&D; the *Basic* sets of Eric Holmes, Tom Moldvay, and Frank Mentzer; Advanced Dungeons & Dragons 1st edition, 2nd, 3rd, v3.5, 4th, you name it. All editions were endlessly evaluated and researched through playtesting processes, such as *D&D Next*, in an attempt to reconnect and reestablish the core values of the game. The designers were not only longtime fans eager to revive the glory days; they were also intent on capturing the essence of a forty-year-old game system as they shepherded it further into the twenty-first century. The fan community got its wish. The tangible trail of its predecessors traverses the paintings of the 5th edition. Mud tracked all the way from the swamps of Blackmoor soak the boots of this new generation of adventurers. The result is a palpable, lived-in world imbued with the history of millions of player characters that have fought and died in these storied realms.

Each piece of key and cover art is intent on distilling the essence of D&D down to something as fantastic as it is tangible—imagery with a style that clearly embraces and services the story it is telling. With this visual directive at its foundation, the bar has been set, almost necessitating that every subsequent piece not only mesh with the shared experience, but elevate it. Each panel is also a reminder that the look has completely graduated from that of yesteryear, with many pieces communicating a full, cinematic story, imbued with setting, character, conflict, scope, and tone—an ability to convey a sense of time, while challenging and inspiring players to take the narrative further in their own minds.

Most important, and almost ineluctably, nearly every piece of art is a meditation on what came before. Interpretations of Tiamat, Strahd, Zuggtmoy, or Acererak, for example, riff on their signature qualities to conjure up bold new visions, thereby allowing each character to transcend the past and stand on their own as *the* landmark incarnation of something already deemed iconic. The success of these efforts is surely due to the fact that 5th edition's creators, many of whom were involved in prior editions, had tremendous perspective on the subject and were able to harness that knowledge to gauge what works.

To date, 5th edition has presented some of the tabletop titan's richest fantasy imagery, melding scope, scale, and heightened realism into a majestic visual feast that entices the reader to leap into the image on a dramatic adventure. With the past as its guide, there is no reason 5th edition won't complete its quest to be the finest version of Dungeons & Dragons yet, and its sales figures and player base, which has more than tripled since 4th edition—roughly 8.6 million Americans alone according to Wizards' 2017 estimates—seem to agree.

ABOVE AND RIGHT The 2014 *Starter Set* provided something that the other beginner sets never had: textured dice.

OPPOSITE A photo-realistic wall of curios and in-world horrors, illustrated by Cyril Van Der Haegen, give readers a sense of place and reality in the 5th edition *Player's Handbook*.

PREVIOUS SPREAD This marketing art by Tyler Jacobson for the release of the 2015 *Rage of Demons* campaign book shows Zuggtmoy, Demon Queen of Fungi, at her wedding to Juiblex.

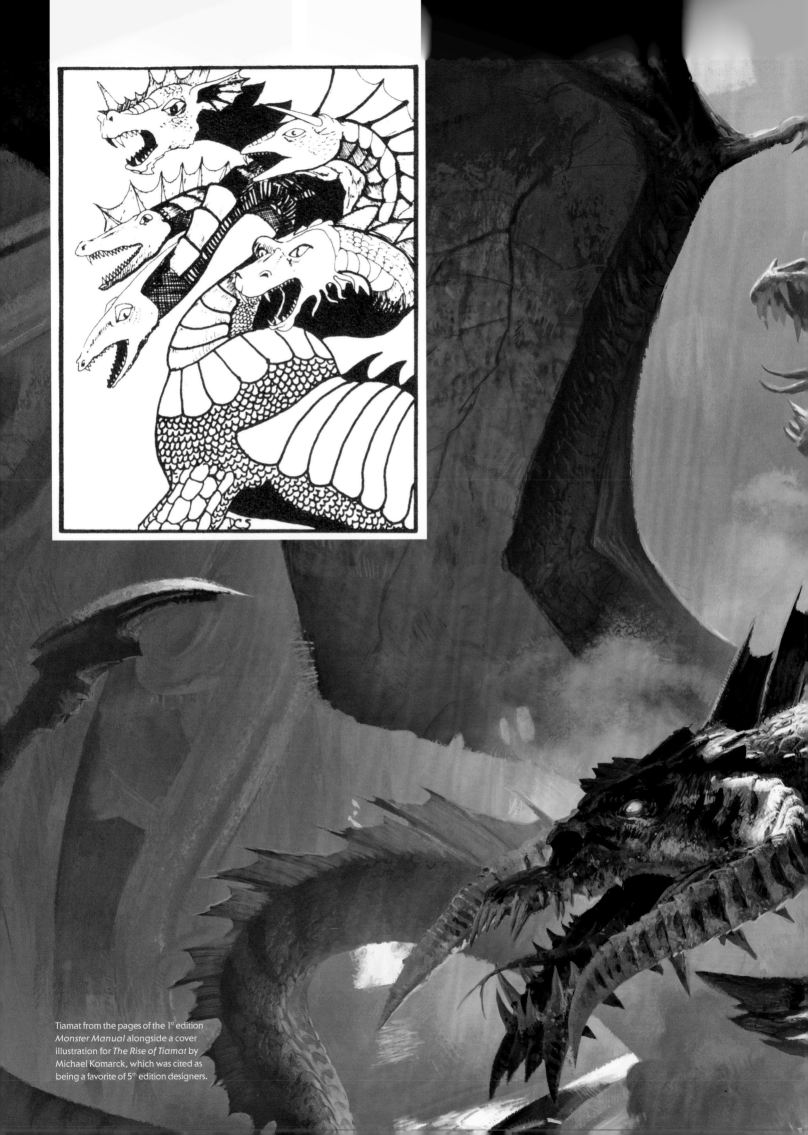

Tiamat from the pages of the 1st edition
Monster Manual alongside a cover
illustration for *The Rise of Tiamat* by
Michael Komarck, which was cited as
being a favorite of 5th edition designers.

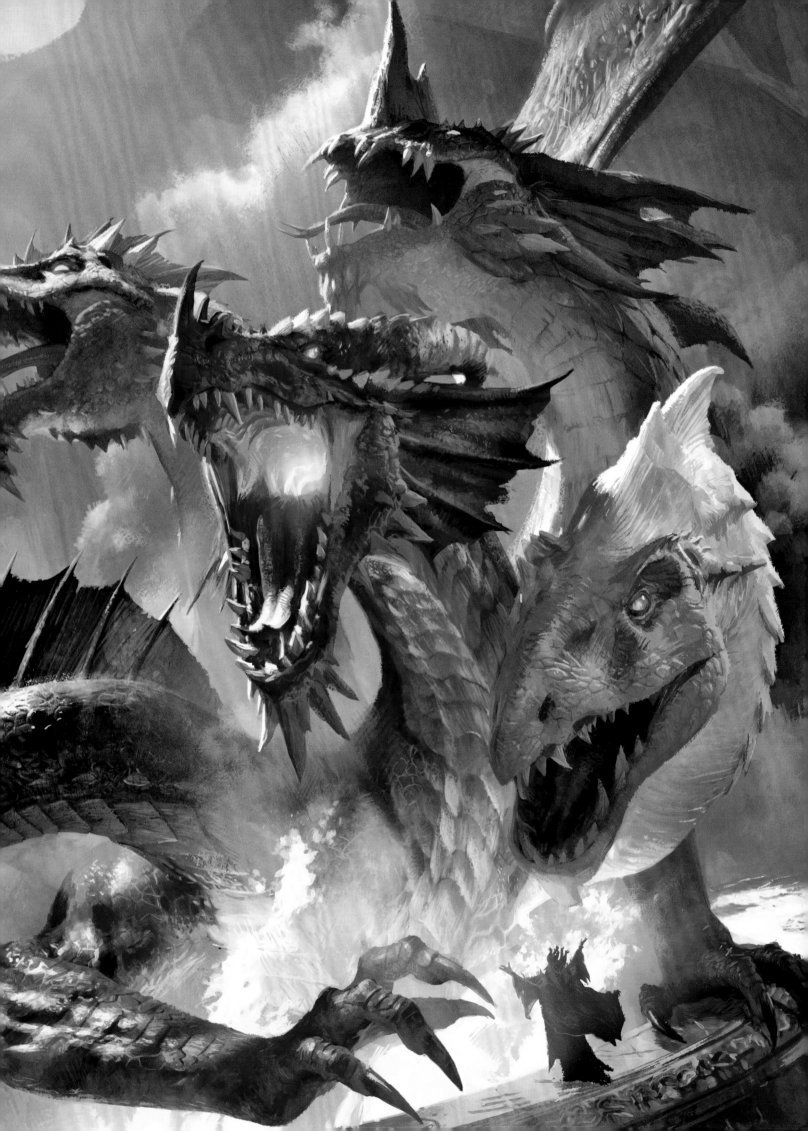

TABLETOP EVERYWHERE

A pencil is sharpened, eraser at the ready. A *Player's Handbook* lies open to spells beside a freshly filled-out character sheet; a set of translucent dice gleams in the hazy basement light. The Dungeon Master ominously sets the scene: *"A low, flat-topped hill, about two hundred yards wide and three hundred yards long, protrudes from the earth. Ugly weeds, thorns, and briars grow upon the steep sides and bald top of the sixty-foot-high mound. Black rocks crown the hilltop . . ."* Yet this game won't be played in one room; its players will be seated across the world from each other on different continents, adventuring in real time together over the Internet, sharing everything except the same bowl of cheese puffs. Welcome to modern D&D.

Since 1974, game designers, Dungeon Masters, and players alike have striven to find new ways to visualize and experience Dungeons & Dragons. The very nature of the game elicits that raw desire. Its innovative design and adherence to detail provides a level of fantasy realism that the game demands. But while Dungeons & Dragons was birthed as a tabletop game, over its storied, forty-plus year history there have been countless attempts to translate the unique communal experience into whatever digital format was en vogue.

Early D&D computer games were archaic at best, borrowing basic visual and mechanical content, remaining largely solitary experiences that merely hinted at the medium's potential. Later, console-style games emboldened by innovations in graphics offered collaborative ways to conjure spells and cross swords with bits and bytes, but these forays remained incapable of harnessing the unpredictability of their pen and paper counterpart. Meanwhile, immersive MMORPG-style build-outs afforded players to connect globally via avatars, but these formats never yielded products as potentially expansive or endless as the tabletop version, often struggling to capture the collaborative storytelling element so fundamental to the core of classic Dungeons & Dragons.

Despite several attempts to capture the correct balance of analog and digital role-playing, such as the unrealized 4th edition D&D "virtual table," it wasn't until independently produced software like Roll20 and Fantasy Grounds hit the scene that synergy was finally achieved. Players from around the world can "meet up"

to enjoy the game as it was intended to be experienced: together. Gaming groups are no longer limited to the neighborhood. With a global community at everyone's fingertips, the emphasis has shifted back to the basics. And Dungeons & Dragons is free to be what it was designed to be: a communal role-playing game.

These innovations have done more than unite players; they also have made gameplay easier and more interactive for people actually in the same room. The flat screen becomes the tabletop and quite often, literally, the map. Ever-changing stats are instantly collected and reflected for all to see. How bloodied is that harpy? Well, now a player can see based on the hue of the token's life status. Even the map is synced with character movement, unveiling obstacles, traps, monsters, and secret doors as they would actually be experienced. Tools like "dynamic lighting" grant the Dungeon Master another level of detail so that players see only what they are capable of seeing, capturing the true spirit of the "fog of war."

And with this has emerged a newfound audience of not just players, but viewers. For decades, it was inconceivable that people would ever *watch* strangers play D&D. But video websites like Twitch and YouTube have proven that not only is there a massive audience for this new form of content, but there is just as much desire to watch Dungeons & Dragons as there is to play it.

Matt Mercer's acclaimed Geek & Sundry-produced series *Critical Role*, which follows the trials and tribulations of a group of heroes known as Vox Machina, took the web by storm when it launched in 2015. On *Critical Role*, veteran voice actors are filmed playing classic-style D&D, recorded and distributed using the latest tech available. The ever-present banter synonymous with role-playing games finally has returned to the digital game, as role-playing resumes center stage, with camaraderie as the main attraction.

Shows like *Critical Role* have vaulted firmly to the forefront of a gaming revolution. At popular conventions like PAX, fans gather by the thousands to watch D&D be played live on stage and broadcast simultaneously to tens of thousands more on shows such as *Acquisitions Incorporated*, usually Dungeon Mastered by a Wizards of the West Coast staffer such as Chris Perkins. A new form of entertainment has been born. Not to be left behind,

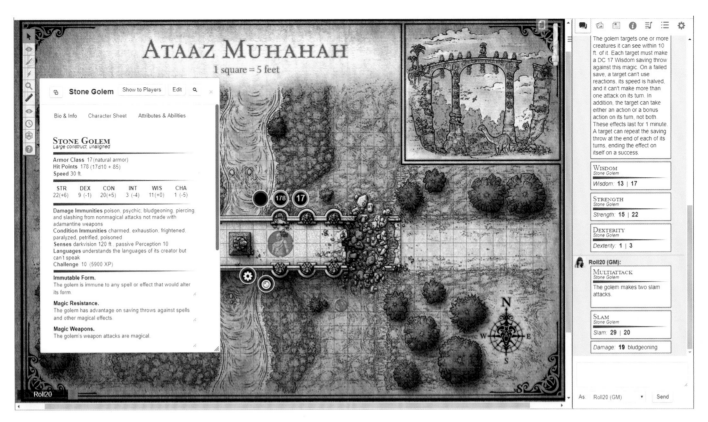

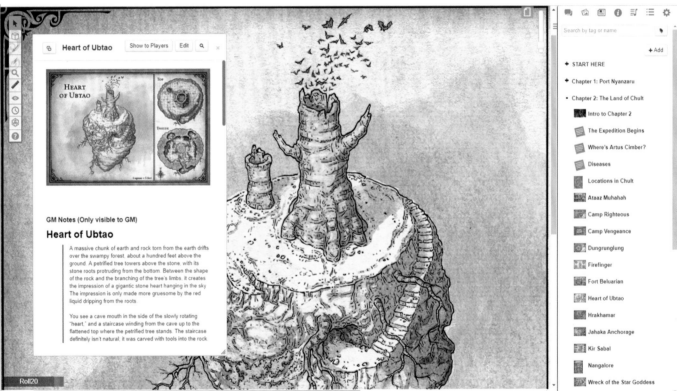

The Roll20 virtual tabletop features video conferencing, interactive maps, and digital dice, providing everything a Dungeon Master needs to run D&D games for friends online.

WHO NEEDS TO HANG AROUND?
I'VE GOT CRITICAL ROLE

JOIN THE ADVENTURE
AND BE A PART OF
THE NEW CAMPAIGN
FROM THE VERY BEGINNING.

STARRING **MATT MERCER, LIAM O'BRIEN, ASHLEY JOHNSON, LAURA BAILEY, TALIESIN JAFFE, MARISHA RAY, SAM RIEGEL,** AND **TRAVIS WILLINGHAM**

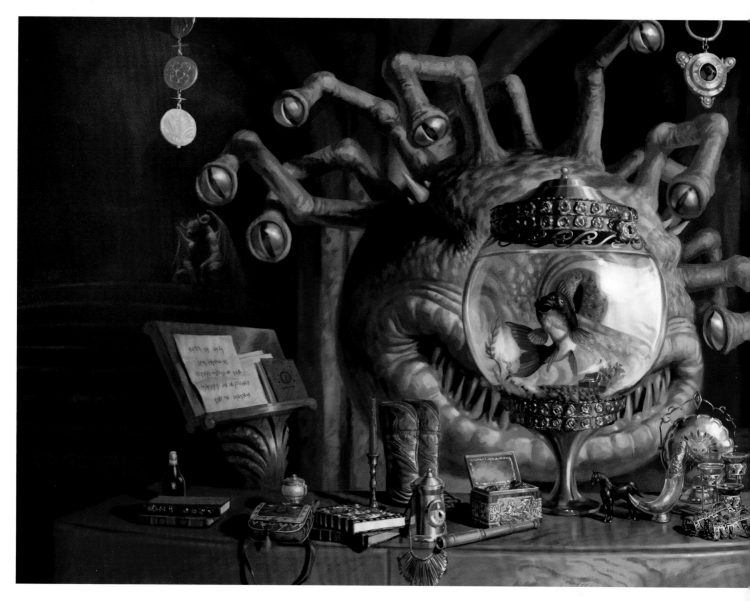

ABOVE Jason Rainville's cover art to the best-selling 2017 D&D supplement *Xanathar's Guide to Everything*.

OPPOSITE The cast of *Critical Role* gives a fun nod to one of the game's most famous ads of the 1980 (see page vi). Has the game finally become cool? Millions of subscribers seem to think so.

Wizards of the Coast launched their own series, *Force Grey*, also Dungeon Mastered by *Critical Role*'s Matthew Mercer, to promote their current campaign releases. All of this attention bodes well for the health of the brand, proving again that D&D is much more than just a game.

But has any of this new attention and innovation altered the traditional "hands-on" allure of the game? Miniatures have and always will be a vital component of the way the role-playing game is played. Mercer often utilizes them along with three-dimensional, modular, miniature settings created by companies like the Kickstarter-driven Dwarven Forge to help visualize combat for both players and viewers alike.

Just as 5th edition looked to the game's roots for inspiration, the modern player remains seemingly nostalgic for homebrew adventures, pencil-filled character sheets, and self-rolled dice, indicating that the tactile experience may be more coveted than ever. Perhaps this resurgence of vintage-style play, and the

dramatic boom in the tabletop gaming industry in general, is providing a reprieve from the sensory overload of PlayStation, Xbox, and the like. Why have computer game designers do your imagining for you? Wizards continues to tap in to the creative reserve of its player base to this day: through the Dungeon Masters Guild, a partnership between Wizards and OneBookShelf, the D&D community can publish its own adventures, and even expansions to the rules, in a common marketplace, a step beyond even the OGL that propelled so much industry growth around 3rd edition.

One thing is certain: the modern player remains open to new ways to visualize the game. While the rich universe and mythology will always inspire new interpretations, the digital tools designed to expand the tabletop experience have become the norm. This blend of physical and digital within Dungeons & Dragons remains totally unique—a new, hybrid style of play bringing out the best of the game, while taking a battering ram to old barriers and conceptions.

Miniature terrain-maker Dwarven Forge's 2017 "Dungeon of Doom" Kickstarter raised a record-breaking $3 million, bringing their fan-funded campaign total into the tens of millions.